"Michael Bruner has managed to beautifully convey the strange wonder of Flannery O'Connor's fiction. Even as he locates more precisely the sources of O'Connor's theological structure, he deftly shows the deep power and beauty of her images. This could well be the spark of an O'Connor revival!"

William Dyrness, author of *Insider Jesus*

"Michael Bruner's new book on Flannery O'Connor is as radical as its title suggests, showing that O'Connor is one of the most accomplished modern writers of Catholic theological aesthetics. Tracing this accomplishment not only to the familiar foundations of Thomism, Bruner breaks new ground in O'Connor studies by discussing in detail the influence of Friedrich von Hügel upon her work, showing how this early twentieth-century Austrian Catholic helped O'Connor understand the importance of the theological transcendentals in great art. Seeing O'Connor's work as an expression of the many subversive elements of the Christian gospel, Bruner's critical approach helps us understand how O'Connor asks us to reimagine what beauty, goodness, and truth might mean in the modern world."

Gregory Maillet, professor of English, Crandall University

"Asked to adapt Flannery O'Connor's final novel, *The Violent Bear It Away*, into a screenplay, Michael Bruner found that the assignment brought him closer to the beating heart of the author's fiction than he had ever felt as a literary critic. In effect rewriting *The Violent Bear It Away* from the inside out rather than from the outside in, Bruner came to appreciate 'her startling and sometimes pulverizing vision of things.' He felt he understood the 'theological profundity' of her fiction more fully, especially the profound care she brought to her deeply flawed, often grotesque characters. She regarded her backwoods prophets, Bruner tells us, with an 'almost primal, filial empathy as a fellow sufferer on the road to redemption.' In *A Subversive Gospel*, Bruner helps readers understand that O'Connor's fiction is founded upon limitations: the disease she inherited from her father, the demands of her craft, and what he calls her 'unwavering adherence to the strict delineations, even confines, of Christian dogma.' Such limitations explain, in part, why O'Connor 'wrote with such ferocity.' Equally attuned to her penchant for tragicomedy and to her theological fluency (the Austrian theologian Friedrich von Hügel, neglected by previous scholars, looms over this account), Bruner provides a compelling reading of the redemptive quality of O'Connor's major work. As Bruner aptly describes it, 'she was performing surgery on the soul, without anesthesia.'"

Mark Eaton, professor of English, Azusa Pacific University, editor, *Christianity & Literature*

A SUBVERSIVE
GOSPEL

FLANNERY
O'CONNOR
AND THE
REIMAGINING
OF BEAUTY,
GOODNESS,
AND TRUTH

Michael Mears Bruner

IVP Academic

An imprint of InterVarsity Press
Downers Grove, Illinois

InterVarsity Press
P.O. Box 1400, Downers Grove, IL 60515-1426
ivpress.com
email@ivpress.com

InterVarsity Press® is the book-publishing division of InterVarsity Christian Fellowship/USA®, a movement of
students and faculty active on campus at hundreds of universities, colleges, and schools of nursing in the United
States of America, and a member movement of the International Fellowship of Evangelical Students.
For information about local and regional activities, visit intervarsity.org.

Cover design: David Fassett
Interior design: Beth McGill and Daniel van Loon
Images: Flannery O'Connor: © Joseph De Casseres/Getty Images
 pattern: © EnginKorkmaz/iStockphoto

ISBN 978-0-8308-5066-2 (print)
ISBN 978-0-8308-9036-1 (digital)
Printed in the United States of America ∞

Library of Congress Cataloging-in-Publication Data

Names: Bruner, Michael Mears, 1965- author.
Title: A subversive gospel : Flannery O'Connor and the reimagining of beauty,
 goodness, and truth / Michael Mears Bruner.
Description: Downers Grove : InterVarsity Press, 2017. | Series: Studies in
 theology and the arts | Includes bibliographical references and index.
Identifiers: LCCN 2017038107 (print) | LCCN 2017033991 (ebook) | ISBN
 9780830890361 (eBook) | ISBN 9780830850662 (pbk. : alk. paper)
Subjects: LCSH: O'Connor, Flannery--Criticism and interpretation. |
 Christianity in literature. | Truth in literature.
Classification: LCC PS3565.C57 (print) | LCC PS3565.C57 Z616 2017 (ebook) |
 DDC 813/.54--dc23
LC record available at https://lccn.loc.gov/2017038107

P	25	24	23	22	21	20	19	18	17	16	15	14	13	12	11	10	9	8	7	6	5	4	3	2	1
Y	36	35	34	33	32	31	30	29	28	27	26	25	24	23	22	21	20	19	18	17					

To my wife, Jenna, and my two children,

Arabelle Rose and William Smiley

Tarwater clenched his fist. He stood like one condemned, waiting at the spot of execution. Then the revelation came, silent, implacable, direct as a bullet. He did not look into the eyes of any fiery beast or see a burning bush. He only knew, with a certainty sunk in despair, that he was expected to baptize the child he saw and begin the life his great-uncle had prepared for him. He knew that he was called to be a prophet and that the ways of this prophecy would not be remarkable. His black pupils, glassy and still, reflected depth on depth his own stricken image of himself, trudging into the distance in the bleeding stinking mad shadow of Jesus, until at last he received his reward, a broken fish, a multiplied loaf. The Lord out of dust had created him, had made him blood and nerve and mind, had made him to bleed and weep and think, and set him in a world of loss and fire all to baptize one idiot child that He need not have created in the first place and to cry out a gospel just as foolish.

FLANNERY O'CONNOR, THE VIOLENT BEAR IT AWAY

Who hath believed our report? and to whom is the arm of the Lord revealed?

And he shall grow up as a tender plant before him, and as a root out of a thirsty ground: there is no beauty in him, nor comeliness: and we have seen him, and there was no sightliness, that we should be desirous of him:

Despised, and the most abject of men, a man of sorrows, and acquainted with infirmity: and his look was as it were hidden and despised, whereupon we esteemed him not.

ISAIAH 53:1-3

And from the days of John the Baptist until now, the kingdom of heaven suffereth violence, and the violent bear it away.

MATTHEW 11:12

But the sensual man perceiveth not these things that are of the Spirit of God; for it is foolishness to him, and he cannot understand, because it is spiritually examined.

1 CORINTHIANS 2:14

Contents

List of Excursuses

Acknowledgments

We are instructed by our limitations, and so it was only with the generous help of those around me, who could see further and delve deeper into the many aspects of this present concern, that this project found its voice.

This book came out of my dissertation, and I am particularly indebted to my first and second mentors, Robert Johnston and William Dyrness, who served as my able guides through the crossdisciplinary labyrinth that this study represents. Bill, my suitemate seven cubicles down on the second floor of the Huntington Library, introduced me anew to Dante's *Commedia* and, more specifically, to the problem of beauty. He also introduced me to Robert Johnston, whose expertise in theology and literature and steady editorial hand made the pursuit of this project not only possible, but joyfully so. This book would have been considerably weaker without Rob and Bill's indispensable help over these many years, and they have my sincerest thanks. I also want to thank Ralph Wood, my third reader, for his unsparing—nay, withering—critique at this project's dissertation stage, which I can only hope helped to improve what you now hold in your hands. His comments, bracing as they were, are the kindest form of flattery.

And then there are those who allowed me the resources—personal, spiritual, and financial—to pursue this course of study. Film writer, director, and friend Scott Derrickson thrust O'Connor into my lap back in 2009 when he, along with another friend, film producer Ralph Winter, invited me to write a screenplay adaptation of O'Connor's *The Violent Bear It Away*. The Fraser Fund Scholarship, under the auspices of the First Presbyterian Church of Hollywood and the fund's able custodian, Arlene Creitz, funded my entire educational journey. What does one say in the face of such immense indebtedness—or, in my case, the lack of it? I wrote the bulk of this

study in my home away from home, the Huntington Library in San Marino, where I was given blissful quiet and acres of space, two things much needed to get any good writing done.

I must also thank William Sessions (Requiescat in pace), friend of Flannery O'Connor's and friend of mine, and Louise Florencourt, O'Connor's first cousin and manager of the O'Connor estate, for their generous time, indispensable help, and kind attention. They showered me with southern hospitality and Christian charity. I am grateful to both of them for their personal insights into their friend and cousin.

The latest addition to this village of collaborators, my editor, David McNutt, gifted me with his patience, encouragement, and, above all, unblinking editorial eye for detail as well as the big picture, all of which allowed me to see this project through to its completion.

As for my family, I can only repeat what they have been hearing for years: thank you, thank you, thank you! My parents, Dale and Kathy Bruner, showed an abiding interest in this journey each step of the way, and their support in every conceivable form—from daily babysitting and early-morning conversations at the local Starbucks about the various drafts of the project (they read each chapter at least five times!) to prayers offered up on my behalf every evening—was the glue that kept this whole enterprise together. And words cannot suffice for the countless blessings I received from my wife, Jenna, and my two children, Arabelle Rose and William Smiley, who lived this study from start to finish and whose unbounded patience and good humor saw me through it all. This is how love is made . . . and how this book was written. So I dedicate this book to them as a humble sign of my deepest gratitude and abiding affection.

Abbreviations

CW Flannery O'Connor. *O'Connor: Collected Works*. New York: Literary Classics of the United States, Inc, 1988.

Essays Friedrich von Hügel. *Essays and Addresses on the Philosophy of Religion*. 2 vols. London: J. M. Dent & Sons, 1921–1925.

HB Flannery O'Connor. *The Habit of Being: Letters of Flannery O'Connor*. Edited by Sally Fitzgerald. New York: Farrar, Straus and Giroux, 1979.

Letters Friedrich von Hügel. *Letters to a Niece*. Chicago: Henry Regnery, 1955.

MM Flannery O'Connor. *Mystery and Manners: Occasional Prose*. New York: Farrar, Straus and Giroux, 1970.

Mystical Friedrich von Hügel. *The Mystical Element in Religion as Studied in Saint Catherine of Genoa and Her Friends*. London: J. M. Dent & Sons, 1923.

Prayer Flannery O'Connor. *A Prayer Journal*. Edited by William Sessions. Journal New York: Farrar, Straus and Giroux, 2013.

VBA Flannery O'Connor. *The Violent Bear It Away*. New York: Farrar, Straus and Giroux, 1960.

WB Flannery O'Connor. *Wise Blood*. New York: Harcourt, Brace, 1952.

Introduction

A Medieval Modern

There may never be anything new to say, but there is always a new way to say it.

FLANNERY O'CONNOR, *MYSTERY AND MANNERS*

This book makes the argument that, through her fiction, Flannery O'Connor subverted the conventional notions of truth, goodness, and beauty, not merely from a position of Christian dogma but out of an aesthetic impulse. O'Connor loved God and loved literature, and through her unique expression of this dual affection, her stories serve as a dual critique—a call to arms, really—against both the weak-kneed sentiments of conventional religion and what she termed the "domesticated despair" of contemporary culture's narrative.[1] One of O'Connor's essential points is, in fact, that devotion to Jesus Christ is as much a matter of aesthetic commitment as it is of religious devotion. Old Mason Tarwater doesn't simply stand as a backwoods bulwark against the atheism of his urban nephew, but he ridicules and resents Rayber's urbane sophistications and academic pretensions. Hulga Hopewell wouldn't be nearly as pathetic and tragic of a character if she didn't have a PhD, which causes her to openly resent the backward ways of her bumpkin ("good country") mother. As it happens, O'Connor's aesthetic impulse and religious devotion were of a piece, which made her writing an act of creative disobedience against the banalities of modernity in all its forms, both religious and

[1] O'Connor, *Mystery and Manners: Occasional Prose* (New York: Farrar, Straus and Giroux, 1970), 159. Hereafter *MM*.

secular, and such creative disobedience was meted out directly on her characters and, indirectly, on her readers.

By subverting conventional notions of beauty, goodness, and truth, O'Connor is not extolling their opposites—ugliness, evil, and dissemblance. It isn't as if what is ugly is actually beautiful, or what is true suddenly appears as a lie, or what is evil is actually divine goodness. She is instead suggesting, by creative implication through her fiction, that our conventional categories be baptized, as it were, to include their divine extensions, so that what is beautiful is also sometimes terrible, and what is true is also sometimes foolish, and what is good is also sometimes violent. Seen in this way, the conventional notions of the transcendentals are not wrong so much as they simply do not exhaust the category.

In order to understand O'Connor's subversion, I am suggesting that we apply a kind of *crucifix hermeneutic* to her fiction—a kind of crosshairs reading that alerts us to the fact that when something violent happens in her stories, or someone is or says or does something foolish, or something terrible or awful appears, there is a decent chance that O'Connor is actually trying to show us something good, true, or beautiful, respectively.[2] We look to the example of Jesus on the cross, whose death was violent even by Roman standards, whose cry of dereliction was ridiculed as he was left hanging on the tree for dead, and whose form was marred beyond recognition. In that cosmic and very local moment, goodness, truth, and beauty reached their divine apex, thus not merely extending but exhausting—even exploding—the categories of the Greeks and thenceforth establishing a new order of things, a new way of seeing.

Another way to understand this dual dynamic in O'Connor and her fiction is by suggesting that she subverted the conventional understanding of the transcendentals of goodness, truth, and beauty not simply because of her tenacious commitment to orthodox Christian dogma, but because she herself was a subversive. O'Connor was, in some sense, out of time and place in the twentieth-century South, not so much an old soul as a medieval modern whose life was an indictment of the "fashionable" in almost all its contemporary forms, a fact that her location in rural Georgia additionally demanded. Indeed, she was not only a practicing Catholic in the fundamentalist stronghold of rural Georgia but also an unconventional artist who lived with

[2]I had been teaching O'Connor's short stories for years to my students at a Christian university, and I always looked forward to shocking them with the news that O'Connor was a deep and avowed Christian.

her mother on the family farm. The first allowed her to criticize the tawdry conventions and folksy theologies of American religion (of the fundamentalist, mainstream liberal, and Roman varieties), and the second gave her freedom to blast the popular pretensions of the literary and cultural establishment. In this sense, O'Connor was a true subversive in both method and temperament, in both theological convictions and artistic commitments. She was a fiercely independent thinker of the most rarified kind, not by simply opposing stodgy or traditional ways of thinking (which would have simply been fashionable) but by resisting the fashions of the day, both literary and religious. Yes, she was confirmed in the Roman Church and schooled at the Iowa Workshop, but neither prevented this iconoclastic southern writer from being an equal critic of both religious guilds and literary traditions.[3]

MEDIEVAL TO MODERN: THE ROOTS OF THIS STUDY

My true initiation into O'Connor began in the second year of my doctoral program at Fuller Seminary in Pasadena, which had evolved in its first year toward my intention of becoming a late medievalist. In retrospect, this proved to be invaluable preparation for my work on O'Connor, though at the time O'Connor was the furthest thing from my mind. I spent a considerable amount of that first year examining Aquinas and his Scholastic contemporaries, reading Dante, and musing over the notion of *theologia poetica*.[4]

[3]This book also claims that the writings of Friedrich von Hügel, a fellow subversive, exercised a deep influence on O'Connor, which gave rise to—or at least served as a benediction upon—her subversive posture.

[4]I was considering a dissertation that would explore the dialectic of beauty and terror from a theological perspective. More specifically, I was interested in how the notion of *theologia poetica* (see Stephen John Campbell, *The Cabinet of Eros: Renaissance Mythological Painting and the Studiolo of Isabella D'Este* [New Haven, CT: Yale University Press, 2004]) might be related to the church's elevation of beauty as one of the transcendentals and how such a dialectic might be used to more fully understand the distorting effects of sin on our temporal apprehensions of beauty. Such an elevation of beauty (to the level of the transcendentals) is generally attributed to Bonaventure, but it is also associated with Aquinas—often via Jacques Maritain—and it finds its contemporary expression in Hans Urs von Balthasar. Aquinas never explicitly states that beauty is one of the transcendentals, but he implies as much in his *Summa* and elsewhere when he states, for example, that all things are beautiful because they exist. See Leo J. Elders, *The Metaphysics of Being of St. Thomas Aquinas in a Historical Perspective* (Leiden: E. J. Brill, 1993), 140, for a fuller treatment of this question. See also Umberto Eco's study on Aquinas, *The Aesthetics of Thomas Aquinas* (Cambridge, MA: Harvard University Press, 1988), and Alice Ramos's highly readable *Dynamic Transcendentals: Truth, Goodness, and Beauty from a Thomistic Perspective* (Washington, DC: Catholic University of America Press, 2012), both of which serve as wonderful primers on the aesthetics of Aquinas and on his theology in general, especially as it relates to the transcendentals.

In the fall term of my second year, I received an invitation to write a screenplay adaptation of O'Connor's second novel, *The Violent Bear It Away*, which I immediately accepted. There was, however, the prickly issue of my doctorate. I could not pursue both and do both well. To enter into the screenwriting process would require a wholesale shift of attention, not only in research emphasis from the Europe of the late Middle Ages to the twentieth-century American South, but in writing style, from academic dissertation to creative fiction. I considered, for a brief moment, dropping out of the program altogether. I was at a crossroads.

Then I made the only sensible decision someone in my position could make: I changed the focus of my doctoral program from the medieval world of Aquinas to the Christ-haunted South of Flannery O'Connor. To my immense relief and surprise (and with the crucial blessing of my doctoral mentors), in making such a leap I immediately saw the deep affinities between O'Connor and the man she considered in many ways her spiritual mentor. She once referred to herself as a "hillbilly Thomist" and wrote of Aquinas, "I feel I can personally guarantee that St. Thomas loved God because for the life of me I cannot help loving St. Thomas."[5] In another letter, O'Connor expresses exasperation that someone hadn't acknowledged her self-identification with St. Thomas.[6] Needless to say, O'Connor's theological debt to Aquinas is immense, and so the rationale for making a mid-course correction in my doctoral program was, surprisingly enough, there for the taking.[7] A critical piece of the puzzle, one that has ineluctably influenced my approach to O'Connor, was thus cemented: my primary introduction to the woman and her work was not as a reader, but as a writer.

In being tasked to adapt *The Violent Bear It Away* into a screenplay, I was forced to read each line of that novel multiple times, seeing the whole, and then each part—each scene and transition—with an eye toward retelling the story. I wrote draft upon draft, struggling to picture young Francis and his backwoods great-uncle and *Pater Patriae* of Powderhead, Mason Tarwater, in

[5]Flannery O'Connor, *The Habit of Being: Letters of Flannery O'Connor*, ed. Sally Fitzgerald (New York: Farrar, Straus and Giroux, 1979), 93. Hereafter *HB*.

[6]Ibid., 125.

[7]O'Connor also acknowledged debt to her contemporary Jacques Maritain, whom she considered an artistic mentor, and he himself a devotee of Aquinas, which only strengthened the legitimacy of such a chronological leap. The spirit of Aquinas was very much alive, in other words, in O'Connor.

such a way that they would be brought to life in my mind and then on the screen. I struggled, as I learned that O'Connor had, to faithfully render the character of Rayber, the more urbane and educated uncle, and his "idiot child" Bishop without caricaturing either or reducing them to "types."[8] I tried to sense—somehow to *see* and *hear*—the contours of each of O'Connor's characters and their twisted and complicated, urgent but primal, multilayered relations. I listened to each syllable of O'Connor's diction, felt around in the dark for the crucial gesture in each scene, and forced myself to ask at almost every turn why she had gone *this* way instead of *that*, why her characters had said *A* instead of *B*. I tried, most audaciously, to echo O'Connor's diction in my own. I lived in the world of *The Violent Bear It Away* full time for nearly half a year, and it was a harrowing experience, one I would never repeat.

And yet it left me with something I now understand to be an indispensable element in my appreciation and understanding of O'Connor. As I attempted to live inside her head and to read and rewrite her central story from the inside out rather than from the outside in, I was given the opportunity to catch a glimpse of her startling and sometimes pulverizing vision of things and got to meet firsthand "the twisted, the neurotic, the guilt-ridden and God-haunted protagonists who might best be designated '*criminal compulsive*' [but] who serve as spiritual catalysts in the central conflict of her fiction."[9] Trying to live inside her world was a bracing experience—the normal filters that would have been in place had I come from a position of merely academic curiosity were gone. The experience left an indelible mark, not only on my view of the artistry and theological profundity of her fiction and on the woman herself, but also on me and on my approach to her stories.

I grew to appreciate, for example, the care she gave to her characters in the midst of the terrible things she inflicted on them, a care that came not only from a well of creative and theological concern but also from an almost primal, filial empathy as a fellow sufferer on the road to redemption—as another grotesque, in other words: "When you write about backwoods prophets, it is very difficult to get across to the modern reader that you take these people seriously, that you are

[8]This is the danger in any attempt to fit O'Connor's method too neatly into a theological system or literary critical school.

[9]Preston Browning, as quoted in *Flannery O'Connor: An Annotated Reference Guide to Criticism*, ed. R. Neil Scott (Milledgeville, GA: Timberlane Books, 2002), 702.

not making fun of them, but that their concerns are your own and, in your judgment, central to human life."[10] It took one to create one, I supposed—"It takes a story to make a story."[11] Her unique empathy for her characters also led me to understand something else: the more obvious limitations and constraints for which she was well-known—her lupus, her "confinement" on a farm in Georgia, her absolute commitment to the unforgiving demands of her craft, and her un-wavering adherence to the strict delineations, even confines, of Christian dogma— were not grist for the self-pity mill but rather divine graces met upon her. Her limitations were the creative frame out of which she wrote, in other words, and were also a reason that she wrote with such ferocity.

Coming to Terms

T. S. Eliot argued that theology as a mode of inquiry should be applied to fiction only if the text yields up issues proper to theology in some significant way.[12] Eliot's position on the matter serves as a central rationale for this book. Flannery O'Connor's fiction is particularly suited for theological interpre-tation precisely because it is so theologically freighted. Indeed, O'Connor, perhaps more than any other American writer, presents us with the perfect model for such an inquiry because she saw herself not merely as an artist, but as an artist in the tradition of Jacques Maritain, who believed that the *habitus* of the artist was an intrinsic and crucial element in all artistic considerations.[13]

But what does it mean to engage literature from a theological perspective— or at least what do I mean by such an engagement—and what is accomplished in such an endeavor?[14] This book is, in part, an answer to both questions.

[10]*MM*, 204. O'Connor confided to a friend that she probably wouldn't have liked her characters very much but that she had "unbounded tolerance" for them, "however sordid, because they were all in some sense herself." Thomas Gossett, "Flannery O'Connor on Her Fiction," *Southwest Review* 51, no. 1 (Winter 1974): 35. As to the careful attention she exerted on her craft to write the novel, the novelist E. L. Doctorow contended that even though O'Connor wrote "down" to her characters, she nonetheless loved them (from an on-stage interview at the "Startling Figures" conference in Milledgeville, Georgia, April 15, 2011).

[11]*MM*, 202.

[12]T. S. Eliot advocated for the distinction between literature that has theological import and that which does not in his seminal essay, "Religion and Literature," in *Essays: Ancient and Modern* (New York: Harcourt, Brace, 1932), 92-115.

[13]This crucial word, *habitus*, will be discussed at length throughout this study. In short, it indicates an artist's interior disposition toward any particular mode of creation.

[14]In the introduction to her book, *Conversations with Flannery O'Connor* (Jackson: University Press of Mississippi, 1987), Rosemary Magee acknowledges O'Connor's ability to weave the two seemingly incon-

There is another challenge pertinent to the concerns of this study, which is the relationship between art and the Spirit of God, as well as the relationship between those and the interpreting—or reading—subject. From a theological critical-realist perspective, neither human subject nor artistic object is an autonomous entity inhabiting its own epistemic vacuum.[15] An author enters into a story as a story enters into an author. In an analogous way, as God enters inscrutably into creation, so, too, an artist is ineluctably present in the work of her hands. Indeed, the entire world is shot through with the Spirit of God, who moves in and through the things of this world, so that any methodology or approach that presumes to engage art without acknowledging the primary agency of the Spirit is, from a theological perspective, crucially limited.[16] God is in the midst of creating and inspiring us as we ourselves are inspired to create, and in mysterious and unmeasurable ways the Spirit inspires the artist, who is, after all, created in the image of God, this God who is, finally, the first subject and final object in all artistic endeavors, even when those very endeavors (and those who engage in them) make every effort to deny, distort, or destroy the *imago Dei* in themselves. The *imago Dei* is intrinsic to the creative process as such, even when the artist has no intention of reflecting the image, or consciously wants to deny or destroy it.

Immanuel Kant set the modern aesthetic agenda by defining the terms implicit in all artistic engagement—for both interpreter and creator—which, he argued, involved multiple interactions occurring simultaneously.[17] Not only are we engaging the object of art itself as its viewing and apprehending subject, but also we ourselves are actively being engaged both by the culture around us and by what Kant called "common sense," those categories of mind that are both

gruous worlds of literature and religion together, writing that "for O'Connor, the fabric of her life and her theology was interwoven with her fiction" (ix-x) and that "despite the different ends of theology and literature, [O'Connor] managed to integrate them; she then added a strong dose of common sense" (xi).

[15]This perspective understands the Spirit of God to be an epistemic reality who must be accounted for in all genuine construals of reality. It also claims that the object of study determines the method of study. See a classic expression of this in T. F. Torrance's *The Christian Frame of Mind: Reason, Order, and Openness in Theology and Science* (Colorado Springs, CO: Helmers & Howard, 1989), esp. xxiv, 70-73.

[16]The rich and varied tradition of the Orthodox view of icons is instructive here, icons being those images and sounds that mediate or reflect the image of God through their material existence (as opposed to idols, which purport to embody the image in themselves).

[17]Immanuel Kant, *Critique of Judgment*, trans. J. H. Bernard (New York: Dover, 2005), 27-57. See in particular his "Critique on Aesthetical Judgment" and the first, second, third, and fourth "moments" of critical engagement.

necessary and universal and that allow for aesthetic judgments. A crucial element was left out of Kant's equation, however, which Hans Urs von Balthasar and others attempted to put back, which is the role of the Spirit of God in the aesthetic transaction. The object, like the subject, has a life of its own by virtue of its having been created, which gives its significance greater substance—*anima*—than what is contained, say, in a mere inanimate object. The text, thus, is no latent artifact created in a vacuum and signifying into neutral space. The more the Spirit is made manifest in the work, the greater the work's resonance, since this same Spirit is "imaged" in both writer and reader.[18]

EXCURSUS: KANT AND VON BALTHASAR ON AESTHETICS

Kant acknowledges the role of the spirit (small *s*) in the act of creation when he talks about the role of "genius" in artistic production and apprehension, which provides "soul" or "spirit" (*Seele* in German) to what would otherwise be uninspired.[19] Kant, following Aristotle, means to suggest an aesthetic aspect that brings something to life over and above its mere material nature, but he does not go far enough, it seems to me, in allowing the object to speak for itself. From Kant's perspective, a work of art must always be *spoken for.*

I should note that Kant's particular representation of beauty as "the object of an entirely disinterested satisfaction" differs significantly from my position regarding beauty and its apprehension, which I believe involves and inherits the vagaries of sin beset by the fall, which can and ultimately must be brought under submission by the interposition of the Holy Spirit, who plays a definitive and redemptive role in all aesthetic judgment.[20] The practical corollary to this is that not everyone sees and apprehends all beauty in the same way, even though beauty itself, in its completed form as the manifestation of goodness and truth, finds its singular origin (and destination) in God.

Regarding the essential difference between Kant's and von Balthasar's approach to aesthetics and philosophy in general, von Balthasar summed it up

[18]See Michael Camille's notion of simulacrum in *Critical Terms for Art History*, ed. Robert S. Nelson and Richard Shiff (Chicago: University of Chicago Press, 1996), 31-44, which draws out the tension between questions of icon and simulacrum. The historic tension is suggestive, it seems to me, of a vigorous dynamism at play in the act of reading, and particularly in the act of reading O'Connor's work.

[19]Kant, *Critique of Judgment*, sect. 49.

[20]Ibid., 33.

best in an interview when he was asked about the difference between him and Karl Rahner: "Rahner has chosen Kant, or if you will, Fichte, [for] the transcendental approach. And I have chosen Goethe, my field being German literature. The form (*Gestalt*), the indissoluble unique, organic, developing form . . . this form, which Kant does not know what to do with, even in his aesthetics . . . one can walk around a form and see it from all sides. One always sees something different, and yet one sees the same thing."[21] One should not assume from this comment that von Balthasar eschews the transcendental categories of beauty, goodness, and truth. On the contrary, he builds his entire program around them. Where he parts from Kant is in his insistence that an objective reality, separate from our apprehension of it, truly does exist in a meaningful semblance, which Kant denied. The transcendental properties of Being, he argued, are not merely attributions set up from the side of subjectivity.

In returning to consider O'Connor, then, we acknowledge that the objective reality of God gives her stories their theological resonance, a resonance that is acknowledged even by those who do not see her theological commitments as being particularly pertinent to her fictional output. One simply cannot ignore the central concerns of her fiction, which always revolve around existential-theological questions of human identity, the fragility of the social fabric, and God's divine purposes—and the mess that is created when they all collide, as they invariably do, in her fiction.

DUAL COMMITMENTS, DUAL CRITIQUES

This book's opening epigraph effectively distills its central thesis: that through the medium of her art, Flannery O'Connor showed her readers how following Christ is a commitment to follow in his shadow, which becomes a subversive act aesthetically ("bleeding"), ethically ("stinking"), and intellectually ("mad"). But to understand *how* and *why* she does this, one must take seriously both her theological and artistic commitments.

O'Connor wrote with one eye trained on her work as an artist and the other trained on Christian dogma as a believer, and the result was, as mentioned

[21]Hans Urs von Balthasar, "Geist und Feuer: Ein Gesprach mit Hans Urs von Balthasar," *Herder Korrespondenz* 30 (1976): 76.

earlier, a critique of dual banalities: of the world's materialist assumptions that serve as a cover for its "domesticated despair" on the one hand, and the church's all-too-often easy spirituality on the other. O'Connor abhorred both banalities to an equal degree and constructed a rigorous challenge to each through her fiction by subverting (if only implicitly) conventional understandings of the transcendentals.

This challenge, so witheringly yet winsomely construed in her writing, reflected O'Connor's method, which was not principally to entertain but to educate and enlighten, even—or especially—if that meant getting hurt in the process.[22] And she does this not with a heavy didactic hammer (though it feels like that at times) but with the rhetorical precision of a scalpel, all the while simultaneously managing to present a picture of faith that is full of vitality and life.[23] When O'Connor writes she is performing surgery on the soul, without anesthesia, and yet she leaves her readers wanting more.

From beginning to end, O'Connor was a Christian writer with dual commitments, both to her artistic mandate as a writer and to her Christian faith as a believer (the same realities that gave rise to her dual critique), and she held firmly to both in equal measure, believing that the best of one did not contradict the other but, on the contrary, reified it. The fruit of such commitments was a bracing collection of tragicomedies in the form of eighteen short stories and two novels, a comparatively small output when measured in words, but a unique and lasting literary legacy when measured in depth of meaning.[24]

[22]O'Connor objected to the idea that she wrote stories to send a message: "I don't write to bring anybody a message . . . this is not the purpose of the novelist" (HB, 147). But she goes on in the same letter to exclaim, "Many of my ardent admirers would be roundly shocked and disturbed if they realized that everything I believe is thoroughly moral, thoroughly Catholic, and that it is these beliefs that give my work its chief characteristics." Modern audiences in particular are afflicted with an aversion to any suggestion that stories may have a message, subliminal or not, as if writers simply signify from a neutral position into empty space. In his review of Wayne Booth's work, Craig Mattson notes that "modernists deny the didactic import of the novelist's work, and postmodernists deny the centered intentionality of the authorial self, [so that] both ignore that an author, or rather an implied author, is always speaking to an audience." Craig Mattson, "Keeping Company with Wayne Booth—A Review Essay," Christian Scholar's Review 38, no. 2 (2009): 298.

[23]As a simple point of lexical, and perhaps theological, interest, it is instructive to note that the word *faith* appears only four times in all of O'Connor's stories, with three of them in a single short story, "The River."

[24]Some may question my characterization of O'Connor's work as tragicomic, but I am with Randall Craig here when he states that "the commitment to realism, with the concomitant resistance to notions of artistic decorum and generic rules, is essential to tragicomedy. . . . Like the realist, the tragicomedian rejects the centrifugal impulse to[ward] purely tragic or comic forms, subordinating genre to a specific conception of the mixed world of human experience." Randall Craig, *The Tragicomic Novel: Studies in a Fictional*

O'Connor's stories are thus to be approached, it seems to me, in a way that is sensitive to both sides of this dynamic—to her artistry and to her faith, to the movement of the Spirit (grace) and to the contours of her aesthetic (nature). O'Connor's deep theological commitments become of paramount importance in considering her literary output, as they give a sense of the level to which she consciously and unconsciously invoked the Spirit of God in the telling of her stories. Anyone who might have questioned that she would make such invocations is answered by the publication of her prayer journal, where page after page is an open invitation—nay, a pleading—for God to be involved in her art. An interpretive approach, then, that is sensitive to this dynamic will consider the significance of the *writer as person* as seriously as it might any technique the writer may possess or literary theory she may espouse.[25]

An Anagogical Approach

O'Connor's conviction that writers write with their "whole personality" means that even the seemingly ancillary material like her marginalia, her casual correspondence, and her book reviews are crucial to understanding both her intent as well as her sympathies.[26] Indeed, O'Connor's theological

Mode from Meredith to Joyce (Newark: University of Delaware Press, 1989), 14. O'Connor's commitment to realism and to the realities of human experience compelled her to mirror the tragicomic nature of life in her stories and in the lives of her characters, where tragedy often came on the heels of comedy, and vice versa. Her friend and mentor Robert Fitzgerald appears to agree: "John Crowe Ransom was the first reader known to me to realize and say that Flannery O'Connor was one of our few tragic writers, a fact that we will not miss now in reading 'The Displaced Person' in the first volume or 'The Comforts of Home' in this [present volume]. But it is far from the whole story. On the tragic scene, each time, the presence of humor is like the presence of grace. Has not tragicomedy at least since Dante been the most Christian of *genres*?" From his introduction to *Everything That Rises Must Converge* (New York: Farrar, Straus and Giroux, 1964), xxiii.

[25]This idea, that grace cannot be separated from nature, is one she adopted from Baron Friedrich von Hügel, who was O'Connor's most important theological influence and whose ideas form the frame around her theological commitments (where Aquinas forms the bedrock). The more I read von Hügel, in fact, the more convinced I became that his ideas were seminal for O'Connor as both writer and believer, and so his influence became a crucial element for me to consider in assessing her overall approach to fiction and to the theology she weaves in and through it.

[26]Sarah Gordon opined, "That a critic would find her marginalia in her books important would have infuriated O'Connor" ("Startling Figures" conference, Milledgeville, GA, April 2011). On the contrary, I think O'Connor's marginalia often gives us an unedited version of what she thought—or at least was thinking at the time. I was particularly fascinated, for example, to find the words *mea culpa* written in pen next to this passage from Baron von Hügel: "For I have, on the contrary, somehow to love my neighbor affectively as well as effectively, and I have to bring light and strength to his interior life. And to do this becomes necessary in exact proportion as it becomes difficult. A *creative* love is required here—a lived

and literary intentions and sympathies are likely to be more obvious and trans-
parent in such sources than they would be in her published fiction, much of
which was written with a calculated eye toward what she believed to be a
generally hostile audience. Not only what she published, then, but also the
artifacts that O'Connor never intended for public consumption, are grist for
the mill of this study.

Because she wrote in the turbulent 1950s and 1960s in the South, not merely
as a Southerner but also as a committed Catholic, and not merely as a woman
but as one with a genteel pedigree, O'Connor's "whole personality" suddenly
becomes fascinatingly relevant when considering her stories, given the ten-
sions she was forced to contend with while living in such dichotomies. Such
dichotomies, in fact, inevitably gave rise to her idiosyncratic ways of looking
at the world, particularly those dichotomies that related to her faith.[27]
O'Connor writes in "Novelist and Believer,"

> It makes a great difference to the look of a novel whether its author believes
> that the world came late into being and continues to come by a creative act
> of God, or whether he believes that the world and ourselves are the product
> of a cosmic accident.[28]

love? life? which loves, not in acknowledgement of an already present lovableness, but in order to render
lovable in the future what at present repels love." Friedrich von Hügel, *Essays and Addresses on the Phi-
losophy of Religion* (London: J. M. Dent & Sons, 1921–1925), 2:159-60. Hereafter *Essays*. Why else would
O'Connor bother with such marginalia, which, as it turns out, is more infrequent than one might think?
Arthur Kinney's very helpful resource, *Flannery O'Connor's Library: Resources of Being* (Athens: Univer-
sity of Georgia Press, 1985), which claims to account for "all the passages O'Connor marked in her books,"
misses this passage altogether. In fact, Kinney's book leaves out a sizeable amount of O'Connor's margi-
nalia, some of which provides fascinating insight into O'Connor, such as the passage noted above.

[27] O'Connor writes out of a committed Catholic sensibility with Catholic concerns and informed by
Catholic dogma. But a signal emphasis of this book is that she also writes, perhaps more importantly and
significantly, from the wider ecumenical concern of a Christian, which allows her, then, to move seam-
lessly from a self-conscious position informed by Catholic doctrine to more traditionally considered
Protestant or even fundamentalist sympathies, and then back again. There are many instances, for
example, where she uses the word *Catholic* to mean simply "Christian." Of course, there are also instances
when she deliberately invokes the Catholic moniker to mean something uniquely Roman Catholic. But
at least in *The Habit of Being* and *Mystery and Manners*, she uses the term *Christian* about as often as she
uses the term *Catholic*, which points, I believe, to a more fundamental ecumenical spirit than she has
heretofore been commonly granted. Given, also, O'Connor's resistance to being labeled or molded into
a "type," her use of the Catholic moniker was often intended, I suspect, as much for shock value (parti-
cularly in rural Georgia) as it was a descriptor of her particular religious affiliation.

[28] *MM*, 156. My method for interpreting O'Connor's fiction shares the same theological commitments that
O'Connor and her theological mentor Baron Friedrich von Hügel shared, which center on the conviction
that the ancient creeds of the church were not merely an expression of the church's theology but also an
accurate expression of essential reality.

It makes a difference to the *feel* of a novel, too—to its literary contours and metaphysical assumptions.

O'Connor was not able, nor did she desire, to separate her theological commitments from her writing. To that end, my approach to her work is also intentionally anagogical in that it invokes theological realities in the act of interpretation, an approach O'Connor herself advocated:

> The action or gesture I'm talking about would be on the anagogical level, that is the level which has to do with the Divine life and our participation in it. It would be a gesture that transcended any neat allegory that might have been intended or any pat moral categories a reader could make.[29]

The anagogical method of interpretation is a calling forth of *religious* commitments in the service of *literary* ends. In "The Nature and Aim of Fiction," O'Connor acknowledges this duality in the interpretive task, not only for interpreting religious fiction but also for understanding life itself:

> The medieval commentators on Scripture found three kinds of meaning in the literal level of the sacred text: one they called allegorical, in which one fact pointed to another; one they called tropological, or moral, which had to do with what should be done; and one they called anagogical, which had to do with the Divine life and our participation in it. Although this was a method applied to biblical exegesis, it was also an attitude toward all of creation, and a way of reading nature which included most possibilities, and I think it is this enlarged view of the human scene that the fiction writer has to cultivate if he is ever going to write stories that have any chance of becoming a permanent part of our literature. It seems to be a paradox that the larger and more complex the personal view, the easier it is to compress it into fiction.[30]

I suspect O'Connor favored such an approach because her own stories demanded it—that is, if they were to be understood in the manner in which she intended. Of course, O'Connor did not count on many to have such an understanding of her stories and regularly lamented the degree to which they would be misunderstood: "The general intelligent reader today is not a believer. He likes to read novels about priests and nuns because these persons are a

[29]*MM*, 111.
[30]Ibid., 73. O'Connor's recognition of this paradox, that something so large can be compressed into something smaller, is a variation on the theme of the *mise en abyme*, which I discuss below.

curiosity to him, but he does not really understand the character motivated by faith."[31] O'Connor is all but resigned to the fact that the nonbelieving reader will misunderstand her characters' motivations, if not her stories as a whole.[32]

All of this has led me to the conviction that an "anagogical" or spiritual approach to O'Connor's fiction logically extends to—and comes from—an anagogical reading of her life.[33] Because O'Connor averred that she wrote from her entire being, such a reading of her life is, I think, wholly appropriate.

William Sessions, a friend of O'Connor's, cautions against such an interpretation, however, and for good reason. He has seen her life mythologized to the point that some are advocating for her beatification:

> The danger always after a certain point in understanding any life, especially that of a person who lived with a special depth, is, like the accounts of Exodus and *Phaedo*, that another process takes over. Idealizations of the actual life take place, but idealizations fail to reveal the negative along with the positive.[34]

But even as I grant Sessions's point, I nonetheless believe that in order to understand O'Connor's stories at any sufficient depth, one must *at least* understand O'Connor's theological commitments, which, in turn, will help us to see her limitations ("the negative")—her "liminal frame" as I am calling it—as *the means by which* God's grace is bestowed not only upon her, but also upon her characters *through* her. O'Connor wrote of this dynamic of limitation, or what she called poverty (and what she would later term, borrowing from Pierre Teilhard de Chardin, "passive diminishment"[35]),

> The novelist writes about what he sees on the surface, but his angle of vision is such that he begins to see before he gets to the surface and he continues to see after he has gone past it. He begins to see in the depths of himself, and it seems

[31]Ibid., 181-82.

[32]It must be acknowledged that much good can be taken from O'Connor's stories that is bereft of any anagogical basis, in the same way that a secular artist's perspective of the cathedral at Notre Dame can encompass helpful insights related to symmetry and form and can appreciate the beauty of its flying buttresses, Gothic nave, Cloister stained glass windows, and bejeweled crucifixes.

[33]The term *anagogical*, as it used throughout this book, is not synonymous with its use in medieval hermeneutics to denote a "mystical" reading, but carries, rather, the more general sense in which O'Connor used it to indicate a spiritual interpretation of reality.

[34]William Sessions, "'The Hermeneutics of Suspicion': Problems in Interpreting the Life of Flannery O'Connor," in *Flannery O'Connor in the Age of Terrorism: Essays on Violence and Grace*, ed. Ava Hewitt and Robert Donahoo (Knoxville: University of Tennessee Press, 2011), 201.

[35]*HB*, 512.

to me that his position there rests on what must certainly be the bedrock of all human experience—the experience of limitation or, if you will, of poverty.[36]

Such limitations, both in her own life and in the lives of her characters, though often severe, nonetheless often happen to redemptive effect and serve to reframe for the reader a vision of the God of Abraham, Isaac, and Jacob, whose severity came out of a divine commitment to love.

As I trust becomes increasingly clear in the pages that follow, I remain convinced by O'Connor's insistence that separating her aesthetics from her theology—her fiction from her faith—is to tear flesh from bone and to eviscerate the depth of meaning in her stories. O'Connor writes in another place that "to try to disconnect faith from vision is to do violence to the whole personality, and the whole personality participates in the act of writing."[37] Aesthetics and theology are distinct disciplines that stem from distinct impulses, each utilizing and occupying its own unique *habitus,* but both are taken up in the larger service of one's holy vocation as it is reflected in a person's life and commitments, or what Sally Fitzgerald referred to as O'Connor's "habit of being."[38] O'Connor's aesthetic and theological approaches, her artistic and moral vision, her vocation and her life, were woven together into a unified whole that ineluctably led, through the medium of her craft, to a depiction of the terrible beauty, violent goodness, and foolish truth of God.

The Baron

After making the official switch from Aquinas to O'Connor in the fall of 2010, I now needed to become more formally acquainted with O'Connor scholarship. I attended my first O'Connor conference in Milledgeville, Georgia, in April of 2011, where I delivered a paper related to the theme (and name) of the conference, "Startling Figures."[39] I argued that of all the startling figures in her novel *The Violent Bear It Away,* none was more startling than the shadowy

[36]*MM*, 131-32.

[37]Ibid., 181.

[38]HB, xvii.

[39]The full name of the conference was "Startling Figures: A Celebration of the Legacy of Flannery O'Connor." The title comes from a famous line of O'Connor's found in her essay, "The Fiction Writer and His Country": "When you can assume that your audience holds the same beliefs you do, you can relax a little and use more normal means of talking to it; when you have to assume that it does not, then you have to make your vision apparent by shock—to the hard of hearing you shout, and for the almost-blind you draw large and startling figures" (*MM*, 34).

figure of the invisible God, who shocked reader and character alike with his terrifying providence and the often violent means by which he accomplished it. The Lord's presence, manifested variously as fire and shocking visions, was more terrifying, frankly, than anything the devil could conjure up (or that O'Connor could conjure up on his behalf). Her characters certainly thought so. As Old Mason Tarwater understood all too well and warned his nephew about on several occasions, it is the Lord one must fear, not the devil. Such a theology, so unfamiliar to the mainline Christian ear, was, I quickly realized, key to understanding O'Connor's subversive approach.

I wanted to know from whence or from whom she adopted such a dark and terrible theo-literary schema. I thought at first that perhaps it was her own invention. No one else wrote like she did, certainly no other Christian writer did, with that bizarre mix of provincial colloquialisms and circus sideshow freaks with a medieval religious sensibility. O'Connor's voice was unique in American fiction—indeed, in all of fiction. Nevertheless, was there a particular influence who might have encouraged such a point of view, or at least provided some kind of theological rationale or scaffolding for inventing such fictions? She would variously mention Poe and James and Hawthorne as literary influences, but none of them shared her strong Christian convictions nor wrote with the same spiritual ferocity and metaphysical economy. Poe taunted where O'Connor preached. James soliloquized where O'Connor shouted. Hawthorne implied where O'Connor impaled. Dante came closest, but she mentions him only once in her letters—"For my money Dante is about as great as you can get"—once in her fiction ("The Artificial Nigger"), and twice in her essays.[40] And Aquinas was, in this regard, not much help. He was, after all, the great doctor who painstakingly laid out an argument from reason for the existence of God. She, on the other hand, was the soft-spoken undertaker who saw fit to lay her subjects low, character and reader alike. Aquinas clearly gave O'Connor, in very general terms, the theological foundation on which she worked and thought, but was there something or someone else who might have given her, for lack of a better phrase, the *theological imprimatur* to write from such an exacting spiritual vision of things?

O'Connor took her theological and aesthetic cues from, among others, Jacques Maritain, Étienne Gilson, Karl Adam, Teilhard de Chardin (late in her

[40]*HB*, 116; *MM*, 47.

life), François Mauriac, Gabriel Marcel, and Romano Guardini, all of whom exercised an influence on O'Connor and her writing. But as far as I could tell, none of them could account for O'Connor's dark and comic tone. As I continued to dive more deeply into her world, I began to notice almost immediately that my research kept bumping up against what was, at the time, an unfamiliar name: Baron Friedrich von Hügel. In O'Connor's correspondence, book reviews, and essays, she routinely quoted, praised, and acknowledged this man as an important voice in Catholic letters and, more importantly, as a direct influence on her writing. But rather than settle any questions I had about the origins of her tragicomic tone, the plurality of references to von Hügel was strangely disconcerting. Why had his name not come up in any of my previous research?[41] Had I not dug deeply enough? Why did virtually no O'Connor scholar, whose studies I was at the time devouring, have much of *anything* to say about this thinker, one who had so clearly influenced O'Connor (or so I assumed at the time)? I discovered later that there was a small handful who gave more than a passing nod to von Hügel's influence on O'Connor, which helped to explain why the magisterial *vade mecum* of O'Connor criticism, R. Neil Scott's 1,061-paged *Flannery O'Connor: An Annotated Reference Guide to Criticism*, contained only a single reference to the man. But why this paucity? This book is, in part, an answer to that question.

Von Hügel's particular brand of Catholicism was, like O'Connor's, an upsetting of the religious status quo, and yet he managed to stay within the church's good graces and committed to its central orthodoxies, all the while writing from the edges of the Roman Catholic establishment. O'Connor occupied a similar liminal space, both metaphorically and physically. The family farm where she spent virtually all her adult years, Andalusia, was situated just outside of Milledgeville. Not coincidentally, the historical region of Andalucía, after which the farm was originally named (and the name that

[41]Part of the difficulty of pinning down literary influences has much to do with the nature of literary influences themselves, which, I contend, generally work in two directions. A writer can have a vague intuition of something that is later confirmed and codified by someone else, or alternately, a writer can be introduced to a whole new set of ideas that proves later to be seminal in her work. I call these the influences of *confirmation* and *introduction*, respectively, and want to suggest that both are operative in von Hügel's influence on O'Connor. I also have come to believe that von Hügel served as a surrogate father figure of sorts to a young woman who had lost her own father when she was only fourteen. Von Hügel and O'Connor never met—he died two months before she was born—but her deep regard for his writings, not to mention her expressed affection for the *man*, convince me that he was more than just a theo-literary influence.

O'Connor chose to readopt after she and her mother moved there from Savannah), was an established autonomous community of the kingdom of Spain. So too was O'Connor's home autonomous, made up of O'Connor, her mother, a few farm hands, some cows, a mule, and a muster of peacocks. Andalusia allowed her to stay connected to the church and to the wider world (the town of Milledgeville was just a short ten-minute drive away), but it also provided her with a place of retreat away from "the madding crowd," a region at the edge of the "edge," if you will, where she felt free to critique both the world and the church.[42] Similar to von Hügel, who was an Austrian, born in Italy, and who became an English subject, O'Connor was a Catholic, born in Georgia, who became a writer. Both lived and wrote, in other words, from a place at or near the cultural margins, which imbued their writing with an empathy for the immigrant status—spiritual and otherwise—of their characters, whether historical or fictional.

Chapter Summaries

Chapter one introduces the reader to the method used to examine O'Connor's work. The inherent difficulty in assessing her fiction is traced through the evolution of its reviews, which vary considerably depending on the assumptions of the reviewer about O'Connor's intentions and the purpose of her religious themes. The tonal shift in O'Connor's work, or what I am calling her "theological turn," from her Iowa years to her Milledgeville years, and then from the early 1950s to the mid to late 50s, is then considered before the chapter pivots to a focus on Baron von Hügel and his signal influence on O'Connor's writing and thought. I examine von Hügel's influence on O'Connor's theology and the mysterious critical neglect of von Hügel by O'Connor scholarship. Similarities are drawn between O'Connor and von Hügel that account, I believe, for O'Connor's admiration and affability for von Hügel, which helps to explain her openness to his ideas and her willingness to be so deeply influenced by them.

Chapter two focuses on O'Connor's moral vision and the theological foundations of her work, which includes her personal faith commitments as well as the artistic limitations she placed upon herself as a Roman Catholic writer in the South and as someone who had to face down a protracted struggle with

[42]The town on the edge of which she lived was, itself, on the edge: Mill-edge-ville.

what turned out to be a terminal illness. I argue that O'Connor's liminal status, conferred to her in part by those limitations, translates in her fiction to what I call her "crypto-fundamentalism." Such a move not only challenges the popular perception that O'Connor wrote from an exclusively Roman Catholic perspective, but also makes her work more amenable to claims of Protestant theological sympathies, which are readily apparent not only in her fiction but in her letters and essays as well.

Chapter three moves to a focus on O'Connor's dramatic vision and her "aesthetic habitus," a term she borrows from Jacques Maritain's work on the intersection of art and theology. I establish a connection between her dramatic vision and subversive aesthetic before examining authorial intent and O'Connor's relationship to the New Critical School. I then introduce a taxonomy of diversions as a way of putting O'Connor's literary approach—her art—into some historical perspective. O'Connor's prophetic voice is considered (via Frederick Asals) in light of Walter Brueggemann's understanding of the role of the prophet. The chapter ends by looking at O'Connor's use of the term *grotesque*.

Chapter four focuses more deliberately on O'Connor's subversion of the transcendentals of beauty, goodness, and truth in a selection of her short stories, which serve as the fictional arena wherein her moral and dramatic visions (what I call her theo-literary approach) are embodied and brought to life. A crucial distinction between divine and demonic violence in O'Connor's stories is also examined, a distinction whose underlying principle is based on von Hügel's insistence that grace and nature must never be separated, and that when and where they are, the divine ceases to take hold.

Chapter five serves as an extended interpretation of O'Connor's second novel, *The Violent Bear It Away*, and uses it as a case study for applying the approach developed in this study in a more sustained and systematic way. I look separately at the terrible beauty, violent goodness, and foolish truth of God as each is embodied in the characters, themes, and settings of the novel. Von Hügel's famous "three elements of religion" is brought into the conversation as a kind of tropological placeholder for the subverted transcendentals of beauty, goodness, and truth.

A brief conclusion distills the main points of the book, followed by an addendum that considers how O'Connor's work might be incorporated into a liturgical celebration of the Eucharist.

The Baron

O'Connor's Theological Turn

Baron von Hügel, one of the great modern Catholic scholars, wrote that "the Supernatural experience always appears as the transfiguration of Natural conditions, acts, states . . . ," that "the Spiritual generally is always preceded, or occasioned, accompanied or followed, by the Sensible. . . . The highest realities and deepest responses are experienced by us within, or in contact with, the lower and lowliest." This means for the novelist that if he is going to show the supernatural taking place, he has nowhere to do it except on the literal level of human events, and that if he doesn't make these natural things believable in themselves, he can't make them believable in any of their spiritual extensions.

FLANNERY O'CONNOR, MYSTERY AND MANNERS

I see, as a mysterious but most real, most undeniable fact—that it is precisely the deepest, the keenest sufferings, not only of body but of mind, not only of mind but of heart, which have occasioned the firmest, the most living, the most tender faith.

BARON FRIEDRICH VON HÜGEL,
ESSAYS AND ADDRESSES ON THE PHILOSOPHY OF RELIGION

When I first read a story of O'Connor's in college, I was immediately intrigued. Who was this maniacal writer who also claimed to be a serious Christian? Since when was Christianity, and since when were Christians, so freakish, so violent, so foolish? After deciding many years later to do my PhD on her work, I read

reviews of her work, and the earlier ones, in particular, confirmed my initial suspicions and were virtually unanimous on one count: O'Connor's stories, and especially her characters, were a strange combination—indeed, many argued, a contradiction—of the holy and the grotesque, of faith and violence, of divine wisdom mixed with hillbilly superstition.[1] Beyond this consent, however, the unanimity fell apart. Though most reviewers agreed that her stories were odd, some found them disturbing and offensive to the point that they either dismissed her as a hack or castigated her for being such a misanthrope, while others found in them a profound and beautiful truth creatively wrought by a budding genius. All agreed that this writing was audacious stuff, heady and esoteric material for a young Catholic girl from the Deep South. Evelyn Waugh remarked that "if this is the unaided work of a young lady it is a remarkable product."[2]

The divergent and even contradictory reactions to O'Connor's stories reminded me of G. K. Chesterton's paradoxical quip about the "tremendous figure which fills the gospels":

> Suppose we heard [of] an unknown man spoken [of] by many men. Suppose we were puzzled to hear that some men said he was too tall and some too short; some objected to his fatness, some lamented his leanness; some thought him too dark, and some too fair. One explanation would be that he might be an odd shape. But there is another explanation. He might be the right shape.[3]

Maybe O'Connor's stories were "the right shape" in that they told—or rather, showed—the truth embodied in that towering—even paradoxical—gospel figure. Perhaps both sides of the debate, in other words, were right about O'Connor's stories. Maybe the truth of things was both disturbing *and* profound, offensive *but* beautiful. Maybe her stories were compelling because they reflected not only the paradoxical nature of Christ but also the paradoxical nature of life. As a believer myself, I was familiar with such paradoxes

[1] The deeper point here, of course, is that this contradiction is in fact the fundamental nature of the human condition. Jordan Cofer considers the contradictory nature of O'Connor's characters a "trick" and "technique," and he draws inspiration for this view from Vladimir Nabokov's indictment of the "trick" that Fyodor Dostoevsky's characters play by "sinning their way to Jesus." Jordan Cofer, *The Gospel According to Flannery O'Connor* (New York: Bloomsbury, 2014), 1. But isn't this, again, the story of human redemption? Don't we all manage, one way or another, to sin our way to Jesus? This was no literary trick that O'Connor was pulling. This reflected, on the contrary, O'Connor's commitment to Christian realism.

[2] As quoted in Neil Scott and Irwin Streight, eds., *Flannery O'Connor: The Contemporary Reviews* (Cambridge: Cambridge University Press, 2009), 43.

[3] G. K. Chesterton, *Orthodoxy* (London: John Lane, 1908), 164-65.

in Scripture: of the minor prophet Nahum's jealous and avenging God, on the one hand, who was also Jesus' loving and gracious Father, on the other; of the profound purpose of life reflected in the Genesis accounts of creation tempered by the equally profound meaninglessness of life echoed in the pages of Ecclesiastes.[4] But I sensed also something else in this unity of opposites so prevalent in O'Connor's stories (especially the later ones): a theological influence, perhaps, that gave O'Connor the language to embody such paradoxes.

As I continued to read and study O'Connor's work, I also began to notice a subtle but noticeable shift from her earlier to her later work. Though I couldn't quite name it at first, it became clear that her later stories had a theological depth that her earlier stories lacked, and I couldn't help but wonder if her proclivity for a "unity of opposites" was somehow related to this shift in depth. This impulse to *place* O'Connor somewhere and to pin down the reason(s) for this change in her work gave the whole question of the provenance of her paradoxical vision an even greater urgency. Where on earth did she come up with this kind of material? Who gave her the permission to write like this? Whence the vision?

The search would eventually lead me to a name I did not recognize, nor was it one I had run across in O'Connor scholarship. I would come to find that a relatively obscure figure, especially in American theological circles, had helped to lay the foundation for O'Connor's radical vision. It had begun, I suspected, with O'Connor's acquiring an English translation of Saint Catherine of Genoa's *Treatise on Purgatory* in 1949.[5] But before we examine this figure, Baron Friedrich von Hügel, and his influence on O'Connor, we need first to establish that a shift in theological depth did, indeed, occur between O'Connor's early and later stories.

A SHIFT IN TONE, A CHANGE OF DEPTH

A shift in both theological depth and moral seriousness from O'Connor's early to her later stories is evident to many of her critics, but the event, idea, or influence that led to such a change continues to be debated.[6] Of course, there is

[4]Some have argued that O'Connor's stories are, in both structure and essence, a creative recapitulation of the biblical stories. See Cofer, *Gospel According to Flannery O'Connor*, as perhaps the most explicit example of this.

[5]Saint Catherine of Genoa, *Treatise on Purgatory: The Dialogue* (New York: Sheed and Ward, 1946).

[6]Regarding her influences, O'Connor once wrote this to Betty Hester: "Which brings me to the embarrassing subject of what I have not read and been influenced by. I hope nobody ever asks me in public. If so I

nothing morally fatuous about the murder of an entire family ("A Good Man Is Hard to Find") or the drowning of a small child ("The River"), both of which are found in O'Connor's first collection of short stories, but in the main, O'Connor's later fiction exhibits a theological and spiritual weightiness that her earlier fiction lacks. Robert Golden and Mary Sullivan suggest that the body of early criticism largely rejects—or at least does not see the centrality of—a religious foundation in O'Connor's work.[7] In discussing the "four schools of thought" that predominate in O'Connor studies, Golden and Sullivan observe that the fourth school

> denies the religious intent completely, preferring to read her work in various other ways: as another example of "southern gothic" and its interest in private neurosis and public degeneracy, as a humanistic cry against the evils of the American South, as O'Connor's way of working out the frustrations of her inner life, or as a closed fictional world, a world in which questions of ideology or belief are not relevant. Much of the early criticism of O'Connor belongs in the fourth school; religious readings of her work increased as her fiction became more familiar and as she increasingly made clear her religious intent, but the fourth school is not silent, occasionally sallying forth against the other schools, especially the first and the second.[8]

The reason why much of the early criticism largely ignored O'Connor's religious intentions is that her early stories (pre-1954) are not primarily religious—and by this I mean they are not primarily theological. The six stories O'Connor submitted for her master's thesis tend to content themselves with societal and psychological questions and concerns, with race relations, for example, and familial turmoil and dysfunction—with "manners" more than "mystery." "The Turkey" is an exception, but even here its "spiritual" elements fall more squarely into the category of adolescent religious recalcitrance than genuine religious curiosity.

intend to look dark and mutter, 'Henry James Henry James'—which will be the veriest lie, but no matter. I have not been influenced by the best people" (*HB*, 98).

[7] Robert Golden and Mary Sullivan, eds., *Flannery O'Connor and Caroline Gordon: A Reference Guide* (Boston: G. K. Hall, 1977), 5-6.

[8] Ibid., 6.

EXCURSUS: THE "THING"

"The Geranium," "The Barber," "Wildcat," "The Crop," "The Turkey," and "The Train," the six short stories that O'Connor submitted for her master's thesis at the Iowa Workshop in 1947 under the title "The Geranium: A Collection of Short Stories," essentially limit their theological reflection to what would become a signature literary device for O'Connor: the mysterious "thing" that haunts her fiction, which her characters can never name but that symbolizes their abiding fears. In "The Geranium," it is referred to as that "thing inside him [that] had sneaked up on him for just one instant"; in "The Barber," the main character has "a blind moment when he felt as if something that wasn't there was bashing him to the ground"; the entire premise of "Wildcat" centers on an unseen and foreboding "thing" (a wildcat for the purposes of the story) that never actually shows up; "The Crop" mentions a character's "thinking about something big way off—";[9] and in "The Train," the main character (Haze) is terrified to get into the sleeping berth of a train—it reminds him of the coffin his mother was put in—and then, when he finally does go in, "He lay there for a while not moving. There was something in his throat like a sponge with an egg taste." The darkness itself takes on the objective materiality of death in the story so that, after he's been lying in the berth for some time,

> from inside he saw it closing, coming closer, closer down and cutting off the light and the room and the trees seen through the window through the crack faster and darker and closing down. He opened his eyes and saw it closing down and he sprang up between the crack and wedged his body through it and hung there moving, dizzy, with the dim light of the train slowly showing the rug below, moving, dizzy.[10]

Even "The Turkey," the most explicitly "theological" of her first stories, ends with a reference to "Something Awful [that] was tearing behind him with its arms rigid and its fingers ready to clutch."[11]

[9] Flannery O'Connor, *O'Connor: Collected Works* (New York: Literary Classics of the United States, 1988), 702, 718, 736. Hereafter *CW*.

[10] Ibid., 761.

[11] Ibid., 752. *Wise Blood* too makes use of this unnamed and threatening force, as, for example, in chapter ten, where Haze turns to a stranger next to him and says, "If you don't hunt it down and kill it, it'll hunt you down and kill you." "Huh? Who?" the woman replies (*WB*, 95).

It would be too convenient—and incorrect—to reduce every reference of this "thing" in O'Connor's earliest stories to something divine or evil, but there are clearly spiritual undertones to its presence. It seems plausible to consider that in each of these stories, the anonymity of this "thing" signals an ambivalence on O'Connor's part regarding the paradoxical nature of God's good but terrible character, and it is an ambivalence she appears to only begin to come to terms with in her second novel, *The Violent Bear It Away*, where the mysterious thing is introduced to us as a character in the story, first named the "Stranger" and then, eventually, the "Friend."

As a counter to the suggestion that O'Connor's earliest stories are not theological, one might argue that the sociological and psychological elements of the South can hardly be separated from their cultural religious expressions, in which case all of O'Connor's early stories are theological to one degree or another. Caroline Gordon touches on this inescapable blending of southern culture and its religion, and of O'Connor's fascination with this blending, in a book review she wrote in 1955 of *A Good Man Is Hard to Find*, where she suggests that many of O'Connor's critics "misunderstand her because they do not see her characters as symbols for spiritual and social aspects of southern life."[12] Gordon is entirely correct, but she seems to have missed the implicit irony in her suggestion: the characters in O'Connor's early stories are indeed *merely* "symbols for spiritual and social aspects of southern life"; anything as vague and benign as a "symbol for . . . [an] aspect" generally leads to misunderstandings.

Even O'Connor's most explicitly religious of her early stories, her first novel, *Wise Blood*, is peppered with themes that are more ecclesial and institutional than properly theological, and the earlier short stories in O'Connor's first collection, *A Good Man Is Hard to Find*, seem content to deal more with conventional religious themes than with any substantive theological questions.[13] Her characters begin to attain a greater spiritual

[12]Caroline Gordon, "With a Glitter of Evil," *New York Times Book Review*, June 12, 1955, 5.

[13]O'Connor herself, in the preface to the second edition of *Wise Blood*, essentially distilled the theme of the novel down to one of free will or freedom, which is not an exclusively theological concern. And with two notable exceptions ("A Good Man Is Hard to Find" and "The River," both written in 1953), none of the other three stories in that first collection written prior to 1954—"A Late Encounter with the Enemy,"

and theological depth—or commensurate lack of both—with her second novel and second collection of short stories (which probably also helps to explain why her first collection of stories is the more commonly anthologized of her two collections; it is, in many ways, the more theologically accessible of the two). It is in her later stories that the classic binaries of good/evil and God/devil are infused with the weightier theological concerns of divine agency, prophetic calling, mystical union, and the liturgical (as opposed to institutional) significance of the sacraments of baptism and the Eucharist.

EXCURSUS: THE EARLY AND LATER REVIEWS

A paragraph in the opening pages of Neil Scott's *Flannery O'Connor: An Annotated Reference Guide to Criticism* encapsulates the dark themes of O'Connor's theological and literary impulses (particularly from her later period, after 1955), or what O'Connor referred to as her moral and dramatic vision:

> Much of this criticism focuses upon her sharp ear for Southern dialect and her use of symbolism, grotesque imagery, shocking characterization, apocalyptic violence, and bizarre, paradoxical irony, as she drives home her themes of redemption, Christian mystery, original sin, and the action of grace upon sinful humanity.[14]

The earliest reviews, from 1952, of O'Connor's first major work, *Wise Blood*, were deeply divided in their assessments of the book's merit (which, even six decades later, still manages to resist simple interpretations and continues to confound readers and critics alike). Between 1952 and 1955, twenty reviews were written of her first novel, and only half of them were positive. Many of the negative reviews traded on speculations behind the reasons for what they considered to be O'Connor's misanthropic tone, writing, for example, that the novel is "an indefensible blow delivered in the dark" and that it "does not even define a world of darkness, not even that—for there has been no light to take

"A Stroke of Good Fortune," and "The Life You Save May Be Your Own"—has the theological or religious depth so characteristic of O'Connor's later work.

[14]R. Neil Scott, ed., *Flannery O'Connor: An Annotated Reference Guide to Criticism* (Milledgeville, GA: Timberlane Books, 2002), xiii. Scott's tome reflects the burgeoning field of O'Connor scholarship with its nearly three thousand entries added since the publication of its precursor twenty-five years earlier, Golden and Sullivan's *Reference Guide*, and its comparatively modest 189 pages of references.

away"; that it is "gloomy" and "repulsive" and "close to blasphemy."[15] Another reviewer wrote that she could "hardly wait to see what Miss O'Connor may write about some happy people."[16]

There are a few notable exceptions in her early reviews that manage to see past the surface of her stories to the traceable edges of O'Connor's commitment to Catholic orthodoxy. Carl Hartman presciently observes that O'Connor employs the grotesque in order "to make us see the world by distortion," thereby recognizing an implicit religious indictment of the world.[17] Caroline Gordon, in a review of *A Good Man Is Hard to Find*, writes that "the rural South is, for the first time, viewed by a writer whose orthodoxy matches her talent," thereby suggesting the central importance of O'Connor's own dictum: that one's moral and dramatic visions cannot be rent asunder and that one's beliefs play a central role in the rich moral and aesthetic fabric of one's stories.[18]

Reviews from 1955 through 1959 of *A Good Man Is Hard to Find* were, on the other hand, largely positive. One striking quality in these reviews, however, is the diametrically opposed conclusions they make about the same material. Her stories are called "nihilistic," "realistic," and "fantastic" and are considered both "highly comical" and "deadly serious." They are simultaneously praised for their "unsentimental compassion" and damned for their "unreflective compassion." What virtually all of O'Connor's reviews up until 1959, both positive and negative, agree on is the one thing they cannot deny: her stories' violent and grotesque themes.[19]

Again and again these qualities of her fiction, along with other adjectives like "repulsive," "gloomy," "savage," and "animalistic," are trotted out as examples of the southern gothic style, and yet these same reviews acknowledge the stories' strong moral and religious tone. It is this simultaneous quality of disturbing violence and religious morality that will eventually become O'Connor's literary signature.

Paul Engle, in a review published in 1960 of *The Violent Bear It Away*, writes that O'Connor's "humor, and her quiet and disenchanted view of people, everywhere shine in the book, lighting up the grave darkness in which the incidents take place."[20] More than most of O'Connor's critics, Engle saw the

[15]In Golden and Sullivan, *Reference Guide*, 14-15.

[16]Ibid., 15.

[17]Carl Hartman, "Jesus Without Christ," *Western Review: Journal of the Humanities* 17 (1952): 76-80.

[18]Golden and Sullivan, *Reference Guide*, 19.

[19]Orville Prescott quotes O'Connor as saying that her "gruesome concoctions [have] the most exalted intentions." Golden and Sullivan, *Reference Guide*, 35.

[20]Golden and Sullivan, *Reference Guide*, 31.

deeper—and thus heard the quieter—strains of religious orthodoxy and rightly inferred that her enchanted view of reality would lead to a disenchanted view of people, not in some morbid sense, but in an almost exuberant admission of human limitations.[21] O'Connor believed, for example, that "to know oneself is above all to know what one lacks."[22] Southern folk, O'Connor understood, still believed that "man has fallen and that he is only perfectible by God's grace, not by his own unaided efforts."[23] But she said these things while simultaneously recognizing that "man is created in the image and likeness of God . . . [and] that all creation is good but what has free choice is more completely God's image than what does not have it."[24]

After the publication of *The Violent Bear It Away* in 1960, the reviews exponentially increased, and though O'Connor was never ignored as a writer, 1960 was a turning point in her critical reputation. Fifty-nine reviews of *The Violent Bear It Away* were published in that year, compared with only twenty-seven in 1955 for *A Good Man Is Hard to Find*. The confusion over the meaning of her stories would persist, and occasionally reviewers felt the need to justify O'Connor's difficult material with psychological insight. *The Violent Bear It Away*, readers were told in one review, is essentially saying that "the primitive Protestant experience is breaking loose into consciousness and activity of fantasies which can be recognized as unconscious components of the modern experiences of alienation and self-creation." In this case the fantasy is primarily one of "homosexual incest," which is demonstrated by the references to seeds, by the numerous violations of the self, and by the literal rape near the end of the novel. Despite the novel's "fantastic brilliance," the reviewer remains unconvinced because O'Connor presents these fantasies "too abruptly, too nakedly."[25] O'Connor anticipated such reviews, telling Hester in a letter in 1959, with no small tone of sarcasm, that "a Freudian could read this novel and explain it all on the basis of Freud."[26]

In the main, however, the reviews of her work through the 1960s were both more positive and more incisive and, in many cases, were able to recognize the

[21]*HB*, 92. Engle was, after all, the first to greet O'Connor when she came to the Iowa Writers' Workshop in the fall of 1945, and he not only got to know the demure, quietly intense young woman with a fierce religious depth, but also served as an important mentor of hers during those crucial, formative years.

[22]Ibid., 125.

[23]Ibid., 302.

[24]Ibid., 104.

[25]Golden and Sullivan, *Reference Guide*, 28.

[26]*HB*, 343.

powerful religious element in O'Connor's stories—even if they could not name it themselves. A few, though, could name it. Sister Bede Sullivan, who Neil Scott tells us was essentially alone among Catholics in her praise of O'Connor's thoroughgoing Catholicity (capital C), understood that the spiritual well from which O'Connor's imagination drew was based on "sound theological dogma."[27]

Robert Drake, in his *Flannery O'Connor: A Critical Essay* in 1966, was another reviewer who could name the deeper theological strains in O'Connor's writing. It likely helped that he had had the chance to meet O'Connor on one occasion, remarking that

> she spoke softly and directly and with some finality: she looked her guest right in the eye and said what she had to say, no more, no less. In fact, she talked altogether "head-on," very much as she wrote. And when she had finished what she had to say, she just stopped: it was then the visitor's turn.[28]

O'Connor, as it turns out, wrote the same way that she lived and spoke: with a clear-eyed intention and a sense of finality. She embodied the truism that she often extolled: that a writer's moral judgment is part of the very act of seeing. Drake was one of the first to see, for example, that O'Connor was not belittling the rural religious folk she so often depicted in her stories:

> The Southern Baptists, the Holy Rollers may be violent or grotesque or at times even ridiculous; but, she implies, they are a whole lot nearer the truth than the more "enlightened" but godless intellectuals or even respectable do-gooders and church-goers who look on the Church as some sort of glorified social service institution while preferring to ignore its pricklier doctrines.[29]

It is also significant to note here that Drake intuits the transcendental categories that I am suggesting O'Connor works with (and subverts) when he writes that her "Holy Rollers may be violent or grotesque or at times even ridiculous," which parallels, in their subverted forms, the transcendental categories of goodness, beauty, and truth. This use of the categories is mirrored, again, in the title of his essay, "'The Bleeding Stinking Mad Shadow of Jesus' in

[27]In Golden and Sullivan, *Reference Guide*, 37.
[28]Robert Drake, *Flannery O'Connor: A Critical Essay* (Grand Rapids: Eerdmans, 1966), 11. The essay was originally titled "'The Bleeding Stinking Mad Shadow of Jesus' in the Fiction of Flannery O'Connor."
[29]Ibid., 16.

the Fiction of Flannery O'Connor." Critic Gilbert H. Muller compares the grotesque imagery of O'Connor with that of the millennium triptych of Dutch Renaissance painter Hieronymus Bosch, claiming that "for these two artists, the grotesque does not function gratuitously, but in order to reveal underlying and essentially theological concepts."[30] O'Connor herself admitted that she took her characters seriously, that she was not making fun of them, and that their concerns were her own and, in her judgment, "central to human life."[31]

Drake also understood the fundamental irony implicit in O'Connor's work: if you came off looking too good, you were likely a rake, and probably damned. This unflinching perspective on things, Drake cautioned, "should come as no surprise to us . . . the Christian religion is a very shocking, indeed a scandalous business . . . and its Savior is an offense and stumbling block, even a 'bleeding stinking mad' grotesque to many."[32] Drake compares O'Connor's God to Blake's "Christ the tiger" who comes in "terrifying glory. . . . There is nothing sweet or sentimental about Him, and He terrifies before He can bless."[33]

Some of O'Connor's more recent critics have also understood the implicit theological irony embedded in O'Connor's work. George Kilcourse believes that O'Connor's deep religious convictions actually *help* readers to more fully accept the stringent elements of her fiction, arguing that "the violence that Jesus suffers in redemptive love helps O'Connor's readers to interpret the presence of 'violent' grace in her fiction."[34] Christina Bieber Lake, on the other hand, is not so sure: "As careful as O'Connor is to separate the violent and true love of the kingdom of heaven from a sentimental and false love, it is sometimes difficult to see how the gun-toting, gruff, and abrasive old man *loves* more than Rayber."[35]

Lake's concern, which she ameliorates in the very next passage, nonetheless points to an inherent difficulty in O'Connor's fiction. Assessed from a vertical vantage point, God's violence may be more amenable to some form of theological adjudication, but seen on the strictly horizontal plane, God's violence,

[30]Gilbert H. Muller, *Nightmares and Visions: Flannery O'Connor and the Catholic Grotesque* (Athens: University of Georgia Press, 1982), 5.

[31]*MM*, 204.

[32]Drake, *Flannery O'Connor*, 17.

[33]Ibid.

[34]George Kilcourse, *Flannery O'Connor's Religious Imagination: A World with Everything Off Balance* (New York: Paulist Press, 2001), 42.

[35]Christina Bieber Lake, *The Incarnational Art of Flannery O'Connor* (Macon, GA: Mercer University Press, 2005), 152.

as it is meted out person to person, suddenly becomes, not simply a problem
for theology, but a serious question of ethics. The trouble principally arises, not
surprisingly, for those who believe there is only a horizontal plane; that is, an
ethics bereft of theological concerns. From such a one-dimensional perspective,
however, God's violence becomes a tautology, as there is no God to inflict
the violence.

Frederick Asals anticipates O'Connor's reply to such concerns when he sug-
gests that "for O'Connor, the intellect is at best a useless defense against inherent
human depravity [and] it is also a stumbling block to genuine vision."[36] Such an
answer would be cold comfort to those who do not share O'Connor's religious
convictions, but that only raises the question: what would a satisfying expla-
nation look like to an unbeliever? The subversive elements in O'Connor's
fiction—indeed, the subversive nature of her fiction as a whole—does not lend
itself to easy solutions. But perhaps this is why she shouted and drew startling
figures, because she cared enough about her hostile audience, and about the
truth, to shake things up. Prophets, after all, are not inclined to give their hearers
the benefit of the doubt. Their mission is to tell (or show) the truth, however
subversive it might be, in order that their hearers' assumptions are themselves
subverted. Prophets root out the people's doubts by forcing them into a crisis of
belief. And if a crisis of belief is not possible, then a simple crisis will have to do.

Such a shift in theological depth and tone is seen, for example, in the dif-
ference between "The Turkey," a story O'Connor wrote for her master's thesis
while in Iowa in 1947, and its rewritten version, "An Afternoon in the Woods,"
penned seven years later in Milledgeville, in 1954. They are, for the most part,
identical, save for a few crucial changes. Unlike the other five stories that
made up her master's thesis, "The Turkey" is conspicuous for its religious
overtones. Early on, O'Connor hints at questions of divine providence when
the main character, Ruller, who has been chasing an injured turkey through
the woods in vain, muses that "it was like somebody had played a dirty trick
on him."[37] In short order, Ruller determines that that "somebody" is, in fact,
God, who henceforth replaces the turkey and takes up the role of Ruller's

[36]Frederick Asals, *Flannery O'Connor: The Imagination of Extremity* (Athens: University of Georgia Press,
 1982) 139.
[37]CW, 744.

antagonist. The story then shifts to Ruller's experimenting with disobedience and sin ("going bad" as he puts it), mainly in the form of blasphemous thoughts and taking God's name in vain.[38] Indeed, one of the central themes of "The Turkey" is about "going bad," and at one point the story raises questions about the devil and damnation, at another about God's calling on Ruller and the need for Ruller to perform an act of charity toward a beggar as a show of penance for his disobedience.

In contrast, the protagonist in "An Afternoon in the Woods," now named Manley, does not begin by speculating that it was "someone" playing a dirty trick on him; he immediately speculates that it's probably "God [who] had played a dirty trick on him." Then, just as quickly, Manley is chastened for even asking such a question: "He checked himself here, always being careful what he let himself think about God."[39] Indeed, questions of God are brought up more carefully in the second version of this story. The more adolescent preoccupation with "going bad" in "The Turkey" is replaced by a more mature acceptance of the pride involved in having already "gone bad." In the second version, the question of beauty and our ability to apprehend it is indirectly considered when at the beginning of the story Manley is overwhelmed by the beauty of the woods, but by the time he has engaged in open disobedience his ability to see that beauty vanishes, as if his goodness and his ability to apprehend beauty are connected (as they were for Jacques Maritain, O'Connor's aesthetic mentor, and for von Hügel as well): "He had ceased entirely to notice the colors of the woods."[40]

[38]In light of the recent publication of O'Connor's prayer journal (Flannery O'Connor, *A Prayer Journal*, ed. William Sessions [New York: Farrar, Straus and Giroux, 2013]; hereafter *Prayer Journal*) written at the same time as these stories (1946–1947), the whole question of "going bad" takes on an added poignancy and significance. It is clear that O'Connor, too, was experiencing (if not experimenting with) many of the same impulses that Ruller feels: "I do not mean to deny the traditional prayers I have said all my life," she writes in the first, undated entry, "but I have been saying them and not feeling them." In another entry toward the end of the journal, O'Connor openly laments, "I have proved myself a glutton for Scotch oatmeal cookies and erotic thought." Clearly her early stories provided O'Connor with the opportunity to exorcise her demons, or at least indirectly to confess them.

[39]*CW*, 766.

[40]Ibid., 767. For Maritain, "If [the artist] truly loves beauty and if a moral vice does not hold his heart in a dazed condition . . . he will recognize love and beauty." Jacques Maritain, *Art and Scholasticism* (London: Sheed & Ward 1943), 79-80. One's ability to recognize true beauty, in other words, is conditional: *if* an artist truly loves beauty and *if* a moral vice does not hold his heart, *then* he will be able to recognize beauty. This is similar to von Hügel, for whom the separation of grace from nature resulted in a spiritual obliqueness, an inability to see God's creation fully.

Manley goes on to consider the nature of just punishment for his sins and of the inevitable loss of innocence in facing such questions. He now believes that blasphemy is "a sin open to children as well as adults."[41] Where Ruller ruminates over trivialities, like what it means exactly to gnash one's teeth, Manley (who at the tender age of ten nonetheless asks "manly" questions) is able to make distinctions between different kinds of evil: "The feeling of this evil was murky but cold. It was not like the feeling of his secret sins or the more open kind like smashing the bottle."[42] Manley questions the nature of God's motives and recalls the biblical stories of the lost sheep and the prodigal son. He openly wrestles with the voices in his head, which, for O'Connor, was where the devil usually resided, and when he resists these voices, he is once again able (allowed) to see "the gorgeous violent woods."[43]

To conclude that O'Connor becomes more theologically astute between the first and second versions of the story is to admit the obvious. And yet it needn't have turned out that way. She might have taken a more secular turn in her stories. No doubt the increasing theological depth in O'Connor's stories was due, in part, to her increasing spiritual and theological astuteness. It was also certainly due to the books she had read in the interim. It could also be explained by the onset of her lupus, which would compel anyone forced to consider their mortality at the age of twenty-five to become more serious. Whatever the reasons, the turn is evident, not only when one compares her Iowa stories with her Milledgeville ones, but when her two novels are examined side by side.

From *Wise Blood* to *The Violent Bear It Away*

Though they were completed almost eight years apart, O'Connor would begin writing what eventually became the first chapters of *The Violent Bear It Away* almost immediately after she completed *Wise Blood*, which was published in May of 1952. Her first mention of the as-yet-unnamed second novel comes in a letter to Elizabeth McKee in October of that year: "I am writing something that may turn out to be a short novel or something of that kind."[44] She would

[41]*CW*, 767.
[42]Ibid.
[43]*CW*, 769. The paradoxical coexistence of beauty and terror in a single object was already becoming a trope in O'Connor's fiction.
[44]*HB*, 44.

eventually shelve the project and turn her attention to her first collection of short stories. The lion's share of *The Violent Bear It Away* was written between 1955 and 1959, and it is during this time (and in the drafts she completes during this period) that we see a maturing theological vision that turns *The Violent Bear It Away* into a distinctly different beast than *Wise Blood*. Where *The Violent Bear It Away* is concerned with questions of theological substance, *Wise Blood* appears more preoccupied with religious effect.[45]

It is no overstatement to say that *Wise Blood* contains very little, if any, mysticism, and no balance exists between the immanence and transcendence of God because *Wise Blood* is almost entirely bereft of God.[46] For O'Connor, mysticism was usually attached to ordinary experience, but barely a page of *Wise Blood* deals with ordinary experience, and in this sense, the novel seems almost cartoonish.[47] O'Connor even alludes to the "comic effect" she was after in *Wise Blood*.[48] Needless to say, unlike *The Violent Bear It Away*, with its dreams and visions and the sacramental elements of bread, blood, and water soaking practically every other page, there are few if any mystical encounters with God in *Wise Blood*.[49]

Essentially, the farcical tone of O'Connor's first novel means, among other things, that conversations between the characters rarely reach the level of theological concerns, and questions of religion are essentially primal in nature,

[45]Asals argues that "the transformation in O'Connor's vision, so dramatically revealed by juxtaposing the two novels, actually occurred more gradually" (*Imagination of Extremity*, 168). I agree. It is a progression, in fact, more than a transformation. William Sessions, in his excellent essay "Real Presence" (in *Inside the Church of Flannery O'Connor: Sacrament, Sacramental, and the Sacred in Her Fiction*, ed. Joanne Halleran McMullen and Jon Parish Peede [Macon, GA: Mercer University Press, 2007]), contends that O'Connor recognized the need to change her sacred language in order to speak more directly to our disenchanted times: "O'Connor herself sought . . . a language that would express her own sense of holiness but in a Misfit world" (25). I think this change in language occurs gradually, ineluctably, as she matures in her faith and in her skill as a writer.

[46]Nature, which becomes a canvas for God's sacramental presence in many of O'Connor's later stories (as it was for Aquinas), does not figure in *Wise Blood* in any prominent way—both the novel's setting and conceits are essentially urban. Robert Drake considers *Wise Blood* O'Connor's least successful work, adding that "Miss O'Connor was trying too hard to say too much too soon." Drake, *Flannery O'Connor*, 19.

[47]O'Connor alludes to this in one of her letters to Hester where she describes how, in the new novel (*The Violent Bear It Away*), she is trying to make it "more human, less farcical" (*HB*, 111).

[48]*HB*, 403. Marian Burns contends that "the range of O'Connor's work demonstrates the growth in her vision from low comedy to mysticism" ("The Ridiculous to the Sublime: The Fiction of Flannery O'Connor" [PhD diss., University of Manchester, 1984]) as quoted in Scott, *Reference Guide*, 704.

[49]*Wise Blood* is funnier than *The Violent Bear It Away*, as O'Connor herself attests: "This book is less grotesque than *Wise Blood* and as you say less funny" (*HB*, 343). O'Connor goes on to say about *The Violent Bear It Away* that "if it had been funny, the tone would have been destroyed at once" (*HB*, 176).

almost adolescent. The novel does include serious elements, exploring, for example, "both the absurdity and the seriousness of salvation and redemption through finding Jesus Christ,"[50] but the churlish and chaotic manner in which Hazel Motes goes about finding redemption ends up overtaking the solemn urgency implicit in the search for it.

And rather than their connection being affirmed, the body and the spirit are at odds throughout the story, an antagonism that is brought to its denouement in Haze's self-blinding. The body and spirit are often at odds in *The Violent Bear It Away* too, but there is an equal number of affirmations of their unity, as when young Tarwater's spiritual emptiness is manifested in his hunger for a loaf of bread, or, most poignantly, when Bishop is drowned and baptized simultaneously, as if the two were connected in some kind of hypostatic union.

The words *mercy, grace, fire, burn,* and *Lord* do not appear a single time in *Wise Blood*, and in this sense, it is a novel with more formally religious or ecclesial preoccupations. Questions of institutional religion and the institutional church predominate; the word *church* occurs thirty times in the *Wise Blood*, whereas it is entirely absent from *The Violent Bear It Away*. The elements of sin, redemption, and judgment are certainly present in *Wise Blood*, but they are not as fully worked out as they are in *The Violent Bear It Away*. This is not so much a criticism of O'Connor's first novel as it is a recognition that almost ten years separate the completion of the two stories, and O'Connor grew considerably, theologically speaking, in that interim.

In *Wise Blood*, descriptions of beauty hardly exist, and the emphasis on the truth of the gospel is mitigated by caricature and banal foolishness; gorilla suits, mummified heads, and an oddball assortment of characters more suited for a freak show than for a normal southern town are the means by which the plot unfolds. By comparison, the characters in *The Violent Bear It Away* are more controlled. The large, bold, sometimes careless brushstrokes of *Wise Blood* are replaced by the more discordant hymn of *The Violent Bear It Away*, which shifts the focus from the eye to the ear and helps to explain why O'Connor's second novel is less easily caricatured than its predecessor: in a

[50]Matt Mazur, "Wise Blood," *PopMatters: The Magazine of Global Culture,* July, 20, 2009, www.popmatters .com/review/108026-wise-blood.

medium that depends on words for meaning, it is easier to control the words than the images they create.

In some ways, *Wise Blood* is the more prodigious effort, being the product of such a young and relatively inexperienced mind (in both the worldly and literary sense). It is a work of precocious genius, to be sure, but one that is still in its rough beginnings. I agree with Asals, who contends that "the strongest objection that can be lodged against *Wise Blood* is not a matter of faults at all, but of limitation: O'Connor's first novel simply does not have the richness and depth that she achieved in her later work."[51]

In *American Gargoyles: Flannery O'Connor and the Medieval Grotesque*, Anthony Di Renzo writes,

> Despite *Wise Blood*'s real genius, it remains the capstone of O'Connor's juvenilia, not the cornerstone of her mature fiction. It is a youthful book, a piece of *jeu d'esprit*, her first full-fledged experiment with the grotesque after the conventional prentice work of her Iowa years; but it is an experiment with decidedly mixed results. *Wise Blood* has all the merits and faults of a young writer finally hitting her stride: it is energetic, playful, daring, and inventive, but it is also facetious, self-conscious, and a trifle heavy-handed. At its best the novel resembles Goya's *Caprichos*—a funny, frightening, black-and-white world with clever caricatures etched in acid. It is a miniature masterpiece; but it lacks color, subtlety, complexity, and humanity. O'Connor's use of the grotesque in *Wise Blood* does not have the range and depth of her later work. It is solely at the service of satire, not of characterization.[52]

There is something instinctive, even primitive, about the faith expressed in *Wise Blood*. O'Connor's prodigious theological instincts are on display, to be sure, but prodigious as they may be, they are nevertheless more *instinct* than carefully considered doctrine. In *Wise Blood*, one gets the sense that O'Connor is experimenting. Her theology is drawn in sketches, though the rudiments of a much deeper and more profound rendering, which will come to full bloom in her later stories, are there *in utero*, as it were. We see this especially in the

[51]Asals, *Imagination of Extremity*, 63. For an alternate and more sympathetic assessment of *Wise Blood*'s theological depth, see Robert Brinkmeyer's "'Jesus, Stab Me in the Heart!': *Wise Blood*, Wounding, and Sacramental Aesthetics," in *New Essays on "Wise Blood,"* ed. Michael Kreyling (New York: Cambridge University Press, 1995), 71-89.

[52]Anthony Di Renzo, *American Gargoyles: Flannery O'Connor and the Medieval Grotesque* (Carbondale, IL: Southern Illinois University Press, 1995), 25.

difference between the protagonists in each novel and the depth of their con-
comitant struggles, which Asals underscores in his suggestion that what Hazel
Motes essentially decides is that life is not worth living and that

> the best thing to do is get out of it as soon as possible. And that seems to me to
> be very different from what is implied towards the ending of *The Violent Bear It*
> *Away*, and, in fact, all the way through [that novel], in which the whole thrust
> of the novel is to return the action to this world. . . . Tarwater finds that, little
> as he may like it, he's doomed to live.[53]

Asals goes on to argue that *The Violent Bear It Away* "is a measure of the
distance her later work travels from *Wise Blood*. To put the two novels side
by side is to discover dramatically what endures and what is transformed in
her vision after 1952."[54]

Asals primarily assesses the novels on their comparative literary merits
and not on the relative depth of their theological visions (though the en-
during truth remains that *how* something is said ineluctably affects *what* is
said), but his literary comparison nonetheless helpfully points to their coun-
tervailing theological differences. He praises *The Violent Bear It Away* for its
"tighter narrative," which corresponds, it seems to me, to the "tighter" theo-
logical profundity of O'Connor's more carefully realized dogmatic positions,
expressed in and through the words and actions of her characters.[55] If *Wise*
Blood is a more centrifugal novel in that it extends outward from the pro-
tagonist in all directions, as Asals suggests, then the centripetal force of *The*
Violent Bear It Away, theologically understood, stems from the more con-
fident position of its sympathetic narrator, who tells the story from a wiser
and more chastened theological perspective. The spiritual changes within
Francis Tarwater control the movement of *The Violent Bear It Away* more
profoundly than the external havoc caused by Haze's often impulsive actions
controls *Wise Blood*. A single example of this difference can serve as a contrast
by comparing two almost identical plot movements in both stories. When
Haze kills the prophet Solace Layfield by running over him with his car
(twice), it is grimly comic and without redemptive effect in the conceit of the

[53]Frederick Asals, "Panel Discussion. April 7, 1974," *Flannery O'Connor Bulletin* 3 (1974): 61.
[54]Asals, *Imagination of Extremity*, 160. I believe that the difference is far more apparent after 1954, for reasons
I discuss below.
[55]Ibid., 162.

story. Its main purpose is simply to build on Haze's gnawing and growing spiritual psychosis toward his eventual breakdown. When Tarwater kills the boy Bishop, however, it is done in the midst of a sacrament (baptism) and is devoid of comic effect. Where Solace's death is gruesome, Bishop's is sacramental, which, in some sense, makes it all the darker. But in O'Connor's moral universe, darker often means holier.

When Asals ventures into theological comparisons between the two novels, he comes to the same essential conclusions about their relative merits: "Whereas Enoch's unconscious mockery of the Mass had denied that nature was capable of any genuine revelation [or] that sacramental vision in the world of *Wise Blood* was possible, both Rayber and Tarwater affirm its potency in *The Violent Bear It Away*."[56] Asals points to the "reductive landscape" of the paradigmatic park scene in *Wise Blood* as emblematic of "a final death," whereas its counterpart in *The Violent Bear It Away* is a "resonant scene that vibrates with the presence of mystery."[57] Asals's conclusion is no less dramatic in claiming that "the 'sacramental vision' of which O'Connor so often spoke is genuinely operative in *The Violent Bear It Away* in a way it is not in *Wise Blood*,"[58] which is due to "the reversal in vision between *Wise Blood* and *The Violent Bear It Away* [and] between the O'Connor who viewed this world as a nightmarish excrescence of reductive and repellent matter and the O'Connor who saw it through her Christian sacramentalism."[59]

A shift occurs in O'Connor's writing, then, somewhere between her two novels and collections of short stories. But what was the impetus for such a shift? All indications in my research pointed to the unlikely influence of Friedrich von Hügel.[60] It is to his influence that we now turn our attention.

[56]Ibid., 164.

[57]Ibid., 165. This reductive tone in *Wise Blood* (as compared to *The Violent Bear It Away*) is evident, too, in the fact that the words *grace* and *mercy*, which came to occupy such a central place in the lexicon of O'Connor's late fiction, do not occur a single time in *Wise Blood*.

[58]Asals, *Imagination of Extremity*, 165.

[59]Ibid., 167. It is interesting to note that when *Wise Blood* was published in France, it was "received as an important Existentialist novel." See Stanely Edgar Hyman, *Flannery O'Connor* (Minneapolis: University of Minnesota Press, 1966), 9.

[60]It must be recognized, of course, that no influence—just as no interpretation of such influence—occurs independent of other cultural sources. O'Connor was clearly influenced by many figures, François Mauriac and Romano Guardini being the most prominent among them.

"THE BARON IS IN MILLEDGEVILLE"

In late March of 1959, O'Connor sent off some late drafts of *The Violent Bear It Away* to her editors Robert and Sally Fitzgerald, one of which included this important line: "GO WARN THE CHILDREN OF GOD OF THE TERRIBLE SPEED OF MERCY."[61] That the draft is a later one, written sometime in 1959, is indicated by the inclusion of the baptism of Bishop, which was a late addition to the story.[62] Though it is impossible to make exact determinations of dates when the drafts were written, when cross-referenced with her private correspondence, for example, a window of within a few months can generally be ascertained. Language about Tarwater being sent as a prophet to Mason "to burn [his] eyes clean" appears for the first time in draft 183b, a draft that was written sometime just before or during the summer of 1959, and an even later addition (189b) has the slightly longer entry: "GO WARN THE CHILDREN OF GOD, . . . OF THE TERRIBLE SPEED OF JUSTICE, OF THE TERRIBLE SPEED OF MERCY. WHO WILL BE LEFT? WHO WILL BE LEFT WHEN THE LORD'S MERCY STRIKES?" What is noteworthy about this is that it is only after O'Connor had read Baron von Hügel's *The Mystical Element of Religion* that working drafts of *The Violent Bear It Away* begin to include burning imagery and the notion of the terrible speed of God's mercy.

A few weeks later, in May 1959, O'Connor wrote to her friend Fannie Cheney to thank her for sending von Hügel's massive two-volume—almost nine hundred pages—biography of St. Catherine of Genoa (*The Mystical Element of Religion*):

> The Baron is in Milledgeville and I am highly obliged to you. I have almost finished the first volume and will send it along when I finish it. You are contributing greatly to my education. I see nobody has checked these books out since 1954. Them Tennessee theologians must all be Baptists.[63]

The crucial addition of the line about God's terrible mercy, at precisely the time she was reading von Hügel's *Mystical*, is not coincidental, and the

[61]*HB*, 323. Emphasis original.

[62]See Stephen Driggers et al., *The Manuscripts of Flannery O'Connor at Georgia College* (Athens: University Press of Georgia, 1989), 88.

[63]C. Ralph Stephens, ed., *The Correspondence of Flannery O'Connor and the Brainard Cheneys* (Jackson: University Press of Mississippi, 1986), 86.

connection is made all the more clear by a letter O'Connor sends to the Cheneys a few months later, in August, where she attributes the idea of the speed of God's mercy directly to von Hügel:

> Thank you both for reading [*The Violent Bear It Away*]. About the end: I meant that Tarwater was going to the city to be a prophet and the "fate" that awaits him is the fate that awaits all prophets or as the old man said, "the servants of the Lord can expect the worst." I reckon on the children of God doing Tarwater up pretty quick. What he means by the speed of mercy is that mercy burns up what we are attached to, the word is a burning word to burn you clean (see Vol. II Baron von Hügel, *The Mystical Element of Religion*).[64]

The fact that O'Connor attributes the cryptic meaning of the novel's epigraph to von Hügel is not so surprising given her effusive praise of the man in her correspondence, essays, book reviews, and the contents of her personal library, which all point in one form or another to von Hügel's significant and profound influence on O'Connor. She had read von Hügel's *Letters to a Niece* sometime before the fall of 1954, and so these two books (*Letters* and *Mystical*) served as bookends to O'Connor's writing of *The Violent Bear It Away*, with von Hügel's *Essays* captivating her theological imagination in between.[65] By the time O'Connor had finished her second novel, von Hügel's legacy in O'Connor's theology was solidified, and the considerable influence these books had had on her writing can be inferred in her change in thematic direction from her earlier to her later work. Clearly, her opinion of her influences had changed between the letter she wrote to Fannie Cheney in 1959 (see previous paragraphs) and her earlier, more sardonic letter to Betty Hester in 1955 (see note 6 of the current chapter). Von Hügel's writings had already proved to be an invaluable companion to, and crucial influence on, O'Connor's growing storehouse of theological knowledge, and her latest foray into his first book, *The Mystical Element of Religion*, would serve as a capstone on that influence during what was her busiest and most productive writing period, from 1954 to 1960.[66]

[64]Ibid., 93 (parentheses O'Connor's). O'Connor may have meant vol. 1, as the word *mercy* rarely appears in vol. 2. Burning imagery and language, however, can be found throughout both volumes.

[65]William Kirkland, one of O'Connor's most perceptive critics and a personal friend, claimed that "from about 1954 . . . to the end of her life, the Baron was one of her mentors" and that O'Connor "was significantly influenced by the man and his writings." William Kirkland, "Baron Friedrich von Hügel and Flannery O'Connor," *Flannery O'Connor Bulletin* 18 (1989): 29.

[66]Notwithstanding O'Connor's obvious debt to von Hügel especially during the middle period, tracing specific and direct lines of theological influence from a writer's library to her published output is a largely speculative enterprise, particularly as it relates to fiction and to the tools of that craft—symbolism,

EXCURSUS: O'CONNOR'S WRITING PERIODS

I divide O'Connor's writing into three general periods: 1949–1953, during which she began her career as a professional writer, completed her first novel, *Wise Blood*, and wrote the early short stories that would eventually be included in her first collection; 1954–1959, when four of the stories in *A Good Man Is Hard to Find* were written and the collection as a whole was published, *The Violent Bear It Away* was both written and published, and three of the stories that would eventually be published in her second collection were written; and 1960–1964, when the remaining six stories in her last collection were written and *Everything That Rises Must Converge* was published. Despite the second period representing just over one-third of O'Connor's professional writing career, it accounts for almost two-thirds of her published correspondence and nearly half of the essays she wrote and delivered.

The opening page of the first section of Brad Gooch's biography of Flannery O'Connor recounts the final lecture O'Connor gave, in the fall of 1963, at Georgetown University, where he quotes her as saying, "The things we see, hear, smell and touch affect us long before we believe anything at all."[67] This lecture was adopted from an earlier essay titled "The Catholic Novelist in the Protestant South," which O'Connor had written, and subsequently gave as a lecture, in April of 1960, less than a year after she had completed—more accurately, devoured—Baron von Hügel's massive *The Mystical Element of Religion*.[68] The pertinent passage from O'Connor's essay reads:

metaphor, and thematic shadowing—all of which, as Aristotle reminds us in his *Poetics*, eschew obvious meanings and straightforward claims of provenance. Because of this, I do not usually attempt to draw direct lines from one phrase in von Hügel to a particular phrase in O'Connor—though some direct lines can and will be drawn—so much as I seek to illustrate how von Hügel's ideas influenced O'Connor's writing (and thought) more generally. Indeed, ascertaining von Hügel's direct influence on any single work of O'Connor's is nearly impossible (with some exceptions). She read or reviewed his books from 1954 to 1958 and made subsequent references to his work up to the last year of her life, so his influence on her was both deep and long lasting even if it cannot be precisely quantified.

[67]Brad Gooch, *Flannery: A Life of Flannery O'Connor* (New York: Little, Brown, 2009), 13.

[68]In May of 1959, she wrote to her friend Betty Hester, "I am reading a corker called *The Image Industries* by William Lynch, S.J. I have four piled up to review but they will have to wait for me to finish the Big Thing, namely: The Mystical Element of Religion. Mrs. Cheney checked it out of the Vanderbilt theological library for me, two volumes. I have read it in too big a hurry but at least I am reading it. Also I have persuaded my editor to read Von Hügel and I have an eye to trying to persuade him further to bring out a collection of the essays. This would be a great contribution to the tone of American Catholicism" (*CW*, 1097).

The things we see, hear, smell, and touch affect us long before we believe anything at all, and the South impresses its image on us from the moment we are able to distinguish one sound from another. By the time we are able to use our imaginations for fiction, we find that our senses have responded irrevocably to a certain reality. This discovery of being bound through the senses to a particular society and a particular history, to particular sounds and a particular idiom, is for the writer the beginning of a recognition that first puts his work into real human perspective for him. . . . The fiction writer finds in time, if not at once, that he cannot proceed at all if he cuts himself off from the sights and sounds that have developed a life of their own in his senses.[69]

This passage is notable for its similarity to, and likely its dependence on, a strikingly similar passage in Baron von Hügel's *The Mystical Element of Religion* where he talks about what he calls the first element of religion, which he suggests comes to us as infants, or as O'Connor phrases it, "from the moment we are able to distinguish one sound from another":

Now if we will but look back upon our own religious life, we shall find that, in degrees and in part in an order of succession varying indefinitely with each individual, three modalities, three modes of apprehension and forms of appeal and of outlook, have been and are at work within us and around. 1. *Sense and Memory, the Child's means of apprehending Religion.* In the doubtless overwhelming majority of cases, there came first, as far as we can reconstruct the history of our consciousness, the appeal to our infant senses of some external religious symbol or place, some picture or statue, some cross or book, some movement of some attendant's hands and eyes. . . . The little child gets these impressions long before itself can choose between, or even is distinctly conscious of them; it believes whatever it sees and is told, equally, as so much fact, as something to build on. . . . The five senses then, perhaps that of touch first, and certainly that of sight most; the picturing and associative powers of the imagination; and the retentiveness of memory, are the side of human nature specially called forth. And the external, sensible, readily picturable facts and the picturing functions of religion correspond to and feed this side, as readily as does the mother's milk correspond to and feed that same mother's infant.[70]

[69]*MM*, 197-98.
[70]Friedrich von Hügel, *The Mystical Element in Religion as Studied in Saint Catherine of Genoa and Her Friends* (London: J. M. Dent & Sons, 1923), 50-51. Hereafter *Mystical*.

In that same essay (and presumably in her final lecture), O'Connor brings up one of her most often-quoted phrases, that of "grace as working through nature," which echoes von Hügel.[71] Indeed, earlier in the same essay, she quotes the man:

> Baron von Hügel, one of the great modern Catholic scholars, wrote that "Supernatural experience always appears as the transfiguration of Natural conditions, acts, states . . . ," that "the Spiritual generally is always preceded, or occasioned, accompanied or followed, by the Sensible. . . . The highest realities and deepest responses are experienced by us within, or in contact with, the lower and lowliest."[72]

Such phrases, so commonly associated with O'Connor, turn out to be a common refrain—a trope, really—in von Hügel's writings, and one that O'Connor explicitly credits to him, not only in her essays but in her letters and book reviews, as well.[73]

O'Connor praised von Hügel's ideas and would quote them often, especially between 1954 and 1960, which makes her reference to his ideas in her last public lecture in 1963 so significant. It shows how von Hügel's influence continued almost unabated until the end of her life.

The difficult question remains, however, of how, exactly, O'Connor translated von Hügel's theology into her fiction. Von Hügel was a systematic thinker to a fault—everything seemed to come in sets of three for him—while O'Connor was a storyteller who explicitly rejected theoretical and literary strictures that reduced storytelling to particular formulas.[74] My claim, then, is that three of von Hügel's ideas, in particular, served as a catalyst for a clearer merging of O'Connor's theological and aesthetic visions, which necessitates a closer look at the ideas themselves and how they animated O'Connor's theological vision. Only then can we follow any possible thread of von Hügel's

[71]*MM*, 197.

[72]*MM*, 176.

[73]See her review of von Hügel's *Essays* in *The Presence of Grace and Other Book Reviews by Flannery O'Connor*, ed. Leo Zuber and Carter Martin (Athens: University of Georgia Press, 1983), 21. This is not to suggest that such ideas—of grace working through nature, for example—are not common in Aquinas and other Catholic literature, but only that whenever O'Connor brings up such ideas, she invariably credits von Hügel as the source.

[74]Some critics, like Jonathan Sykes, believe otherwise, arguing, for example, that O'Connor wrote from a New Critical perspective. I largely disagree; see "O'Connor's New Critical Pedigree" in chap. 3.

influence as she wove his ideas—often unconsciously—into the fabric of her fiction.

THE THREE ELEMENTS OF RELIGION

Von Hügel was no incidental figure of twentieth-century Roman Catholicism, and his monumental work on the life of St. Catherine of Genoa, considered the primary text of her life and thought, remains one of the definitive studies on mysticism. He was Evelyn Underhill's spiritual mentor—herself one of the important voices in the mystical tradition of the twentieth century—and he was also the first Catholic since the Reformation to be awarded an honorary doctorate from Oxford. He was invited to give the Gifford lectures of 1924–1926 but had to decline because of poor health, and though he only began to be published later in his life—in his mid-fifties—he nonetheless managed to pen some of the seminal books of the Catholic intellectual renaissance of the twentieth century.[75] O'Connor, unlike many of her American Catholic contemporaries, seemed to understand the importance of von Hügel and wrote in a review of his work that he was "frequently considered, along with Newman and Acton, as one of the great Catholic scholars."[76]

Von Hügel's principal contribution to theology (and a recurring theme in virtually everything he wrote) was his notion of the "three elements of religion," which suggests that the life of a person, and of one's religious life in particular—indeed, even of history itself—can be divided into three elements or periods:

1. the historical/institutional/sensible

2. the scientific/intellectual/rational

3. the mystical/experiential/spiritual

Each element represents a chronological stage in development, though none replaces the others as development progresses. They coexist in a "friction" of claims and counterclaims, and von Hügel believed that all three must necessarily be in tension in order to maintain a healthy balance of creative forces

[75]Von Hügel's three major works were *Mystical; Essays and Addresses on the Philosophy of Religion*, 2 vols. (London: J. M. Dent & Sons, 1921–1925); and *Letters from Baron Friedrich von Hügel to a Niece* (London: J. M. Dent & Sons, 1928). O'Connor wrote glowing reviews of von Hügel's *Letters* and *Essays* but considered *Mystical* his finest work. See her reviews in Zuber and Martin, *Presence of Grace*.

[76]Zuber and Martin, *Presence of Grace*, 21.

within a person (or period of history). Yet this balance of tensions is also what gives rise to difficulties, most acutely realized in the religious life.

O'Connor's interest in von Hügel initially grew out of her fascination with his third element, the mystical/experiential/spiritual, and his work on mysticism in general, and in particular his work on St. Catherine of Genoa.[77] Her early interest in Catherine of Genoa, dating back to at least 1949, when O'Connor acquired her *Treatise on Purgatory*, was likely the catalyst that eventually led O'Connor to von Hügel (perhaps via Evelyn Underhill, who was another likely catalyst).[78] O'Connor's signature and the year 1949 are written on the inside cover of her copy of Catherine's *Treatise*. Von Hügel figures prominently in this edition (he is mentioned half a dozen times in the introduction), given his distinction as the principal biographer of Catherine of Genoa. O'Connor wrote to her friend Betty Hester in a letter in November of 1955 that Hester would enjoy Evelyn Underhill's book on mysticism; and then in the very next sentence, O'Connor expresses her own desire to "to read Baron von Hügel's book, *The Mystical Element in Religion*. Do you reckon the Atlanta PL would have that?"[79] This is the first mention of von Hügel in *The Habit of Being*. In the only other letter where O'Connor mentions Underhill, she references von Hügel as well.[80]

A Unity of Frictions

Von Hügel's three elements, though distinct, form an essential unity in much the same way that O'Connor insisted on the irrevocable unity of the writer's dramatic and moral vision. Von Hügel repeatedly stressed the importance of keeping the three elements in a unified tension ("unity in multiplicity" is a ubiquitous von Hügel expression) for the sake of religious balance and spiritual health:

> Hence, here as elsewhere, but more than anywhere, our ideal standard will be the greatest possible development of, and inter-stimulation between, each

[77]"I got interested in St. Catherine of Genoa," O'Connor writes, "when I saw her picture—a most beautiful woman" (*HB*, 113). O'Connor was also interested in St. Catherine of Siena, Simone Weil, and Edith Stein, writing of the latter two, "[Weil] and Stein are the two 20th-century women who interest me most" (*HB*, 93).

[78]St. Catherine of Genoa, *Treatise on Purgatory: The Dialogue*, ed. Charlotte C. Balfour, Helen Douglas-Irvine, and Battistina Vernazza (London: Sheed & Ward, 1946).

[79]*HB*, 116. Evelyn Underhill, *Mysticism: A Study in the Nature and Development of Spiritual Consciousness* (New York: Noonday Press, 1955).

[80]*HB*, 297.

and all of the religious elements, with the greatest possible unity in the resulting organism.[81]

Such a unity is difficult, though, because it is fraught with a necessary *friction* (another favorite word of von Hügel's) of opposing forces, as when, for example, supernatural grace comes in contact with and elevates nature, or when we come in contact with the mercy of God that burns with a purgatorial fire.

In *The Violent Bear It Away*, the largely sympathetic narrator is describing young Tarwater's increasingly unsettling realization that he has been fated (called, predestined) to be a prophet. In O'Connor's moral universe, to be called by God, even to interact with him, is to experience things not always— or even usually—altogether pleasant. God's love burns, his truth make fools of us all, and the speed of his mercy knocks us down. Such literary distinctions seem to suggest (and mirror) von Hügel's elemental distinctions of *sacramental, intellectual,* and *mystical/ethical* (body, mind, and soul) to the point that O'Connor incarnates them (perhaps unconsciously) in her fiction through the three ideas she explicitly credits to him:[82]

1. the inseparability of grace and nature (beauty, the sacramental element);

2. the centrality of the mystery, even foolishness, of the gospel (truth, the intellectual element); and

3. the need to accept the severe limitations or "costingness" of the Christian life (goodness, the mystical/ethical element).

The naked parallelism of the three phrases in the central passage from *The Violent Bear It Away* ("bleeding stinking mad," "blood and nerve and mind," and "bleed and weep and think")point, I believe, to an implicit scaffolding in O'Connor's mind of the transcendental categories of beauty, goodness, and truth, respectively, categories that she distorts in order to reflect her own (and von Hügel's, and the church's) sacramental vision of reality:[83]

[81]*Mystical*, 2:116.

[82]I hasten to reiterate that von Hügel's "elements," which have many and various permutations, are not distinctions that O'Connor used in any systematic or explicit way, though she does mention them in her review of von Hügel's *Essays* (Zuber and Martin, *Presence of Grace*, 41) and refers to them a number of times in her own essays in *MM*.

[83]Von Hügel writes, "This Supernaturalness does not concern Goodness alone, but also Truth and Beauty, [for] God is the Fountain and the Fullness, the Origin and End, the ultimate Measure of every kind and

Tarwater clenched his fists. He stood like one condemned, waiting at the spot of execution. Then the revelation came, silent, implacable, direct as a bullet. He did not look into the eyes of any fiery beast or see a burning bush. He only knew, with a certainty sunk in despair, that he was expected to baptize the child he saw and begin the life his great-uncle had prepared for him. He knew that he was called to be a prophet and that the ways of this prophecy would not be remarkable. His black pupils, glassy and still, reflected depth on depth his own stricken image of himself, trudging into the distance in the bleeding stinking mad shadow of Jesus, until at last he received his reward, a broken fish, a multiplied loaf. The Lord out of dust had created him, had made him blood and nerve and mind, had made him to bleed and weep and think, and set him in a world of loss and fire all to baptize one idiot child that He need not have created in the first place and to cry out a gospel just as foolish.[84]

Von Hügel's influence extends further than notions of the spiritual made manifest in and through the material, or of their essential and indivisible union in this world, or even of the central mystery of God being heightened precisely because of its manifestation in the material world. In her essays, letters, and reviews, O'Connor often referred to the "cost" of Christianity and of how faith and obedience cannot be easy things if they are to be of any lasting value. Such a cost is, in fact, an important part of what it means to be a Christian.[85] Which is to say that three iconic themes commonly attributed to O'Connor—that high spiritual realities are manifested in low material things ("grace through nature"; *bleeding*); that the life of the prophet and Christian believer is costly and often fatal ("mercy is a burning word"; *stinking*); and that God's mercy and grace are most intimately expressed in the form of mysterious and difficult, even foolish truths ("the strangeness of truth"; *mad*)—come from or out of ideas she attributes to von Hügel.[86] Furthermore, such themes not only represent a subversion of the traditional

degree, as much of Beauty and of Truth as of Goodness" (*Mystical*, 198). Note that O'Connor inverts the last two of von Hugel's elements in this passage, so that the ethical ("stinking/nerve/weep") comes before the intellectual ("mad/mind/think").

[84]*CW*, 388.

[85]See *MM*, 112; *HB*, 336.

[86]*MM*, 153; Stephens, *Correspondence of Flannery O'Connor*, 93; *HB*, 343. It is important to remind ourselves that even though O'Connor quotes from or alludes to von Hügel's writing more than she does any other writer, his influence on her was more a matter of absorption and assimilation than duplication or direct appropriation, particularly in her fiction; fictional characters do not carry the burden of listing their creator's debts. And in O'Connor's case, because von Hügel's influence wove its way

understanding of the transcendental categories of beauty, goodness, and truth, respectively, but also provide a hermeneutical lens for understanding her stories more fully, particularly from a theological perspective.

O'Connor likely read more pages of von Hügel's than she did any other writer, including Aquinas, so it should not be surprising that her writing began to take on a moral profundity and theological depth reflective of von Hügel's own commitments and thematically related to his ideas.

The simple fact that O'Connor acknowledges von Hügel as the source of such ideas, ideas that lie at the heart of her fiction, confirms that von Hügel serves as no mere theological balustrade for O'Connor's identity as a Catholic writer but, instead, that he belongs at her spiritual center. This question then naturally arises: Why hasn't more been done to examine O'Connor's interest in and theological debt to mysticism in general, and to von Hügel's influence on her in particular? Von Hügel veritably led O'Connor to the well of the mystical tradition and gave her the language to incorporate that tradition into a more incarnational, even gothic voice in her dark and yet comical southern fictional landscape. And yet, von Hügel remains a conspicuously absent figure in O'Connor scholarship.[87]

The most conspicuous evidence of this curious reluctance of O'Connor scholarship to recognize von Hügel's influence, however, can be found by simply noting that Neil Scott's exhaustive account (nearly a thousand pages of references) of articles, essays, books, and monographs written about O'Connor between 1975 and 2002 includes only a single entry on von Hügel (William Kirkland's essay). My rigorous search of publications since 2002 reveals the same pattern of neglect. Indeed, no single book, monograph, article, or dissertation that I could find written since her death, with two or three exceptions, makes more than a few cursory references to von Hügel, and most never mention him at all. Apparently this strange silence regarding von Hügel was true even in O'Connor's day, which she notes with no small measure of sarcasm in her review of his *Letters*:

through her work over the long span of her most productive writing period and late into her final years, it was necessarily more diffuse but also, as a result, more pervasive.

[87]See my chapter "'The Baron Is in Milledgeville': Friedrich von Hügel's Influence on O'Connor," in *Revelation and Convergence: Flannery O'Connor and the Catholic Intellectual Tradition*, ed. Mark Bosco and Brent Little (Washington, DC: Catholic University of America Press, 2017), for a fuller treatment of the conspicuous neglect of von Hügel by O'Connor scholarship.

A Protestant minister once remarked to the reviewer that he had never met an American Catholic priest who had read Baron von Hügel. Since Friedrich von Hügel is frequently considered, along with Newman and Acton, as one of the great Catholic scholars, it is to be hoped that the minister's acquaintance with priests was limited. With the publication of Baron von Hügel's letters to his niece, this great man and his vigorous, intelligent piety may become better known to Americans.[88]

In another review a year later, this time of von Hügel's *Essays*, O'Connor continues her lament regarding von Hügel's relative obscurity, even among Catholics:

> The writings of Baron von Hügel have apparently been little read in this country by Catholics in spite of the reissue of his *Letters to a Niece*. This is unfortunate because a consideration of the always measured and intellectually just tone of his essays on religious subjects would serve as an antidote to the frequently superficial methods by which many popular American Catholic writers approach and sidestep the problems of faith or meet them with the Instant Answer.[89]

Of the few scholars who do mention him, one in particular, Robert Brinkmeyer, exemplifies the cognitive dissonance that even the most attentive of O'Connor scholars seem to exhibit in relation to von Hügel. This dissonance can best be described as a strange admixture of attributions of his clear influence on the seminal ideas present in O'Connor's work with a simultaneous neglect of an acknowledgment of that influence. Thus, in his *The Art and Vision of Flannery O'Connor*, for example, Brinkmeyer makes reference to von Hügel in a discussion of O'Connor's distinctive commitment to the idea of the spiritual coming exclusively in and through the physical:

> At the center of O'Connor's thinking was her conviction that the writer of fiction can express the mysteries of existence only as embodied in concrete human experience. In "Catholic Novelists and Their Readers" she cites several observations by Baron Friedrich von Hügel on the concreteness of spiritual experience [and] then notes the relevance of von Hügel's insights to the artist.[90]

[88]Zuber and Martin, *Presence of Grace*, 41.
[89]Ibid.
[90]Robert Brinkmeyer, *The Art and Vision of Flannery O'Connor* (Baton Rouge: Louisiana State University Press, 1989), 167.

Brinkmeyer immediately goes on to talk about O'Connor's insistence that "only by making their stories believable on a dramatic level can Christian writers suggest what she frequently called the 'added dimension'—the Christian mysteries."[91] In this lone citation of von Hügel, Brinkmeyer manages to distill von Hügel's immense influence on O'Connor's work down to a single point about what is arguably one of the key characteristics of her stories— namely, their deeply *incarnational* quality that gives her stories their *inherent mystery* and peculiar resonance—and then acknowledges that O'Connor gets this directly from von Hügel. Inexplicably, his discussion of von Hügel ends there.

Brad Gooch's biography mentions von Hügel only twice, both in passing, while Ava Hewitt and Robert Donahoo's edited collection of essays, *Flannery O'Connor in the Age of Terrorism*, a book replete with references to the action (and speed) of mercy and to burning imagery, neglects von Hügel altogether.[92]

Needless to say, many O'Connor scholars seem to have neither heard about nor read von Hügel, or at least do not consider him an important influence on her work. One could reasonably surmise that von Hügel is neglected precisely because those scholars who did read his work found little evidence of his influence, which invites the obvious question: Why not? Given O'Connor's frequent and almost universally exuberant praise of von Hügel in her writing, it is puzzling indeed why there is such a critical silence. This obvious lacuna in O'Connor studies becomes stranger still when one considers the central themes in O'Connor's fiction and nonfiction, which are deeply informed by, and in some cases borrowed directly from, von Hügel.

KIRKLAND AND EBRECHT

William Kirkland and Anne Ebrecht are two of the three exceptions (George Piggford is the third) who recognize and understand the influence von Hügel had on O'Connor's work.[93] Kirkland suggests that O'Connor was a Catholic

[91]Ibid.

[92]Ava Hewitt and Robert Donahoo, eds., *Flannery O'Connor in the Age of Terrorism: Essays on Violence and Grace* (Knoxville: University of Tennessee Press, 2011).

[93]George Piggford understood the important role von Hügel played in O'Connor's writing, and he examines the relationship of O'Connor's mysticism to von Hügel's influence and argues that O'Connor found four of von Hügel's ideas particularly useful: the insight that "supernature" is always encountered through nature; the tension between the historic and the "superhistoric"; the maxim that authentic liberty is freedom not to sin and that evil actively seeks to constrain choice; and the "cost" of the spiritual life as a response

modernist roughly in the vein of von Hügel, de Chardin, and Guardini, "individuals who, like her character Haze Motes . . . had difficulty with the Church. 'If they are good they are dangerous,'" he quotes O'Connor as saying about de Chardin.[94] Kirkland tries to make clear, however, that O'Connor's relationship to modernity was more complicated than a simple comparison with these men bears out. (Von Hügel's relationship to modernism was equally complicated and nuanced.) Perhaps this suggests at least one reason why von Hügel is essentially ignored by most scholars: he was considered by some to be an enfant terrible of the Catholic Church, and those who admire O'Connor do not want her reputation besmirched by too close of an association with the Catholic Modernist movement.

Ebrecht argues that von Hügel's main contribution to O'Connor's thought involved the notion that the material and spiritual planes are of a piece and cannot be separated without doing violence to both.[95] She writes, "For von Hügel, Catholicism is essentially a 'twice-born temper, a moving indeed into the visible and sublunar; yet this in order to raise the visible . . . to the invisible and transcendent.'"[96] This is O'Connor at her core, and Ebrecht acknowledges O'Connor's debt to von Hügel in this regard:

> It is easy to understand why O'Connor valued von Hügel's ideas so highly. For a central idea in each of the pieces in his Essays and Addresses is the complex nature of man—flesh and spirit, one half incomplete without the other. For von Hügel, man is not simply mind. He is also sense, imagination, feeling, and will. Human personality holds and harmonizes all these forces in a difficult but thorough interpenetration. Throughout his writings he emphasizes the richness of the interrelated elements of the unique creature man and the richness of this relation to [the] physical world.[97]

Kirkland saw O'Connor's debt to von Hügel even more clearly than Ebrecht. Kirkland, an Anglican priest who moved to Milledgeville in the spring of 1954

to supernature/grace. See his thoughtful "Contentment in Dimness: Flannery O'Connor and Friedrich von Hügel," in *Ragione, Fiction, e Fede: Convegno internazionale su Flannery O'Connor*, ed. Enrique Fuster and John Wauck (Rome: Edizioni Santa Croce, 2011), 26-39.

[94]Kirkland, "Baron Friedrich von Hügel and Flannery O'Connor," 29. *HB*, 571.

[95]Ann Ebrecht, "Flannery O'Connor's Moral Vision and 'The Things of This World'" (PhD diss., Tulane University, 1982). She is quoting from von Hügel's *Essays*, 233.

[96]Ebrecht, "O'Connor's Moral Vision," 34.

[97]Ibid., 28. See, for example, *MM*, 41-42.

and met Flannery later that summer, writes that what stood out about their first meeting was their mutual admiration of von Hügel, which surprised them both since he was so little-known outside of England. He remembers her exclaiming at that first encounter, "He's wonderful!"[98] According to Kirkland, at the time of their meeting (late summer, early fall of 1954) they each owned a well-worn copy of von Hügel's *Letters*, so well-worn in her case, apparently, that O'Connor tells Betty Hester in a letter the following year that she intends to order another copy of the book—a copy, incidentally, she later sends to Ted Spivey in the spring of 1959.[99]

Kirkland argues that von Hügel's influence on O'Connor was more on a personal than on a professional level: "As important as the von Hügel legacy was to Flannery O'Connor the artist, it must have had a more profound meaning in her personal life . . . and in the strengthening of her religious faith."[100] But by O'Connor's own admission, a writer writes with her entire being, her whole personality: "For the writer of fiction, everything has its testing point in the eye, and the eye is an organ that eventually involves the whole personality," and "it is a fact that fiction writing is something in which the whole personality takes part—the conscious as well as the unconscious mind."[101] Kirkland's claim introduces a dichotomy that O'Connor herself rightly rejects. Though distinct, the person and writer are finally inseparable.[102]

Kirkland acknowledges that "from about 1954 . . . to the end of her life, the Baron was one of her mentors" and that O'Connor "was significantly influenced by the man and his writings."[103] He goes on to spell out this significance,

[98]Kirkland, "Baron Friedrich von Hügel and Flannery O'Connor," 28. It is likely that Kirkland is the Protestant minister to whom O'Connor is referring in her review of von Hügel's *Letters*, where she quotes a minister as saying that he's "never met an American Catholic priest who had read Baron von Hügel."

[99]See *HB*, 330. In lieu of an inscribed copy of von Hügel's *Letters* with a date that would confirm O'Connor's possession of the book before 1956 (her only existing copy has that date inscribed), we can nonetheless surmise that sometime before the fall of 1954—and perhaps well before—O'Connor owned (and had read) a copy of von Hügel's *Letters*.

[100]Kirkland, "Baron Friedrich von Hügel and Flannery O'Connor," 37.

[101]*MM*, 91 and 101; see also 181.

[102]In a letter to Ted Spivey in 1959, O'Connor explains how she writes, recalling Jacques Maritain's notion of the habit of art, and then adds, "The greater the love, the greater the pains he [the author] would take" (*HB*, 387). She likely borrowed this idea from St. Catherine of Genoa's *Treatise*, a book she had in her library from 1949, where St. Catherine writes, "and the more perfect is the love of which God has made them capable, the greater is their pain" (see *Treatise*, chap. 12). In other words, O'Connor wrote from the depths of her being, with her heart and soul as well as her mind.

[103]Kirkland, "Baron Friedrich von Hügel and Flannery O'Connor," 29.

claiming, for instance, that O'Connor's belief "that the supernatural is known in and through the natural: the God of Grace is also the God of Nature" was taken from von Hügel.[104] Von Hügel talks of the God of the heavens interpenetrating the whole of the cosmos, including "his little planet," and though the heavens seem infinitely distant they are yet "near, near at least to the complete and fundamental Jesus; for it is assuredly part of, it is penetrated by, the spirit of Christ living in the Church to bless and to purify all the gifts and calls of the God of Nature by the calls and gifts of the God of Grace."[105] Von Hügel also writes, "The dispensation under which we men actually live is not a dispensation of Simple Nature but a dispensation of Mingled Nature and Supernature."[106] Again and again, O'Connor makes the identical point, that "the fiction writer presents mystery through manners, grace through nature,"[107] that the two are ineluctably related and that "the more a writer wishes to make the supernatural apparent, the more real he has to be able to make the natural world," and "if [the novelist] is going to show the supernatural taking place, he has nowhere to do it except on the literal level of natural events."[108] O'Connor consistently warns against separating the two because one "cannot show the operation of grace when grace is cut off from nature," and "as grace and nature have been separated, so imagination and reason have been separated, and this always means an end to art."[109]

O'Connor's choice to connect the inseparability of grace and nature with the inseparability of "mystery and manners," an idea she credits to and borrows from von Hügel, is brought up again in her complaints about her readers' need for easy solutions by which they are "transported, instantly, either to a mock damnation or a mock innocence."[110] She extends this temptation to all Catholics, writing, "We Catholics are very much given to the Instant Answer. Fiction doesn't have any. It leaves us, like Job, with a renewed sense of mystery."[111]

[104]Ibid. The significance of this idea for O'Connor can be seen in her repeated references to it in *MM* (see 82, 112, 115, 147, 153, 166, 184, and 204).

[105]*Essays*, 143.

[106]Ibid., xiv.

[107]*MM*, 153.

[108]Ibid., 116, 176.

[109]Ibid., 166, 82; see also 184.

[110]Ibid., 49.

[111]Ibid., 184. O'Connor uses the curious phrase "the Instant Answer" only one other time—in her review of von Hügel's *Essays*, where she is quoting him directly.

In another essay, "Catholic Novelists and Their Readers," after spending the first few pages talking about the talent necessary to be a decent novelist of any kind, O'Connor moves to a long discussion of the necessity of mystery in fiction and makes what amounts to the essay's central point—and to one of the singular emphases of O'Connor's entire approach as a Catholic writer: "the main concern of the fiction writer is with mystery and how it is incarnated in human life."[112] She immediately cites von Hügel and, for the next few pages, builds up her argument for mystery by using von Hügel's ideas as her foundation. She then laments the Christian instinct to dispense with mystery, and again quotes von Hügel regarding the particular temptation of Catholic novelists to "tidy up reality."[113]

What is apparent in all these examples is how O'Connor attaches von Hügel, explicitly or implicitly, to the central and controlling ideas of what amounts to her entire oeuvre, at least after 1954–1955. Much of the rest of her "Catholic Novelists and Their Readers" amounts to an homage to von Hügel's ideas. Kirkland contends that these ideas (the inseparability of grace and nature and their connection to mystery and manners, the need to dispense with the Instant Answer, etc.), all iconic themes in O'Connor, were "crucial for her as a believer and as a writer of a unique kind of fiction."[114]

Kirkland explicates another of von Hügel's ideas that influenced O'Connor, namely, his notion of the "cost" of one's faith. He writes, "'Friction' and 'costingness' were, von Hügel thought, the *sine qua non* of healthy growth for the individual and for institutional religion."[115] Von Hügel often spoke of cost, in one way or another, in all of his books. A typical example comes from his *Essays*: "And there is, finally, no such thing as appurtenance to a particular religious body without cost—cost to the poorer side of human nature and cost even, in some degree and way, to the better side of that same nature."[116] O'Connor remarked on von Hügel's frequent use of the word *cost* in a letter to

[112]The fact that O'Connor cites von Hügel twice in this essay, which she wrote just before her death in 1964, tells us that O'Connor meant what she said when she told Hester almost a decade earlier that von Hügel was "something for a lifetime and not any passing pleasure" (*HB*, 165).

[113]*MM*, 177, 178. See also *Essays*, 288.

[114]Kirkland, "Baron Friedrich von Hügel and Flannery O'Connor," 29.

[115]Ibid., 32.

[116]*Essays*, 15. See also *Mystical*, 47, 256, 281, 358, 382; and von Hügel, *Letters to a Niece* (Chicago: Henry Regnery, 1955; hereafter *Letters*), 21, 26, and this: "I want, then, to wish you a very rich, deep, true, straight and simple growth in the love of God, accepted and willed gently but greatly, *at the daily, hourly, cost of self*" (62; italics his). Redemption is costly, in other words.

Spivey as she castigates Beat writers for being too self-consciously and *conveniently* countercultural:

> They seem to know a good many of the right things to run away from, but to lack any necessary discipline. They call themselves holy but holiness costs and so far as I can see they pay nothing. It's true that grace is the free gift of God but in order to put yourself in the way of being receptive to it you have to practice self-denial. I observe that Baron von Hügel's most used words are derivatives of the word *cost*.[117]

In the composite essay "On Her Own Work," O'Connor acknowledges that this notion of cost is crucial for her fiction and that we, like her characters, usually have such hard heads that "reality is something to which we must be returned at considerable cost" and that though this cost can often involve violent means, it is a cost that is nonetheless "implicit in the Christian view of the world."[118] For her characters, the cost usually found its resolution by violent means, through an apocalyptic vision or gunshot to the chest, or from the piercing of a bull's horn. That such an idea, replete with violence, stands at the center of her fiction and of her theology is not a matter of scholarly debate.

Von Hügel made much of this "costingness" in his *Letters to a Niece*, of which the following excerpts from a single letter are typical examples:

> It all only means, that nowhere does God leave Himself without *some* witness, and without *some* capacity on the part of the soul *(always more or less costingly)* to respond to, and to execute this His witness. . . .
>
> Yet with each such fidelity and sacrifice, the peace, the power, the joy, the humble fruitfulness of the soul grow. Always it is a search for expansion and happiness, found in acts of gentle costly and increasingly exacting. . . .
>
> The heathen philosophies, one and all, failed to get beyond your fastidiousness; only Christianity got beyond it; only Christianity. But I mean a deeply, *costingly* realized, Christianity.[119]

In O'Connor's own life, this cost of obedience found its most poignant expression in her fourteen-year struggle with lupus, which set limits on her

[117]*HB*, 336.
[118]*MM*, 112.
[119]*Letters*, 64-65; emphases his.

that she never wanted, but to which she nevertheless eventually relented as a blessing. And in this too she found a kindred spirit in von Hügel, who was sick much of his life, a fact he bore with the same equanimity that O'Connor appears to have mustered in the face of her struggle.[120]

There are other scholars besides Kirkland and Ebrecht who acknowledge O'Connor's debt to von Hügel. According to Lorine Getz, von Hügel is "among the most heavily annotated of her holdings,"[121] a fact confirmed by Arthur Kinney's study of O'Connor's library and marginalia, where the single longest theological or philosophical citation of O'Connor's marginalia is from von Hügel's *Essays*.[122]

Jean Cash asks why O'Connor, "with her dedication to writing fiction, her extensive correspondence with numerous friends, and her desire to lecture as widely as she was able," took on "the added responsibility of becoming a regular reviewer for *The Bulletin*"? Cash answers her own question:

> Writing regular reviews gave [O'Connor] the opportunity both to read and comment on books that she probably would have found and read anyway [and] writing about them helped her to focus her understanding of the ideas of the Catholic theologians whom she most admired, among them Romano Guardini, Baron Friedrich von Hügel, Karl Adam, Gustave Weigel, and Pierre Teilhard de Chardin.[123]

O'CONNOR ON VON HÜGEL

In *The Habit of Being*, O'Connor mentions von Hügel more than either Maritain or de Chardin and as many times as Mauriac and Guardini, and is more expansive in her praise of him than she is any of the others. She writes to Hester in 1956 about von Hügel's *Essays*:

> I didn't know the essays existed where they could be got hold of, and I can think of nothing that I am gladder to be reading. . . . The old man I think is

[120]See Michael de la Bedoyere, *The Life of Baron von Hügel* (London: J. M. Dent & Sons, 1951), 342-44, as well as Tim Basselin's thoughtful study, *Flannery O'Connor: Writing a Theology of Disabled Humanity* (Waco, TX: Baylor University Press, 2013).

[121]Lorine Getz, *Flannery O'Connor: Her Life, Library and Book Reviews* (New York: The Edwin Mellen Press, 1980), 70.

[122]Arthur Kinney, *Flannery O'Connor's Library: Resources of Being* (Athens: University of Georgia Press, 1985), 29-32.

[123]Jean Cash, *Flannery O'Connor: A Life* (Knoxville: University of Tennessee Press, 2004), 299.

the most congenial spirit I have found in English Catholic letters, with more to say, to me anyway, than Newman. . . . They [von Hügel's essays] require to be read many times and you have given me something for a lifetime and not any passing pleasure.[124]

In a letter to Ted Spivey in 1958 (not included in *The Habit of Being*), in response to his question about her influences and favorite Catholic novelists and theologians, O'Connor lists five writers: Bernanos, Guardini, Karl Adam, Marcel, and von Hügel.[125]

O'Connor first mentions von Hügel by name in *The Habit of Being* in a letter to Hester in November of 1955, writing that she'd "like to read Baron von Hügel's book, *The Mystery* [sic] *Element in Religion*."[126] Two weeks later in another letter to Hester, she writes of her intention "to order off after his *Letters to a Niece*."[127] Only a few months later, in March of 1956, O'Connor was already absorbing ideas from von Hügel's *Letters* and incorporating them into her own thought. In a letter to Eileen Hall, editor of *The Bulletin*, a diocesan publication for which O'Connor would write many book reviews, she articulates for the first time in print what eventually becomes an iconic "O'Connorism":

> Fiction is the concrete expression of mystery—mystery that is lived. . . . It's almost impossible to write about supernatural Grace in fiction. We almost have to approach it negatively. As to natural Grace, we have to take that the way it comes—through nature.[128]

This often-quoted phrase of O'Connor's expresses one of the central motifs in her writing, and it is an idea that she attributes to von Hügel. Compare her wording in that letter to the following passage from von Hügel's *Letters*, which O'Connor had recently received and was now rereading for a review for *The Bulletin*:

> If there is one danger for religion . . . it is just that—that allowing the fascinations of Grace to deaden or to ignore the beauties and duties of Nature. What *is* Nature? I mean all that, in its degree, is beautiful, true, and good, in this

[124]*HB*, 165.
[125]Ted Spivey, *Flannery O'Connor: The Woman, the Thinker, the Visionary* (Macon, GA: Mercer University Press, 1997), 45.
[126]*HB*, 116.
[127]Ibid., 119.
[128]Ibid., 144.

many-leveled world of the one stupendously rich God? Why, Nature (in this sense) is the expression of the God of Nature; just as Grace is the expression of the God of Grace. And not only are *both* from God, and to be loved and honored as His: but they have been created, they are administered and moved, by God, as *closely inter-related parts of one great whole*. . . . No Grace without the substrata, the occasion, the material, of Nature; and . . . no Nature without Grace . . . because without these not directly religious interests and activities, you—however slowly and unperceivedly—lose the material for Grace to work in and on.[129]

In May of 1956, she tells Hester that she has already written her review of von Hügel's *Letters* for *The Bulletin* (published a month later), and in that review she directly quotes—misquotes, actually—a portion of the passage above:

> He warns her against the mentality that reads only religious literature, however good, and allows the fascinations of Grace to deaden the expressions of nature and thereby "lose the material for Grace to work on."[130]

O'Connor asks Hester if she'd like to read the book, telling her that it is "absolutely finer than anything I've seen in a long long time," high praise coming from someone who had just digested, in that year alone, books by Kristen Undset, Romano Guardini, Simone Weil, Raissa Maritain, William Michelfelder, Eric Gill, and Marcel Proust, among others.[131] In her review, she expresses the hope that his books will become more well known to American readers.[132]

Von Hügel comes up again in another letter, this time to Hester in July of 1956, where she writes that von Hügel's "*Essays* are better than his *Letters*" and that she's "marked up the first three essays thoroughly" with the intention of going back to read them again after she finishes the biography on von Hügel.[133] Barely a week later she is offering yet more praise for von Hügel in separate letters to Bill Sessions and Hester, and in her last letter of 1956 O'Connor writes to Hester, "Well, a happy new year and more thanks than I can tell you

[129]Von Hügel, *Letters*, 121; emphases his.
[130]Zuber and Martin, *Presence of Grace*, 21.
[131]*HB*, 155-56.
[132]Zuber and Martin, *Presence of Grace*, 21.
[133]*HB*, 165.

for the many things you have done for me, for Baron von Hügel and Simone Weil."[134]

Eight months later, in August of 1957, O'Connor writes that she's just sent off a review of both volumes of *Essays*,[135] and in September of 1958 tells Hester once again that she'd like to read von Hügel's book on Catherine of Genoa but that it is unobtainable. Apparently not that unobtainable, as nine months later, in June of 1959, she tells Hester all about the book and says, "I am more than ever impressed with the greatness of von Hügel."[136] In a letter to Ted Spivey written around the same time, she says that von Hügel's spirit is "an antidote to much of the vulgarity and rawness of American Catholics," and a few weeks after that sends Spivey her duplicate copy of von Hügel's *Letters*, which she encourages him to read.[137] Her last mention of von Hügel in *The Habit of Being* comes in another letter to Spivey where she mentions von Hügel's repeated use of the word *cost*; the rest of the letter is essentially a recapitulation of von Hügel's central ideas.[138] Needless to say, from 1955 until 1959, in separate letters to multiple correspondents, O'Connor expresses her continued and unwavering enthusiasm for von Hügel and his writings, an enthusiasm at a level she expresses for no other writer.

EXCURSUS: THE FUNCTION OF FIRE IN O'CONNOR'S FICTION AND ST. CATHERINE'S TREATISE

Fire and burning imagery play an important role in O'Connor's stories. That God's mercy burns is a signature of O'Connor's fiction, particularly after 1954.[139]

[134]Ibid., 192.
[135]Ibid., 236.
[136]Ibid., 335.
[137]Ibid., 331.
[138]Ibid., 336.
[139]Burning imagery only enters into O'Connor's corpus for the first time in "The Artificial Nigger," written in the latter half of 1954, right around the time she expresses to her friend William Kirkland her affection for von Hügel's work. It should also be noted that, according to Mary Neff Shaw in her article "'The Artificial Nigger': A Dialogic Narrative" (*The Flannery O'Connor Bulletin* 20 [1991]: 104-16), the phrase "action of mercy," another phrase commonly associated with O'Connor, is inserted sometime in December of 1954 in the final draft of what would become the last story included in "A Good Man Is Hard to Find," which was published in April of 1955. We remember that in the "late summer/early fall" of 1954, according to William Kirkland, O'Connor expresses her admiration for von Hügel's *Letters to a Niece*. In *HB*, O'Connor refers to "The Artificial Nigger" as "a story in which there is an apparent action of grace" (160).

In a letter to her friends Lon and Fannie Cheney in August of 1959 about her soon-to-be-published second novel, she thanks them for sending her von Hügel's *The Mystical Element in Religion*, his study of St. Catherine of Genoa. She credits von Hügel with the notion of "the speed of mercy" and also that it is a "burning word."[140] O'Connor is likely referring not to a single passage but to the whole of *The Mystical Element of Religion* and its many references to God's burning love as a merciful extension of his grace, and even as a descriptor von Hügel uses of God himself:

> For in [St. Catherine's] teaching, which is but symbolized or at most occasioned by those physico-psychical fever-heats, the Fire is, at bottom, so spiritual and so directly busy with the soul alone, that it is ever identical with itself in Heaven, Hell, Purgatory, and on earth, and stands for God himself; and that its effects are not the destruction of a foreign substance, but the bringing back, wherever and as far as possible, of the fire-like soul's disposition and equality to full harmony with its Fire-source and Parent, God Himself.[141]

It should not be missed that one of O'Connor's characters in *The Violent Bear It Away*, the child evangelist Lucette Carmody, uses the very phrase "burning word," which O'Connor attributes to von Hügel, in one of the pivotal scenes in the novel: "The Word of God is a burning Word to burn you clean!"[142]

This prevalence of burning imagery in O'Connor's stories (and particularly in her second novel) appears to be influenced by O'Connor's having read St. Catherine of Genoa's *Treatise on Purgatory* in 1949, an interest that was "reignited" a few years later when she picked up von Hügel's writings, especially his lengthy study of St. Catherine, *The Mystical Element in Religion*.[143] Note the opening lines of Catherine's *Treatise* and the repetition of fire imagery:

As it happens, the term "action of grace" is implied throughout von Hügel's *Essays*, which O'Connor was reading at the time, where, for example, von Hügel writes that "Supernatural Religion awakes if and where the human soul has, by Supernatural Grace, been enlarged and raised beyond its natural capacities and natural desires, and if this same soul is presented with facts, actions, realities of a supernatural kind" (*Essays*, xiv).

[140]Stephens, *Correspondence of Flannery O'Connor*, 93.

[141]*Mystical*, 2:125. The more direct connection to mercy as a burning word is perhaps von Hügel's insistence that God's grace works to slowly purify the complete personality and that God's "Divine Love and mercy" are the prevenient acts behind the soul's plunge into Purgatory.

[142]*VBA*, 134.

[143]See also, for example, *Mystical*, 2:125.

TREATISE ON PURGATORY

How by Comparing it to the Divine Fire which she Felt in Herself, this Soul Understood what Purgatory was like and how the Souls there were Tormented.

SECTION I

The state of the souls who are in Purgatory, how they are exempt from all self-love. This holy Soul found herself, while still in the flesh, placed by the fiery love of God in Purgatory, which burnt her, cleansing whatever in her needed cleansing, to the end that when she passed from this life she might be presented to the sight of God, her dear Love. By means of this loving fire, she understood in her soul the state of the souls of the faithful who are placed in Purgatory to purge them of all the rust and stains of sin of which they have not rid themselves in this life. And since this Soul, placed by the divine fire in this loving Purgatory, was united to that divine love and content with all that was wrought in her, she understood the state of the souls who are in Purgatory.[144]

Compare this with a passage in von Hügel's *The Mystical Element of Religion*:

Here God and the fire are clearly one and the same. And the soul does not leave the fire, nor is any question raised as to what would happen were it to be put back into it; but the soul remains where it was, in the Fire, and the Fire remains what it was, God. Only the foreign substance has been burnt out of the soul, and hence the same Fire that pained it then, delights it now.[145]

The centrality of fire imagery in both passages reflects O'Connor's own use of fire in her stories, which typically serves the purposes of purgatory as opposed to hell. (Von Hügel, as we have seen, also ties mercy to the fires of purgatory—it is a burning word for him.)[146] Nowhere, in fact, in any of O'Connor's

[144]Catherine, *Treatise*, 1.
[145]*Mystical*, 1:293.
[146]See chapter four, "Purgatorial Visions," in Susan Srigley's excellent *Flannery O'Connor's Sacramental Art* (Notre Dame, IN: University of Notre Dame Press, 2004), and the important distinction she draws

correspondence or essays does she speak of the fires of hell. When she does talk of hell in any serious way (as opposed to when she uses the word in one of her favorite expressions, "to hell with it"), she mentions it in connection with the absence of God's love.[147] On the other hand, more than half of her references to purgatory are connected either to St. Catherine or directly to fire. She calls Mrs. Turpin's fiery vision at the end of "Revelation" a "purgatorial vision,"[148] and in the final lines of her story "A Circle in the Fire," O'Connor appears to intentionally invoke the idea that God had willed the fire that destroys the property for the purpose of saving Mrs. Cope's soul: "She stood taut, listening, and could just catch in the distance a few wild high shrieks of joy as if the prophets were dancing in the fiery furnace, in the circle the angel had cleared for them."[149]

The multivalent meanings and rich depth of burning imagery in O'Connor's fiction is mirrored in von Hügel's rendering of St. Catherine of Genoa's equally rich understanding of the function of fire as both symbolic and physical reality:

> And her last simplification consists in taking the Fire of Hell, the Fire of Purgatory, and the Fire and Light of Heaven as profoundly appropriate symbols or descriptions of the variously painful or joyous impressions produced, through the differing volitional attitudes of souls towards Him, by the one God's intrinsically identical presence in each and all. In all three cases, throughout their several grades, there are ever but two realities, the Spirit-God and the spirit-soul, in various states of inner-relation.[150]

But again, for O'Connor the role of fire in her stories almost always had the end of redemption in mind. It was never merely fire for fire's sake, nor was it (usually) for the purpose of simple destruction.

To sum up then, the purgatorial role of fire in O'Connor's fiction mirrors the role of fire in Catherine of Genoa's *Treatise on Purgatory*, and the setting for O'Connor's stories is, in effect, a place of purgatory for her characters. Von Hügel also saw the salutary nature of interpreting this life as purgatorial existence. He writes in his *Essays*, "We must also not forget that there need be no real question of Hell even for the majority of the supernaturally awakened souls, if there actually

between "purgation and destruction" (137).
[147]*HB*, 244, 354.
[148]Ibid., 577.
[149]*CW*, 251.
[150]*Mystical*, 2:215.

exists a state and process of purgation in the Beyond, as there undoubtedly exists
such a state and process here."[151] In *The Mystical Element of Religion*, he comments
on and quotes from Augustine's view of a this-world purgatory:

> When, during the last years of his life, he came, somewhat tentatively, to
> hold an other-world Purgatory as well, he throughout assimilated this
> Purgatory's fire to the fire of this-world sufferings. Thus in 422 A.D.:
> ". . . Whether men suffer these things in this life only, or such-like judg-
> ments follow even after this life in either case, this interpretation of that
> text is not discordant with the truth." "'He shall be saved yet so as by fire,'
> because the pain, over the loss of the things he loved, burns him. It is
> not incredible that some such thing takes place even after this
> life . . . that some of the faithful are saved by a certain purgatorial fire,
> more quickly or more slowly, according as they have less or more loved
> perishable things."[152]

One of the implicit contentions in this chapter has been that many of the
terrors in O'Connor's stories, particularly after 1954, were intended by
O'Connor to be understood as divine in origin and divinely orchestrated, and
thus *essentially* beautiful, good, and true, and that those characters who either
were forced to confront or meet such terror, even if someone died in the
process—or perhaps *especially* if they did—nevertheless come to a redemptive
end. Von Hügel believed as much, and it is an idea we see playing itself out
again and again in his writings, as in his biography of St. Catherine of Genoa.
The following passage from that book is a representative example of this deep
and mysterious theological truth, namely, that some of the basest suffering
comes from the love of God and not from the miscreance of the devil, an idea
that O'Connor verily reveled in in her fiction:

> I find myself every day more restricted, as if a man were (first) confined within
> the walls of a city, then in a house with an ample garden, then in a house without
> a garden, then in a hall, then in a room, then in an ante-room, then in the cellar
> of the house with but little light, then in a prison without any light at all; and then
> his hands were tied and his feet were in the stocks, and then his eyes were ban-
> daged, and then he would not be given anything to eat, and then no one would

[151]*Essays*, 1:206-7.
[152]*Mystical*, 2:217.

be able to speak to him; and then, to crown all, every hope were taken from him of issuing thence as long as life lasted. Nor would any other comfort remain to such a one, than the knowledge that it was God who was doing all this, through love with great mercy; an insight which would give him great contentment. And yet this contentment does not diminish the pain or the oppression.[153]

One cannot but wonder how O'Connor must have reacted when she read that passage for the first time and realized that what had come instinctively for her in her early fiction was now given an imprimatur in the life of an actual saint of the church. This central paradox, long celebrated by the church in the centrality of the cross, O'Connor compellingly encounters in, and then fully adopts from, Baron von Hügel's writings. It is practically considered a truism in O'Connor studies that these central paradoxes—these "frictions"—are a crucial part of what gives O'Connor's writing its peculiar depth and vitality. Is it claiming too much to say that this tension, so present also in O'Connor, is perhaps the defining characteristic of her legacy?

O'Connor's debt to von Hügel was both obvious and immense, which makes his almost complete neglect in O'Connor scholarship mystifying and unfortunate. For von Hügel and O'Connor, mystery and manners (grace and nature) were two sides of the same coin, each strictly unthinkable without the other. The incarnation of divine realities was the very thing that made them so mysterious, and God's mercy and love, so often presented by the church in sentimental and tawdry ways, become in O'Connor's hands burning fixities of the religious life.

If one is to accept von Hügel's role as the catalyst that helped to develop, or at the very least to invigorate, such ideas for O'Connor, it seems difficult to overestimate his decisive influence on her writing. The inseparability of grace and nature and their connection to the whole paradox of mystery and manners; the need to dispense with the Instant Answer and to accept the "costingness" of Christian belief; the centrality of mystery as a critical reality in religious life as well as a controlling device in fiction—if these are not central themes (and devices) in O'Connor's writing, she would have been a different writer altogether, if not a different person. All of these dominant themes find their source, or at least their theological rationale, in Baron von Hügel, so it should not be

[153]Ibid., 2:268-69.

surprising that O'Connor adopts or assimilates von Hügel's three ideas into her fiction in a way that not only distorts but also actively subverts the normal categories of beauty, goodness, and truth in much the same way that the gospel not only redefines them as fundamental elements of the nature of God but also subverts them in the witness of the incarnated and crucified Christ. O'Connor clearly understood this; when reading her stories, one senses that she felt it in her bones.

2

The Liminal Frame

O'Connor's Moral Vision

> I believe too that there is only one Reality and that that is the end of it, but
> the term, "Christian Realism," has become necessary for me, perhaps in
> a purely academic way, because I find myself in a world where everybody
> has his compartment, puts you in yours, shuts the door and departs.
> One of the awful things about writing when you are a Christian is that
> for you the ultimate reality is the Incarnation, the present reality is the
> Incarnation, and nobody believes in the Incarnation; that is, nobody in
> your audience.

<div align="right">

THE HABIT OF BEING

</div>

In the last chapter, I suggested that the theological frame for O'Connor's
stories came, to a significant degree, from Friedrich von Hügel's writings,
but it is equally true that von Hügel's influence alone cannot account for
the peculiarity of O'Connor's vision. Von Hügel's role in O'Connor's
theo-literary subversion of the transcendentals of beauty, goodness, and
truth was crucial but limited: he provided O'Connor a theological ra-
tionale—I have also called it a scaffolding—for such things, but O'Connor's
subverting tendencies came also from who she was and from her own ex-
periences. And I do not mean to suggest that some idiosyncratic elements
of her personality alone—or even mainly—contributed to these subversive
tendencies. I mean that in the depths of O'Connor's being, below the con-
cerns of her personality, in the way she saw the world with anagogical pre-
cision—which has to do "with the Divine life and our participation in it"—

exactly *there* the seeds of her blistering vision took root.[1] O'Connor would often advise young writers that "the meaning of a story does not begin except at a depth where adequate motivation and adequate psychology and the various determinations have been exhausted."[2] Surely the meaning of a life, then, begins in the same place? But what does a writer's life have to do with her work?[3]

The incarnation was a crucial aesthetic lens through which O'Connor wrote, as the quotation at the head of the chapter indicates. It was neither merely a belief O'Connor held nor a reality she took for granted.[4] The fact that O'Connor weds both "Reality" and "Christian Realism" to the incarnation, claiming that the latter is both the present and ultimate reality, suggests that for O'Connor, everything found its present and ultimate meaning in the incarnation, in God becoming one of us, and that aside from the incarnation, nothing finally makes any sense.

A SOUTHERN SOPHOCLES

As noted in chapter one, an essential key to the unique tone and depth of O'Connor's stories was her easy familiarity with Catholic medieval theology. O'Connor not only admired St. Thomas Aquinas but also limned his metaphysical commitments by creatively incorporating Thomist categories into her fiction. In crucial ways, her theological affinities had more in common with the "Dumb Ox" than they did with many of her own contemporaries. Thomas Merton once wrote of O'Connor, "When I read Flannery I don't think of Hemingway, or Katherine Anne Porter, or Sartre, but rather of someone like

[1] *MM*, 72.

[2] Ibid., 41-42.

[3] I am convinced that the lack of knowledge about O'Connor as a person led many an early critic to misunderstand her work as a writer. O'Connor, in particular, is one whose personal commitments and experiences disproportionately inform both the style and tone of her fiction as well as its thematic content. Carol Shloss disagrees. In *Flannery O'Connor's Dark Comedies: The Limits of Inference* (Baton Rouge: Louisiana State University Press, 1980), she argues that it is "not warranted . . . to assume, a priori, that the world of the novel is the world of the writer's own life. To do so is to credit fiction only as an expressive extension of a writer's personal code and to deny it any meaning independent of private connotation" (85). I agree. To assume a one-to-one correlation between a writer and her work is unwarranted. But to deny any relationship between the two is to make the equal but opposite error.

[4] Later in that same letter she reiterates what I am calling her *theo-literary* connection: "You are right that I won't ever be able entirely to understand my own work or even my own motivations. It is first of all a gift, but the direction it has taken has been because of the Church in me or the effect of the Church's teaching, not because of a personal perception or love of God" (*HB*, 92).

Sophocles."[5] O'Connor's voice—her diction, often stentorian tone, colloquial dialogue, economy of syntax—betrays antiquated, indeed medieval and even ancient sensibilities, though this is not due to any particular idiosyncrasies in her personality. On the contrary, the region of the South from whence O'Connor hailed—"A half-hour's ride in this region will take [a person] from places where the life has a distinctly Old Testament flavor"[6]—was steeped in Old World superstitions and Old Testament impulses, manifested variously as a strong belief in the presence and reality of the devil, biblical justifications for slavery and racial prejudice, the religious function of gentility, patrician roles within the ideals of Christian domesticity, and the belief in the power of signs and symbols.

EXCURSUS: THE SOUTHERN SUPERNATURALISM

Some scholars take exception to any characterization of the South that emphasizes superstition and devil talk, which they infer to mean that the South is or was somehow anti-intellectual or ignorant of the cultural trends in science and the arts. Ralph Wood, for example, writes,

> Eugene Genovese and others have observed [that] the South was the most modern of the American regions, precisely because of its radical capitalist reliance on slavery as the means of production. Much of the pre-19th century South was deist insofar as it was religious at all. The South's radical religiosity is the result of 19th century revivalism, which in turn (as Billy Abraham and Mark Noll have shown) was a thoroughly modern phenomenon.[7]

Wood spells his argument out in more detail in the second chapter of his *Flannery O'Connor and the Christ-Haunted South*.

Allen Tate, on the other hand, a leader of the twentieth-century Southern Literary Renaissance and mentor to O'Connor, provides this perspective in his *Essays of Four Decades*:

> The South was settled by the same European strains as originally settled the North. Yet, in spite of war, reconstruction, and industrialism, the

[5]Thomas Merton, *The Literary Essays of Thomas Merton* (New York: W. W. Norton, 1985), 161.
[6]*MM*, 209.
[7]From private correspondence, April 2015.

South to this day finds its most perfect contrast in the North. In religious and social feeling I should stake everything on the greater resemblance to France. The South clings blindly to forms of European feeling and conduct that were crushed by the French Revolution and that, in England at any rate, are barely memories. . . . The anomalous structure of the South is, I think, finally witnessed by its religion. . . . Only in the South does one find a convinced supernaturalism: it is nearer to Aquinas than to Calvin, Wesley, or Knox.[8]

Wood quotes the very same passage from Tate and then adds, "O'Connor herself spotted the fly in the Agrarian ointment: they ignored what Mencken rightly saw as the heart of Southern culture—its fundamentalist Christianity."[9] To be sure, the South has been uncritically disparaged by many, particularly in the North, as being culturally backward and intellectually indolent, neither of which is true. But that its base of operations came out of a fundamentalist reading of Scripture is, on the whole, uncontested. See both James Turner's excellent study of the South[10] and Michael O'Brien's massive two-volume study, considered by Turner to be the best study available on southern intellectual life in the nineteenth century.[11] Neither Turner nor O'Brien understands the South's inherent religiosity as precluding a rigorous intellectual culture. Turner writes,

By contrast, southerners, residents of a region less caught up in these currents, appeared more comfortable with divine mystery and less swept away by science. Granted, the Northeast was also the intellectual center of the nation, the earliest recipient of new ideas; but by no means did all southerners languish in gothic ignorance. Yet one scholar of southern Protestantism reports that "intellectual abstractions and scientific theories" scarcely ruffled feathers until well after 1900; and the sermons and reminiscences of well-educated southern clergymen reflect little intellectual turmoil or sense of challenge during the 1870s and 1880s, in either their congregations or their own minds: a sharp contrast to the experience of their northern

[8]Allen Tate, *Essays of Four Decades* (Chicago: Swallow Press, 1968), 520-21.
[9]Ralph Wood, *Flannery O'Connor and the Christ-Haunted South* (Grand Rapids: Eerdmans, 2004), 52.
[10]James Turner, *Without God, Without Creed* (Baltimore: Johns Hopkins University Press, 1986).
[11]Michael O'Brien, *Conjectures of Order: Intellectual Life and the American South (1810–1860)* (Durham: University of North Carolina Press, 2003).

brethren. Educated southerners did not lack access to new ideas; they lacked interest.[12]

O'Brien, for his part, makes clear that southern intellectuals were well aware of the animated discussions regarding, for example, the ideas of Kant, Hume, Feuerbach, Schiller, and the German Transcendentalists, but very few of these Southerners took the bait. Perhaps by dint of their agrarian sensibilities, southerners were more grounded than their northern counterparts and, as such, were not as susceptible to many of what they would have considered the more esoteric (i.e., disembodied) claims of modernity. About her fellow southerners, O'Connor wrote, "We don't discuss problems; we tell stories."[13]

Themes related to the demonic, to the power of signs and symbols, and to the crucial role of preachers and prophets simmer beneath and often explode to the surface in O'Connor's fiction, thus more appropriately placing her in the tradition of the ancient, classical, and medieval writers (as Thomas Merton rightly asserts), all of whom relied heavily on the biblical narrative, than in the tradition of modern American literature with which she is usually anthologized. There are, to be sure, other writers from the South with "dark" sensibilities (Edgar Allen Poe, Truman Capote, Carson McCullers), but their approach to the darkness stands in direct contrast to O'Connor's; where hers is a darkness *unto* light, theirs is a darkness shorn of light. O'Connor's approach could be mistaken for Eliot's conception of the darkness in his verse drama *Murder in the Cathedral*, where "the darkness / declares the glory of the light," but the dark in O'Connor's stories is not typically used to draw out the light of the holy. The darkness, which is often the shadow of God, is part and parcel of the holy. With O'Connor's "dark sensibilities," I am reminded not so much of Eliot as of the poet Rainer Maria Rilke and his *Duino Elegies*, or his poem from 1903, "You, Darkness":

You, darkness, that I come from,
I love you more than all the fires that fence in the world,
For the fire makes a circle of light for everyone,
And then no one outside learns of you.

[12]Turner, *Without God, Without Creed*, 201-2.
[13]Rosemary Magee, ed., *Conversations with Flannery O'Connor* (Jackson: University Press of Mississippi, 1987), 83.

But the darkness pulls in everything:
Shapes and fires, animals and myself,
How easily it gathers them!—
Powers and people—
And it is possible a great energy
Is moving near me.
I have faith in nights.[14]

A Theo-literary Approach

O'Connor's moral and dramatic senses, or what I am calling her theo-literary approach, converged in the woman in such a way that O'Connor's theology and her aesthetics must be considered together. They were so integrated in O'Connor, in fact, that to separate them—even, at times, to clearly distinguish one from the other—is to run the risk of severing the baby in Solomonic fashion. O'Connor's moral and dramatic vision were of a piece, so that to ignore or pay insufficient attention to her life and faith is to surrender the possibility of a full accounting of her work. The following representative passages underscore O'Connor's belief in the essential unity of one's moral and dramatic visions:

> In the greatest depth of vision, moral judgment will be implicit [she also mentions in this passage the indissoluble connection between mystery and manners].[15]
>
> In the greatest fiction, the writer's moral sense coincides with his dramatic sense, and I see no way for it to do this unless his moral judgment is part of the very act of seeing.[16]
>
> When the grotesque is used in a legitimate way, the intellectual and moral judgments implicit in it will have the ascendency over feeling.[17]

[14]Rainer Maria Rilke, *Selected Poems of Rainer Maria Rilke* (New York: Harper & Row, 1981), 21. O'Connor knew of Rilke. In a letter to Ted Spivey dated May 25, 1959 (a letter, incidentally, in which we learn that O'Connor has shipped him her extra copy of von Hügel's *Letters*), she tells him that she is "reading a book I like called *The Disinherited Mind* by Erich Heller—essays on Goethe, Nietzsche, Rilke, Spengler, Kafka, and a few others" (*HB*, 334).

[15]*MM*, 30.

[16]Ibid., 31.

[17]Ibid., 43. This not only challenges Kant's understanding of the effects of beauty, and of the sublime, as ending in pleasure, but more significantly, it indicates O'Connor's conviction that von Hügel's three elements represent an ultimate unity, just as they did for von Hügel.

The writer's moral sense must coincide with his dramatic sense.[18]
Your beliefs will be the light by which you see.[19]

The opening quoted passage serves to illustrate an important point regarding O'Connor's approach to writing. She believed that her theology was essentially an aesthetic impulse, insofar as she connects the fact of our redemption through the incarnate Christ to the subject of her fiction. Too many interpretations of O'Connor's fiction insufficiently understand the theologically subversive nature of her work because they either misunderstand or simply don't care about O'Connor's faith. Faith concerns, they believe, are a distraction. Those interpretations, for example, that see in the violence of her stories the expression of a sublimated anger toward God because of her lupus miss the thrust of O'Connor's central theological convictions, namely, that redemption is hard because life is hard, and life is hard because we are sinners who resist redemption with every fiber of our being, preferring the easy stroll to the arduous pilgrimage, a pilgrimage fraught with dragons at the side of the road waiting to devour us. Those who follow Christ are called to follow not merely in his light but in the shadow of that light, and for those who follow more closely, that shadow looms large and dark. This means that the farcical energy in her stories and the torn and ragged terrain of her fictional world were not fed by, or created out of, a sublimated anger but were, instead, wrought from a clear vision of the exacting severity of God's divine love, so that the mayhem that ensues in her stories is often nothing more than an illustration of what happens to those who follow "in the bleeding stinking mad shadow of Jesus." But it is a shadow of grace they walk in, a shadow of that peace that surpasses all understanding (Eph 4:7). To put it another way (and to borrow another phrase from her second novel), O'Connor's stories are a fictional rendering of "the terrible speed of mercy."

But could the mere fact that O'Connor had herself followed in Jesus' dark shadow, that she herself had suffered, fully explain the theological depth of her stories? If that were the case, it seems to me, anyone who suffered would have equal access to such depths. But this is most certainly not true, and if true, would run the risk of becoming a platitude, as if suffering by itself were the key

[18]Ibid., 76.
[19]Ibid., 91. O'Connor's entire approach becomes a repudiation of the New Critical insistence on bracketing such considerations when interpreting a work of fiction.

to artistic or theological genius. It may be, as Martin Luther believed, that suffering is the cauldron out of which theology comes, but it cannot account, on its own, for the inspiration that follows.

O'Connor declared that a writer's moral and dramatic visions cannot be separated without doing harm to both. To do justice to either in O'Connor, in other words, means we must look at both. O'Connor's life—her experiences as well as her faith—ineluctably shaped her moral vision. And yet, I share William Session's caution regarding the biographical fallacy, which is "the mistaken belief that if we know where William Wordsworth and his sister Dorothy went for their walks in the Lake District, we can . . . understand 'Tintern Abbey.'"[20] But such a caution can be taken too far, as too many of her critics have done. O'Connor insisted that "to try to disconnect faith from vision is to do violence to the whole of personality, and the whole personality participates in the act of writing."[21] Her fiction needs to be understood, then, not only with an eye to the work itself but also to O'Connor as a person. In doing so, we acknowledge Michael Polanyi's insistence that no act of creation or interpretation is done apart from personal commitments.[22] Polanyi's notion of "personal knowledge" held that "into every act of knowing there enters a passionate contribution of the person knowing what is being known, and that this coefficient is . . . a vital component of his knowledge."[23] Polanyi insisted that all knowing ultimately involves the subject's personal commitments and an active comprehension, which does not make the knowledge subjective because "comprehension is . . . a responsible act claiming universal validity."[24]

Christina Bieber Lake maintains that O'Connor was essentially trying to show her readers, through her fiction (particularly in its later forms), that "redemption begins and ends in a different place. It begins with human limitation

[20]Jan Nordby Gretlund and Karl-Heinz Westarp, eds., *Flannery O'Connor's Radical Reality* (Columbia: University of South Carolina Press, 2007), 58-59. Sessions goes on to say, "At the moment this generic fallacy and faulty historicist analysis appears with some frequency in O'Connor studies. To this kind of analysis, including my own, I pose the following question: if we know where O'Connor garnered her ideas of prophecy, choice, and the fundamental horror of the human condition, do we automatically understand O'Connor's dense and violent texts? . . . I doubt it" (59). Automatically? I doubt it too, but it is as fine a place as any to begin looking.

[21]*MM*, 181.

[22]See Michael Polanyi, *Personal Knowledge* (Chicago: University of Chicago Press, 1958).

[23]Ibid., viii.

[24]Ibid., vii.

and ends with the *Imago Dei*."[25] This is true, I believe, from the human side. But from the divine end of things, redemption begins and ends in Jesus Christ, the Alpha and Omega, the beginning and the end. O'Connor understood this, which is why her characters are variously responding to or reacting against the startling figure of God, whose presence lurks on virtually every page. O'Connor once said that Hazel Motes would see "Jesus move from tree to tree in the back of his mind, a wild ragged figure motioning him to turn around and come off into the dark."[26]

I cannot help but wonder if O'Connor had similar visions as she sat at her desk each morning after Mass, crutches propped up against the wall behind her, conjuring up the lives and fates of the men, women, and children who would populate her dangerous country—dangerous because O'Connor understood (to Bieber Lake's point) that the *imago Dei* cannot be realized without a profound recognition, even celebration, of our profound human limitations. Or as the pilgrim Dante discovered, paradise cannot be reached without first passing through hell and purgatory. Or as St. Cyril of Jerusalem understood it, in a phrase O'Connor often cited and that sat at her bedside table, you cannot get to the Father of Souls without passing by the dragon that seeks to devour you. Or as Psalm 23 suggests, the banquet table is prepared only for those who have walked through the valley of the shadow of death.

In God's Shadow

Flannery O'Connor's God was the unexpunged version of Thomas Jefferson's Christ, the "immortal hand or eye" that dared frame the "fearful symmetry" of William Blake's "Tyger." She said herself that her characters were Yeats's "rough beast slouching towards Bethlehem to be born" (again). The first stanza of Yeats's "The Second Coming" is, in fact, as good an explication of a typical O'Connor story as one is likely to find:

> Things fall apart; the centre cannot hold;
> Mere anarchy is loosed upon the world,
> The blood-dimmed tide is loosed, and everywhere
> The ceremony of innocence is drowned;

[25] Christina Bieber Lake, *The Incarnational Art of Flannery O'Connor* (Macon, GA: Mercer University Press, 2005), 242.

[26] *CW*, 11.

The best lack all conviction, while the worst
Are full of passionate intensity.[27]

Things fall apart in O'Connor's stories like clockwork, the "centre" never
holds, and the ceremony of innocence is drowned, in some cases quite literally.
O'Connor's God was mainline liberal Christianity's worst nightmare, a God
you could not control, one who was neither respectable nor tame. This was a
ferocious deity to match O'Connor's ferocious stories (though I suspect the
pairing ran in the opposite direction for O'Connor). Brian Abel Ragen nicely
captures this scathing vision of O'Connor:

> By embodying the most lofty Christian doctrines in stories that seem gro-
> tesque and violent, O'Connor reclaimed a large region of literature for the
> religious writer. In earlier centuries, especially in the Middle Ages, religious
> concerns were not separated—in literature or in life—from the grotesque or
> violent. In Dante or in the mystery plays, Christian doctrines are presented
> in images that may offend the nose or shock the eye. But in twentieth-century
> America the usual assumption is that religious matters must be discussed in
> gentle and decorous ways—and anything that is always gentle and decorous
> can, in the end, only seem trivial. When O'Connor follows the example of
> the Old Testament prophets and presents the Lord's message in harsh and
> violent images, she restores life and interest to religious literature. In her
> stories, the acceptance or rejection of the offer of grace does seem a matter
> of life and death, for it is presented with the same seriousness as other life and
> death matters.[28]

Like Ragen, I sensed in O'Connor's fiction something more holy than sin-
ister. There was, beneath all of the mayhem of her stories, a theological foun-
dation that was unshakeable, grounded, even sacramental.[29] Hers is the kind of
fiction that could only be written by someone who had celebrated the Tridentine

[27]W. B. Yeats, *The Collected Poems of W. B. Yeats*, ed. Richard Finneran, 2nd ed. (New York: Simon & Schus-
ter, 1996), 187. The final couplet in Robert Frost's poem "Once by the Pacific" also comes to mind: "There
will be more than ocean-water broken / Before God's last Put out the Light is spoken." Robert Frost, *The
Poetry of Robert Frost: The Collected Poems*, ed. Edward Lathem (New York: Henry Holt, 1979), 250.

[28]Brian Abel Ragen, *A Wreck on the Road to Damascus* (Chicago: Loyola University Press, 1989), 197-98.

[29]Walter Elder catches in O'Connor's stories a "'glimpse of the surface' that suggests a 'surpassing peace'"
("That Region," *Kenyon Review* 17 [1955]: 661-70), which points to a deeper region that O'Connor's work
both comes out of and is pointing to. I am reminded here of David Bentley Hart's work regarding the
contradictory opposition of the gospel's ontology of peace under and against the world's various ontolo-
gies of violence. David Bentley Hart, *The Beauty of the Infinite: The Aesthetics of Christian Truth* (Grand
Rapids: Eerdmans, 2004).

Rite every day and drank from (as the words of institution in that Rite translate Jesus' words in English) "the chalice of my blood."[30] Surely O'Connor was no stranger to God's severity, then, having tasted it almost every day of her adult life. At only seventeen, with the premature death of her father a few years before still fresh in her mind, her fierce spiritual acuity was already in evidence:

> The reality of death has come upon us and a consciousness of the power of God has broken our complacency like a bullet in the side. A sense of the dramatic, of the tragic, of the infinite, has descended upon us, filling us with grief, but even above grief, wonder. Our plans were so beautifully laid out, ready to be carried into action, but with magnificent certainty God laid them aside and said, "you have forgotten—mine?"[31]

She wrote these lines years before she ever published a single line of fiction. This is to say that if O'Connor's stories were merely a spectacle of holy severity—something intended to get our attention for its sheer ludicrous intensity, which some of her reviewers accused them of being—her fiction would be nothing more than a cliché, and O'Connor herself nothing more than a talented but tawdry peddler of her own tragic misfortunes.

But O'Connor embodied what she believed, and thus wrote from that place. Unless a writer's intentions are exclusively ironic—and O'Connor's were not—one writes from out of such belief, and if such a writer has integrity, tries to live accordingly. O'Connor, often in spite of herself and her explicit denials, had a thoroughly Christian message to convey to her readers. She did not merely write from such a position, in other words, but fully intended to communicate it. Wayne Booth valorizes such intentions, arguing that "narrative uniquely helps us to find our metaphysical bearings by practicing 'the art of listening to conflicts in such a way as to keep honest perplexity alive, and thus to lead to new inventions/discoveries.'"[32] O'Connor understood the function of narrative as being more than simply a vehicle to tell a story. Every story has a meaning, a sense, even at times a message (or two) for its audience, which, far from usurping the true function of fiction,

[30]The words of this ancient rite remind Christians at every celebration of the Eucharist that we show forth Christ's *death*—not his life, not his power, not his love or grace or beauty—until he comes again. Blood is spilled, a body is broken, and the meal begins.

[31]As quoted in Brad Gooch, *Flannery: A Life of Flannery O'Connor* (New York: Little, Brown, 2009), 72.

[32]As quoted in Craig Mattson, "Keeping Company with Wayne Booth—A Review Essay," *Christian Scholar's Review* 43, no. 2 (2009): 299.

embraces its intrinsic ethical imperative. Stories are told in order to elicit responses, feelings, and ideas in the reader, and often what is elicited actually changes the way that reader sees, hears, and understands himself and the world around him. There is always something at stake in telling stories, even if it is to merely present the mystery of reality. Perhaps presenting the mystery of reality is fiction's main contribution.[33]

And yet her audience was hard of hearing and almost blind. So she shouted and drew large and startling figures in order to get that message across, but did so with a sense of artistic urgency. There was, again, a *sacramental* timbre to her work that was borne of a particular kind of genius that only comes through suffering (a similar thing could be said of von Hügel)— though not all who suffer attain it. At the risk of sounding sentimental, perhaps these stories could only be written by a woman who was dying— who, in effect, wrote under a death sentence. Her lupus was the "gun to her head to shoot her every day of her life" that made her, if not a good woman, at least a fiercely beautiful writer. A particular clarity comes from a life lived so near to death—and thus, so near to God.

Saint Catherine of Genoa, the subject of von Hügel's *The Mystical Element in Religion* and a figure for whom O'Connor had particular affection, had a similar clarity, though perhaps a more pronounced version. Such a moral and spiritual clarity of vision, which almost always comes across as a kind of theological severity, was, for both O'Connor and St. Catherine, fire and brimstone preaching with a wry smile, even a hint of laughter, at its core. If one didn't know better, it could look demonic. But what O'Connor had learned somewhere in her experience, lodged like a bullet in her precocious spirit, was this: at the heart of things, laughter and anguish, beauty and terror, foolishness and wisdom, goodness and violence, all mingle together in a mystical conspiracy of divine love, which comes bearing down on us at the terrible speed of mercy.

This mystical element in O'Connor has moved some to claim that O'Connor herself was a modern-day mystic, but I remain unconvinced. She was too much a country girl realist, too invested a sacramental Catholic, and had too

[33]Mattson concludes his review of Wayne Booth's work by suggesting that Booth's criticism "put a kind hand to our elbows, taking us beyond the sometimes specious consolations of closure [and] pointing out the path where honest perplexity flourishes" (ibid., 300). I'm not sure O'Connor's hand could be called "kind," but her stories certainly pointed her readers on the path "where honest perplexity flourishes."

much stubbornly pragmatic Irish blood coursing through her veins to be fully taken in by mysticism on its own, much less become a mystic herself. She was fascinated by mysticism, to be sure, but what she needed was someone to systematize and physicalize mysticism and, by doing so, make it more accessible to a "sensible" Catholic like herself. She found this in Friedrich von Hügel, who, as I have argued in the previous chapter, would come to serve as a theological bridge between O'Connor's interest in mystical spirituality and her commitment to a thoroughgoing sacramentality; his ideas codified the connection between heaven and earth.

EXCURSUS: O'CONNOR'S MYSTICISM

In *A Prayer Journal*, O'Connor's lyric meditation on the state of her soul and her belief in God, she expresses some of her deepest and most intimate desires, and one desire in particular surfaces over and over again, which is her wish to *experience* God and to become a mystic:

> What I am asking for is really very ridiculous. Oh Lord, I am saying, at present I am a cheese, make me a mystic, immediately. But then God can do that—make mystics out of cheeses. But why should He do it for an ingrate slothful & dirty creature like me. . . . The rosary is mere rote for me while I think of other and usually impious things. But I would like to be a mystic and immediately. But dear God please give me some place, no matter how small, but let me know it and keep it. If I am the one to wash the second step everyday, let me know it and let me wash it and let my heart overflow with washing it. . . . My soul too. So then take it dear God because it knows that You are all it should want if it were wise You would be all it would want and the times it thinks wise, You are all it does want, and it wants more and more to want You. Its demands are absurd. It's a moth who would be king, a stupid slothful thing, a foolish thing, who wants God, who made the earth, to be its Lover. Immediately.
>
> If I would only love God in my mind. If I could only always just think of Him.[34]

The journal entry certainly sounds like something written by a mystic. At the very least, it was written by someone desperate to experience God intimately

[34]*Prayer Journal*, 39.

and immediately. One gets the sense in reading her journal that, because of her perceived lack of an experience of God, she experiences him vicariously through her characters. Perhaps that is why so many of them are backwoods mystics or have mystical experiences and visions.

Ted Spivey writes that O'Connor "was no less a visionary than earlier Catholic mystics who looked to the sky for inspiration," but adds that "her mysticism was directed at nature and society."[35] William Kirkland thinks that O'Connor's "deep sense of mystery and her Thomistic reliance on reason *and* revelation came together in a nonpietistic mysticism that was peculiarly Catholic."[36] In a letter in 1958 to Spivey, however, O'Connor writes, "I got a double dose of the mystics, mostly Spanish and Italian, and I haven't had a taste for them since," though in the very next line she expresses an interest in reading von Hügel's *Mystical*:

> I have always wanted to get hold of Baron von Hügel's book on St. Catherine of Genoa—*The Mystical Element in Religion*. This is supposed to be a classic on mysticism. Evelyn Underhill learnt what she did from him apparently. However the book is not obtainable.[37]

Her desire to read the book apparently remained unabated since she had first expressed an interest in it four years earlier in her letter to Hester in 1955. Perhaps the urgency of her disease also led to a heightened interest in such matters. Whatever the reason for her continued interest in von Hügel's last book, what we see in the diaries prior to her diagnosis of lupus is a young woman with an incredibly sensitive spiritual disposition who is yearning for a mystical connection with God. Her trip to Lourdes as a reluctant pilgrim appears on the surface to be quite another matter, given her sardonic assessment of the trip; she quipped to many a friend that "the miracle at Lourdes is that there are no epidemics."[38] And yet later, and quite poignantly, O'Connor expressed gratitude for the place after her doctor told her that there had been a significant improvement in her condition. "Maybe this is Lourdes," she wrote. "Anyway, it's something to be thankful to the same Source for."[39]

[35]Ted Spivey, *Flannery O'Connor: The Woman, the Thinker, the Visionary* (Macon, GA: Mercer University Press, 1995), 103.

[36]William Kirkland, "Baron Friedrich von Hügel and Flannery O'Connor," *Flannery O'Connor Bulletin* 18 (1989): 30. See also Cecilia McGowan, "The Faith of Flannery O'Connor," *Catholic Digest*, February 1983, 74-78.

[37]*HB*, 297.

[38]Ibid., 286.

[39]Ibid., 305.

Whatever her disposition might have been toward mysticism, it certainly cannot be denied that many of O'Connor's fictional characters see visions and dream dreams and generally carry on in ways that might be considered a twentieth-century southern backwoods version of medieval mysticism. It also seems that O'Connor herself was drawn, likely in spite of herself, to the mystic tradition. What is also most certainly true is that O'Connor had read about the deep font of divine experience that mysticism provided for those who practiced it, and she wanted something like it for herself, as her early diary entries at Iowa, the books in her personal library related to mysticism, and her trip to Lourdes all seem to indicate.

Like O'Connor, von Hügel was suspicious of the *merely* spiritual and insisted that the religious life must be marked by a commitment to—and balance with—the sensible, material world, a point he goes to great lengths to defend in virtually all his works. He writes in *Essays*, for example, "Indeed, the Spiritual generally, whether natural or even supernatural, is always preceded or occasioned, accompanied or followed, by the Sensible—the soul by the body."[40] As we have already seen, O'Connor quotes this very line in "Catholic Novelists and Their Readers," where she, too, argues for the inseparability of such realities.[41]

The mystery of God, both O'Connor and von Hügel believed, is mysterious largely *because* it is embodied in the material, sensual world, namely, in Jesus Christ. Its incarnational nature, in other words, is precisely what gives God's divine mystery a peculiar vitality, so that to separate the two—the spiritual from the material—would be to fall into either one of two equally egregious but opposite errors of rank materialism or dualistic Manichaeism. Indeed, von Hügel's "Three Elements" are a repudiation of the strictly mystical. The mystical is only one element of the religious experience and is mixed and mingled together with the other two elements so that, all together, they present a picture of the religious life that is full of vitality and fraught with "frictions."[42]

[40]*Essays*, 292.

[41]Von Hügel puts it more succinctly in his *Essays*: "Throughout reality, the greater works in and with and through the lesser" (58). This indissoluble connection of the spiritual and the material is, of course, the very "mystery and manners" to which the title of O'Connor's collection of essays refers.

[42]*Essays*, vol. 1.

Flannery's Frame

O'Connor did not begrudge her limitations nor think they were an encumbrance on her craft as a writer. On the contrary, she claims in "Catholic Novelists," "Possibility and limitation mean about the same thing. It is the business of every writer to push his talent to its outermost limit, but this means the outermost limit of the kind of talent he has."[43] She adds that last phrase to suggest that a writer's possibilities/limitations are the frame out of which one writes. What I am calling "Flannery's frame" had, like the frame of a picture, four sides—that is, four limitations—that, when taken together, conspired to give her stories their peculiar artistic vitality and theological resonance:

- her effective confinement in Milledgeville, Georgia
- her protracted, fourteen-year struggle with lupus
- her rigorous commitment to the habit of art
- her dogmatic but deeply personal Catholic faith

These four sides that make up O'Connor's frame act not only as boundaries that marked her limitations as a writer but also as bridges to the possibilities of her art. Sally Fitzgerald understood this about O'Connor and wrote of this creative tension in O'Connor's life,

> From Teilhard de Chardin she eventually learned a phrase for something she already knew about: "passive diminishment"—the serene acceptance of whatever affliction or loss cannot be changed by any means—and she must have reasoned that the eventual effect of such diminishment, accompanied by a perfecting of the will, is to bring increase, which is not to say that acceptance made matters easy.[44]

G. K. Chesterton once famously remarked that "the essence of every picture is its frame," thus indicating that the frame or boundaries of a work of art both limit its scope and simultaneously allow for its artistic essence.[45] There are touch points here with Victor Turner's notion of liminal boundaries, as well, and the idea that "the attributes of liminality or of liminal *personae* ('threshold

[43]*MM*, 170.
[44]*HB*, 53.
[45]G. K. Chesterton, *Orthodoxy* (New York: John Lane, 1908), 71.

people') are necessarily ambiguous."[46] One's sense of identity disintegrates, which brings about disorientation but also the possibility of redemption,[47] and so I want to suggest that these frames are liminal spaces where limitation and possibility coexist.

Another way to put this is that it is only in the presence of constraints, and not in their absence, that artistic freedom (or any freedom, for that matter) is possible. Absent constraints, art devolves into chaotic expression, giving the lie to the idea that great art represents the apex of "free" expression. It is precisely the opposite. The greatest art represents firmly fixed boundaries *within which* artistic expression is free to roam and reign. O'Connor's fiction would have been profoundly different, and markedly inferior, if any one of the sides of this four-sided frame were removed. Furthermore, the four sides were interconnected for O'Connor and were mutually dependent, and each provides commentary on the other three. This dynamic of constraints is especially operative in O'Connor's work and contributes to its particular vitality. I want to briefly look at each of the sides in order to construct a frame for how we might better understand her perspective.

"Somewhere is better than anywhere." "Southern writers are stuck with the South, and it's a very good thing to be stuck with," O'Connor remarked in an interview.[48] The mystery and limitations of "place," which for O'Connor meant the South and, more specifically, Milledgeville, Georgia, and her farm, Andalusia, provided O'Connor's essential setting for her writing, both behind and on the page, and it was a place of limitation by anyone's standards, including O'Connor's. But her view of limitations was anything but standard: "To call yourself a Georgia writer is certainly to declare a limitation, but one which, like all limitations, is a gateway to reality."[49] This comment indicates the very paradox of limitations, that from the confines of her farm in rural Georgia, O'Connor could see more deeply and

[46]Victor Turner, *The Ritual Process: Structure and Anti-structure* (Chicago: Aldine, 1969), 81.

[47]Turner suggests that, when regarded as a time and place of withdrawal from normal modes of social acceptance, a liminal experience can be seen as periods of heightened scrutiny of one's core beliefs and values (ibid., 156). Such liminal experiences occur throughout Scripture, in Jacob's wrestling with the angel, for example, or in Abraham's sacrifice of Isaac, or most pointedly, in Jesus' death and resurrection.

[48]Magee, *Conversations with Flannery O'Connor*, 37.

[49]*MM*, 54. Sally Fitzgerald writes that O'Connor "loved Andalusia . . . and she was by no means a complete misfit in Milledgeville" (*HB*, 53). Not a "complete misfit," perhaps, but a misfit nonetheless, and yet, at least from O'Connor's perspective, right at home among her kind.

widely than if she'd stood atop the Empire State Building or written from within the ivory tower on some Ivy League campus. Being able to see deeply in one place was as good, or better, than traveling the world over and only catching glimpses of the surface of things. O'Connor seems to have intuited that the roots one lays down in a place reminds a person of what holds us all in common, namely, the earth beneath our feet, the soil from where we all come, and that the intimate knowledge of the subterranean depths of any one place can somehow transcend the cultural, national, political, and even religious boundaries of all places.

This deeply Thomistic vision of the world, where nature is the means by which and through which God's grace is manifested, freed O'Connor from that conspicuous modern affliction of wanting to be everywhere at once, which entails being no place at all. O'Connor also understood that her geographically limited field of vision was compensated for, even redeemed, by her Christian vision, which allowed her to see the world around her (and beyond) with a prophet's pair of eyes—to be a "realist of distances"—which meant "seeing near things with their extensions of meaning and thus of seeing far things close up."[50] O'Connor did not need to travel. She simply needed to look.

And look she did, with "von Hügel-esque" clarity: "The things we see, hear, smell, and touch affect us long before we believe anything at all."[51] This attachment to one's locality, of course, placed constraints on the writer, as she was limited to what her senses could show her, but "this discovery of being bound through the senses" was the first step in the writer's finding her perspective.[52] The imagination, O'Connor would often say, was bound, not free, precisely because the boundaries of one's imagination are determined by one's senses. This "unpleasant discovery," as she would call it, cannot be escaped or mitigated in any way, no matter how much one desired to escape it:

> [Writers] feel that the first thing they must do in order to write well is to shake off the clutch of the region. They would like to set their stories in a region whose way of life seems nearer the spirit of what they think they have to say, or better,

[50]MM, 44.
[51]Ibid., 197.
[52]Ibid.

they would like to eliminate the region altogether and approach the infinite directly. But this is not even a possibility.[53]

The writer, and the southern writer in particular, is left not merely to accept this limiting fact, but must, since the shadow cast by that region is so all-consuming, "wrestle with it, like Jacob with the angel, until he has extracted a blessing."[54] Blessings come through struggle, through woundedness, and, for the writer, through being rooted in a particular place: "The Catholic novel that fails is a novel in which there is no sense of place."[55]

She once quipped that "lives spent between the house and the chicken yard do not make exciting copy,"[56] but as John Bailey notes,

> This may have been Flannery O'Connor's terse judgment on the constricted confines of her family home. . . . But in a small bedroom of that house, at first on a battered typewriter and late in life on a new electric, [O'Connor] created a world of the hardest edged and most memorable characters in all of American fiction.[57]

Indeed, her place influenced the diction, cadence, character, setting, and atmosphere of her stories: this was, after all, her world, or as she preferred, her country:

> The word usually used by literary folk . . . would be "world," but the word "country" will do; in fact, being homely, it will do better, for it suggests more. It suggests everything from the actual countryside that the novelist describes, on, to, and through the peculiar characteristics of his region and his nation, and on, through, and under all of these to his true country, which the writer with Christian convictions will consider to be what is eternal and absolute. This covers considerable territory.[58]

O'Connor wrote about what she knew, and she was keen to advise other writers to do the same. Write out of your region, not in spite of it, she declared. Or, if not your region, at least your country. And so she did, not simply because she had to, but because she could.

[53]Ibid., 198.
[54]Ibid.
[55]Ibid., 199.
[56]*HB*, 290-91.
[57]John Bailey, "Flannery O'Connor: Andalusia in Milledgeville," *The American Society of Cinematographers* (blog), April 9, 2012, www.theasc.com/blog/2012/04/09/flannery-oconnor-andalusia-in-milledgeville/#more-5073.
[58]*MM*, 27.

There was yet another country, another place, from which she wrote, a place called "sickness."

One of God's mercies.

I have never been anywhere but sick. In a sense, sickness is a place, more in-structive than a long trip to Europe, and it's always a place where there's no company, where nobody can follow. Sickness before death is a very appropriate thing and I think those who don't have it miss one of God's mercies.[59]

The poignant irony in such a statement is that O'Connor would live in that place for another eight years, though her almost stoic acceptance of her con-dition never gave any indication that she saw herself as a victim. (Teilhard de Chardin's concept of "passive diminishment" comes once again to mind.) Indeed, O'Connor grew impatient with anyone who sought to bring her illness to bear on her writing, as if the two were practically indistinguishable. And yet her struggle with lupus is a factor that must be considered, though not for the reasons that some of her critics think (that we find in her struggle the source of the violence in her stories, for example, which, according to a critic like Joyce Carol Oates, effectively served as a mask for deep-seated resentments she had toward God and other people).[60] No. O'Connor's disease is important to con-sider because O'Connor herself insisted again and again that one's life and one's art were inextricably bound; that one's life extended into one's writing and in-volved the whole personality. Indeed, she said herself, after admitting that she could "with one eye squinted" take her disease as a blessing, that "what you have to measure out, you come to observe closer."[61] And observe closely she did, with a prophet's eye and unremittingly realistic sense of distance.

O'Connor essentially wrote under a death sentence, and her disease was, in some ways, the gun to her head "to shoot her every minute of her life." Unlike the hypocritical grandmother in "A Good Man Is Hard to Find," however, the gun to her head did not make her a better person, but it probably made her a better writer. James Parker writes in his review of O'Connor's *A Prayer Journal*,

Health and sex and adventure had been taken from her, and in their place was a vision, her world, blast-lit and still reeling under the first shock of creation.

[59]HB, 163.
[60]Joyce Carol Oates, *New Heaven, New Earth* (New York: Vanguard, 1974), 166-67.
[61]HB, 57.

"The air was so quiet," she wrote in "The River," "he could hear the broken pieces of the sun knocking on the water." It was a gift. And we are left with a question: Without this terrible narrowing-down, would she have achieved the greatness she prayed for? This illness, this thing that confined her, that hauled her, crutches clanking, into premature spinsterhood, and finally killed her at the age of 39, can we call it by the name of grace? Dare we?[62]

Parker comes dangerously close to a line that shouldn't be crossed, that of romanticizing another's affliction, but he is correct in bringing it up. It is the question many have asked, and continue to ask. William Sessions, a friend of O'Connor's, was asked such a question in a recent interview in the Italian magazine *Tempi*:

Q. So can it be said that [Flannery's prayer to be a great writer] has been mysteriously answered [in her disease]?

A. I leave this question open, but perhaps: God heard Flannery's prayers throughout her life. It is during her illness that she wrote her best and most famous texts.[63]

Almost eight years to the day after she wrote the letter suggesting that sickness is one of God's mercies, she wrote to Louise Abbott in a postscript of a letter dated May 28, 1964, just a few months before she died, "Prayers requested: I am sick of being sick."[64] Such a naked expression from O'Connor offers a cautionary note to anyone—including this author—who too quickly makes of O'Connor's disease some kind of divine conspiracy.

Vocation implies limitation. In an early letter, this one to John Selby, O'Connor was already showing her proclivity for seeing through limitations to possibilities: "I feel that whatever virtues the novel may have are very much connected to the limitations you mention," which brings us to the third side of the frame, the limitations of her art, and of art in general.[65] "The writer," she says in her essay "Catholic Novelists,"

[62]James Parker, "The Passion of Flannery O'Connor," *The Atlantic*, November 2013, 36-37.

[63]From the online version of the article "La mia amica Flannery O'Connor, la grande scrittrice Americana che non smise mai di 'perseguitare la gioia,'" *Tempi*, July 13, 2014, www.tempi.it/la-mia-amica-flannery -oconnor; translated from the Italian.

[64]*HB*, 581.

[65]Ibid., 10; letter to John Selby in Feb. 1949.

in order best to use the talents he has been given, has to write at his own intel-
lectual level. For him to do anything else is to bury his talents. This doesn't
mean that, *within his limitations*, he shouldn't try to reach as many people as
possible, but it does mean that he must not lower his standards to do so.[66]

O'Connor is paradoxically insisting that to go beyond one's limits is to go
beneath one's talents; it is to regress, to lower one's standards. You can't tran-
scend the boundaries set for you and hope to do good work—this is a paradox
that runs in the face of the clichés manufactured by contemporary culture
about not being held back by anything and "shooting for the stars." In this
connection, Chesterton once quipped that you may think yourself free to
draw a giraffe with a short neck, but what you will find is that you have freed
yourself from drawing a giraffe.[67] Art imposes limits, in other words, that must
be respected. Art demands a frame, and the true artist understands this.
Indeed, "Vocation implies limitation," she wrote to Cecil Dawkins, "but few
people realize it who don't actually practice an art."[68]

O'Connor abjured from writing only that fiction that was suitable for
Christian tastes, whatever "Christian tastes" might actually mean. She left that
thankless task up to the church and went on about the task of working her craft:

> The business of protecting souls from dangerous literature belongs properly to
> the Church. All fiction, even when it satisfies the requirements of art, will not
> turn out to be suitable for everyone's consumption, and if in some instance the
> Church sees fit to forbid the faithful to read a work without permission, the
> author, if he is a Catholic, will be thankful that the Church is willing to perform
> this service for him. It means that he can limit himself to the demands of art.[69]

Interestingly, such a *religious* conclusion on O'Connor's part is based entirely
on *artistic*, as opposed to theological, considerations:

> The fact would seem to be that for many writers it is easier to assume universal
> responsibility for souls than it is to produce a work of art, and it is considered
> better to save the world than to save the work. This view probably owes as much
> to romanticism as to piety, but the writer will not be liable to entertain it unless

[66]*MM*, 186, emphasis mine. She also wrote, "We are limited human beings, and the novel is a product of our
best limitations" (*MM*, 193).
[67]Chesterton, *Orthodoxy*, 71.
[68]*HB*, 221.
[69]*MM*, 149.

it has been foisted on him by a sorry education or unless writing is not his vo-
cation in the first place.[70]

And yet, as we have seen, O'Connor's faith and art were inseparable. By
taking her aesthetic cues from Aquinas via Maritain and her theological
cues from both Aquinas and von Hügel, O'Connor understood that grace
comes through nature; through the person of Christ, first and foremost,
but also through the material sacraments of the church and, not least,
through the tangible experiences of our own lives. The light of her faith,
in other words, shone through the natural material of the page. It couldn't
help but do so.

Catholic dogma as limit unto freedom. One might be tempted to think,
given the previous quotation about abjuring any responsibility for the reader's
soul, that O'Connor avoided being limited by any constraints of the theo-
logical variety, leaving the church to worry about that while she wrote without
constraints, in total freedom, as the muses directed her. But this is decidedly
not so. She was, in fact, insistent that the church (with all its dogma) was es-
sential to her freedom as a writer and that it added to, did not take away from,
her work: "For me, dogma . . . is an instrument of freedom and not of re-
striction. It preserves mystery."[71]

> A belief in fixed dogma cannot fix what goes on in life or blind the believer to
> it. It will, of course, add a dimension to the writer's observation which many
> cannot, in conscience, acknowledge exists, but as long as what they *can* ac-
> knowledge is present in the work, they cannot claim that any freedom has been
> denied the artist. A dimension taken away is one thing, a dimension added is
> another; and what the Catholic writer and reader will have to remember is that
> the reality of the added dimension will be judged in a work of fiction by the
> truthfulness and wholeness of the natural events presented. If the Catholic
> writer hopes to reveal the mysteries, he will have to do it by describing truth-
> fully what he sees *from where he is*.[72]

And this wasn't dogma that she cherry-picked from the doctrines of the church
to suit her artistic purposes:

[70]Ibid., 149-50.
[71]*HB*, 92.
[72]*MM*, 150; emphasis mine.

> I write with a solid belief in *all* the Christian dogmas, [and] I find that this in no way limits my freedom as a writer and that it increases rather than decreases my vision. . . . For the fiction writer, to believe nothing is to see nothing.[73]

And she believed this not simply as a Christian, but as a Catholic:

> I write the way I do because and only because I am Catholic. I feel that if I were not a Catholic, I would have no reason to write, no reason to see, no reason to ever feel horrified or even to enjoy anything. . . . I have never had the sense that being a Catholic is a limit to the freedom of the writer, but just the reverse.[74]

O'Connor goes on to say that her "being a Catholic saved [her] a couple of thousand years in learning to write."[75]

As for the limitations placed on her by her own Catholic expression of faith, O'Connor was unapologetic: "Dogma is the guardian of mystery," and it "preserves mystery for the human mind."[76] This paradoxical vein runs through all of O'Connor's writing—that restraint is requisite to appreciating mystery—and is key to understanding not only her theology but also her literary sensibilities. In spite of her self-avowed tendency to shout and to draw large and startling figures, O'Connor was keen to respect the essential mystery that lies at the heart of things, which meant that she operated firmly within the boundaries established by the Roman Church and by her craft. O'Connor believed that the mystery of religion was essentially moral and that the mystery of fiction was dramatic, and since for the writer, both senses—the moral and dramatic—were inseparable, this meant, among other things, that her faith and her craft were of a piece. A writer's "moral judgment is part of the very act of seeing" (and his "moral sense must coincide with his dramatic sense").[77] The dramatic integrity of a story, in other words, depends in some measure on the writer having a moral vision.

O'Connor did not rail against limitations but against excesses, largely because she understood them to be, more often than not, their opposites. What the world considered limitations, in other words, were often merely opportunities in divine disguise, in the same way that much of what the world celebrated

[73]*HB*, 147.
[74]Ibid., 114.
[75]Ibid.
[76]Ibid., 365, 103.
[77]*MM*, 31; *HB*, 124, 147.

as excess was actually an embracing of death. There are, in O'Connor's fiction, genuine limitations that actually *limit*; and not only limitations but also virtues that limited, or perhaps *especially* virtues that limited and would become, as we see in her story "Revelation," dross for the fire of purgation. For O'Connor, the most limiting of our virtues was our unaided reason, and unaided reason, Marion Montgomery reminds us, had turned the medieval dance that celebrated life into the modern race that tried in vain to pursue it.[78] Frederick Asals goes further in suggesting that, from the perspective of the modernist, unaided reason moves from the mere pursuit of life to its ultimate conquest:

> For the great temptation of reason is the illusion it creates of self-sufficiency, of domination and control of the world beyond itself, of *transcendence of* the limitations of the body, of matter, indeed even of human mortality. It is for O'Connor the most seductive of the human faculties, for it both imitates and mocks the powers of God Himself.[79]

Refusing to admit one's own human limitations was, for O'Connor's characters, a mortal proclivity, but—and here's the paradox once again—also a religious opportunity, since such a refusal was often a prerequisite for revelation. In O'Connor's literary and theological calculus, the first were last and the last first; the beginning the end and the end often the beginning, as we see in "The River," "Greenleaf," "Revelation," and "Judgment Day." This subversive tendency in O'Connor went to the ground level of her being: "The virgin birth, the incarnation, the resurrection are the real laws of the flesh and the physical. Death, decay, destruction are a suspension of these laws."[80] In other words, the limitations we normally regard with awe or even disdain were, for O'Connor, at best, temporary realities. So in saying that she was a champion of limitations, of constraints, is to suggest that the normal things we consider constraints and limitations were, for her, negotiable realities, while those things the world

[78]Marion Montgomery, *Hillbilly Thomist: Flannery O'Connor, St. Thomas and the Limits of Art* (Jefferson, NC: McFarland, 2006). I am reminded of something Chesterton says in *Orthodoxy*: "The unpopular parts of Christianity turn out when examined to be the very props of the people. The outer ring of Christianity is a rigid guard of ethical abnegations and professional priests; but inside that inhuman guard you will find the old human life dancing like children, and drinking wine like men; for Christianity is the only frame for pagan freedom. But in the modern philosophy the case is opposite; it is its outer ring that is obviously artistic and emancipated; its despair is within" (292).

[79]Frederick Asals, *Flannery O'Connor: The Imagination of Extremity* (Athens: University of Georgia Press, 1982), 210-11.

[80]*HB*, 100.

considers virtues and possibilities were, from her perspective, often the severest of limitations.

It is instructive to note that in the sections where O'Connor discusses art in *Mystery and Manners*, she uses the words *limits* and *limitations* twice as often as she uses the words *free* and *freedom*, which suggests that for O'Connor, the demands of art were more about limitation and constraint than liberty and emancipation. But again, in her subversive world, this is a good thing. Untethered freedom isn't all that it's cracked up to be. On the contrary, "Free will has to be understood within its limits."[81] So even freedom has its limits, according to O'Connor.

THE CATHOLIC-FUNDAMENTALIST IMAGINATION

The opening epitaph in Andrew Greeley's important *The Catholic Imagination*, quoting Alfred North Whitehead, essentially discloses Greeley's thesis: "Religions commit suicide when they find their inspiration in dogma."[82] Flannery O'Connor, as we have already seen, believed that dogma is "the guardian of mystery" and that it "frees the story-teller to observe . . . by guaranteeing his respect for mystery," which, in turn, will "add a dimension" to the writer's craft.[83] For O'Connor, Christian dogma served not as a hindrance to her imagination but as a lens through which it came alive. Even Greeley's opening lines, which describe for the reader the essence of the Catholic imagination, stand in stark contrast not only to the world O'Connor created for her characters but also to the world in which she lived:

> Catholics live in an enchanted world, a world of statues and holy water, stained glass and votive candles, saints and religious medals, rosary beads and holy pictures. . . .
>
> The assertions in the last paragraph are not statements of what Catholics should be like. . . . They are . . . factual descriptions of Catholics . . . and the Catholic religious imagination that shapes their lives.[84]

[81]Ibid., 488.

[82]Andrew Greeley, *The Catholic Imagination* (Berkeley: University of California Press, 2000).

[83]*HB*, 365.

[84]Greeley, *Catholic Imagination*, 1. Greeley also writes that "Catholics are more likely than Protestants to endorse the more benign view of the world . . . [and] are more likely to feel that the world is good rather than evil" (169). O'Connor, with Aquinas, believed that nature was inherently good, but as for the world (meaning its inhabitants), O'Connor was far more pessimistic—or as she might claim, realistic: "[My] stories are hard but they are hard because there is nothing harder or less sentimental than Christian real-

Compare this to O'Connor's life as recorded in her letters, where the rosary is mentioned only twice (and both times somewhat derisively)[85] and votive candles, statues, and stained glass not a single time. This is not to question O'Connor's devotion to the Catholic Church, but only to suggest that her Catholicism (and Catholic imagination) were of a distinctly different stripe than Greeley's depiction of the same.

To be sure, both O'Connor and her characters lived in a world where daily life offered up punctuated revelations of grace (for those with eyes to see), but the sorts of revelations O'Connor created for her characters were not the sort Greeley had in mind when he described the nature of these revelations as being permeated by God's love "as a sandwich is physical, and nutritious and pleasurable, and within it is love, if someone makes it for you and gives it to you with love."[86] There are no love sandwiches in O'Connor's fictional world. There is the occasional meal, but more often than not it is interrupted or followed by a drowning or rape, a goring or gun shot. And even where a meal is consumed, it often represents, not a love sandwich, but the broken and bloody host.

Greeley writes about what he calls the "Catholic sensibility," insisting that

Catholic artists and writers tend to hunger for the salvation of their char-
acters. . . . They want salvation for the characters (and of course for themselves,
too) because they find themselves in a grace-filled world, a world in which grace
surges all around. A God who discloses Herself so recklessly, so prodigally,
must necessarily be a God who wants salvation for all Her children. The
Catholic sensibility is at worst bittersweet (like the slow movement of Mozart's
no. 26) but never, never desperate, never pessimistic, never hopeless. . . . [Cath-
olics] tend to picture God, creation, the world, society, and themselves the way
great artists do—as drenched with grace, that is to say, with God's passionately
forgiving love, His salvation.[87]

ism" (*HB*, 90); or as she indicated in her essays, the stated purpose of her fiction was "to show the action of God's grace in territory held largely by the devil" (*MM*, 18). It would seem from Greeley's perspective that, at least in some respects, O'Connor's imagination is strikingly Protestant.

[85]"I was brought up in the novena-rosary tradition too, but you have to save yourself from it someway or dry up" (*HB*, 139), and "I said the rosary for you last night & actually managed to stay awake through all 5 decades. Very unusual. The Rosary is at least tangible" (ibid., 582).

[86]Greeley, *Catholic Imagination*, 2. Though I do agree with John Desmond that O'Connor is "a comic writer whose work is grounded in love" (John Desmond, *Risen Sons: Flannery O'Connor's Vision of History* [Athens: University of Georgia Press, 1987], 118), it is a love that is severe, not sentimental.

[87]Greeley, *Catholic Imagination*, 168.

Any reader of O'Connor's will not recognize in Greeley's depiction of the Catholic sensibility a single one of her stories. One never gets the sense that O'Connor hungered for her characters' salvation, for example, as much as she shouted and yelled for their need for redemption. This points to an essential difference between Greeley's and O'Connor's imaginations: the lexical distinction between *salvation* and *redemption* is the difference between an *outcome* and a *process*. O'Connor famously wrote, "I believe that there are many rough beasts now slouching toward Bethlehem to be born and that I have reported the progress of a few of them."[88] O'Connor's "Catholic sensibility" is *at best* bittersweet and often desperate, even pessimistic (though never and by no means entirely hopeless), and she is far more interested in her characters' slow, slouching, often violent, humorous, and pathetic process toward redemption than she is in the laurel-wreathed coronation of salvation that awaits them. O'Connor's imagination—her Catholic sensibility—denies Greeley's central thesis. It is not surprising, then, that the most prominent American Catholic fiction writer of the twentieth century is not mentioned a single time in Greeley's book.[89]

EXCURSUS: O'CONNOR'S FUNDAMENTALIST CHARACTER(S)

Ralph Wood uses the term *fundamentalist* to describe O'Connor's characters' expressions of faith in his chapter "A Roman Catholic at Home in the Fundamentalist South" in *Flannery O'Connor and the Christ-Haunted South*. Wood claims that O'Connor's "tough narrative voice is really her [voice],"[90] and, in another publication, that O'Connor's "Protestant characters [are] advocates

[88] *HB*, 90.

[89] Toward the end of Greeley's book, he revisits his thesis, claiming that his modest goal "was to show that there is a low-level correlation between the great works of art created by Catholics and the imaginations of ordinary Catholics, that there is a correlation between the sensibility of Nicholas of Verdun, Bernini, St. John of the Cross, Hopkins, Greene, Scorsese, Vermeer, and Mozart on the one hand and the ordinary Catholic laity today on the other" (*Catholic Imagination*, 184). One is left to wonder about the sensibilities of Theresa of Avila, Dante, Chaucer, Hieronymus Bosch, Shusaku Endo, François Mauriac, and O'Connor. To be fair to Greeley, he states that his study was not intended to be "a definitive statement about either the Catholic artistic sensibility or the Catholic popular sensibility" (ibid., 183). Nevertheless, it seems clear that O'Connor is not a representative example of someone Greeley would say had a "Catholic imagination."

[90] Wood, *Christ-Haunted South*, 13.

[of] her own distinctly Catholic form of Christian faith."[91] The thrust of Wood's argument begins with the importance of choice in O'Connor's characters, which at one point he seems to see as a distinctly Catholic emphasis. But Catholics, as Wood no doubt believes, are not alone in their emphasis on the importance of choice in a believer's life. Wood then quotes O'Connor: "man [is] so free that with his last breath he can say *No*" (*Mystery*, 182), but she was clearly no Pelagian either (Wood would agree), as her more nuanced stance on free will indicates.[92] Wood then offers up Mason Tarwater, who believes in infant baptism, as additional proof of O'Connor's distinct Catholicism. But most Protestants, of course, practice infant baptism as well (though Baptists, as a general rule, do not). Wood writes that "the river preacher [in "The River"] advocates an unprotestant view of baptism as actually conferring grace."[93] Protestants believe this too. Generally speaking, Protestants do not hold to an automatic conferral of the benefits of regeneration or conversion at baptism, but, as Donald Bloesch points out in his multivolume *Essentials of Evangelical Theology*, they "affirm the reality of baptismal grace."[94]

Another curious omission related to this question of the appropriateness of the term *fundamentalist* to describe O'Connor's characters is that at no time do any of her characters read the Bible, save but twice. The first occurs when Mrs. Shortley, in "The Displaced Person," reads a Bible in order to find a way to rid the farm she lives on of some meddling immigrants from Poland. The second instance is when Rufus Johnson, a character in "The Lame Shall Enter First," who is meant to represent the devil, reads from a Bible he stole. Otherwise, Bibles are kept in the attic (as opposed to the bedside) or are hollowed out to store a flask of liquor in. Indeed, O'Connor's satanic characters either read or quote from the Bible as much or more than her properly "Christian" ones—to the point of an Ezekiel-like ingesting of it in "The Lame Shall Enter First"! O'Connor writes in a letter to a nun, "In the gospels it was the devils who first recognized Christ and the evangelists didn't censor the information. They apparently thought it was pretty good witness."[95]

[91]Ralph Wood, "The Catholic Faith of Flannery O'Connor's Protestant Characters: A Critique and Vindication," *Flannery O'Connor Bulletin* 13 (1984): 16.

[92]*MM*, 182; see also 115-17, 192; *HB*, 488.

[93]Wood, "Catholic Faith," 21.

[94]Donald Bloesch, *Essentials of Evangelical Theology* (New York: HarperCollins, 1978), 2:12. Both Luther and Calvin, as well as the Westminster Confession of Faith—indeed, the whole Presbyterian Book of Confessions—teach that baptism confers grace.

[95]*HB*, 517.

Which is all to say that we should not therefore conclude from such omissions (of church attendance and Bible study) that O'Connor believed the Bible was unimportant or that it was merely a tool of the devil's or that church is a waste of time. The omission of any explicitly Catholic "forms" in her stories does not, therefore, automatically indicate a commensurate lack of commitment to Catholic teachings. And, given their lack of connection to any church and their curious reluctance to read the Bible, it may be that her characters' unusually iconoclastic expressions of faith are more befitting Ralph Wood's moniker "folk Christians" than the usual "fundamentalists." I opt for "fundamentalist" only because that is how O'Connor refers to them, but there is much to commend Wood's *term d'art*.

O'Connor's Crypto-fundamentalism

O'Connor's devout Roman Catholicism comes as a surprise to many of my students who read her for the first time, particularly given that she populates her fiction with fundamentalist Protestant Christians who are, at least for some readers, about as far from Roman Catholicism as a Christian can get. She is also surprisingly sympathetic to her characters' fundamentalist expressions of faith. In one notable letter, O'Connor expresses complete sympathy of belief with Old Mason Tarwater, one of her more virulently fundamentalist protagonists, declaring that "it is the old man who speaks for me."[96]

This unlikely theological allegiance of Catholic author with her fundamentalist characters is significant for our purposes as we now examine how O'Connor's expressions of faith in her fiction and her pre-Reformation, even medieval, Catholic sensibilities were ineluctably mixed with the southern Protestant, rural fundamentalist, "Christ-haunted" Zeitgeist shimmering in the air around Andalusia. She was, in this sense, a crypto-fundamentalist, a variation on a term O'Connor once used to describe her theological doppelgänger, Old Mason Tarwater: "Old Tarwater is not typical of the Southern Baptist or the Southern Methodist. Essentially, he's a crypto-Catholic."[97] In making such a claim, one must be careful to avoid the error

[96]*HB*, 350. In an interview with Granville Hicks, she repeats this sentiment, but in more emphatic terms: "Old Tarwater is the hero of *The Violent Bear It Away*, and I'm right behind him 100 per cent" (Magee, *Conversations with Flannery O'Connor*, 83).

[97]*HB*, 517.

Sarah Gordon warns against, that to "ignore the Catholic center of O'Connor's work [is] to miss the forest for the trees . . . it is to mistake accident for essence."[98]

O'Connor was, of course, the first to defend her Catholic position against any Protestant encroachments, and she would take any opportunity presented her to clarify the differences that existed between the two. One of her correspondents, Ted Spivey, offered her many opportunities to do so, and in one notable (and long) letter, she spells out in painstaking detail just where the heart of those differences lie:

> If you want to know what Catholic belief is you will have to study what the Church teaches in matters of faith and morals. And I feel that if you do, you will find that the doctrinal differences between Catholics and Protestants are a great deal more important than you might think they are. I am not so naïve as to think such an investigation would make a Catholic of you; it might even make you a better Protestant; but as you say, whatever way God leads you will be good. You speak of the Eucharist as if it were not important, as if it could wait until you are better able to practice the two great commandments. Christ gave us the sacraments in order that we might better keep the two commandments. You will learn about Catholic belief by studying the sacramental life of the Church. The center of this is the Eucharist.[99]

O'Connor's distillation of the essential difference between Protestants and Catholics as coming down to the Eucharist is instructive for our purposes because it points, ironically, to the essential unity she believed Protestants and Catholics shared and to how she manifested that unity in her characters.[100]

[98]Sarah Gordon, "Seeking Beauty in Darkness: Flannery O'Connor and the French Catholic Renaissance," in Gretlund and Westarp, *Flannery O'Connor's Radical Reality*, 70. In this same volume, Patrick Samway, SJ, questions "the legitimacy of calling her fiction 'Roman Catholic' . . . and argues that O'Connor's views are wider than narrowly 'Roman Catholic,'" which makes their "appeal more ecumenically relevant" ("Toward Discerning How Flannery O'Connor's Fiction Can Be Considered 'Roman Catholic,'" 162). See also Joanne Hallernan McMullen's essay, "Christian but Not Catholic: Baptism in Flannery O'Connor's 'The River,'" in *Inside the Church of Flannery O'Connor: Sacrament, Sacramental, and the Sacred in Her Fiction*, ed. Joanne Halleran McMullen and Jon Parish Peede (Macon, GA: Mercer University Press, 2007), for a sustained argument that O'Connor's stories are less specifically Catholic than generally Christian.

[99]*HB*, 346.

[100]She says a few years later in a letter that she is "more and more impressed with the amount of Catholicism that fundamentalist Protestants have been able to retain. Theologically, our differences with them are on the nature of the Church, not on the nature of God and our obligation to him" (*HB*, 518). O'Connor's temperament was essentially reactive in this regard; around Catholics she would often emphasize her

Her characters were not Catholics except in this respect: they were drawn to the waters of baptism and to the elements of bread and wine in ways even they could not describe or even account for, and often did not understand or recognize. This is most palpably evident in the *The Violent Bear It Away*. There, both the old and young Tarwaters, in their obsession with—and compulsion toward—the idiot child's need for baptism, are anything but Baptist (infant baptism and the efficacy and necessity of baptism for salvation are not typical Baptist tenets). O'Connor appears to sidestep one controversy, infant baptism, by putting the child's age at the so-called age of accountability (ages seven to nine), but then simultaneously ups the ante by making that child mentally disabled and so, effectively, of no accountability. As for the efficacy of baptism unto salvation, this crucial piece of Catholic dogma is never questioned except by Rayber, who, at least on his better days, does not believe in God, much less the means of grace attributed to him.

The usual religious elements that one might expect to find in stories written by a devout Roman Catholic are almost entirely absent from O'Connor's fiction for the simple reason that she didn't write about Catholics but instead fashioned her characters around the backwoods fundamentalists that populated her region. She writes about them,

> Wise blood has to be these people's means of grace—they have no sacraments. The religion of the South is a do-it-yourself religion, something which I as a Catholic find painful and touching and grimly comic. It's full of unconscious pride that lands them in all sorts of ridiculous religious predicaments. They have nothing to correct their practical heresies and so they work them out dramatically.[101]

The pope gets only a single mention in all of her stories (and a derisive one at that); there are no rosaries, no holy confessions, no signs of the cross, and no mention at all of the Holy Virgin. Indeed, at no point in her entire corpus do any of her characters attend church (though a few make it as far as a tent revival). O'Connor explains this conspicuous absence of Catholicism in her fiction with what, at first, is an aesthetic appeal:

more Protestant sympathies, while around Protestants (like Spivey) she would emphasize her more Catholic commitments.

[101]*HB*, 350.

If you are a Catholic and have this intensity of belief you join the convent and are heard no more; whereas if you are a Protestant and have it, there is no convent for you to join and you go about the world getting into all sorts of trouble. . . . This is one reason why I can write about Protestant believers better than Catholic believers—because they express their belief in diverse kinds of dramatic action which is obvious enough for me to catch.[102]

Backwoods fundamentalists, apparently, make better copy. But this explanation alone does not account for the absence of Catholic forms in her fiction. O'Connor goes on to say, "When you leave a man alone with his Bible and the Holy Ghost inspires him, he's going to be a Catholic one way or another, even though he knows nothing about the visible church."[103] A Catholic who knows nothing about the visible church would sound, to most Catholic ears at least, like a contradiction in terms. Such a claim—that with nothing but a Bible, the Holy Ghost, and sufficient time, a backwoods fundamentalist will become a Roman Catholic—is surprising, indeed, coming from a deeply committed Catholic like O'Connor. The normal means of salvation for the Catholic—the church—is apparently, in this case at least, deemed unnecessary. And instead of qualifying this claim, she emphasizes it: "His kind of Christianity may not be socially desirable, but it will be real in the sight of God."[104]

O'Connor apparently did not believe, neither for her characters nor for her friends, that salvation was only possible within the Roman Church. In her review of Yves Congar's book *The Wide World, My Parish*, she adumbrates a position essentially identical to Congar's:

Understanding of the formula, "Outside the Church, no salvation," has changed drastically since the time of its originator, St. Cyprian, who understood it in an exclusive sense. Today it is understood to mean that the Church is the only institution to which universal salvation is committed, that she is the only institution able to *ensure* salvation for every person who does not refuse it.[105]

O'Connor is expressing such opinions, it is instructive to note, just six months after the convening of the Second Vatican Council in December of 1962, which

[102]Ibid., 517.

[103]Ibid.

[104]Ibid.

[105]Leo Zuber and Carter Martin, eds., *The Presence of Grace and Other Book Reviews by Flannery O'Connor* (Athens: University of Georgia Press, 1983), 159. Italics mine.

she supported—"I think the Council is great"—and yet, O'Connor was also deeply committed to pre–Vatican II, Thomistic doctrine, and to suggest otherwise is both foolhardy and tendentious.[106] One of her most sustained defenses of the Roman Church comes in a letter to Ted Spivey, her friendly Protestant interlocutor, dated July 18, 1959, where she writes,

> We mean entirely different things when we each say we believe the Church is Divine. You mean the invisible Church . . . somehow related to its many forms, whereas I mean the one and only visible Church. It is not logical to the Catholic to believe that Christ teaches through many visible forms all teaching contrary to doctrine. . . . For us the one visible Church pronounces on these matters infallibly and we receive her doctrine whether subjectively it fits in with our surmises or not. We believe that Christ left the Church to speak for him, that it speaks with his voice, he the head and we the members.[107]

But it is precisely this deep reverence for the institution that makes her theological sympathies with her anti-institutional characters so surprising. Indeed, her theological sympathies with the "traditional enemy" of Roman Catholicism is refreshingly ecumenical: "The fundamentalist Protestants, as far as doctrine goes, are closer to their traditional enemy, the Church of Rome, than they are to the advanced elements in Protestantism."[108] This ecumenical vein in O'Connor's work did not simply come in response to Vatican II, either. It was there from the beginning, and it allowed her to be independent, even critical, of the church while also being deeply committed to it.

O'CONNOR'S AND VON HÜGEL'S UNCONVENTIONAL CATHOLICISM

O'Connor shared with von Hügel a distrust of much common Catholic social convention, which was a point of connection that she seemed to revel in:

> He advises [his niece] also not to be "churchy," to love Holy Communion but "tactfully, unironically, to escape from all Eucharistic Guilds . . . to care for God's work in the world . . . and yet (again quite silently, with full contrary

[106]HB, 500. O'Connor's theology is deeply Thomistic in that it reflects the inseparability of grace and nature, where grace completes and perfects nature (as opposed to the other way around!). See Andrew Dean Swafford's preface in *Nature and Grace: A New Approach to Thomistic Ressourcement* (Eugene, OR: Pickwick, 2014) for a helpful historical overview of the struggle to define a Catholic approach to the question of the interrelation of grace and nature.

[107]HB, 341.

[108]Ibid.

encouragement to others who are helped by such literature) never opening a Church paper or magazine." This last piece of advice, so gallantly subversive to the organizational appetite, may explain handily why Baron von Hügel has not been widely read in American Catholic circles, but the reader who has been fed (sufficiently) on Irish piety may find Baron von Hügel's letters a welcome relief.[109]

She also wrote to Ted Spivey that "the Baron's spirit is an antidote to much of the vulgarity and rawness of American Catholics."[110] Von Hügel was, in fact, accused of blurring the lines between Catholicism and Modernism. Two of his closest friends, Alfred Loisy and George Tyrrell (the Catholic *malgré lui* of the Modernist controversy), formed the center of the Catholic Modernist movement. Tyrrell was expelled from the Jesuits in 1906, and Loisy was excommunicated *vitandus* from the Roman Church two years later, in 1908. Von Hügel never suffered a similar fate, but he was considered by the consensus of Catholic leadership to be dangerously close to Modernist progressive elements. Official opinion changed as his subsequent writings were published, which removed any doubt of his commitment to Catholic orthodoxy. Indeed, he would eventually make a name for himself as one of the reigning voices in the Catholic intellectualism of the twentieth century.

A marvelous essay by a Catholic nun and friend of O'Connor's, Sister Mariella Gable, on the subject of O'Connor's "ecumenic core," makes much of this tension:

> [O'Connor] is a totally committed Catholic. To her the dogmas of the Catholic Church are not something she accepts grudgingly, but they are the sun-bright center from which shines the light that lifts her work to sheer greatness. . . . Where else except in the South, that "breeding ground for prophets," could Miss O'Connor find the vitalized faith she needs for her ecumenic message?[111]

[109] Zuber and Martin, *Presence of Grace*, 21-22.

[110] *HB*, 331.

[111] Sister Mariella Gable, OSB, "The Ecumenic Core in the Fiction of Flannery O'Connor," *American Benedictine Review* 15 (June 1964): 128, 134. Gable goes on to suggest that, using Father Yves Congar's three levels of ecumenism as a means of measure (the last being the most authentic and intense), O'Connor belongs in the third level, where, as Congar puts it, Catholics must accept "in the very area of our Catholic truth, the salutary shock produced by the dialogue with 'the others' and by renewing our own doctrinal positions at the deepest sources of biblical revelation and the great Catholic tradition" (as quoted in ibid., 141).

Catholic dogma is central to O'Connor, in other words, and yet the place she finds it best expressed is in the backwoods fundamentalism of her southern neighbors, as Wood and others have pointed out.

Even where O'Connor most explicitly delineates her Catholicism in her letters, particularly in her correspondence with Betty Hester and Spivey, she nonetheless sings the praises of the likes of Martin Buber, Paul Tillich, and Karl Barth, the first of whom she credits as "a good antidote to the prevailing tenor of Catholic philosophy," and the latter two of whom she considers "the greatest of the Protestant theologians writing today and it is to our misfortune that they are much more alert and creative than their Catholic counterparts. We have very few thinkers to equal Barth and Tillich, perhaps none. This is not an age of great Catholic theology."[112] She writes in her review of Barth's *Evangelical Theology*, "There is little or nothing in this book that the Catholic cannot recognize as his own. In fact, Barth's description of the wonder, concern and commitment of the evangelical theologian could equally well be a description of the wonder, concern and commitment of the ideal Catholic life."[113]

O'Connor's allegiance to the Roman Church and to the church's central dogmas, though unwavering, was not blind, and she could be deeply critical, not only of the institution, but also of her fellow Catholics and particularly of that brand of Catholicism unique to the West, at least as O'Connor saw it, that tended to find solace and identity in Catholic guilds and "churchy" newsletters.

There is, in spite of this (and perhaps because of it), a reticence in certain corners of O'Connor scholarship to give her evangelical sympathies their rightful due. Such critics have witnessed how too many of their southern evangelical and their fundamentalist brethren have long demonized the Catholic Church, and to a regrettable extent still do, and so they have rightly tried to defend O'Connor's theological legacy against those who would seek to use her work as propaganda against the very church she loved. For these reasons, such impulses to protect O'Connor's Catholicism are understandable, even necessary, but such impulses cannot be uncritically leveraged against the unassailable fact that O'Connor's theological sympathies with her fundamentalist and evangelical characters ran deep.

[112]*HB*, 303, 6.
[113]Zuber and Martin, *Presence of Grace*, 164.

In his essay "Flannery Ain't No Baptist," Kevin Cole argues that O'Connor's characters are fundamentally Protestant in their "preference of non-liturgical non-sacramental theology; [their] dependence on an overly-cognitive (though paradoxically, anti-intellectualist) faith; and lastly, [their] perpetual flirtation with the twin influences of Manichaeism and Gnosticism."[114] Cole also argues that O'Connor's stories could not have been written by anyone *other than* a Catholic and then proceeds to build his case for O'Connor's essential Catholicism. But in doing so, he manages (as far as I can see) to persuade his readers even more of her fundamentalist Protestant sympathies. He quotes Mark Noll, for example, who distinguishes "traditional Roman Catholic thinking (where grace perfects nature) with the approach of [Evangelicalism] (where grace destroys nature and perfects it)." If Noll is correct, as I believe he is, then it could be reasonably argued that O'Connor is in some sense more traditionally evangelical than strictly Catholic in her fiction *insofar as* she destroys her characters *before* they are redeemed; or, more accurately, that they are destroyed *as* they are redeemed, which places the work of purgatory in this realm and not the next, which, as we have discussed earlier, is an idea with which both O'Connor and von Hügel were sympathetic.

With few exceptions, there are also no properly liturgical elements in O'Connor's stories because there is rarely a church in any of them; and the paradox of "overly cognitive" yet "anti-intellectualist" faith, as Cole puts it, exemplifies Old Mason's as well as young Francis's approaches, as representatives of a position that stands over and against the hyperintellectualism of their more urbane relation, George Rayber. An overly cognitive and anti-intellectualist paradoxical approach to faith even describes Haze Motes's religious impulses, with his desire to establish the Church of Christ Without Christ that stems from a position that is all head and no heart, which is as much a repudiation of Christian praxis as it is of Christian orthodoxy. I am reminded of Chesterton's paradoxical quip that "a madman is not someone who has lost his reason. A madman is someone who has lost everything but his reason."[115]

[114]Kevin Cole, "Flannery Ain't No Baptist," http://kevers.net/baptistflannery.html.
[115]Chesterton, *Orthodoxy*, 32.

Early in her career, O'Connor was accused by some of having Manichaean and Gnostic tendencies.[116] Though a dubious charge, it is certainly true, at least in her novels, that right knowledge appears to trump right action as the indication of one's salvific status. If right action were a criterion for attaining salvation, most of O'Connor's protagonists would be in hell. Such a claim appears to run in the face of O'Connor's contention that "our salvation is worked out on earth according as we love one another, see Christ in one another, etc., by works" and again in another place where she sums up the human condition as man being "incomplete in himself, as prone to evil, but as redeemable when his own efforts are assisted by grace."[117] But this is precisely, I am arguing, where O'Connor writes in such a way as to challenge, or at least reenvision, the Catholic teachings of her day. The traditional Catholic doctrine termed (often derisively) "works righteousness," even when properly considered from the Catholic perspective—where one is justified by doing good deeds *in cooperation with* God's grace—is not a theme easily drawn out of O'Connor's stories. Few, if any, of her central characters are good by any normal standard of measurement (whether assisted by God or not) in that they perform good deeds or "love one another" or "see Christ in one another," all of which are, O'Connor is right to point out, central to Catholic soteriology. The Council of Trent is regulative in this regard, where it speaks of the symbiotic relationship of grace and works in Catholic theology:

> If anyone says that man can be justified before God by his own works, whether done by his own natural powers or by the teaching of the Law, without divine grace through Jesus Christ, let him be anathema. (Session 6; can. 1)
>
> If anyone says that the sinner is justified by faith alone, meaning that nothing else is required to cooperate in order to obtain the grace of justification and that it is not in any way necessary that he be prepared and disposed by the action of his own will, let him be anathema. (Session 6; can. 9)

Young Tarwater, to use perhaps the most blatant example, stands at almost the opposite end of any notion of what might be considered good, even by the Catholic standard of the grace of justification. And as I try to show later, his

[116]Frederick Asals, for example, accuses O'Connor of Manichaean tendencies. See Asals, *Imagination of Extremity*, 206.

[117]HB, 102; MM, 197.

will is challenged and contravened at almost every juncture (in spite of his constant boasts that he can "act"), but perhaps most especially where he performs what might be reasonably considered the only salvific action in the novel, the baptism of Bishop. Of course, he drowns him too, which makes his action—at least sacramentally, liturgically, and soteriologically considered—complicated. One is equally hard pressed to see how any of O'Connor's other main characters—Mason Tarwater, Mrs. May, Ruby Turpin, even Haze Motes—characters who, we are led to assume, achieve some measure of (if not total) salvation, properly fit the definition of people who "cooperate" with God and are "prepared and disposed by the action of [their] own will[s]." At the very least, the issue at hand warrants no clear, definitive conclusions. What does seem clear is that O'Connor anticipated in her fiction what the Catholic Church would eventually concede in its doctrine.

EXCURSUS: THE JOINT DECLARATION ON THE DOCTRINE OF JUSTIFICATION

With the official adoption of the Joint Declaration on the Doctrine of Justification, published in 1999 by the Lutheran World Federation and the Roman Catholic Church, the Catholic Church significantly altered its historical position on the means of justification:

> In faith we together hold the conviction that justification is the work of the triune God. The Father sent his Son into the world to save sinners. The foundation and presupposition of justification is the incarnation, death, and resurrection of Christ. Justification thus means that Christ himself is our righteousness, in which we share through the Holy Spirit in accord with the will of the Father. Together we confess: *By grace alone, in faith in Christ's saving work and not because of any merit on our part, we are accepted by God and receive the Holy Spirit, who renews our hearts while equipping and calling us to good works.*[118]

Following the historic declaration, an essay in the *Wall Street Journal* summed it up thus:

[118]The Joint Declaration on the Doctrine of Justification 3.15; emphasis mine.

Exactly 482 years after Martin Luther nailed his 95 theses to the church door in Wittenberg, leaders of the Lutheran and Roman Catholic churches met in Augsburg on Sunday to settle the dispute that formed the core of their schism and that led to the Protestant Reformation and the Thirty Years War. At issue was the concept of "justification"—whether, as Lutherans (and most Protestants) believe, man finds salvation in faith alone, or, as Catholics have long emphasized, a life of good works is an integral part [of salvation]. . . . The joint declaration issued by the two churches was the product of 30 years of work at doctrinal reconciliation. It effectively concedes the theological debate to Luther.[119]

Ralph Wood argues in favor of the "thoroughly Catholic character of the Protestant doctrine of justification by faith alone" and cites Hans Küng's book *Justification: The Doctrine of Karl Barth and a Catholic Reflection* as the most helpful book on the subject.[120] And yet the fact remains that this "thoroughly Catholic character" of justification by faith was not officially sanctioned by the Roman church until long after O'Connor's death.

O'Connor's theological sympathies with her Protestant brothers and sisters, in her fiction as well as in her life, are a significant characteristic of the "ecumenic" tone of her fiction and should be considered before any final interpretation of her stories is rendered. O'Connor believed that "the universe of the Catholic fiction writer is one that is founded on the theological truths of the Faith, but particularly on three of them—the Fall (or Sin), the Redemption, and the Judgment"[121]—which, together, also formed the theological vision of her southern neighbors: "I accept the same fundamental doctrines of sin and redemption and judgment that they do."[122]

[119]"By Grace Alone," *Wall Street Journal*, November 3, 1999, www.wsj.com/articles/SB941493201223649984.

[120]Hans Küng, *Justification: The Doctrine of Karl Barth and a Catholic Reflection* (Philadelphia: Westminster Press, 1964). As cited in Wood, "The Catholic Faith," 21.

[121]*MM*, 185.

[122]*HB*, 350. Haze Motes declares, "I'm going to preach there was no Fall because there was nothing to fall from and no Redemption because there was no Fall and no Judgment because there wasn't the first two." *WB*, 59. This three-tiered typology serves as a central motif in O'Connor's stories and in Catholic theology. Von Hügel uses the same three doctrinal categories of creation, redemption, and judgment in his own typology (see, for example, *Mystical*, 258ff).

In the hands of someone like O'Connor, who in many ways stands in a liminal space at the ecumenical boundary of Protestant and Catholic expressions of faith, these doctrines, along with the incarnation,[123] which O'Connor understood as regulative in all her fiction and which she often referred to as the "mystery of the redemption,"[124] depict a God whose terrible beauty, violent goodness, and mysterious, often foolish truth represent biblical subversions, not merely of the conventional understanding of the classical transcendental categories, but also of the categories themselves.

[123]The incarnation not only is prefigured in all three doctrines—as Christ entering into his *fallen* creation for the purpose of *redeeming* it from *judgment*—but also encompasses all three: the fall indicates its necessity, redemption its efficacy, and judgment its inevitability, when the incarnated and risen Christ will make all things new (1 Cor 15). At some points, O'Connor refers to the three doctrines as "sin and . . . suffering . . . and hope" (*MM*, 192), while at others she conflates the doctrinal categories of creation, redemption, and judgment, understanding that they find their ultimate unity in the incarnation, in much the same way that she conflates the moral and aesthetic and intellectual habits in the artist.

[124]*HB*, 102.

3

Artistic *Habitus*

O'Connor's Dramatic Vision

An identity is not to be found on the surface; it is not accessible to the poll-taker; it is not something that can become a cliché. It is not made from the mean average of the typical, but from the hidden and often the most extreme. It is not made from what passes, but from those qualities that endure, regardless of what passes, because they are related to truth. It lies very deep. In its entirety, it is known only to God, but of those who look for it, none gets so close as the artist.

MYSTERY AND MANNERS

The Southern writer is forced from all sides to make his gaze extend beyond the surface, beyond mere problems, until it touches that realm which is the concern of prophets and poets.

MYSTERY AND MANNERS

We cannot be enlightened by the divine rays except they be hidden within the covering of many sacred veils.

ST. THOMAS AQUINAS (QUOTING DIONYSIUS), *SUMMA* 1.1.9

In the previous chapter, the fragile line between O'Connor's moral vision (her theology and faith) and her dramatic vision (her art and imagination) was intentionally and unavoidably breached. We nonetheless focused most of our

attention on her moral vision and the ways her life and faith informed this vision. In this chapter, we turn our attention to O'Connor's artistic vision to see how her artistic approach contributes to her subversive aesthetic (and ethic). What about her particular aesthetic lent her stories their singular intensity and sacramental quality? What were the "many sacred veils" of her art that made her fiction so raw and compelling? What were the various qualities that made O'Connor's artistic expression so unique? These will be the preoccupying questions in the following pages.[1]

In the second passage from *Mystery and Manners* above, O'Connor defines the writer's aesthetic vision in a literal sense as the "gaze" that a writer (notably, a "Southern writer") is "forced from all sides" to use, again tying the way one writes to what one believes, which, in the case of the southern writer, belongs in "that realm which is the concern of prophets and poets." By naming it the realm of "prophets and poets," O'Connor is once again insisting that her moral (prophets) and dramatic (poets) visions are inseparable. And why is this a particular burden of the *southern* writer? Because the South was still a region of the world that believed in God, and not just in God but in Christ—it was "Christ-haunted."[2] In her essay "The Fiction Writer and His Country," O'Connor refers to the South as her country and says that it had everything to do with both the material forms that a writer could draw from and how the writer understood those forms:

> It suggests everything from the actual countryside that the novelist describes, on to and through the peculiar characteristics of his region and his nation, and on, through, and under all of these to his true country, which the writer with Christian convictions will consider to be what is eternal and absolute.[3]

Being from the South and being a Christian (or at least infected by that spiritual historical temperament) were, for O'Connor, as inseparable as one's dramatic and moral vision (indeed, *were* the writer's dramatic and moral vision). She moves seamlessly, in both her essays and letters, from speaking of the southern writer to speaking of the Christian writer, and she does it almost

[1] See Susan Srigley's provocative and excellent study on O'Connor's sacramentalism in *Flannery O'Connor's Sacramental Art* (Notre Dame, IN: University of Notre Dame Press, 2005). Srigley convincingly ties O'Connor's storytelling to an ethic of responsibility in the real world.

[2] *HB*, 418.

[3] *MM*, 27.

unconsciously. It is, in fact, this seamless transition from one to the next and back again that, I believe, allows her to sum up the artistic dictum for which she is famous: "The Christian writer will feel that in the greatest depth of vision, moral judgment will be implicit" and that to insist on their separation manages only to produce "a soggy, formless, and sentimental literature." But "in the greatest fiction," she continues,

> the writer's moral sense coincides with his dramatic sense, and I see no way for it to do this *unless his moral judgment is part of the very act of seeing*, and he is free to use it. I have heard it said that belief in Christian dogma is a hindrance to the writer, but I myself have found nothing further from the truth. Actually, it frees the storyteller to observe. It is not a set of rules which fixes what he sees in the world. *It affects his writing* primarily by guaranteeing his respect for mystery.[4]

O'Connor also believed that the ultimate reality of the incarnation has proximate and present significance, not just as an idea but as a mystery that "is incarnated in human life," and it was the fiction writer's concern to show this mystery. An implicit function of Christian literature (that is, literature with Christian concerns), then, is in some sense to redeem, and it is a function wrought by the event of the incarnation, by God becoming "incarnate in human form." For O'Connor, to incarnate the mystery of Christ in her stories was both a burden and a calling. It is no surprise, then, that O'Connor took Jacques Maritain at his word when he wrote,

> It would therefore be futile to try to find a technique, a style, a system of rules or a way of working which would be those of Christian art. The art which germinates and grows in Christian man can admit an infinity of them. But these forms of art will all have a family likeness, and all of them will differ substantially from non-Christian forms of art; as the flora of the mountains differs from the flora of the plains.[5]

In other words, O'Connor was doing something different from what non-Christian writers were doing, not merely from a technical or stylistic standpoint, but substantively, to the degree that her artistic *habitus* assumed a kind of divine responsibility that operated with a different set of "purposes, rules,

[4]Ibid., 30-31; emphases mine.
[5]Jacques Maritain, *Art and Scholasticism* (London: Sheed and Ward, 1943), 68.

and measures."[6] Maritain cautions against any deliberate desire "to demonstrate the propriety of Christian dogma," and he uses the example of the medieval cathedral builders, whose work "revealed the truth of God, but without doing it intentionally. . . . As they were, so they worked," Maritain concluded, which could very well serve as the emblem of O'Connor's *modus*.[7] "As she was, so she worked" also indicates the nature of her religious intentions vis-à-vis her art, which were often subconsciously realized more than deliberately employed. And yet, the nihilistic assumptions of modern culture demanded from O'Connor an intention that the cathedral builders of Europe never had to consider. Given that she assumed that the majority of her audience did not believe in the incarnation meant that one of her primary burdens as a Christian artist was to bring a dose of that incarnational reality to her audience.

Authorial Intent

The debate over O'Connor's authorial intentions is a well-trod road, and positions that suggest even a hint of evangelistic purpose on her part are roundly criticized by those who insist that O'Connor had no hidden message to bring to her readers, no covert theological axe to grind as a subtext in her fiction. She herself appears to have insisted as much:

> The novel is an art form and when you use it for anything other than art, you pervert it. I didn't make this up. I got it from St. Thomas (via Maritain) who allows that art is wholly concerned with the good of that which is made; it has no utilitarian end. If you do manage to use it successfully for social, religious, or other purposes, it is because you make it art first.[8]

What is notable in that passage is O'Connor's unwillingness to decry using fiction for social or religious ends. Her concern is that it not be *merely* or *principally* used for such purposes. A story is a work of art first. Clearly, O'Connor was not writing tracts disguised as fiction, but that she had a thoroughly Christian view of reality, which she intended to get across to her audience, is confirmed time and time again in her essays and letters.

There will always be those critics (typically from the New Critical school), however, who are not swayed by such an argument. Edward Kessler is a

[6] I am borrowing here from Shane Drefcinski. See "Excursus: Subverting the Transcendentals" later in this chapter.
[7] Maritain, *Art and Scholasticism*, 63.
[8] *HB*, 157.

representative example. In the opening pages of *Flannery O'Connor and the Language of Apocalypse*,[9] he makes explicit his intention to disregard "even O'Connor's own interpretations of her work," and he buttresses such a move with the apparent blessing of Jacques Maritain, whom he quotes from *Art and Scholasticism*:

> Any thesis, whether it profess to demonstrate or to move, is an alien importation in art and as such an impurity. It imposes upon art, in its own sphere, that is to say in the actual production of the work, an alien rule and end; it prevents the work of art issuing from the heart of the artist with the spontaneity of a perfect fruit; it betrays calculation, a dualism between the intelligence of the artist and his sensibility, which the object of art is to have united.[10]

What Kessler fails to include is the sentence just preceding the quotation (from the preferable Joseph Evans translation):

> Let us designate as thesis every intention *extrinsic to the work itself, when the thought animated by this intention does not act on the work through the artistic habitus moved instrumentally, but juxtaposes itself* to this habitus in order itself to act directly on the work. . . . In this sense, any thesis, whether it profess . . .[11]

It is clear that Maritain is *not* saying that any thesis should be rejected, but only those theses that serve at counter-purposes to the artistic *habitus*. But for O'Connor, her dogma and her art were one, so any "thesis" she might have brought to her work—and she did—was principally in the service of her art, which, it turns out, is exactly the point Maritain makes elsewhere:

> Do not make the absurd attempt to dissociate in yourself the artist and the Christian. They are one, if you *are* truly Christian, and if your art is not isolated from your soul by some system of aesthetics. But apply only the artist to the work; precisely because the artist and the Christian are one, the work will derive wholly from each of them.[12]

[9]Edward Kessler, *Flannery O'Connor and the Language of Apocalypse* (Princeton, NJ: Princeton University Press, 1986).

[10]Ibid., 6. Kessler quotes from the English edition translated by J. F. Scanlan (New York: Charles Scribner's Sons, 1962).

[11]Maritain, *Art and Scholasticism*, 64; emphases mine.

[12]Ibid., 66.

My point here is simply that an artist like O'Connor cannot be expected to create *for the sake of* the act of creation, as if such an act precludes or prevents any ethical or moral intentions. God's act of creation was purposeful, not whimsical. So too O'Connor's stories, though intended to be understood as literature, were also a vehicle for what she believed to be the truth. Indeed, what higher purpose can an artist have?

EXCURSUS: O'CONNOR'S NEW CRITICAL PEDIGREE

It is impossible to distill O'Connor's approach to a single school or theory or literary movement because, to use *The Violent Bear It Away* as an example, she did not use any particular method to write it: "With me it was not a matter of using a method but of doing it the only way that seemed possible to get it done. It was certainly a harder novel to write than the other and demanded more of me."[13] O'Connor reluctantly calls her approach to writing "Christian Realism," but even that does not ultimately answer the question of what method she favored, as her views of realism were fluid.[14] Literary nomenclature is useful in making general distinctions, but it can be unhelpful, even misleading, in attempting to characterize any one author's approach, particularly someone of O'Connor's unique social and theological background: a deeply observant Catholic woman living in the rural South; a fiercely independent woman who lived with her mother until her death at thirty-nine; a Christian writer of violent stories.

In any case, O'Connor's disavowal of any particular "method" is at least an oblique reference to her New Critical past, which she politely seeks to distance herself from, and so the urge to place or pigeonhole O'Connor into any single method or school of literary theory is unwarranted. Sarah Fodor argues that O'Connor's canonical status cannot be explained by the "posthumous laurel" she received from her fellow (and quite influential) New Critics for being that movement's "most diligent student."[15] Although Fodor admits that New

[13]*HB*, 357.

[14]"I think that every writer, when he speaks of his own approach to fiction, hopes to show that, in some crucial and deep sense, he is a realist" (*MM*, 37), and yet, a few pages later, O'Connor admits that "the realism of each novelist will depend on his view of the ultimate reaches of reality" (ibid., 40). O'Connor thus acknowledges that there is no single realist approach because there is no agreed upon single view of ultimate reality. As far as she was concerned, however, ultimate reality *necessarily* entailed a Christian vision of things.

[15]Sarah Fodor, "Marketing Flannery O'Connor: Institutional Politics and Literary Evaluation," in *Flannery O'Connor: New Perspectives*, ed. Sura Rath and Mary Neff (Atlanta: University of Georgia Press, 1996), 12-13.

Criticism did indeed influence O'Connor's writing, "the power of this institutionally dominant group" cannot sufficiently explain her status as one of America's greatest writers.[16] Fodor points out, on the contrary, that O'Connor has been important in American literary circles precisely because of debates over how to characterize her fiction.

O'Connor had the chance at many points to give New Criticism its rightful due as a chief influence on her. Not only does she not do this, but also at almost every juncture where the question of theory comes up, she eschews any connection to any particular school or method. "There is no literary orthodoxy that can be prescribed as settled for the fiction writer," she writes, and "the virtues of art, like the virtues of faith, are such that they reach beyond limitations of the intellect, beyond any mere theory that a writer may entertain."[17] Indeed, it seems that whenever she had the chance, she would poke fun at notions of theory and would warn young writers to avoid them at all costs. It wasn't a theory that drove O'Connor's literary choices so much as it was her deep commitment to the central claims of Christian orthodoxy. O'Connor casts her lot, both literarily and theologically, with the incarnation. It was the ontic frame through which O'Connor crafted her stories and into which she wove and developed her maturing dramatic vision.

In *Flannery O'Connor, Walker Percy, and the Aesthetic of Revelation*, John Sykes Jr. argues that O'Connor's method of writing, and approach to fiction in general, were reflective of her New Critical pedigree.[18] Through the creation of "an independent sphere for art" that was in reaction to radical historicism and the rise of scientism, Sykes claims that New Criticism served "a religious function" by creating room "for what might be called linguistic mystery, a sacred dimension." He goes on to suggest "that New Critics could speak of 'heresies' points to their main relevance for O'Connor," given that the word *heresy* "is a figure of speech that draws upon the capital of a religious practice."[19]

In making such religious claims for New Criticism, however, Sykes threatens to undo the movement's central presupposition, which is that each story must be judged solely on its own internal merits and can never make statements

[16]Ibid.

[17]*MM*, 49, 158.

[18]John Sykes Jr., *Flannery O'Connor, Walker Percy, and the Aesthetic of Revelation* (Columbia: University of Missouri Press, 2007), 9-13.

[19]Ibid., 11-12. Sykes appears to be doing here what he later claims the Agrarians were doing, which was yearning "to complete the spiritualization of the secular" (ibid., 13).

"whose truth and wisdom can be judged [from some outside set of imposed standards]."[20] This is a problematic position to apply to O'Connor for a host of reasons, not least of which because, as Sykes himself points out, O'Connor wished "to render the transparent scenes of divine mystery ordinarily invisible to world-weary modern eyes," thereby making the story "derivative as a mode of truth."[21] Indeed, "the Christian artist actually joins God in the work of redemption" and "the artist's role is more properly that of joining God in saving humanity—not through sacrament and proclamation, but through a special kind of making with its own restorative goodness."[22]

The intentional fallacy—the practice of basing one's interpretations on the expressed or implied intentions of the author (one of the two main "heresies" of New Criticism)—cannot thus be avoided in O'Connor's case, given that her intentions, both implied and expressed, were precisely the point of the meaning of the work for her, as she indicates in the following passage, which is but one of many examples:

> I am no disbeliever in spiritual purpose and no vague believer. I see from the standpoint of Christian orthodoxy. This means that for me the meaning of life is centered in our Redemption by Christ and what I see in the world I see in its relation to that. I don't think that this is a position that can be taken halfway or one that is particularly easy in these times to make transparent in fiction.[23]

A work's chief characteristics are precisely what the New Critic is concerned with, but those characteristics are not to be looked for from outside the story itself, in the author's intentions or anywhere else for that matter. And yet it is clearly the intention of O'Connor to communicate her religious vision and intentions *through* her work: "The novelist must be characterized not by his function but by his vision, and we must remember *that his vision has to be transmitted* and that the limitations and blind spots of his audience will very definitely affect the way he is able to *show what he sees.*"[24] And this demand to wrestle with the larger meaning in a text is not limited to the writer but functions for the reader, as well:

[20]David Richter, ed., *Falling into Theory: Conflicting Views on Reading Literature*, 2nd ed. (New York: Bedford/St. Martin's, 2000), 40.
[21]Sykes, *Aesthetic of Revelation*, 3.
[22]Ibid., 8.
[23]*MM*, 32.
[24]Ibid., 47; emphases mine.

There is something in us, as storytellers and as listeners to stories, that demands the redemptive act, that demands that what falls at least must be offered the chance to be restored. The reader of today looks for this motion, and rightly so, but what he has forgotten is the cost of it.[25]

O'Connor did not write for mere shock value. She intended her reader to be confronted, and not simply by the text, but more importantly, by the God who stood behind the text. She wanted her reader to bring their religious and existential commitments to the text and have them burned by the light of revelation: "I shall have to speak, without apology, of the Church, even when the Church is absent; of Christ, even when Christ is not recognized."[26] O'Connor's theological convictions, in other words, did not stop at the pen but flowed right through it and onto the page:

> The good novelist not only finds a symbol for feeling, he finds a symbol and a way of lodging it which tells the intelligent reader whether this feeling is adequate or inadequate, whether it is moral or immoral, whether it is good or evil. And this theology, even in its most remote reaches, will have a direct bearing on this.[27]

Could O'Connor be any more clear in her total opposition to the central tenets of the New Critical method? Indeed, O'Connor used the New Critical approach where it benefited her technique and used it to great effect, but beyond any consideration of the practical exigencies of her craft, she dispensed with its doctrinaire positions and was never, in my estimation, its true disciple.

In characterizing New Criticism's supposedly religious character, Sykes talks of its belief in "the religious nature of poetic language," that it compares literature to "a quasi-religious, ontological sanctuary," and then he references John Crowe Ransom's God *with* thunder who is "the author of evil as well as good."[28] None of this, however, resonates with O'Connor to even the slightest degree, who detested the idea of the "religious nature" of anything, railed against the "quasi-religious" in all its forms, and lamented that "we live in an unbelieving age but one which is markedly and lopsidedly spiritual."[29] And as for Ransom's unnamed god and his "orthodox version of the God of Israel," she had this to say:

[25]*MM*, 48.
[26]Ibid., 155.
[27]Ibid., 156.
[28]Sykes, *Aesthetic of Revelation*, 13.
[29]*MM*, 159.

We have to look in much of the fiction of our time for a kind of sub-religion which expresses its ultimate concern in images that have not yet broken through to show any recognition of a God who has revealed himself. As great as much of this fiction is, as much as it reveals a whole-hearted effort to find the only true ultimate concern, as much as in many cases it represents religious values of a high order, I do not believe that it can adequately represent in fiction the central religious experience. That, after all, concerns a relationship with a supreme being recognized through faith. It is the experience of an encounter, of a kind of knowledge which affects the believer's every action. . . . All my own experience has been that of the writer who believes . . . in the "God of Abraham, Isaac, and Jacob and not of the philosophers and scholars." This is an unlimited God and one who has revealed himself specifically. It is one who became man and rose from the dead. It is one who confounds the senses and sensibilities, one known early on as a stumbling block. There is no way to gloss over this specification or to make it more acceptable to modern thought. This God is the object of ultimate concern and he has a name.[30]

In Sykes's attempt to build his case for O'Connor's New Critical position, his positive statements fall short of a full declaration that she was indeed part of the New Critical movement, and they are often qualified into neutrality. For example, he writes that "New Critical assumptions influenced both O'Connor's technique and her conception of herself as a writer" and compared O'Connor to Sarah Gordon, but then a page later admits that we can see O'Connor "straining to do what seems to come naturally to Gordon," and "we can feel O'Connor itching to make the kinds of judgments the New Critical aesthetic forbids."[31] We learn later that "O'Connor would continue to labor within the terms of New Critical formalism" and that in "significant ways she would bend its rules."[32]

In *Religion and Modern Literature: Essays in Theory and Criticism*, G. B. Tennyson writes that New Criticism came to be

synonymous with the notion that a literary work was a thing unto itself, that it had no reference to matters outside itself, and that it could be understood only on its own terms. A consequence of such a view of

[30]Ibid., 160-61.
[31]Sykes, *Aesthetic of Revelation*, 17, 20, 21.
[32]Ibid., 25.

literature was a concern with the aesthetic or pleasing aspect to the virtual exclusion of the useful or instructive.[33]

This hardly explains O'Connor's approach to her writing, which, though she was deeply influenced by Jacques Maritain's notion of the artistic *habitus* and his insistence on being principally concerned only with the good of the work, nevertheless insisted that one of her main concerns in writing was to introduce a deeply Christian vision of the world to her reader, even to the point of shouting when necessary.

ARTISTIC *HABITUS* AS AESTHETIC APPROACH

O'Connor wrote to a friend that she "cut her aesthetic teeth on" Jacques Maritain's book *Art and Scholasticism*.[34] In the introduction to *The Habit of Being*, Sally Fitzgerald inserts this extended quotation from Maritain's book, which sums up his approach, and in particular, his notion of what he called the artistic *habitus* (translated here simply as "habit"):

> Operative habit resides chiefly in the mind or the will. . . . Habits are interior growths of spontaneous life . . . and only the living (that is to say, minds which alone are perfectly alive) can acquire them, because they alone are capable of raising the level of their being by their own activity: they possess, in such an enrichment of their faculties, secondary motives to action, which they bring into play when they want. . . . The object [the good of the work] in relation to which (the habit) perfects the subject is itself unchangeable—and it is upon this object that the quality developed in the subject *catches*. Such a habit is a virtue, that is to say a quality which, triumphing over the original indetermination of the intellective faculty, at once sharpening and hardening the point of its activity, raises it in respect of a definite object to a maximum of perfection, and so of operative efficiency. Art is a virtue of the practical intellect.[35]

O'Connor adopted one claim in particular as an artistic fixity—that the artist must be principally committed to the good of the work *in itself*. This meant, among other things, that literary technique was not as much an abiding

[33]G. B. Tennyson, *Religion and Modern Literature: Essays in Theory and Criticism* (Grand Rapids: Eerdmans, 1975), 14.
[34]*HB*, 216.
[35]Ibid., xvii.

concern for O'Connor as was the authenticity of her characters' experiences, not as mere vehicles to move the plot forward, but as the organic result of the decisions that they (the characters) had made from within the conceits and confines of the story itself. This is the "operative efficiency" Maritain refers to, which is perfected "in respect of a definite object," that object being "the good of the work." In other words, one's artistic *habitus* allows—even impels—one to understand what is best for the art as *art*, which, as far as Maritain was concerned, has "for [its] sole end the work itself and its beauty."[36]

The "secondary motives" to which Maritain alludes were, for O'Connor, the hand of divine providence, which she believed helped shape and guide her characters' experiences, usually unbeknownst to the characters themselves and often at their expense.[37]

O'Connor was famously uninterested in her characters' various psychological motivations, claiming in "The Grotesque and Southern Fiction," "If the novelist . . . believes that actions are predetermined by psychic make-up or the economic situation or some other determinable factor, then . . . such a writer may produce a great tragic naturalism," but it will be a tragedy shorn of any transcendent mystery. "On the other hand," she continues,

> if the writer believes that our life is and will remain essentially mysterious, if he looks upon us as beings existing in a created order to whose laws we freely respond, then what he sees on the surface will be of interest to him only as he can go through it into an experience of mystery itself. His kind of fiction will always be pushing its own limits outward toward the limits of mystery, because for this kind of writer, the meaning of a story does not begin except at a depth where adequate motivation and adequate psychology and the various determinations have been exhausted. . . . To the modern mind, this kind of character, and his creator, are typical Don Quixotes, tilting at what is not there.[38]

The fact that O'Connor equates herself with her characters by sharing the indictment of being "typical Don Quixotes" is instructive insofar as it indicates

[36]Maritain, *Art and Scholasticsm*, 42.

[37]The element of divine providence played itself out for O'Connor, I believe, on two levels: on herself as the artist crafting a story, and on a *meta*-level within the story itself, as if God were a willing participant in O'Connor's fictive creations (which I believe he was). This double narrative, of particular interest for the writer of Christian concerns and convictions, plays a crucial role in my interpretation of O'Connor.

[38]*MM*, 41-42.

a ready willingness to be identified with her characters' beliefs. O'Connor's clear convictions about the central role that mystery must play in a fiction writer's life—a mystery that stretches through and beyond the human plane—must be understood in the context of her equally passionate insistence elsewhere that fiction is "about everything human":

> One of the most common and saddest spectacles is that of a person of really fine sensibility and acute psychological perception trying to write fiction by using these qualities alone. This type of writer will put down one intensely emotional or keenly perceptive sentence after the other, and the result will be complete dullness. The fact is that the materials of the fiction writer are the humblest. Fiction is about everything human and we are made out of dust, and if you scorn getting yourself dusty, then you shouldn't try to write fiction. It's not a grand enough job for you.[39]

This willingness to get dirty is another indication of O'Connor's commitment to take seriously the "sufficiently complexity" of her characters, characters with deep and abiding commitments that ran deeper than even their unconscious.[40] One of the operative assumptions of such an approach is the active role the Holy Spirit plays in all modes of creation, so that the more one's art is aligned with the activity and purposes of the Spirit—and thus one's artistic *habitus* is in play—the more one's work will show forth an inner resonance, or what Jacques Maritain called the "radiance of form."[41] Maritain defined *habitus* as that quality of art that stands in dynamic relationship to the subject in which it exists; it is a "metaphysical title of nobility" that is acquired through exercise and use.[42] He also believed in art's transcendent quality:

[39]Ibid., 68.

[40]Christian Smith, who uses the term "sufficient complexity" to explain the irreducible nature of persons, argues that too many sociological approaches—Christian or otherwise—do not take such complexity into account and thus end up being reductive. See Smith, *Moral, Believing Animals: Human Personhood and Culture* (Oxford: Oxford University Press, 2009) and *What Is a Person? Rethinking Humanity, Social Life, and the Moral Good from the Person Up* (Chicago: University of Chicago Press, 2010). O'Connor addresses the novelist with Christian concerns as one whose "fiction will always be pushing its own limits outwards toward the limits of mystery, because for this kind of writer, the meaning of a story does not begin except at a depth where adequate motivation and adequate psychology and the various determinations have been exhausted" (*MM*, 41-42).

[41]Maritain, *Art and Scholasticism*, 48-49.

[42]Ibid., 11.

Art as such . . . transcends, like the spirit, every frontier of space or time, every historical or national boundary; it has its bounds only in the infinite amplitude of beauty. Like science, philosophy and civilization, by its very nature and object it is universal.[43]

It is a question of *habitus*, then—of the artistic disposition of the Creator. Maritain understood this artistic *habitus* in terms of artists developing certain sensibilities that made them more capable of catching the good of the work they were creating. And though the *habitus* is intent only on the work to be made, the work is never an end in itself, a fact that many of O'Connor's New Critical proponents seem to disregard. The artist must finally be concerned with something more than the work, which Maritain insisted is God, since God is to be infinitely more adored than art:

But for the man working, the work-to-be-made enters—itself—into the line of morality, and on this ground it is only a means. If the artist took the end of his art or the beauty of the work for the ultimate end of his operation and therefore for beatitude, he would be but an idolater. It is absolutely necessary therefore that the artist, qua man, work for something other than his work, for something better loved. God is infinitely more lovable than art.[44]

Which is to say that there is always more at play than merely the reader, the author, and the text.[45] The Spirit silently moves in and through the circumstances of our lives, thoughts, feelings—even our doubts—and we do well to pay attention to him all the more because of this silence. O'Connor paid attention to this movement, which is put on poignant display in her *Prayer Journal*, which shows a precocious young woman brooding, even agonizing, over spiritual matters and concerns:

Let me get away dear God from all things thus "natural." Help me to get what is more than natural into my work—help me to love & bear with my work on that account. If I have to sweat for it, dear God, let it be as in Your service. I

[43]Ibid., 77.

[44]Ibid., 147-48. Susan Srigley talks about O'Connor's commitment as an artist, not only to do good work, but also to "the good that reflects God in art" (Srigley, *Flannery O'Connor's Sacramental Art*, 3).

[45]There have been other claims as to what this "more at play" might be, ranging from the Lacanian unconscious to a person's suppressed fears of mortality. Irving Howe, in an early review of *Everything That Rises Must Converge*, acknowledges this other force in slightly more prosaic, though nonetheless compelling, ways as the action of the writer's imagination against himself (see "Flannery O'Connor's Stories," *New York Review of Books*, September 30, 1965).

would like to be intelligently holy. I am a presumptuous fool, but maybe the vague thing in me that keeps me in is hope.[46]

"O'Connor herself sought a holy life," her friend William Sessions writes, "and above all, a language that would express her own sense of holiness but in a Misfit world."[47] This wish to live a holy life, to find a language for her art that would be in service to God, was a persistent psychic and spiritual force throughout O'Connor's career. She never wrote merely to entertain. She wrote from the depths of her being, out of the suffering she encountered along the way, and within the constraints of her medium as they presented themselves to her. Such was her aesthetic approach.

To suggest that O'Connor had an aesthetic approach is, however, problematic, as she denied having any particular aesthetic to begin with: "I have no foolproof aesthetic theory."[48] It is perhaps true that O'Connor did not have a *foolproof* aesthetic theory, but she certainly had an aesthetic theory (foolproof or not) in that she approached her stories with a particular understanding of the function of art and of the Christian artist in particular. Twice in her letters she invokes the term *Christian Realism* to describe the way she writes, explaining in the first instance that her "stories are hard but they are hard because there is nothing harder or less sentimental than Christian realism," and in the second, that she adopted the term as being "necessary for me, perhaps in a purely academic way, because I find myself in a world where everybody has his compartment, puts you in yours, shuts the door and departs."[49] Her essay "The Grotesque in Southern Fiction" spells out more clearly her notion of realism vis-à-vis her approach to fiction where she connects her characters' "inner coherence" to "fictional qualities [that] lean away

[46]O'Connor, *Prayer Journal*, 18. On a certain level, if one is concerned for the good of the work and one also fears the Lord, as Maritain insisted a Christian artist must (and as O'Connor was and did), the work will in some sense speak for itself. But this means that the artist must allow the work to speak, which, for O'Connor's reading audience, meant that they must accept that the stories may take them places they will not want to go.

[47]William Sessions, "Real Presence," in *Inside the Church of Flannery O'Connor: Sacrament, Sacramental, and the Sacred in Her Fiction*, ed. Joanne Halleran McMullen and Jon Parish Peede (Macon, GA: Mercer University Press, 2007), 25.

[48]*HB*, 123.

[49]*HB*, 90, 92. If we understand O'Connor's use of the term *Christian Realism* in the same way that Reinhold Niebuhr uses it to describe a philosophical perspective that challenged the idealistic anthropology of the Social Gospel movement, as in his *Christian Realism and Political Problems* (New York City: Charles Scribner's Sons, 1953), then its connection to her aesthetics makes no sense.

from typical social patterns, toward mystery and the unexpected. It is *this kind of realism* that I want to consider."[50] O'Connor's commitment to this *kind of realism*—what I understand to be a sacramental realism—often took opposing forms in her fiction, making it "hard" and "less sentimental" but, as a result, also more open to—and dependent on—God's merciful intervention.

It also meant that her approach to her task as a writer of Christian concerns accepted the responsibility of distortion as a means of getting this type of realism across. It is a realism, she insisted, that "does not hesitate to distort appearances in order to show a hidden truth."[51] The *way* such a realism distorts appearances invites a closer examination of O'Connor's subversive aesthetic.

A Taxonomy of Diversion (in Art and Literature)

This impulse to distort in order to show a truth had its most profound effect, I believe, on O'Connor's treatment of the transcendentals, understood historically and within the Christian tradition as the divine attributes of beauty, goodness, and truth. O'Connor, of course, did not invent such subversions. She was, in many respects, merely recovering a biblical tradition.[52] In Scripture, divine violence is often a subversive means of redemption, as when Adam and Eve are banished from paradise for their own sake. Abraham's sacrifice of Isaac, or Jacob's wrestling match with God at the shores of Peniel, where he is left a cripple, are examples of God's subversive goodness.[53] The subversive nature

[50]*MM*, 40; italics mine.

[51]Ibid., 179.

[52]Jordan Cofer's book *The Gospel According to Flannery O'Connor* (New York: Bloomsbury Academic, 2014), argues for such a biblical recovery in O'Connor's work: "I intend to show how O'Connor's fiction was influenced by the Bible itself" (5). Similar to my own approach in this study, Cofer contends that "we can appreciate her incarnational writing—her theological explorations that are grounded in specific, complex, tormented people in unusual situations—by looking at the ways in which these explorations are predicated on specific biblical texts, which she subverts, in order to shock and teach her readers" (10). One liability to Cofer's approach is its tendency at times to reduce O'Connor's characters to biblical types or archetypes as the one-stop shop to explain motive or intent. It is possible to over-determine any master narrative, including the Bible (or von Hügel!) as a way to explain or understand O'Connor's stories, which then runs the risk of turning allusions into allegories. As Cofer rightly suggests, quoting Fredric Jameson, "Interpretation is not isolated act, but takes place within a Homeric battlefield, on which a host of interpretive options are either openly or implicitly in conflict" (1). The tendency, nevertheless, to allegorize O'Connor's fiction is a mainstay in O'Connor criticism. Jill Baumgaertner notes how "many critics have heard an allegoric and emblematic resonance in *The Violent Bear It Away*" and then names three prominent examples: Martha Stephens, Robert Coles, and M. Bruce Gentry. Jill P. Baumgaertner, *Flannery O'Connor: A Proper Scaring* (Chicago: Cornerstone, 1988), 181.

[53]Not all violence in Scripture is, of course, redemptive. Some of it seems—indeed *is*—retributive (an eye for an eye, for example). But the retributive justice in Scripture is, I suspect, more the product of Israel's

of beauty, Isaiah reminds us, comes in the form of the suffering servant, while Paul declares that the foolishness of the gospel is meant to subvert all human pretensions to wisdom. In this way, the classical transcendentals were brought down to earth and radically subverted by the biblical writers, to whom was revealed a new vision of what a life consisting of the good, true, and beautiful actually looks like. The classic text for such a subversion, alluded to above, is 1 Corinthians 1:25-28, where Paul writes,

> God's foolishness is wiser than human wisdom, and God's weakness is stronger than human strength. Consider your own call, brothers and sisters; not many of you were wise by human standards, not many were powerful, not many were of noble birth. But God chose what is foolish in the world to shame the wise; God chose what is weak in the world to shame the strong; God chose what is low and despised in the world, things that are not, to reduce to nothing the things that are.

What is foolishness to the world is precisely the wisdom of God that saves. At the very least, O'Connor understood this to mean that a divinely ordered life would not look like what we have come to expect, which meant that her characters, if they were to be true to life *as it actually is*, would have to look different than what we had come to expect of life—and ourselves.

EXCURSUS: SUBVERTING THE TRANSCENDENTALS

O'Connor's subversion of the transcendentals is a recovery of biblical subversion in a way distinct from Augustine and Aquinas. Augustine hints at a moderated subversion of the classical categories of beauty, goodness, and truth in his notion of "taking the spoils of the Egyptians," but nowhere does he claim that divine goodness, for example, can be violent or that divine truth can appear as foolish in a fallen world. He no doubt believed as much, but Augustine's understanding of the classic transcendentals do not mirror O'Connor's use of them.[54] Fr. John Hardon points out how Aquinas argues that the theological virtue of faith sublimates reason as the final arbiter of what ought to be considered virtuous:

wish fulfillment than an accurate description of God's vengeful ways, as the words of Jesus in the Gospels seem to imply: "You have heard it said of old . . . , but I say to you . . ." is a rhetorical device intended to show Jesus' priority over Scripture, not his priority over God (that is to say, himself).

[54]Augustine, *Confessions*, 2nd ed. (Indianapolis: Hackett Publishing Company, 2006), 128.

Just as prior to faith there are acquired virtues commensurate with reason to assist the natural mind and will in the performance of morally good acts, so with the advent of faith there should be corresponding supernatural virtues commensurate with the light of faith to assist the elevated human faculties in the performance of supernaturally good actions in the moral order. . . . With reason enlightened by faith, the scope of the virtuous operation is extended to immeasurably wider horizons. By the same token, faith furnishes motives of which reason would never conceive, and theological charity offers inspiration that surpasses anything found in nature.[55]

Aquinas puts it more succinctly: "Until through the certitude of the Divine Vision the necessity of such connection be shown, the will does not adhere to God of necessity, *nor to those things which are of God.*"[56] In other words, until such time or in such measure as God reveals to us the true measure of things, we cannot see or understand his divine attributes (goodness, truth, or beauty) as they truly are (*simpliciter*).

Shane Drefcinski highlights the distinctions between the acquired and infused moral virtues in Aquinas with regard to their respective ends (incomplete happiness vs. perfect happiness) as well as their respective rules and measures:

Concerning their respective rules and measures, the acquired moral virtues have as their rule and measure human reason, whereas the infused moral virtues have as their rule and measure Divine Law. Aquinas used the example of temperance to illustrate this difference. In the acquired virtue of temperance human reason dictates that the enjoyment of eating and drinking is proper so long as it does not harm the body or hinder the mind. In the infused virtue of temperance, on the other hand, Divine Law dictates that humans should "chastise their bodies and bring them into subjection" (I Cor. 9:27) by fasting and abstinence.[57]

[55]John Hardon, "The Meaning of Virtue in St. Thomas Aquinas," *Great Catholic Books Newsletter* 2, no. 1, www.ewtn.com/library/SPIRIT/MEANVIR.TXT.

[56]Thomas Aquinas, *Summa Theologiae*, trans. Fathers of the English Dominican Province (New York: Benziger Bros., 1947), Ia, 82.2; emphasis mine.

[57]Shane Drefcinski, "A Very Short Primer on St. Thomas Aquinas' Account of the Various Virtues" (paper presented at the Southwest Wisconsin Medieval and Renaissance Conference, Platteville, WI, September 22, 1999).

One might reasonably deduce from this that Aquinas believes that the infused moral virtues could actually subvert the acquired virtues insofar as rules and measures are concerned (and perhaps even ends), but Aquinas never states as much. The best that can be surmised of Aquinas's view of the infused moral virtues is that they are a way of seeing or perceiving things that is divinely ordered but not explicitly subversive. Alice Ramos agrees:

> I'm not sure that I would put it in terms of a "subversion" of the transcendentals. . . . I think it has to do with a way of seeing or perceiving things. . . . However, it is the case that a person with unruly passions and hence without having cultivated moral virtue will see differently than a virtuous man; for example, someone in a fit of anger may "see" murder as good, while if he were reasoning correctly and if his passions were informed by virtue he would see murder as evil. A temperate person will see sobriety as a good, whereas an intemperate person will not see this as a good. The wisdom of the cross makes us see things from a higher perspective such that poverty, for example, would be seen as a great good and as beautiful in the light of Christ, or the example in my book about Christ, the Suffering Servant, whose face had no external beauty and yet according to Aquinas a certain beauty shone from Christ's face—perhaps one might say the beauty of the virtue of obedience—unto death on a cross.[58]

In a letter to Ben Griffith in 1955, O'Connor writes that she is "interested in making up a good case for distortion, as I am coming to believe it is the only way to make people see."[59] In another letter a few months later, this time to Betty Hester, she writes that she is working on an essay with the provisional title "The Freak in Modern Fiction," in which she wants to justify the use of distortion in fiction. In what likely is a later version of that same essay, now titled "Novelist and Believer," O'Connor does just that, this time making an oblique reference to *The Violent Bear It Away*:

> When I write a novel in which the central action is a baptism, I am very well aware that for a majority of my readers, baptism is a meaningless rite, and so in

[58]From private correspondence. See Alice Ramos, *Dynamic Transcendentals: Truth, Goodness, and Beauty from a Thomistic Perspective* (Washington, DC: Catholic University of America Press, 2012).
[59]*HB*, 79.

my novel I have to see that this baptism carries enough awe and mystery to jar
the reader into some kind of emotional recognition of its significance. To this
end I have to bend the whole novel—its language, its structure, its action. I have
to make the reader feel, in his bones if nowhere else, that something is going on
here that counts. Distortion in this case is an instrument; exaggeration has a
purpose, and the whole structure of the story or novel has been made what it
is because of belief. This is not the kind of distortion that destroys; it is the kind
that reveals, or should reveal.[60]

Besides all but admitting that she has a clear prophetic intention in the for-
mation of her novel, O'Connor reveals that the baptism/death of Bishop in
The Violent Bear It Away also serves a didactic purpose, which is to show,
among other things, the significance of baptism, and its distortion in the
hands of young Tarwater is used as a means to get a deeper truth across. It is,
as she calls it, an "instrument" with a "purpose," and far from detracting from
the novel's artistic integrity, it adds to it by giving the story's central action an
anagogical referent. In O'Connor's biblically saturated and distorted vision,
the urbane sophistication of a college professor would now be upstaged by the
foolishness of a backwoods hillbilly prophet (*The Violent Bear It Away*), in the
same way that in her short story "The Temple of the Holy Ghost" the beauty
of a hermaphrodite would subvert the Clairol-induced prettiness of a couple
of teenaged girls.[61] In a significant way, O'Connor's radical subversions were
merely recovering the equally radical subversions of Scripture.

But what exactly do I mean by the word *subversion* as it relates to
O'Connor's method of writing fiction? I want to suggest four levels at which
human attention is "caught up" by art, each an intensification of the last,
with the final level representing a qualitative, rather than quantitative, step
in intensification (Maritain's quotation above hints at this qualitative step
in intensification with his reference to mountains and plains). This particular
set of terms is not meant to be definitive but only suggestive of the ways that
art can function vis-a-vis human attention, the term *art* understood to

[60]*MM*, 162. Jesus uses similar tactics in his parables, and it has been noted by several scholars that O'Connor's
stories have a parabolic cast to them. See, for example, John May, "The Parables of Flannery O'Connor,"
in *Literary Theories in Practice*, ed. Shirley Staton (Philadelphia: University of Pennsylvania Press, 1987).

[61]Such a thesis, whether played out in Scripture or in O'Connor's stories, is offensive to the modern con-
sciousness, and O'Connor's stories served as her creative commentary on the gospel and its offensive
message.

include the more popular and commercial aspects of music, literature, visual media, as well as the fine arts more broadly considered.

Table 1 provides working definitions for each level along with examples of art in each category, examples of which, in some cases, move from one level to the next depending on their context and perceived quality.

Table 1. Four levels of the function of art on human attention

	Definition	Examples
Diversion/Distraction	introduces outside stimuli; is more often absorbed than reacted to; often innocuous, sometimes irritating; pervasive	highway signs; advertising banners; brand logos; urban murals; background music from electronic devices
Interruption	demands an immediate reaction more than measured response; is a ubiquitous and accessible given its nondisruptive nature; often banal or kitschy; often associated with commercial industries	most forms of commercials and advertisements; urban murals; social anthems; most popular music, film, television, and literature, including Internet media (YouTube, Pinterest)
Disruption	signals a departure from the norm or normal course of day-to-day living, which demands a deliberate response; is usually of higher quality and is associated with a known artist or movement	much "fine art," including paintings, sculpture, literature, music, film, television, drama; urban art, and poetry; some landscape design and architecture
Subversion	contravenes cultural assumptions; uses distortion as a way to create new patterns and modes of reception; always initially resisted; often establishes or codifies new genres; is an implicit critique of the status quo	canonical* art, music, film, literature, and so on; work usually (though not always) associated with a master craftsman, artist, musician, or writer

*By *canonical* I mean only to suggest art that has transcended the conventional bounds of any particular culture or period in history, has stood the test of time (relatively speaking), and has influenced its genre in significant ways. It is part of the artistic canon, inclusively considered. Assessments such at this one are, of course, rarely definitive and unavoidably subjective. It should also be noted, as far as these levels are concerned, that the function of any particular form of art is determined to some extent by the intention and quality of reception by the viewer.

Art's multivalent forms and functions—as imitation (Plato), ideal (Hegel), significant form (Bell), truth (Heidegger), or text (Barthes), to name a few of

the ways it has been conceptualized over the course of its long history—can be fitted into the schema above rather easily, if one takes into account the relative degrees to which it functions as any one of those things (imitation, ideal, form, etc.).[62] There are interruptive imitations just as there are disruptive ideals. Not all art, that is to say, regardless of its form or function, is created equal, as David Hume famously noted:

> Whoever would assert an equality of genius and elegance between OGILBY and MILTON, or BUNYAN and ADDISON, would be thought to defend no less an extravagance, than if he had maintained a mole-hill to be as high as a TENERIFFE, or a pond as extensive as the ocean.[63]

Claiming that O'Connor's particular art form was subversive, then, is to say much. I am suggesting that her work is notable in its subversive effect as literature, that it has already influenced multiple genres (the short story as well as Christian fiction in general), and that it will stand the test of time.[64] One can point to other artists whose subversive creativity, rather than being found in a single work, was coextensive with their total output: Shakespeare, Bach, Picasso, Chesterton. O'Connor represents such a subversive approach in all of her writing. Her thematic blending of deeply religious elements with violence and grotesquery, the startling figuration of her prose, the second-naiveté theological sophistication of her backwoods protagonists, all conspire to create a unique voice in American fiction, perhaps in all of fiction. O'Connor's was clearly a voice not representative of what passed for Christian fiction of her day, and it was certainly not anything like what the Catholic world was writing and publishing. It was a voice, for lack of a better word, that was prophetic, both literarily and theologically.

[62]See Thomas Wartenberg, ed., *The Nature of Art: An Anthology*, 2nd ed. (Belmont, CA: Thomson/Wadsworth, 2007), which systematically puts the historical permutations of art's varying purposes into an easily digestible format.

[63]"Art as Object of Taste: David Hume," in ibid., 42.

[64]One can point to other movements or moments in the history of art where such subversions took place: when Giotto's *Life of the Virgin* and *Life of Christ* fresco cycle was unveiled on March 25, 1305, in the Scrovegni Chapel in Padua, introducing a realist style of painting that, for all practical intents and purposes, ushered in the Renaissance; when an unsuspecting Spanish noble picked up a copy of Cervantes's *Don Quixote* the day it was first published on January 16, 1605, and found himself reading the first modern novel; or the inaugural performance of George Gershwin's *Rhapsody in Blue* at the Aeolian Hall in New York City on February 12, 1924, which announced a new and radical convergence of jazz, pop, and classical music to a stunned audience and bewildered critics. In most cases, the significance of such subversions are not recognized by their contemporary audiences and only find notoriety in future generations.

O'CONNOR'S PROPHETIC VOICE

O'Connor often spoke of the Christian writer as a prophet, understanding a prophet to be a "realist of distances," which meant "seeing near things with their extensions of meaning and thus of seeing far things close up."[65] She found a theological imprimatur for such an audacious claim in Aquinas, who "says that prophetic vision is a quality of the imagination [and] that it does not have anything to do with the moral life of the prophet."[66] Such a prophetic vision, which manifested itself in what I am calling O'Connor's prophetic voice, is distinct in some crucial ways from O'Connor's moral and dramatic visions, which she insisted were inseparable. To begin with, as O'Connor herself indicates in the quotation above, a prophet's vision is not dependent on his or her moral rectitude. Francis Tarwater is a clear illustration of this. He was not called to be a prophet because he was worthy. He was called, in some sense, precisely because he was not. To be called to be a prophet was, from O'Connor's perspective (and Old Mason Tarwater's in *The Violent Bear It Away*), a kind of spiritual demotion, which is a paradox that finds purchase in von Hügel's writing, which, in turn, informed and inspired O'Connor's theological categories. John Desmond writes, "But the way of Christ, as Schillebeeckx and von Hugel suggest, is the 'downward,' incarnating movement into full humanity, which inevitably involves suffering as a whole person. O'Connor reveals this in the fact that Tarwater's destiny as prophet is not grandiose but modest."[67]

O'Connor uses a prophetic voice to give substance to her dramatic vision. In making such a claim, I want to distinguish between what Frederick Asals and others have called O'Connor's prophetic "imagination" (and what others have termed her prophetic vision or prophetic consciousness) with her prophetic "voice." A prophetic voice, as distinguished from a prophetic vision, consciousness, or imagination, is a deliberate move on the part of the writer

[65]*MM*, 44. Cofer delineates three characteristics of biblical prophets: they are "marginalized from society," they are "reluctant to carry the message," and the message they bring is "both destructive and regenerative" (Cofer, *Gospel According to Flannery O'Connor*, 79-80). I would add to Cofer's list three additional characteristics of O'Connor prophets: they are bizarre, violent, and foolish, which serve as alternatives to their conventional counterparts: good looking, well behaved, and well informed, respectively. See also Srigley, *Flannery O'Connor's Sacramental Art*, especially her discussion of the Thomistic notions of prophecy in chapter one.

[66]*HB*, 365.

[67]John Desmond, "Flannery O'Connor and the Displaced Sacrament," in McMullen and Peede, *Inside the Church of Flannery O'Connor*, 70.

to adopt a certain tonal quality for the narrator; it is a more conscious choice to convey and establish a dominant but subtle point of view—perhaps more accurately, a perspective—in the story. A story told in the prophetic voice is one told with didactic—indeed, prophetic—intention for the purpose of uncovering a truth that pronounces judgment on the readers as well as the characters. It is, in this sense, a literary device not dissimilar from a soliloquy, which is dialogue intended, not for the other players on the stage to respond to, but for the audience to hear and interact with. O'Connor's fiction has a similar effect, and she makes clear that such a "double narrative" is operative in her stories as, for example, when she suggests (as she does numerous times) that she has more than just a story to tell: she has a message to deliver, even if she has to shout to do it. And yet, she offers up this double narrative—she shouts—while managing to avoid a heavy didacticism. This is a large part of the peculiar quality of O'Connor's *art*, that she can deliver such a stringent message while remaining a peerless storyteller and artist. It was an extension of the habit of her being.

In *The Prophetic Imagination*, Walter Brueggemann sets out to establish the contours of biblical prophecy by suggesting that it is a matter of the imagination, whose task it is "to nurture, nourish, and evoke a consciousness and perception alternative to that of the dominant culture."[68] O'Connor shares in this task by imposing on her reader, through the medium of her fiction, an alternative vision of things. Brueggemann puts the emphasis on the prophetic *text*, which he claims are "acts of imagination that offer and purpose 'alternative worlds' that exist because of and in the act of utterance."[69] Is this not, in fact, the *modus* of the fictional writer, to offer up alternative worlds *because of and in the act of utterance*? And in making such an offering, O'Connor's writing becomes subversive; that is to say, it is subversive *because* it is prophetic, and not the other way around. If she were merely out to subvert for the sake of subversion, it would be a contrived subversion at best, if indeed there is such a thing—more than likely, her fiction would merely be a creative interruption, or a disruption at best. But because O'Connor understands the task of the Christian writer to be prophetic, her stories end up being subversive in the fullest sense, which gives her stories their weight.

[68]Walter Brueggemann, *The Prophetic Imagination*, 2nd ed. (Minneapolis: Fortress, 2001), 3.
[69]Ibid., x.

Brueggemann contends that the current (since the 1960s) more confrontational model that some of the more conservative churches use "assumes that the 'prophetic voice' has enough clout . . . to gain a hearing," but such churches, he adds, "lack much of that authority, so that the old confrontational approach is largely ineffectual posturing."[70] O'Connor felt this posturing with particular piquancy, and so her characters become a surrogate voice that allowed her to preach, teach, and shout from a literary remove—to tell the truth slant, as it were (to borrow a phrase from Emily Dickinson).

There are five types of narrative voices commonly recognized: objective/dramatic, framed, omniscient, limited omniscient, and first person. I am suggesting that O'Connor uses a sixth in her fiction, the prophetic voice, which is highly subjective but with a corresponding degree of omniscience. Insisting on such a paradoxical definition gets to the heart of the nature of biblical prophecy: the message of the prophet often goes unheeded, but it is reliable all the same. It is as if two versions of reality are contending in the same space. Asals, quoting Abraham Heschel, suggests that the prophetic mind engages in what I have termed a "double narrative": "This world, no mere shadow of ideas in an upper sphere, is real, but not absolute; the world's reality is contingent upon compatibility with God."[71] Both O'Connor and her characters deal with the fallout of such a double narrative—a double reality—and see in the disconnect between both a seemingly irreconcilable dilemma. This is why, as Asals suggests, "suffering is central to the prophetic consciousness."[72] Asals goes on, "For O'Connor's sacramentalism, it is the natural world that becomes the vehicle for the supernatural, and her characters' literal return to their senses becomes the means of opening their imaginations to receive it."[73]

O'Connor's fiction is her pulpit, and it is from such a place that she weaves a tapestry of visions "designed to shock rather than edify,"[74] but which nonetheless shock for all the right reasons. This, I submit, is the sacramental element—the dramatic vision—of her prophetic voice. O'Connor's stories never shock for shock value. They shock because they are true, good, and beautiful. As Brueggemann rightly intuits about O'Connor, the prophetic

[70]Ibid., xii.
[71]As quoted in ibid., xv.
[72]Ibid.
[73]Ibid.
[74]Ibid.

utterances and actions in her stories "turn out to be absurd, but it is an absurdity that may be the very truth of obedient imagination."[75]

In the last pages of another of his books, *Truth Speaks to Power*, Brueggemann quotes Kavin Rowe, who frames the witness of the church in Acts as being

> something more comprehensive or "thicker" than the sense we get from simple everyday occurrences of the word "true," namely, the truth of a habit of being, a kind of true total way of life whose pattern can be falsified by living in a fundamentally different way. We may call this the practical contour of the shape of truth.[76]

As O'Connor employed the prophetic voice in shaping her dramatic vision, she was not merely utilizing a literary technique. She was, as I have been insisting all along, speaking out of the depths of her being. "As she was, so she worked," which means, above all else, that O'Connor's subversive approach to the transcendentals of beauty, goodness, and truth wasn't merely an artistic eccentricity or exercise in paradox that she introduced into her stories in order to be clever. She was making a profoundly theological and prophetic claim in offering up such bracing realities. About her grotesque characters, she writes, "They seem to carry an invisible burden; their fanaticism is a reproach, not merely an eccentricity."[77] The same could be said of O'Connor, whose fourteen-year struggle with a disease that would eventually kill her at thirty-nine (with all the attendant indignities)—a disease that all but limited her to her farm in rural Georgia—introduced not only the obvious visible burdens but a thousand invisible ones besides: the constant presence of an overbearing mother whom she both loved and resented; the festering pangs of unrequited love; the provincial thinking she often encountered around her. All of these things conspired together to make O'Connor as much of a grotesque figure as any one of her fictionalized characters. Coupled with religious commitments that many of her critics considered "severe" (a fact not helped by her creative impulse to express those commitments in such violent ways), O'Connor was often dismissed for her "eccentricities" when, all the while, they were intended

[75]Ibid.

[76]Walter Brueggemann, *Truth Speaks to Power: The Countercultural Nature of Scripture* (Louisville: Westminster John Knox, 2013), 163.

[77]*MM*, 44. This invisible burden, Frederick Buechner has suggested, is their holiness. See his *Wishful Thinking: A Theological ABC* (San Francisco: HarperSanFrancisco, 1993), on "Ugliness," 144.

as a reproach to much of modern life. This way of being and of seeing things, which she called "prophetic," was foundational not only for how she wrote but also for who she was.[78]

EXCURSUS: O'CONNOR'S GROTESQUES—
AN ALTERNATIVE READING TO
DI RENZO'S *AMERICAN GARGOYLES*

The epigraph of the opening chapter of Anthony Di Renzo's study of O'Connor's use of the grotesque is a quotation from Bishop Hurd: "If you judge Gothic by Grecian rules, you will find nothing but deformity, but when you examine it by its own, the results are quite different."[79] From the outset, then, it seems that Di Renzo understands deformity pejoratively (admittedly, most people do). What also becomes clear as one reads further is that Di Renzo, in assuming that O'Connor shares his sentiments about deformity, builds an elaborate argument in his attempt to rescue O'Connor from the term. In reference to Bernard of Clairvaux's exasperation at the gargoyles of his monastery's cloister, for example, Di Renzo concludes, "These freaks and chimeras violate the carefully defined aesthetic and theological norms of medieval Scholasticism."[80] I'm not so sure. They may violate Bernard's more fragile aesthetic tastes, but the gargoyles actually *reflected* the medieval Scholastic aesthetic and theology. One can surmise that this is likely why they were built in the first place.

Stanley Grenz's *Theology for the Community of God* discusses the interest medieval theologians had in angels and the demonic, as evidenced in the great Gothic cathedrals and their attendant gargoyles.[81] Michael Camille, in his *The Gargoyles of Notre Dame*, quotes Jules Michelet, perhaps the most well-regarded French historian of the nineteenth century, that Notre Dame, with all of its gargoyles and imposing architecture, was "Scholasticism in stone" and that "gargoyles were embodiments of [Scholastic] thought."[82] In other words,

[78]James Parker calls it O'Connor's "catastrophic moral context"; "The Passion of Flannery O'Connor," *The Atlantic*, November 2013, 38.

[79]Anthony Di Renzo, *American Gargoyles: Flannery O'Connor and the Medieval Grotesque* (Carbondale: Southern Illinois University Press, 1993), 10; quoting from Hurd's *Letters of Chivalry and Romance*.

[80]Di Renzo, *American Gargoyles*, 2.

[81]Stanley Grenz, *Theology for the Community of God* (Grand Rapids: Eerdmans, 2000), 214-15.

[82]Michael Camille, *The Gargoyles of Notre Dame: Medievalism and the Monsters of Modernity* (Chicago: University of Chicago Press, 2009), 97.

gargoyles were actually the expression, not repudiation, of medieval Scholastic theology and its preoccupation with the demonic.

Di Renzo builds his case from his misperception of the metaphorical function of gargoyles, however, to suggest that O'Connor uses the grotesque to embody our own repressed attraction to evil and the demonic. O'Connor's grotesques, Di Renzo seems to imply, serve the same function as their medieval counterparts: they provide "drainage" for our spiritual and moral sewage. Di Renzo goes on to insist that O'Connor uses the grotesque for redemptive ends by suggesting, rightly, that O'Connor's grotesques are "subversive works of art that undermine reductive orthodoxies," but which orthodoxies precisely they undermine lies at the heart of my disagreement with him.[83] He argues that O'Connor's grotesques are "transgressive" in the sense that they "assert their faith in a post-Christian South," thus acting as a sort of therapeutic or cathartic release from that region's demons. Di Renzo thus too easily adopts a predictable antidogmatism, even in his defense of O'Connor's ultimately religious aims. He acknowledges that the reductive orthodoxy she is critiquing is the twentieth century's version of secular humanism, but he ends up adopting a one-size-fits-all characterization of O'Connor's understanding of faith, and in doing so actually goes too far in his defense of her. O'Connor did not intend for her grotesques to be therapeutic but to be disruptive—indeed subversive—and to subvert her readers *into*, not out of, a dogmatic orthodoxy.

Not surprisingly, Di Renzo quotes Mason Tarwater in the only place in the *The Violent Bear It Away* where he extols the benefits of freedom—a freedom from "the mechanical, do-gooder regimen of the school-teacher, Rayber."[84] What Di Renzo fails to mention is that in O'Connor's theological universe, we are never simply freed *from* but are also simultaneously freed *for*. Tarwater makes abundantly clear to his grandnephew, Francis, that the boy has been freed for servitude to God and, more specifically, to the calling to be one of God's prophets and therefore to suffer the ignominious end that comes with such a calling.

In somewhat ironic fashion, Di Renzo quotes O'Connor (who, in turn, is quoting von Hügel) where she casts aspersion on those who want to "tidy up reality" for the sake of religious propriety and convenience.[85] Di Renzo

[83]Di Renzo, *American Gargoyles*, 4.
[84]Ibid., 6.
[85]Ibid.; see also *Letters*, 288.

interprets this as O'Connor's love of freedom (presumably from religious constraints), but O'Connor makes this point precisely in her defense of dogma, which is "about the only thing left in the world that surely guards and respects mystery."[86] O'Connor's notion of freedom, in other words, is one that accepts the frame—the constraints—of religious dogma. Di Renzo, on the other hand, understands freedom as embracing the "imprecise," as residing in the "mismatched," as that which "offers no resolutions" and instead "aims for 'a regenerating ambivalence.'"[87] To be sure, O'Connor understands the grotesque as an embodiment of seemingly irreconcilable opposites (terrible beauty, violent goodness, foolish truth), but Di Renzo takes it a step further in suggesting that this irreconcilability is a permanent fixture in the text, and in life, to the point that "everything becomes a riotous mishmash."[88]

Not so for O'Connor, for whom the irreconcilability is only temporary and is meant to shock the hard of hearing and the almost blind *into* obedience. For those who have eyes to see, this tension of opposites creates a mysterious whole that bespeaks order, divine symmetry, and finally, sacrament. It is instructive to note that the word *sacrament* is entirely absent from Di Renzo's study. For him, the grotesque descent into the material ends finally in hell, as it apparently does (according to Di Renzo) for Mrs. Chestny in "Everything That Rises Must Converge," whose death "is a kind of damnation."[89] It makes sense that Di Renzo believes this, of course, given his study's premise that O'Connor's characters are "the modern equivalent of monsters and marginalia, griffins and grotesques."[90] The one "marginalia" Di Renzo does not account for, however—the grotesques he fails to mention—are the ones O'Connor creates that are fashioned from "the least of these" from Scripture, who are the naked and imprisoned, the hungry and destitute with whom Christ identifies in toto: "Just as you did it to one of the least of these who are members of my family, you did it to me" (Mt 25:40). These grotesques—the Mason Tarwaters and Bishops and, yes, even the Mrs. Chestnys of the world—are no gargoyles or griffins. They are the ones who embody, to greater and lesser degrees, the crucified Grotesque, on whom all of O'Connor's lesser grotesques are based.

[86]*MM*, 178.
[87]Di Renzo, *American Gargoyles*, 7, 8.
[88]Ibid., 10.
[89]Ibid., 14.
[90]Ibid., 15.

Di Renzo argues in his second chapter that Christ is, in fact, the representative or archetypal grotesque for O'Connor, but he understands this representation as being one of satire, where the representation must be desecrated before it can be re-incarnated, and once reincarnated, desecrated once more in what turns out to be an endless Derridaean loop of tragic-comic absurdity: "Christ, the ideal, must be continually crucified so that he can continually rise in the human condition."[91] In Di Renzo's rendering of O'Connor's fictive universe, her characters are not fools *for* Christ, they are "fools because of him," and it is this "incompatibility between Christ and O'Connor's grotesques" that give her stories their satirical bite.[92]

I want to suggest, alternatively, that O'Connor adopts a theology of the grotesque in her fiction, but in order to do this, I need to specify what I am *not* saying in making such a claim:

1. that the term *grotesque* refers only to a character's physical traits;

2. that the term *grotesque* is a pejorative one in O'Connor's theological lexicon; or

3. that O'Connor adopts any formal definition of the grotesque as a theological category.

When I use the term *grotesque* to characterize O'Connor's theological aesthetic in her fiction, I mean to say that O'Connor uses it as a theo-literary device intended to shock the reader into a subverted vision of the good, the true, the beautiful. O'Connor understands the subversive nature of the gospel, and she uses her fiction as a means by which to render it in all of its artistic possibilities. It is by use of the grotesque, in fact, that she "shouts" and "draws large and startling figures." Furthermore, I want to claim that she uses distortion as a literary tool to "grotesque-ify" her stories and her characters, as it were, and she does so by depicting her grotesquerie through the agencies of a terrible beauty, violent goodness, and foolish truth. By suggesting such a move—that the grotesque as an aesthetic designation is caught up in the manifestations of the other two transcendentals—O'Connor is merely following Maritain's lead, who bases his interpretation of beauty on Aquinas, and in particular on Aquinas's *Commentary on the Divine Names*, when he defines beauty as "the splendor of all the transcendentals together."[93]

[91]Ibid., 20.
[92]Ibid.
[93]Umberto Eco, *The Aesthetics of Thomas Aquinas* (Cambridge, MA: Harvard University Press, 1988), 39. Aquinas also speculates on the shared aspects of beauty and the good, namely, *claritas* and *consonantia*,

In O'Connor's fiction, we see the eschatological nature of reality, and within that reality the manifestations of the grotesque beauty, violent goodness, and foolish truth of God.[94] From this intersection of subverted transcendentals, O'Connor rebukes but does not pass final judgment on her characters, violates but does not diminish their personhood, and critiques—sometimes even satirizes—but never belittles their sense of truth. The sacramental nature of divine reality is caught up in all of this. This is the divine ordering of things. In all of O'Connor's violence and holy terror, in her backcountry fools and the parlor of her grotesques, an eschatological mystery lurks just beneath the surface; it is present in all of her stories, really, and it hints at "a surpassing peace."[95]

which are both "effects of the Good which creates orders," and though they "differ conceptually (*ratione*)," they are both "included in the nature of the good" (ibid., 31).

[94]Rene Girard's seminal study, *Violence and the Sacred* (Baltimore: Johns Hopkins University Press, 1979), essentially seeks to explain the presence of violence through the social mechanism of scapegoating. O'Connor's use of violence, it seems to me, comes from the opposite end by removing the function of the scapegoat and insisting on the necessity of divine violence in the process of each person's redemption.

[95]Walter Elder, "That Region," as quoted in *The Critical Response to Flannery O'Connor*, ed. Douglas Robillard (Westport, CT: Greenwood, 2004), 26.

4

The Subverted Transcendentals in Selected Short Stories

And again, this Supernaturalness does not concern Goodness alone, but also Truth and Beauty. God is the Fountain and the Fullness, the Origin and End, the ultimate Measure of every kind and degree, as much of Beauty and of Truth as of Goodness.

FRIEDRICH VON HÜGEL, *ESSAYS*

Truth, Goodness and Beauty are abstractions and abstractions lead to thinness and allegory whereas in good fiction and drama you need to go through the concrete situation to some experience of mystery.

THE HABIT OF BEING

O'Connor's judgment on the transcendentals as abstractions, and therefore not suitable for good fiction, would have warmed von Hügel's heart. O'Connor is, in fact, taking a page out of von Hügel's playbook by insisting on clothing truth, goodness, and beauty in concrete situations, not by doing away with them. To that end, O'Connor's fiction serves as a particularly apt subject for studying the severity of divine grace and its necessarily subversive effects on the transcendentals, given that her stories typically center on a violent action (subverted goodness) in confrontation with varyingly grotesque characters (subverted beauty) who do, say, and believe foolish things (subverted truth). If O'Connor's stories had simply been severe in order to showcase human depravity or illustrate the ways of evil in the world,

she would have hardly distinguished herself from other major American writers whose stories trade to some degree or another on the grotesque, the severities of violence, and provincial ways of thinking.[1] What distinguishes O'Connor from such company is a theological sophistication regarding the nature and cause of such grotesqueries, severities, and provincialisms, and the purposes for which God uses them, not only to felicitous ends but as *providential means*.

O'Connor was perhaps the most deeply religious and theologically astute of major American fiction writers, certainly of the twentieth century, and she adopted her notion of severe grace from Scripture and from the center of the church's long theological tradition. She also intuited such notions out of her own experience. What makes O'Connor's contribution to American letters all the more remarkable, however, was her unwavering commitment to her *craft*. She was a careful artist *and* discerning theologian[2] and held to the essential symbiosis of one's religious and artistic visions, believing that both operated at the deepest reaches of mystery while being bordered on all sides by generative constraints. This combination of mystery *within* constraints (mystery and manners), a tension she spoke much of in her letters and essays, lent to her writing a peculiar, dark resplendence that is her signature style, and it formed an approach she called Christian Realism.

O'Connor's insistence that mystery not only required but also could only be preserved within a sense of manners served as a liberating credo in her writing. She called such limitations "gateways to reality," which for her meant that the material world and one's region in it were indispensable prerequisites for a vision that extended beyond this world:

> The writer learns, perhaps more quickly than the reader, to be humble in the face of what-is. What-is is all he has to do with; the concrete is his medium; and he will realize eventually that fiction can transcend its limitations only by staying within them.[3]

[1] See David Brion Davis's brief but excellent essay "Violence in American Literature," *Annals of the American Academy of Political and Social Science* 364 (March 1966): 28-36. Davis argues that the preponderance of violence in American literature reflects social and historical patterns unique to America.

[2] She would have dismissed the theologian label out of hand, but hers was among the most impressive private theological libraries in the country at the time of her death.

[3] *MM*, 54, 146.

O'Connor's fiction was her version of the word made flesh.

In his review of Flannery O'Connor's *Mystery and Manners* in *The New York Review of Books*, Richard Gilman recounts his first meeting with O'Connor in September of 1960 on her farm in Andalusia:

> I realize that I have not yet described her, and this delay is true to what happened that day. Before I met her I had found out something about her illness. She was suffering from lupus, a terrifying disease related to arthritis, which generally attacks the blood vessels and of which her father had died in his early forties. I had known she was crippled and that the disease had distorted her face, but the only picture of her I had seen had been on the back of *Wise Blood* and been taken before the illness broke out.
>
> Knowing what I did, I had held off looking at her from the moment of my arrival. Uncertain and afraid of what I might feel, self-conscious and ashamed of it, I had found myself glancing past her face, averting my eyes when she moved laboriously about, not wanting yet to see her. But then, as we talked, something broke and I was looking at her, at her face twisted to one side, at her stiff and somewhat puffy hands and arms, and at her thinning and lusterless hair. From then on, although I would be shaken by an occasional spasm of pity I hated feeling, her appearance was absorbed for me into her presence and—I don't use the word lightly—transfigured by it.
>
> Tough-minded, laconic, with a marvelous wit and an absolute absence of self-pity, she made me understand, as never before or since, what spiritual heroism and beauty can be.[4]

To read Flannery O'Connor's stories is, in some sense, to read Flannery O'Connor. "Her face twisted to one side, [with] stiff and somewhat puffy hands and arms [and] thinning and lusterless hair," a woman of uncommon "spiritual heroism and beauty" who was "tough-minded, laconic, with a marvelous wit and an absolute absence of self-pity": Gilman could have been describing one of O'Connor's fictional characters. To a degree paralleled by few other writers, O'Connor empathizes with and embodies the characters she created, and she inhabited a world of moral and spiritual severity not dissimilar to the backwoods ferocity of her imagination.

[4]Richard Gilman, "On Flannery O'Connor," *New York Review of Books*, August 21, 1969, 24-26. I am reminded, in Gilman's description of O'Connor, of Frederick Buechner's definition of a saint as not someone who is a moral exemplar but as one in whose presence people feel more fully alive. See Buechner, *Wishful Thinking: A Theological ABC* (San Francisco: HarperSanFrancisco, 2001), 55.

In this chapter we examine the theological and artistic ferocity, or what I have called elsewhere the dark resplendence, of O'Connor's short stories. Such ferocity, I will insist, has a theological purpose for O'Connor, which is to incarnate the difficult realities of the Christian faith for the purpose of illumination and instruction, not in any didactic sense but as a sort of Christian midrash that seeks to interpret and illustrate both the divine nature as well as biblical truths through the telling of stories.[5] Aquinas speaks to this reality:

> Divine things should be expounded more properly in figures of vile bodies than of noble bodies . . . because this humbler depiction is more suited to the knowledge that we have of God on this earth: He shows Himself here more in that which is not than in that which is, and therefore the similitudes of those things furthest from God lead us to a more exact notion of Him, for thus we know that He is above what we say and think.[6]

Flannery O'Connor's stories are shocking because the gospel that informed and inspired her stories is shocking. They shock and offend because Scripture shocks and offends. They subvert normal categories because Scripture subverts normal categories. They express a fierce dogmatism because the church at its best has insisted on a dogmatic ferocity in its commitment to Scripture and tradition, and O'Connor founded her very existence in the church. They are free in artistic expression because that same fierce dogma to which she was committed provided the framework for such freedom. Her faith, in other words, informed and infused her content with theological depth and provided the necessary boundaries for her artistic expression.

O'Connor was not attracted to typical notions of beauty. She favored chickens "with one green eye and one orange or with overlong necks and crooked combs. I wanted one with three legs or three wings but nothing in

[5]Midrash used stories and contemporary parables as an interpretive tool to help make sense of, and in some cases reinterpret, the biblical text, a process not unlike O'Connor's interest in framing difficult Christian truths around the parameters of fiction. *Didaktikos*, on the other hand, is a distinctly Greek approach to instruction that has moral instruction as an ulterior motive. O'Connor was not interested in moral instruction per se.

[6]Thomas Aquinas, *Summa Theologiae* 1.1.9; translated by Umberto Eco in his novel *The Name of the Rose* (New York: Harcourt, 1983), 81.

that line turned up."[7] Likewise, her moral vision was, in many ways, utterly at odds with modern sensibilities and more in line with her medieval theological forebears, who gave the violence of her stories theological warrant.[8] As for her intellectual commitments, she was famously suspicious of ivory tower expressions and academic pretensions to learning, in spite of her obvious debt to— and respect for—her graduate training in Iowa. Her essay "The Teaching of Literature" speaks to this suspicion: "I believe it's perfectly possible to run a course of academic degrees in English and to emerge a seemingly respectable Ph.D. and still not know how to read fiction."[9]

THE DIVINE AND THE DEMONIC: O'CONNOR'S
VIOLENCE RECONSIDERED

As Susan Srigley has pointed out, "In much of the general discourse on violence in O'Connor's work, religion is held to be either the cause or a force behind the most penetrating critique. Some would argue even further that for O'Connor violence is a necessary outcome of divine justice."[10] From a theological perspective, much rests on the precise connotation of the word *necessary* if we are to begin to sort out questions of violence and its divine intent in O'Connor's stories. If violence is indeed "a *necessary* outcome of divine justice," then one can reasonably assume that at least some of the violent outcomes in O'Connor's work are themselves the manifestation of God's justice. Far from clearing the matter up, however, this only serves to make the question of O'Connor's use and understanding of violence even murkier.

For some of her critics, the presence of violence in her stories is explained by a deep-seated need O'Connor had to religiously justify her disease. Her long struggle with lupus has become, for better and for worse, an enduring part of her legacy as a writer, but I do not hold to the line of thinking, propagated by Joyce Carol Oates and others, that O'Connor's attraction to

[7]*MM*, 4.

[8]In his book *The Ambivalence of the Sacred: Religion, Violence, and Reconciliation* (Lanham, MD: Rowman & Littlefield, 1999), R. Scott Appleby suggests that "military imagery is deeply rooted in the Christian consciousness," and he uses examples from medieval Christianity, in particular, as especially emblematic of this tendency (12).

[9]*MM*, 123.

[10]Susan Srigley, introduction to *Dark Faith: New Essays on Flannery O'Connor's "The Violent Bear It Away,"* ed. Susan Srigley (Notre Dame, IN: University of Notre Dame Press, 2012), 2.

violence and the redemption inherent in it was due to that struggle and her unconscious (sublimated) desire to see it as redemptive. Why must it be that and nothing else? Oates's insistence that O'Connor's struggle with her disease provides the deepest explanation for her attraction to the grotesque and to violence leads Oates to erroneously claim that O'Connor, by way of Augustine, "prematurely denied the sacredness of the body" because her writing "insists upon a brutal distinction between . . . the City of Man and the City of God."[11] And yet, this Manichaean dualism that Oates alleges against O'Connor, she herself perpetuates in her characterization of O'Connor's theology as body = bad / spirit = good. O'Connor took great and careful pains to protest against such a dualism, which she believed was perpetuated both in the world and the church. Indeed, her theological dogmatism railed against such dualism, even quoting Augustine (of all people!) in one of her letters: "the things of the world poured forth from God in a double way: intellectually into the minds of the angels and physically into the world of things."[12]

Violence and terror are either directly or indirectly related to God and his grace in O'Connor's stories, but the question of how such a pairing of opposites (grace and terror) should be construed often receives little attention beyond some claim to the importance of "mystery."[13] Those who

[11]Joyce Carol Oates, New Heaven, New Earth (New York: Vanguard, 1974), 166-67.

[12]HB, 128. Not only does Oates get Augustine wrong, then, but she gets the genesis of O'Connor's ostensible dualism wrong too. O'Connor's preoccupation with "diseased" things started long before her own disease ravaged her body, and her theological commitment to the singular presence of God in the world as well as above it led her to see not only "the entire process [as] divine" (Oates, 168) but the whole blessed material as divine too (though distorted by sin). In too many places to count, O'Connor limns Aquinas's conviction that nature—that is, the physical world—is fundamentally good, not evil (as Manichaeism contends).

[13]I use the word terror to indicate something dreadful or something that causes great fear, as opposed to something necessarily evil. The word itself, of course, risks association with its contemporary and hyper-politicized meaning as being something morally repugnant, wrought by either some clandestine group of foreign mercenaries or a genre-specific production company headquartered in the Hollywood Hills. In either case, terror is robbed of its deeper and richer original meaning intended here, which, for the purposes of this study, carries no intrinsic moral freight. It can either be glorious or demonic, salutary or despicable, depending on who inflicts it. In O'Connor's fiction, this means either God or the devil. In the Douay-Rheims Bible, from which O'Connor derives the title of her second novel, the word terror occurs thirty-four times and is often used to describe the character of God and God's actions (Deut 26:8—"And [God] brought us out of Egypt with a strong hand, and a stretched out arm, with great terror, with signs and wonders"; Job 37:2, 5—"Hear ye attentively the terror of his voice, and the sound that cometh out of his mouth. . . . God shall thunder wonderfully with his voice, he that doth great and unsearchable things"; Is 10:33—"Behold the sovereign Lord of hosts shall break the earthen vessel with terror, and the tall of

do examine the paradox usually find the devil lurking in the shadows of such a convergence, and for good cause: evil is assuredly present in O'Connor's stories. And yet, I do not believe it plays the leading role that many critics assume.[14]

More often than has been recognized, the terrible things that happen in O'Connor's stories happen at God's behest, not the devil's. The direct role of divine providence in the goring of Mrs. May in "Greenleaf," for example, or the drowning of Bevel in "The River," or Nelson's and his grandfather's difficult and jarring epiphany in "The Artificial Nigger," or Ruby Turpin's damning vision at the end of "Revelation," are all instances of divine intrusion. Indeed, it is the devil who often sits like a vulture on the perimeter of O'Connor's stories, observing the wreckage that God ordains from a distance, hoping to get in on a piece of the action. Young Tarwater's "friend" in *The Violent Bear It Away* is the most obvious example of the devil's being an "unwilling instrument of grace" (Rufus Johnson in "The Lame Shall Enter First" is another). Suffice it to say that in O'Connor's fictional universe, where the devil begins and God leaves off, is not always an obvious demarcation.

A large difference rests here on a subtle distinction. It is one thing to say that a violent action happens at the devil's behest, but then God makes something good come out of it. It is entirely another to suggest that a violent action is directly willed by God, and though the devil may be involved, he is—by necessity as much as by divine fiat—an unwilling participant. In

stature shall be cut down, and the lofty shall be humbled"; Jer 32:21—"And hast brought forth thy people Israel, out of the land of Egypt with signs, and with wonders, and with a strong hand, and a stretched out arm, and with great *terror*"; Mt 28:3-4—"And his countenance was as lightning, and his raiment as snow. And for fear of him, the guards were struck with terror and became as dead men"). In such cases, *terror* is descriptive and not evaluative.

[14]See Regis Martin's excellent study, *Flannery O'Connor: Unmasking the Devil*, 2nd ed. (Ann Arbor, MI: Sapientia, 2005). Martin, to be sure, sees much more than simply "the devil in the details" of the violent and unseemly plot lines and characters of O'Connor's fiction. He writes about *A Good Man Is Hard To Find*, "So many fictional lives spent in flagrant defiance of Almighty God, lived in arrant and repeated flight from His laws; then, all at once, startled and overtaken by a primitive violence divinely calculated to shake even the most hardened habitual sinner" (14). And once the sinner has been thus shaken, "the violence invariably moves the character to an encounter with grace." I want to suggest, however, that in O'Connor's fictional economy, it is often the encounter with grace itself that is violent. David Eggenschwiler, Preston Browning argues, is correct to claim that Hazel Motes is haunted by "Jesus the devourer," which accounts for this ambivalence toward salvation (Preston Browning, *Flannery O'Connor: The Coincidence of the Holy and Demonic in O'Connor Fiction* [Eugene, OR: Wipf & Stock, 2009], 34).

many instances of violence in her stories, O'Connor claimed for herself the second option:

> Story-writers are always talking about what makes a story "work." From my own experience in trying to make stories "work," I have discovered that what is needed is an action that is totally unexpected, yet totally believable, and I have found that, for me, this is *always an action which indicates that grace has been offered. And frequently it is an action in which the devil has been an unwilling instrument of grace.*[15]

Such a position runs afoul of critics who contend that the violence wrought in O'Connor's stories is always—or even mostly—the devil's making and that it is God who sits at the periphery—even offstage—waiting to inject some grace into the chaotic proceedings. But if the devil is an unwilling instrument (i.e., something that is *played*) in a particular action of a story—indeed, if *grace is offered* through the means of such an action—it seems that we are left with but one conclusion: the action was willed by God, though it may have come at the hands of the devil.

The distinction between the divine violence of God and the demonic violence of the devil in O'Connor's fiction is crucial for the purposes of interpretation. Both types of violence are in her stories because both are in her theology (and both are in Scripture), but she understood only the first—divine violence—to be wholly redemptive, though terrible, which only adds to the confusion as to which terror is operative in any given scene in her stories. In a letter to Betty Hester, O'Connor laments the public reception of her collection of stories *A Good Man Is Hard to Find*, writing, "When I see these stories described as horror stories I am always amused because the reviewer always has hold of the wrong horror."[16] Reviewers might be forgiven this oversight, however, since in O'Connor's vision, the second kind of terror—the demonic kind—often does not initially look terrible but appears, instead, in innocuous disguises and enlightened characters.

In table 2, I make a distinction between both types of violence as they are embodied in O'Connor's fiction. The principal difference between the

[15]*MM* 118; emphasis mine.
[16]*HB*, 90.

two relates to the primal human impulse to bifurcate realities that are pro-
foundly complementary, or put another way (as von Hügel and O'Connor
after him understood it), to separate grace from nature.[17] Such an impulse,
to see nature as an end in itself rather than as a means to God, finds its
mythical source in the fall, when Adam and Eve saw the fruit as an end in
itself rather than a means by which we might have communion with God.[18]

O'Connor scholars generally fall into one of two camps regarding
O'Connor's use of violence: that it is intended to be understood as either
the product of the devil or of cruel human nature, on the one hand, which
God then mysteriously turns to his divine purposes from time to time; or
that her violence is meant to be understood as a pitched battle between
(or mysterious alchemy of, as in a Jobian sense) God's and the devil's
machinations, on the other, which they variously ordain for good or evil
purposes.[19] This study provisionally comes out of the second camp, but
the delineations and permutations among this group are so varied as to
hardly render a consensus regarding O'Connor's use of violence.

[17]Susan Srigley makes a similar argument: "O'Connor's prophetic vision, theological and artistic, is directed
toward drawing together the physical and the spiritual; that is, the lived sensible world and the mysterious
unseen reality that is eternally present." *Flannery O'Connor's Sacramental Art* (Notre Dame, IN: University
of Notre Dame Press, 2005), 3.

[18]See Alexander Schmemann, *For the Life of the World* (New York: St. Vladimir's Seminary Press, 1963),
especially chapter one.

[19]This difference is perhaps most palpably seen in the competing interpretations of the verse from which
the title of O'Connor's second novel comes: "From the days of John the Baptist until now, the kingdom
of heaven suffereth violence, and the violent bear it away" (Mt 11:12 Douay-Rheims). Some interpret
the "violent" as the malevolent who try to steal the kingdom of heaven away from the righteous, while
others understand the violent to be the saints themselves, who protect and ultimately fulfill the king-
dom of God by violent means. The former, like John Traynor Jr., thus see Old Tarwater as a malevolent
creature and Francis's subsequent murder of Bishop as an experience of "catharsis" because the boy
"has been uprooted from the fiery brimstone patch of his great-uncle's planting" (John Traynor Jr.,
"Books," *Extension* 55 [July 1960]: 25); Stanley Hyman agrees, concluding that "the verse's clear mean-
ing is that the violent are enemies of the kingdom, capturing it from the righteous" (*Flannery O'Connor*
[Minneapolis: University of Minnesota Press, 1966], 26). The latter camp, represented in John May's
essay "*The Violent Bear It Away*: The Meaning of the Title" (*Flannery O'Connor Bulletin* 2 [1973]: 83-86),
understands the violence of Old Tarwater's fierce visions and Bishop's subsequent baptism by Francis
"as a mark of the enthusiast," rather than enemies of the kingdom of God and such deeds as "a sign of
intensity of belief" (84). In effect, the two camps disagree on which of the two—the baptism or the
drowning—deserves existential priority. See also Bieber Lake's essay, "The Violence of Technique and
the Technique of Violence," in *Flannery O'Connor in the Age of Terrorism: Essays on Violence and Grace*,
ed. Ava Hewitt and Robert Donahoo (Knoxville: University of Tennessee Press, 2011), on the different
kinds of violence in O'Connor (esp. 27-30).

Table 2. Two types of violence in O'Connor's fiction

	Divine Violence (grace and nature together)	Demonic Violence (grace and nature separated)
Wise Blood	the self-blinding and subsequent death of Hazel Motes	the killing of the pedestrian; sleeping with the prostitute
A Good Man Is Hard to Find	the threat of violence and subsequent murder of the Grandma	The murder of the family; the Grandma's sentimental faith; the Misfit's recalcitrance
The River	the drowning of Bevel	the neglect of Harry's (Bevel's) parents
The Life You Save May Be Your Own	Shiftlet's leaving Lucynell with the waiter who saw her as an angel	the mother's objectifying "love" of her daughter; Shiftlet's kidnapping of Lucynell
A Stroke of Good Fortune	Ruby's pregnancy	Ruby's treatment of Bill Hill and Rufus
A Temple of the Holy Ghost	the response of the narrator to the hermaphrodite	the response of the girls to the hermaphrodite
The Artificial Nigger	Mr. Head's and Nelson's mind-altering epiphany at the lawn jockey	Mr. Head's denial of Nelson
A Circle in the Fire	The boys burning down Ms. Cope's woods	
A Late Encounter with the Enemy	General Sash's death after his revelation	Sally's objectifying her grandfather
Good Country People	Manley's theft of Hulga's wooden leg	Manley's scheming ways; Hulga's cynicism; her mother's gentrified religion
The Displaced Person	Mrs. McIntyre's epiphany	the objectification and subsequent murder of Guizac
The Violent Bear It Away	the drowning baptism of Bishop; the collapse of Rayber; the kidnappings	the rape of Francis; Rayber's treatment of Bishop; the Friend's counsel
Everything That Rises Must Converge	the mother's collapse, her revelation, and her death	Julian's and his mother's racism; their distorted love
Greenleaf	Mrs. May's death by (papal) bull	Mrs. May's view and treatment of Mrs. Greenleaf and her family

	Divine Violence (grace and nature together)	Demonic Violence (grace and nature separated)
A View of the Woods		Fortune's treatment of nature and of his progeny; his murder of Mary
The Enduring Chill		Asbury's view of the world and of himself
The Comforts of Home		Thomas's shooting of his mother; his attempted murder of Star Drake
The Lame Shall Enter First	Rufus's truth telling; Sheppard's conversion; Norton's death	Sheppard's distorted love for Norton and concern for Rufus; Rufus's distorted will
Revelation	the teenage girl's assault of Ruby; Ruby's pigsty (prodigal?) conversion	Ruby's racism and classism; Claud's passivity
Parker's Back	Parker's tattoo	Sarah Ruth's rejection of him; her disembodied faith
Judgement Day	Tanner's being attacked and his subsequent revelation	Tanner's racism; the neighbor's complicity in his death; the daughter's distorted love

Some will no doubt disagree with my characterization of the mother's protectiveness of her daughter in "The Life You Save May Be Your Own," or Mrs. May's religious propriety in "Greenleaf," or Sarah Ruth's moral and spiritual piety in "Parker's Back," or the Grandma's sentimental faith in "A Good Man Is Hard to Find" as examples of demonic violence on par with the Misfit's murder of the Grandma, or the rape of Tarwater in *The Violent Bear It Away*, or Fortune's murder of his granddaughter in "A View of the Woods." But tenderness in any guise, "separated from the source of tenderness," leads to genocide, as O'Connor reminds us in her essay "A Memoir of Mary Ann" (and as we also see in the murder of the Grandma's family, which appears to be the high cost of her transformation):

> Camus' hero cannot accept the divinity of Christ, because of the massacre of the innocents. In this popular pity, we mark our gain in sensibility and our loss in vision. If other ages felt less, they saw more, even though they saw with the blind, prophetical, unsentimental eye of acceptance, which is to say, faith. In the absence of this faith now, we govern by tenderness. It is a tenderness

which, long since cut off from the person of Christ, is wrapped in theory. When tenderness is detached from the source of tenderness, its logical outcome is terror. It ends in forced-labor camps and in the fumes of the gas chamber.[20]

In each of the former and seemingly more innocuous examples (see previous paragraph), such apparent nobility (parental protection, religious propriety, moral piety) finds its source in sentimentality, which itself stems from an impulse to objectify, to separate the spiritual from the material (in one's daughter, one's beliefs, and one's actions, respectively). Such sentimentality is born in theoretical tenderness wherein virtues are a matter of familial obligation, or religious propriety, or civic manners ("political correctness"). But "theoretical tenderness," valued as such for its utility and expedience because it is amenable to polite conversation and open to measurable outcomes, is an abiding contradiction in terms that leads to very bad places. Tenderness, for it to be truly tender, needs a grounding in something beyond itself—in a convictional basis that requires fierce commitments. For O'Connor this meant Jesus Christ's redemptive act on the cross, because only from that source can tenderness be understood within a context of severity. It is, in other words, a hard-won tenderness, a tenderness that is *earned*. Ralph Wood refers to this tenderness-in-darkness as "the terrible—the terror-striking—character of God himself."[21]

The axiomatic truism of O'Connor's (via von Hügel), that grace and nature are separated only at our peril, turns out to be a reliable guide for delineating the two kinds of violence present in O'Connor's fiction, where demonic violence seeks to separate grace from nature, and by doing so objectifies nature (whether in the form of humans or nature itself) as if it were an end in itself, while divine violence in O'Connor's stories conspicuously refuses to separate grace from nature and, in such a refusal, thereby grants the recipient of such violence access to redemptive truth, goodness,

[20]*MM*, 227.

[21]Ralph Wood, "God May Strike You Thisaway," in Hewitt and Donahoo, *Flannery O'Connor in the Age of Terrorism*, 48. Wood quotes a character from Walter M. Miller's novel *A Canticle for Liebowitz* to help explain this difficult juxtaposition of tenderness and terror: "To minimize suffering and to maximize security were natural and proper ends of society and Caesar. But then they became the only ends, somehow, the only basis of law—a perversion. Inevitably, then, in seeking only them, we found only their opposites: maximum suffering and minimum security" (48).

and beauty, whether in the form of some teenage boys' prank ("A Circle in the Fire") or some teenage girl's tantrum ("Revelation").

To objectify a person in any form is to kill that person, since the impulse to objectify denies the possibility to love. Such a move either denies a person's status as a child of God or denies nature's reality as an embodiment and reflection of God's goodness, which O'Connor, like the Thomist she was, believed it to be. If this scheme seems far-fetched, it is good to remember that Jesus reevaluates true violence as a metaphysical category that includes one's thoughts and intentions as well as one's actions. Jesus reminds his audience in the Sermon on the Mount that one can do violence with one's thoughts, and not merely with one's hands, by objectifying a person as a "fool." This kind of terror is evil because, among other things, it seeks to explain by theory—and thus to objectify—those whom we are commanded to love. It separates spiritual concerns from material reality, and the sundering of the two was, in O'Connor's view, the essential mistake of modernity, which inevitably leads to a comfortable nihilism: "At its best our age is an age of searchers and discoverers, and at its worst, an age that has domesticated despair and learned to live with it happily."[22] She even saw this tendency in herself, which she says she would have manifested had it not been for the church's teaching:

> If you live today you breathe in nihilism. In or out of the Church, it's the gas you breathe. If I hadn't had the Church to fight it with or to tell me the necessity of fighting it, I would be the stinkingest logical positivist you ever saw right now. With such a current to write against, the result almost has to be negative.[23]

The reader of O'Connor's stories, then, must be prepared to look at the violence of her stories with a biblical vision. If O'Connor believes that sentiment can lead to the gas chambers and Jesus reevaluates violence as a metaphysical category, then readers of O'Connor must be willing to look at the violence in her stories with a similar bias. In this connection, von Hügel distinguishes between *consolation* and *desolation* and insists that one follows the other, "and the latter is when and where God sends it, and we have not ourselves brought it on ourselves by laxness and dissipation."[24] So there is the abomination of

[22]*MM*, 159.
[23]*HB*, 97.
[24]*Letters*, 105.

desolation in Jesus' Olivet discourse, but then there is a desolation wrought by God, and von Hügel thought this the better way to God than consolation. We have to be willing, in other words, to get ahold of the right horror.

To be sure, such a simple delineation of divine versus demonic violence does not do complete justice to the full complexity of the mystery that lies at the heart of so many of O'Connor's violent scenes.[25] The temptation in any approach to O'Connor's stories is to try to explain too much, and by doing so eviscerate the mystery that lies at the heart of her stories. And yet, agreeing that the boys intended to burn down Mrs. Cope's woods ("A Circle in the Fire") does not lessen the mystery of the consequences of such an intention, its effect on Mrs. Cope, nor of the source of the boys' violence. They burned down her woods not merely because they are ruffians—that they are, of course, their expressed intentions bear out—but also because they were sent as messengers of God to redeem Mrs. Cope, and O'Connor makes this quite clear by comparing them to the Old Testament "prophets [who] were dancing in the fiery furnace, in the circle the angel had cleared for them," which is intended to prod the reader to wonder whether God had willed this terrible thing in the first place.[26] Is it not the violent who bear the kingdom of God away?

The antidote to nihilism for O'Connor, in other words, wasn't a sentimentalized, disembodied view of creation, but rather a thoroughgoing respect for the power of divine severity—a sort of fire-fighting-fire approach to the modern current—coupled with a healthy respect for the vagaries of dumb material existence. As an ardent student of Scripture, O'Connor was familiar with this sort of dark tenderness, and she brought it to bear on her stories in the same way that she saw it being brought to bear on the characters and events of Holy Scripture: in the way that God clothes Adam and Eve before banishing them from paradise, or how God confronts Moses at the burning bush and makes himself known to Elijah in the whirlwind before calling both of them to their terrible tasks; in the frightening resplendence of the

[25]One of the deeper ironies is how divine violence is often the more obviously violent of the two.

[26]CW, 251. Of course, it is even more complicated than this. One of the boys objectifies nature by his wish to build a parking lot where the woods now stand, so not all their intentions are pure. But, of course, that's not what happens. Powell, the diminutive leader, gets another idea, but only after "the sun made two white spots on Powell's glasses and blotted out his eyes." His eyes are burned clean, it would seem, and now he gets the idea to burn the woods down, and when it comes to fire in O'Connor's lexicon, it almost always means purgation, not wanton destruction. This is the same boy, after all, who earlier in the story says about Mrs. Cope's woods, which she insists are *hers*, that "Gawd owns them woods and her too."

transfiguration; in the way angels manifest themselves at almost every opportunity; at the cross. One is reminded of Rudolf Otto's own rendering of the Holy as a *mysterium tremendum et fascinans*, as that which elicits a "hushed, trembling, and speechless humility of the creature in the presence of—whom or what? In the presence of that which is a Mystery inexpressible and above all creatures."[27]

In many of O'Connor's stories it is not the devil, then, but God who is the great offense, and his terrible mercy is often more painful than the devil's wickedness. (This is the "costingness" of belief that O'Connor associates with von Hügel in her review of his *Letters*.[28]) Of course, there is violence wrought from evil in her stories, but even then such violence often ends up being the unwitting material of God's gracious and merciful purposes, but more often than not, the violence so often assumed to be evil in nature, like the impaling of Mrs. May in "Greenleaf," or the theft of Hulga Hopewell's leg in "Good Country People," or the hanging of Norton in "The Life You Save May Be Your Own," finds its origins in the inscrutable will of God. In the examples just mentioned, in other words, I am arguing that the violence that is perpetrated is not a violence that was meant for evil but God turned to good (Gen 50:20), but a violence that itself was God's will (Ex 21:12-13).[29] It is too often and too easily assumed that the devil must be the originating source of *all* the havoc in O'Connor's stories because that is what the devil does. Wreak havoc. Cause harm. Beget violence. But might God not do the same? One need only recall the Tower of Babel, or the parting of the Red Sea, or the cross. "Who is this Christ," the poet Rainer Maria Rilke asks, "who interferes in everything?"[30]

[27]Rudolf Otto, *The Idea of the Holy*, trans. John W. Harvey, 2nd ed. (London: Oxford University Press, 1950), 13. See excursus, chapter five.

[28]Leo Zuber and Carter Martin, eds., *The Presence of Grace and Other Book Reviews by Flannery O'Connor* (Athens: University of Georgia Press, 1983), 21

[29]Many will blanch at such a reading of Norton's death, for example, but O'Connor's final line is not ironic; she means it when she says that his death was what "launched his flight into space" to be with his mother. One would be mistaken to take a hard line here on the Catholic view toward suicide, as Norton is not at the age of reason where one would expect him to understand the theological implications of his decision. He wants to be with his mother, whom he loves, and away from his father who, tragically, only learns to love him after he is dead.

[30]Rainer Maria Rilke, from the essay "The Young Workman's Letter," in *Where Silence Reigns* (New York: New Directions, 1978). It is important not to confuse O'Connor's perspective on violence with that of Derrida, Foucault, Nietzsche, and others who, as David Bentley Hart has suggested, essentially theorize an ontology of violence, which ultimately ends in nihilism. See David Bentley Hart, *The Beauty of the*

Yet, this hardly settles the matter regarding the notion that God might indeed be terrible, and so what do we do with this component of O'Connor's fierce theology? She refuses to placate us with religious euphemisms and spiritual jargon, preferring instead to "shout" and "draw large and startling figures" in our faces.[31] She wrote in her letters of the "violence of love" and how "the kingdom of heaven had to be taken by violence, or not at all," and these are themes that continue to develop in O'Connor's fiction through the late 1950s and early 1960s.[32] They become more spiritually urgent and theologically substantive in her later work and a more recurrent theme in her letters after 1955. It cannot be denied that O'Connor herself grew in faith during this time, and the heightened spiritual awareness reflected in her writing (both in her fiction and nonfiction) is a reflection of a commensurate heightened awareness in her own life concerning such weighty matters—of life and death (that death that lurked in the shadows of her always-present disease for fourteen years), of sin and grace, of hopes and fears—matters that are, for the spiritually afflicted, companion ideas to the terrible beauty, violent goodness, and mysterious truth of God.

O'Connor considered humans to be "formed in the image and likeness of God" but wracked by sin and, as such, freaks of nature who cast "strange shadows." She said that she wrote from a "conception of the whole man," which meant from a theological perspective, and the freaks in her stories served one purpose: to be "a figure for our own displacement."[33] In a later essay she discusses the dramatic (and not merely theological) importance of drawing out the rough edges of God's unsentimental grace in order for stories to be worth their salt:

> Today's reader, if he believes in grace at all, sees it as something which can be separated from nature and served to him raw as Instant Uplift. This reader's favorite word is compassion. I don't wish to defame the word. There is a better sense in which it can be used but seldom is—the sense of being in travail with

Infinite: The Aesthetics of Christian Truth (Grand Rapids: Eerdmans, 2004), 35-37. Such a use of violence would be, in my schemata, demonic.

[31]*MM*, 34. See Jonathan Rogers, *The Terrible Speed of Mercy: A Spiritual Biography of Flannery O'Connor* (Nashville: Thomas Nelson, 2012), for an excellent discussion of some of the influences for her ineluctably Christian, and thus necessarily disturbing, vision of things.

[32]*HB*, 381, 229.

[33]*MM*, 45.

and for creation in its subjection to vanity. This is a sense which implies a recognition of sin; this is a suffering-with, but one which blunts no edges and makes no excuses. When infused into novels, it is often forbidding. Our age doesn't go for it.[34]

O'Connor's attenuated view of humans—her low anthropology—which she borrowed directly from her Catholic catechism and from Scripture, had personal as well as artistic impetus and must be foremost in the reader's mind in attempting to understand her stories.[35] But this is a forbidding task for the reader, as O'Connor rightly asserts. God's all-consuming love is a hard-won truth, and most of us would rather not have to come to terms with it.

Each of the transcendentals in O'Connor's stories has violence associated with it, be it a violence against contemporary notions of what is proper and fetching (beauty), a violence against the inherent dignity of humanity (goodness), or a violence against reason (truth). The second and third types of violence (or violation)—of human dignity and of reason—are perhaps the most egregious and offensive to the modern mind. And yet, the ideas (idols, really) that humans possess an "inherent dignity" by virtue of their biology, or that human reason is somehow untainted by sin—which are two ideas that effectively anchor the foundations of much of modern ethics and (it must be added) much contemporary Christian belief—have little biblical warrant and run counter to O'Connor's moral and artistic vision.

Whatever violent form her subversive impulses took, such a subversion was, by its very nature, incongruous with modernity's most cherished and ubiquitous expression of religion, which is some form of providential deism, which states—or more often simply implies—that God's main purpose is to work for the glory, happiness, and satisfaction of humanity. This confusion of ends and means, a monumental reversal theologically considered but a mere sleight

[34]Ibid., 166. This idea likely comes from von Hügel. In a published review of his *Essays*, she writes that they are the antidote to the tendency among popular American Catholic writers to "approach and sidestep the problems of faith or meet them with the Instant Answer"; Zuber and Martin, *Presence of Grace*, 42. Note the similarity in wording.

[35]My own Calvinist upbringing may, at times, predispose me to make too much of human depravity, and I must be careful not to foist this upon O'Connor. There is a middle ground, it seems to me, between the conventional (though not necessarily Calvinist) notion of total depravity as indicating complete human worthlessness, on the one hand, and providential deism on the other, where God becomes a *means* to human happiness. O'Connor explicitly denies both Calvin's position on double predestination (see *HB*, 488) and the tenets of secular humanism (see *HB*, 403) and opts, instead, for what she calls a Christian humanism (see *HB*, 360).

of hand historically speaking was, for O'Connor, the principal trouble modern readers had with her stories. *"People are treated like dirt!"* enlightened readers and critics would cry.[36] One can only imagine O'Connor's rueful response: *Because they are.* What such readers and critics are unwilling to accept is the moral ledger in O'Connor's divine accounting of things. As James Parker puts it, "Where the Word was operational, for O'Connor, it was always disruptive. . . . The upended moment, the breaking-in or breaking-through of a vagrant, unbiddable reality: this is the grace of God and the sign of his love."[37]

So her grotesqueness, her violence, her love of mystery are not incidental qualities of her fiction. Rather, they are indispensable elements of it. Teaching her chicken to walk backward was, it seems, a harbinger of her later, more subversive proclivities. To render the beautiful, the good, and the true in the guise of the grotesque, the violent, and the foolish is, in effect, to make them walk backward. The gospel is a backward way of living (turn the other cheek, cast out the offending eye, walk the extra mile), so perhaps it should be no surprise that the fervent and diligent Catholic girl developed an eye for such things early on.[38]

Seen in an anagogical light, then, O'Connor isn't unjust in her assessment and treatment of her characters: "The Lord out of dust had created him," the

[36]And cry they did. Martha Stephens (*The Question of Flannery O'Connor* [Baton Rouge: Louisiana State University Press, 1973]) is illustrative of this critical reaction and is especially harsh. She wrote that O'Connor's Christian faith "was as grim and literalistic, as joyless and loveless a faith, at least as we confront it in her fiction, as we have ever seen in American letters" (as quoted in Robert Golden and Mary Sullivan, eds., *Flannery O'Connor and Caroline Gordon: A Reference Guide* [Boston: G. K. Hall, 1977], 161), and she laments O'Connor's contempt for humanity and her "stubborn refusal to see any good, any beauty or dignity or meaning, in ordinary human life on earth" (as quoted in Donald E. Hardy, *The Body in Flannery O'Connor's Fiction: Computational Technique and Linguistic Voice* [Columbia: University of South Carolina Press, 2007], 5). More recently, at an O'Connor conference in Milledgeville in 2011, the writer Tom Franklin chastised O'Connor for being mean to her characters, even for disliking them. This is not altogether unfair, though it strikes me as theologically naive. On a lighter note, Martha Smith ends her positive review of *Wise Blood*, "Georgian Pens 'Wise Blood,' a First Novel," with this funny line: "I can hardly wait to read what Miss O'Connor may write about some happy people" (Golden and Sullivan, *Reference Guide*, 15), and Malcolm Muggeridge admitted that the South may be as bad as O'Connor portrays, but he preferred the "cheerful" vision of the South in Twain's *Huckleberry Finn* (Golden and Sullivan, *Reference Guide*, 82).

[37]James Parker, "The Passion of Flannery O'Connor," *The Atlantic*, November 2013, 36-37.

[38]Perhaps this subversive impulse was, quite literally, in her bones, manifested in her lupus, a disease in which the host turns on itself; the body creates antibodies against itself. What gives you life, in other words, kills you—a sort of reversal of the gospel premise—and promise. Never at home in her own body (like a prophet never welcome in his own town), her bodily struggle with lupus conspired to form within her a radically spiritual disposition: an artistic *habitus* with a prophetic vision. Her theology, then, formed antibodies against the host, which was modernity.

narrator says of Francis Tarwater, merely repeating the biblical view of our origin and destination (Gen 3:19).[39] We are animated dust in hopes of redemption, to be sure, but to claim much more for ourselves is, at least for O'Connor, theologically bankrupt:

> When they ask you to make Christianity look desirable, they are asking you to describe its essence, not what you see. Ideal Christianity doesn't exist, because anything the human being touches, even Christian truth, he deforms slightly in his own image. Even the saints do this. I take it to be the effects of Original Sin, and I notice that Catholics often act as if that doctrine is always perverted and always an indication of Calvinism. They read a little corruption as total corruption.[40]

We are to love each other, of course, a point both Jesus and Paul took great pains to make, but the assumption that such an arrangement necessarily constrained God in his actions toward us (as if we were on equal terms with our Creator) or that love itself never involves violence, or that such a love is an unalienable right, would have struck O'Connor as strangely parochial.

Francis Tarwater serves as perhaps the consummate example of a subversive (and subverted) character in O'Connor's fictional universe in that he embodies the terrible beauty, violent goodness, and foolish truth of God in such radical ways as to appear deeply unsympathetic to the average reader. Of course, suggesting that he embodies these paradoxes is not to suggest that Tarwater is like God in any way. On the contrary, the pathos of his character is increased precisely *because* he so imperfectly and awkwardly embodies these characteristics. A prophet is a broken vessel for the providence of God, and the more broken, the more God appears to prefer them as a vessel. We see this in the major figures of Scripture, and we see it in O'Connor's stories. Young Tarwater is not spared the fate of the old prophets, and *The Violent Bear It Away* becomes the battlefield on which the drama of his calling unfolds. And so it is to O'Connor's last novel that we now turn to more closely examine how such a subversion takes place.

[39]*VBA*, 91.
[40]*HB*, 516.

The Violent Bear It Away

A Case Study in Subversion

It is, really, a very hideous thing; the full, truly free, beauty of Christ alone completely liberates us from this miserable bondage.

BARON VON HÜGEL, LETTERS

The boy sensed that this was the heart of his great uncle's madness, this hunger, and what he was secretly afraid of was that it might be passed down, might be hidden in the blood and might strike some day in him and then he would be torn by hunger like the old man, the bottom split out of his stomach so that nothing would heal or fill it but the bread of life.

THE VIOLENT BEAR IT AWAY

A single Bible owned by O'Connor's is available to us, a Douay-Rheims edition published in 1955. It is in remarkably good condition, with the original blue dust jacket still intact and her signature on the inside cover next to the year 1959. If you place the Bible on its spine and allow it to fall open (carefully!), it brings you to the only "dog-eared" page from Genesis to Revelation—actually, it was paper-clipped, the clip having long since been removed but with the rust stain still visible in the upper right-hand corner—Matthew 11:12, which includes this verse, "And from the days of John the Baptist until now, the kingdom of heaven suffereth violence, and the violent bear it away."

O'Connor labored over *The Violent Bear It Away* longer than any other story she wrote, and the labor pays off in the form of the most theologically astute

of any of her stories. In many ways, O'Connor's second novel serves as a bridge from her earlier to her later stories and encompasses the central themes of her fiction: parent-child relations, urban versus city life, the treatment of race, faith versus modernism, intellectualism versus emotion, and baptism and the Eucharist.

The first caution in any endeavor to interpret O'Connor's stories is to make too much of too little. O'Connor encouraged an anagogical reading of her stories, but she spurned any attempt at reading them as allegories. Everything was not a symbol, she had to remind the overly curious again and again. In a letter to Ted Spivey in 1959, O'Connor recalls a visit she made to Wesleyan College for a reading of "A Good Man Is Hard to Find":

> After it I went to one of the classes where I was asked questions. There were a couple of young teachers there and one of them, an earnest type, started asking the questions. "Miss O'Connor," he said, "why was the Misfit's hat black?" I said most countrymen in Georgia wore black hats. He looked pretty disappointed. Then he said, "Miss O'Connor, the Misfit represents Christ, does he not?" "He does not," I said. He looked crushed. "Well, Miss O'Connor," he said, "what is the significance of the Misfit's hat?" I said it was to cover his head; and after that he left me alone.[1]

Insisting on an anagogical approach to O'Connor's work in the first place is, in some people's minds, already to make too much of too little. It is certainly true that in her second novel, God never actually shows up, at least not directly, and he is only indirectly addressed once in the entire story by (of all people) the atheist/agnostic Rayber, who exclaims, "My God how long is this going on?" as he chases the protagonist, young Francis Tarwater, through the city. Which is to say, God is never addressed a single time in the novel. Perhaps this is because O'Connor believed, as von Hügel did, that God makes appearances obliquely, as it were, through the material of this world. If this is true, then his appearance—in all of its divine beauty, goodness, and truth—must necessarily be distorted to accommodate the medium of our fallen condition.[2]

O'Connor uses Franz Kafka's story "The Metamorphosis" to make this distinction: "The truth is not distorted here, but rather, a certain distortion is

[1]*HB*, 334.

[2]Though only their appearance is distorted, not their essence. God's unmediated splendor, as Emily Dickinson reminds us, is too much for us to bear.

necessary to get at the truth."[3] This decision to distort the reader's vision, or
at least to distort the appearance of what, in her stories, she wanted her readers
to *see*—which was essentially O'Connor's entire *modus*—is best summed up
in her most often-quoted comment about shouting to the hard of hearing and
drawing large and startling figures for the almost blind. O'Connor distorted—
shouted, and so forth—in order to provide a contrast by which her audience
might see the beauty, goodness, and truth of God more clearly. It was a type
of realism, she argued, used "in order to show a hidden truth."[4] She believed
that we live in a world of distorted visions and truth to begin with, so to simply
reflect the world and life as it is presented to us—to be "realistic" in the
worldly sense—was to unwittingly participate in that distortion, and the only
way out of this echo chamber was to distort the distortion—to exaggerate
it—in hopes that something of a true vision might become more evident.

For all the startling figures in *The Violent Bear It Away*, from Old Mason to
young Tarwater to little Bishop, none is more so than the invisible God, whose
terribleness haunts every page of the novel and whose summoning of the char-
acters in the story serves as both the story's essential conflict as well as its
denouement. O'Connor manifested, in both words and images, God's myste-
rious and confounding providence, wrought to devastating pitch in the *mise
en abyme* of the baptismal death of little Bishop, which serves as the catalyst
for the death and rebirth of young Tarwater and a figurative death (and pos-
sible rebirth, at least according to O'Connor) of Rayber. Through it all, the
full presence of God's absence is palpable, almost stifling.[5] This presence-in-
absence, by which I mean God's invisible, immeasurable presence—*Deus
abscondus*, the incognito incarnation of the spiritual in the material—is an

[3] *MM*, 98.

[4] Ibid., 178.

[5] Myron Penner, in *The End of Apologetics: Christian Witness in a Postmodern Context* (Grand Rapids: Baker
Academic, 2013), invokes and distills Kierkegaard's argument about the divine incognito in his *Practice in
Christianity*, ed. and trans. Howard V. Hong and Edna H. Hong (Princeton, NJ: Princeton University Press,
1991). Penner puts God's oblique presence in the natural order into a helpful theological framework: "As
Kierkegaard notes, the incarnation in which God becomes human—Jesus of Nazareth—is the founding
event of Christianity and the central proclamation of its revelation. God—the transcendent, eternal, om-
nipotent creator of the universe—appears inside the creation as part of it. The truly remarkable and super-
natural aspect of this is that God can undergo this incognito—as this particular man, Jesus—and be un-
recognizable to the natural eye" (69). I want to suggest, again, that God *must* appear incognito in his own
creation (as in a *mise en abyme*)—in a burning bush, a whirlwind, a Jew—in order for him to appear at all,
for to appear as he is in all his glory would be to contain the uncontainable; the picture would explode the
frame.

essential literary tool of O'Connor's, and one that finds theological resonance in Baron von Hügel's writings.[6]

Accepting the general schema of von Hügel's three elements of religion by way of what I am calling his three ideas, I want to now examine the aesthetic, ethical, and intellectual aspects—"the bleeding stinking mad shadow of Jesus"—in O'Connor's understanding and depiction of God in *The Violent Bear It Away*.[7] We will consider the following:

- the *bleeding beauty* of God (the Son) in the words and forms that O'Connor uses to create worlds of her own imaginings, which strangely mirror our own bereft and beautiful world, populated with characters, plots, settings, and themes that are sacramental (sensible + holy) in form, and which involve both the "grotesque" as well as common elements of blood, bread, and water, each of which has double meanings in her fiction[8]

- the *stinking goodness* of God (the Father), "stinking" understood in the colloquial sense as something foul-smelling and thus contemptible or disgusting, and in the theological sense as involving the process of sanctification through the medium of blood-letting violence, which relates to the ethical and moral conundrums wrought by violence that O'Connor's characters find themselves involved in and often implicated by—and just as often saved as a result of

- the *mad truth* of God (the Holy Spirit) through the mysterious, often foolish-sounding pronouncements and superstitious beliefs of O'Connor's characters, which account for much of the dark humor in her fiction[9]

[6]O'Connor's stories increasingly take on the form of character studies rather than mere character sketches, due in part, I believe, to von Hügel's continued insistence on the cost of belief, which requires that greater attention be placed on the *character* of the characters themselves. We see this in the general rounding out of O'Connor's characters in her later work: the difference between Bevel's parents in "The River" and Sheppard in "The Lame Shall Enter First," or Ruller in "The Turkey" and Manley in "An Afternoon in the Woods," or between Motes and Tarwater.

[7]This makes sense too, given the church's historical insistence that the transcendentals are not entities in themselves but are rather characteristics of God's essential nature.

[8]In another passage about the uses of distortion, O'Connor says that the writer who appreciates the mystery of existence is "looking for one image that will connect or combine or embody two points; one is a point in the concrete, and the other is a point not visible to the naked eye, but believed in by him firmly, just as real to him, really, as the one that everybody sees" (*MM*, 42).

[9]There is a risk in oversystematizing any interpretive approach, but at least in this particular case, none of these distinctions are, I believe, contrived. Take, for example, the inclusion of the three persons of the Godhead into the three-tiered scheme (Son, Father, Holy Spirit). Had it merely been a convenient rhetorical device to designate a person to each of the three elements, it would be a theological contrivance.

O'Connor considered her vocation as a writer to be prophetic, and she was not ignorant of either the role to which prophets were called or to the reception that they typically received as a result of embodying such a role— nor was she reluctant to have both role and reception meted out in her prophetic characters. In *The Violent Bear It Away*, the old prophet Mason Tarwater tells his atheist/agnostic and thoroughly modern nephew Rayber, "THE PROPHET I RAISE UP OUT OF THIS BOY WILL BURN YOUR EYES CLEAN." This boy-prophet is the protagonist Francis Marion Tarwater, whose own ambivalence about his calling forms the backbone of the plot line. His ambivalence is understandable, of course, given the treatment prophets typically receive at the hands of human beings and of God—not to mention of O'Connor.

In O'Connor's moral universe, being burned is an occupational hazard for a prophet, who is alternately a fire-breathing or brimstone-talking incendiary device for Jesus. In fact, burning functions as a trope in O'Connor's material and is used to indicate when a true subversion (read *conversion*) is taking place. God's mercy burns to salvific effect. There is a *cost* to following Christ in his "bleeding stinking mad shadow."

Prophets, however, are not the only ones in O'Connor's stories who feel the "costingness" (von Hügel's word) of following in Christ's shadow. Simple followers of Jesus, and often reluctant and even unwitting ones at that, are introduced to the high cost of following in Jesus' shadow, whether that entails their own drowning/baptism, or being introduced to the business end of a bull's horn for the sake of a "last discovery," or finding themselves in a hog sty, being blasted by a vision that forced them to reconsider the point and purpose of their entire life. God breaks into O'Connor's stories on a regular basis— only it doesn't often look like it is God doing the breaking in—and it is in this

But von Hügel himself explicitly calls for such divisions when he insists that "such a designation is one of the oldest and most universal Christian approaches to this mystery [of the Trinity], to conceive it under the analogy of the three powers of the soul. God the Father and Creator is conceived as corresponding to the sense-perception and Imagination, to Memory-power; God the Son and Redeemer, as the Logos, to our reason; and God the Holy Spirit, as corresponding to the effective-volitional force within us" (*The Mystical Element in Religion as Studied in Saint Catherine of Genoa and Her Friends* [London: J. M. Dent & Sons, 1923], 66). I have also found that each of these three aspects of God can be quite seamlessly represented by one of the characters: God's terrible beauty in Bishop, God's violent goodness in young Francis, and God's foolish truth in Old Mason. Such a schema nonetheless can serve as an interpretive lens through which the story's meaning can be grasped.

cataclysm of realities, at that "peculiar crossroads where time and place and eternity somehow meet," that O'Connor created.[10] Though they rarely just meet. They usually collide.

Take, for instance, one of the main conflicts in the story centering on a Frostian decision regarding which of two roads Francis should take: the well-trod and easy road of modernity, or the treacherous and narrow road of the prophet. He eventually makes his choice, but it is not altogether clear if he makes this decision or if it is made for him. Whatever young Tarwater seems to do in the novel, he seems to do either in spite of himself or at the direction of some unbidden impulse, or because he's drunk (and this from the young man who boasts that at least he can *act*). The reader, of course, cannot blame the boy for his primal confusion, and yet we as readers know which way he will choose—which he is, in fact, fated to choose. Neither road is particularly inviting, but the road of a prophet is least attractive because it carries with it about three millennia of baggage:

> He knew that he was called to be a prophet and that the ways of this prophecy would not be remarkable. His black pupils, glassy and still, re-flected depth on depth his own stricken image of himself, trudging into the distance in the bleeding stinking mad shadow of Jesus, until at last he received his reward, a broken fish, a multiplied loaf. The Lord out of dust had created him, had made him blood and nerve and mind, had made him to bleed and weep and think, and set him in a world of loss and fire all to baptize one idiot child that He need not have created in the first place and to cry out a gospel just as foolish.[11]

O'Connor's authorial voice is rife with implicit irony in this passage. Fourteen-year-old Francis is trying to come to terms with the profundity of his calling to be a prophet, acknowledging all the while the Lord's claim on his life and on his own dusty beginnings out of which the Lord had created him. He accepts that he has been made "blood and nerve and mind" and has been set in "a world of loss and fire." All this, for a teenage boy who can't even enjoy the vagaries of puberty. Such a scene would normally elicit sym-pathy from the reader, particularly if rendered in the words of another writer,

[10]*MM*, 59.
[11]*VBA*, 91.

but the reader who is aware of O'Connor's theo-literary *modus* understands that she happily places the boy in this predicament and is entirely sympathetic to the severity of his calling, no matter how difficult or agonizing it might be. O'Connor uses the word *knew* at the beginning of the passage to indicate the factual status of this calling—Tarwater *really* has been called to be a prophet—and discerning readers understand this because O'Connor herself acknowledged in her letters "the point of significance of what Tarwater sees" and says that she identifies with Francis, going so far as to claim that she "would have done everything he did. Tarwater is made up out of my saying: 'What would I do here?'"[12] The author and character are thus spiritually one; young Tarwater is O'Connor's "incarnated" self.

The question of identity looms large over this story, and it becomes particularly nettling for Francis because he is already in the throes of adolescent development at fourteen. He must move beyond such concerns, however, because he has much bigger existential fish to fry. Should he move gracefully into twentieth-century modernity or languish in his bloodline's atavistic instincts? Should he stay in the country or strike out for the city? And how much control, after all, does he even have over these decisions? The boy is understandably vexed and angry. But these are just the beginning of his concerns. Francis is forced to decide not so much whether he will become a believer in God but whether he will become a martyr for him. He isn't merely in the line of Tarwaters destined to live their days out in some backwater shanty, distilling scatological prophecies and cheap moonshine. He is a direct descendant of Moses, Elijah, and Daniel, which makes his a divine summons of biblical proportions.

And so he must decide, first of all, Who am I? Or, more properly, Whose am I? Rayber's or Old Man Tarwater's? God's or the devil's? In a letter to John Hawkes, O'Connor indicates the critical imperative of such a choice, particularly within the structure of a novel:

> I don't think you should write something as long as a novel around anything that is not of the gravest concern to you and everybody else and for me this is always the conflict between an attraction for the Holy and the disbelief in it that we breathe in with the air of the times. It's hard to believe always but more so in the world we live in now. There are some of us who have to pay for our faith

[12]HB, 328, 358.

every step of the way and who have to work out dramatically what it would be like without it and if being without it would be ultimately possible or not. I can't allow any of my characters, in a novel anyway, to stop in some halfway position . . . everything works towards its true end or away from it, everything is ultimately saved or lost.[13]

Thomas Merton strikes at the heart of Francis's choice in his depiction of the characters the boy has to choose between, each of whom represents a distinct destiny:

Flannery's people were two kinds of very advanced primitives: the city kind, exhausted, disillusioned, tired of imagining, perhaps still given to a grim willfulness in the service of doubt, still driving on in fury and ill will, or scientifically expert in nastiness; and the rural kind: furious, slow, cunning, inexhaustible, living sweetly on the verge of the unbelievable, more inclined to prefer the abyss to solid ground, but keeping contact with the world of contempt by raw insensate poetry and religious mirth: the mirth of a god who himself, they suspected, was the craftiest and most powerful deceiver of all.[14]

And yet, it must be acknowledged that this strain of prophetic identity, which runs throughout the novel, is not where the heart of the crisis for Francis finally rests. It is elsewhere, in a deeper theological conundrum that will manifest itself at the climactic scene of Bishop's baptism. For now, it is enough to say that one of the main tensions in the novel relates to Tarwater's identity and which road he will take to find it.

THE SUBVERTED TRANSCENDENTALS
IN *THE VIOLENT BEAR IT AWAY*

The Violent Bear It Away ends where it begins, at Old Mason Tarwater's grave, which serves to illustrate O'Connor's biblical eschatology, where the beginning is prefigured in the end and time bends back on itself.[15] The reader is thus left to ponder what would have happened if Tarwater had simply been obedient to his call as a prophet and buried his great-uncle under the sign of a cross. Simple

[13]*HB*, 349-50.

[14]Thomas Merton, *The Literary Essays of Thomas Merton* (New York: New Directions, 1985), 159.

[15]The novel itself is constructed in a sort of eschatological architecture, with the first and last sections happening in "real time" and the middle sections taking us backward and forward in time. The central action of the novel (minus the flashbacks) happens over the course of seven days—an intimation of Holy Week, perhaps.

obedience would have spared the life of his cousin, the near-death experience of his uncle, and his own sexual victimization. And yet, the novel ends with the salvation of two of the three of them and the possible redemption of the third, which O'Connor did not entirely discount. This unblinking perspective on the wuthering road to salvation, which seems always to lead through the valley of the shadow of death, is the severe mercy of O'Connor's God, which subverts the impulses of the world's—and often the church's—well-intentioned but sentimental sympathies. It is a severity that does not submit to rational inquiry because it is love, and this fiery love of the Lord is visited especially on those whom he loves—his disciples, his prophets, and his saints—that is, his adopted children. This is the substance of faith and, as such, "it is the beginning," O'Connor wrote, "not the end, of the struggle to make love work."[16]

EXCURSUS: THE SUFFERING OF THE ELECT IN O'CONNOR

O'Connor writes in a letter to Betty Hester, "It has always seemed necessary to me to throw the weight of circumstance against the character I favor. The friends of God suffer, etc. The priest is right, therefore he can carry the burden of a certain social stupidity. This may be something I learned from Graham Greene . . . or it may just be instinct. Anyhow, it seems to me proper."[17] O'Connor also mentions St. Catherine of Genoa in the same letter, and had mentioned von Hügel in another a few days before, which tells me that von Hügel was not too far from her mind, and that, perhaps, *he* too might have been the reason for this instinct, which was developed later and more fully in the character of Bishop (see below). The implications of this for Kant's aesthetics are also notable, particularly as Kant understands the "dynamically" sublime. The main difference between O'Connor's more severe aesthetic posture and Kant's more reasonable approach is that Kant did not account for the role of divine love in the aesthetic transaction (of the sublime)—or what I am calling the terrible beauty of God—which led him (I believe) to erroneously hold reason as an epistemic necessity in apprehending the sublime.

One spurious effect of Kant's position is the logical conclusion that young children (or the mentally handicapped—young Bishop fits both descriptions)

[16]HB, 93.
[17]Ibid., 120-21.

are necessarily less able to apprehend or experience the sublime. And yet, the capacity for awe and wonder is heightened, not diminished, in childhood, as von Hügel insists:

> I am struck too at how the little regarded, the very simple, unbrilliant souls—souls treated by impatient others as more or less wanting, are exactly pretty often specially enlightened by God and specially near to Him. And there, no doubt, is the secret of this striking interconnection between an apparent minimum of earthly gifts and a maximum of heavenly light. The cause is not that gifts of quick-wittedness, etc., are bad, or are directly obstacles of Grace. No, no. But that quite ordinary intelligence—real slowness of mind—will often do as reflections of God's light, and that such limitations are more easily accompanied by simplicity, naïveness, recollection, absence of self-occupation, gratefulness, etc., which dispositions are necessary for the soul's union with God.[18]

Bishop illustrates the very conditions to which von Hügel testifies—to the simpleminded emanating God's light—in the fountain scene where, quite literally, Bishop reflects the light of heaven:

> A blinding brightness fell on the lion's tangled marble head and gilded the stream of water rushing from his mouth. Then the light, falling more gently, rested like a hand on the child's white head. His face might have been a mirror where the sun had stopped to watch its reflection.[19]

Bishop also shows his capacity for innocent wonder, as when he is walking through a forest with his father:

> The forest rose about him, mysterious and alien. . . . Bishop could barely walk for gaping. He lifted his face to stare open-mouthed above him as if he were in some vast overwhelming edifice. His hat fell off and Rayber picked it up and clamped it on his head again and pulled him on. Somewhere below them out of the silence a bird sounded four crystal notes. The child stopped, his breath held.[20]

Would it be too much to suggest that von Hügel's reflections served as O'Connor's inspiration for Bishop?

[18]*Letters,* 159.
[19]*VBA,* 164.
[20]Ibid., 184.

The central premise of this study, that the character of God is manifested in O'Connor's stories in the three paradoxical tensions of his terrible beauty, violent goodness, and foolish truth, does not depend on the assumption that O'Connor used such an approach deliberately in writing her stories. She may have, but even if she did not, this interpretive filter still provides a way for the reader to approach her stories. Either way, O'Connor's thoroughgoing familiarity with Scripture, patristic and medieval theology, and literature—and the attendant uses of religious typologies and medieval hermeneutical structures in the last three—is beyond dispute.[21] The stated purpose of her fiction was "to show the action of God's grace in territory held largely by the devil."[22] The three-tiered anagogical approach (using the lens of the terrible beauty, violent goodness, and foolish truth of God) intends to complement O'Connor's purpose in a double way by (1) lending a sympathetic ear to its implicit premise, which is that the *action* of God's grace, and not the territory held by the devil, is where the central conflict lies;[23] and (2) that the three paradoxical tensions not only eclipse all finite notions of beauty, goodness, and truth but also, finally, *redeem* them.

In drawing such attention to the transcendentals, I run the risk of ignoring O'Connor's own ambivalence about them: "Truth, Goodness, and Beauty are abstractions and abstractions lead to thinness and allegory whereas in good fiction and drama you need to go through the concrete situation to some experience of mystery."[24] I share O'Connor's ambivalence and so, following her and von Hügel's lead, opt for the more concrete—even biblical—equivalents to express the same, where the grotesque often represents God's material beauty; violence, the earthly manifestation of God's divine goodness; and the foolish pronouncements of the characters, God's truth.[25] Such paradoxical

[21]See Donald E. Hardy, *The Body in Flannery O'Connor's Fiction: Computational Technique and Linguistic Voice* (Columbia: University of South Carolina Press, 2007), 7-13.

[22]*MM*, 18.

[23]"So that while predictable, predetermined actions have a comic interest for me, it is the free act, the acceptance of grace particularly, that I always have my eye on as the thing which will make the story work" (ibid., 115), and "When you write about backwoods prophets, it is very difficult to get across to the modern reader that you take these people seriously, that you are not making fun of them, but that their concerns are your own and, in your judgment, central to human life" (204).

[24]*HB*, 520.

[25]I am not suggesting that all manifestations of the grotesque, violent, or foolish in O'Connor's fiction (or in the Bible's stories, for that matter) have a divine referent or purpose, but only that God's beauty, goodness, and truth often wear such disguises.

pairings of opposites represent, after all, biblical binaries themselves (1 Sam 16:7; 1 Cor 1:18-31; 1 Pet 3:3-4; Rev 19:11-16). O'Connor's creative instinct to embody these abstract ideas in their earthly, tangible, even paradoxical incarnations is central to her method, and as we have seen, it is an instinct she attributes directly to von Hügel.[26] O'Connor's theology, in other words, is crucial in understanding her unconventional literary aesthetic of violence and the grotesque.

The terms *grotesque, violence,* and *foolishness,* in other words, are not abstractions like *beauty, goodness,* and *truth.* Two people might reasonably bicker over what is good, but it is easier to imagine their reaching a fairly quick consensus about what is violent (even if they disagree over the relative merits of that violence). Likewise, we know what is foolish almost immediately, which is why farcical comedy translates so easily from one culture to the next. As for the grotesque, O'Connor populated her stories with freaks, with the maimed and the insane, the lowly and discarded, with people on the margins, and with the obviously disfigured emotionally or physically and, almost always, spiritually. The metaphysics of why this is so—that we intrinsically recognize violence, foolishness, and ugliness more readily than we do abstractions like goodness, truth, and beauty—points not only to the Platonic idea that we see the material appearance or shape (*physis*) of existence and not their perfect forms, but to the Pauline insistence in Scripture that now we only see dimly through a mirror (1 Cor 13:12). Or as O'Connor put it, "Though the good is the ultimate reality, the ultimate reality has been weakened in human beings as a result of the Fall, and it is this weakened life that we see."[27] But this, of course, is only half the story when it comes to O'Connor's approach, whose paradoxical intent was to show that in this weakened life that we're forced to contend with, those things that are "obviously" grotesque, violent, and foolish are, more often than we are willing to admit, the earthly manifestations of their divine extensions: the beauty, goodness, and truth of God.[28]

[26]In von Hügel's seminal study of St. Catherine of Genoa in *The Mystical Element of Religion,* he writes about her proclivity toward violent imagery (seen especially in her *Treatise on Purgatory*), a proclivity mirrored in O'Connor's own narrative structure and one that plays a crucial role in her theology of purgatory, which is operative in virtually all of her stories.

[27]*MM,* 179.

[28]A particularly rich letter that offers us an unobstructed view of the deep theological commitments that O'Connor infused into her writing was written to Shirley Abbott in March of 1956. In the letter, O'Connor shares her belief that a writer's moral and dramatic senses "must coincide" and that she knows only one

Table 3 more clearly lays out von Hügel's three elements as I am relating them to the subverted nature of beauty, goodness, and truth in *The Violent Bear It Away* and to the three ideas of von Hügel's that O'Connor found so salutary. I include, also, the three church doctrines that O'Connor refers to when she is attempting to sum up Catholic belief—sin, redemption, and judgment—which, along with the incarnation, form the theological frame through which O'Connor expressed her theological commitments.

Table 3. Theological-literary framework in *The Violent Bear It Away**

Sacramental/ Institutional Element	Ethical/Mystical Element	Intellectual Element
beauty	goodness	truth
"grace through nature"; creation/fall/sin	"costingness"; redemption	"mystery"; judgment
"bleeding"	"stinking"	"mad"
"blood"	"nerve"	"mind"
"bleed"	"weep"	"think"

*The terms *bleeding, stinking, mad*, etc. are lifted directly from the passage in *The Violent Bear It Away* that serves as the epigraph of this study.

For the sake of consistency and clarity, my analysis of *The Violent Bear It Away* examines the three tensions in this order:

1. The tension of God's terrible beauty, which is related to von Hügel's idea that the highest realities are expressed in the lowest forms;

2. The tension of God's violent goodness, which is related to the "costingness" of the Christian life about which von Hügel so often wrote;

3. The tension of God's foolish truth, which is related to von Hügel's repeated insistence that at the center of our faith is a mystery, and that without mystery there is no faith.

way do to this: "Let me make no bones about it: I write from the standpoint of Christian orthodoxy" (*HB*, 147). She writes, she says, "with a solid belief in *all* the Christian dogmas" (emphasis hers) and that this actually increases her field of vision, it does not limit it. For O'Connor, the dark (dramatic) and holy (moral) belong together and cannot be rent asunder, lest one is left with either gratuitous violence on the one hand (nihilism) or religious sentimentality on the other (mainline liberal Christianity).

With the scaffolding of O'Connor's theo-literary scheme in place, we can now turn to a more direct anagogical interpretation of the novel.[29]

THE TERRIBLE BEAUTY OF GOD

Psalm 29 is a hymn to God's awful majesty, to what the second verse calls "the beauty of his holiness" (בהדרת קדש), which is described as the glory of God that thunders on the waters, whose voice of splendor is an earthquake that breaks the cedars of Lebanon and makes mountains skip like a wild ox, or again whose voice splits the flames of fire and shakes the wilderness and makes the oak trees writhe and strips the forests bare. God's beauty is something to behold, even to fear and hold in reverence. It is, above all, a divine mystery whose contours do not fall easily along the lines of symmetry and proportion.

That Bishop is an emblem of divine beauty is lost on most of O'Connor's audience because of its collective inability to see through and past such categories of beauty.[30] We have been convinced by our enlightened and classical (and to a lesser extent, medieval) forebears that beauty is exclusively related to a predetermined set of coordinates or fixed points, or to the pleasure that beauty brings (*id quod visum placet*, according to St. Thomas). This inability to see past such strictures is tied to (and in accordance with) O'Connor's notion that one must be sufficiently tutored in the "good"—indeed, to be good in oneself—to be able to see or apprehend true beauty.[31] This dynamic

[29]By *anagogical* I mean what O'Connor meant by the term: "the level which has to do with Divine life and our participation in it" (*MM*, 111).

[30]This inability accords with what Elaine Scarry called, in her Tanner Lecture on Human Values at Yale University in 1998, the second genre of aesthetic mistake, which is "that something from which the attribution of beauty had been withheld deserved all along to be so denominated." Elaine Scarry, *On Beauty and Being Just* (Princeton, NJ: Princeton University Press, 1989), 14.

[31]Aquinas believed that beauty was a kind of knowledge, a way of seeing that had moral implications. O'Connor famously concluded her lamentation of the state of eighth-grade education by cautioning the teacher against devising a curriculum based on what students might best tolerate. "No one asks the student if algebra pleases him or if he finds it satisfactory that some French verbs are irregular. . . . The high-school English teacher will be fulfilling his responsibility if he furnishes the student a guided opportunity, through the best writing of the past, to come, in time, to an understanding of the best writing of the present. . . . And if the student finds that this is not to his taste? Well, that is regrettable. Most regrettable. His taste should not be consulted; it is being formed" (*MM*, 137, 140). C. S. Lewis argues a similar line in *The Abolition of Man* (New York: HarperCollins, 2001) that aesthetic categories must be taught and cannot be relied upon by instinct alone: "I do not believe that instinct is the ground of value judgements" (39). Just like people have to be taught how to *think*, so, too, they must be taught how to *see*; seeing is a moral category too.

is already in play in one of O'Connor's earliest stories, "The Turkey," where Ruller no longer sees the beauty of the forest because he has entered into a willful state of disobedience. Likewise, O'Connor did not expect most of her readers to understand the subversive nature of divine beauty because most of her readers' moral and artistic visions had been separated. The character of Bishop—indeed, most of her characters in this and her other stories—are O'Connor's way of shouting to the hard of hearing and drawing large and startling figures for the almost blind.

In a world where, as O'Connor puts it, "the popular spirit of each suc-ceeding age has tended more and more to the view that the ills and mysteries of life will eventually fall before the scientific advances of man," Bishop can easily be disregarded as nothing more than a mistake—and an uncorrectable one at that, as his father Rayber believes.[32] But in O'Connor's sacramental world, the ills and mysteries of life—or the grotesques like Bishop—are "a reproach, not merely an eccentricity."[33] Bishop and others like him become an indictment of the world's one-dimensional vision of things, and such gro-tesques, "properly understood, measure how far we are displaced from our own spiritual depths."[34]

Bishop's terrible beauty lies in the inexplicable nature of his existence. He seems gratuitous, unnecessary, even superfluous, the product of a deity with too much time on his hands and a dark sense of humor. But when seen in the light that O'Connor intends for the story, he becomes a necessity, not merely as a foil for the development of Rayber's and Francis's characters, but as the measure by which their progress or regress is marked. In one of the more ironic lines in the novel, Rayber states that he has no doubt that Bishop "was formed in the image and likeness of God," by which he means that God must be deaf and mute too.[35] What Rayber doesn't recognize, of course, is that Bishop, being made in the image of God, is of noble stock and divine heritage. It isn't Bishop's limitations that define God, but God's un-limited love that defines Bishop and imbues him with intrinsic and eternal worth. As it happens, Bishop "the idiot" becomes an even more fitting

[32]*MM*, 41.
[33]Ibid., 44.
[34]Jill P. Baumgaertner, *Flannery O'Connor: A Proper Scaring* (Chicago: Cornerstone, 1988), 237.
[35]*VBA*, 113.

symbol of the biblical paradox of beauty and perfection in brokenness, of the fool on the hill who knows more in his ignorance than the chiders do in their worldly wisdom. It is precisely in and through (and because of) Bishop's brokenness that he is redeemed.[36]

O'Connor provides clues of Bishop's true beauty throughout. He sees, for example, beautiful things that others do not—"The child dragged backwards on his hand, always attracted by something they had already passed. Every block or so he would squat down to pick up a stick or a piece of trash and have to be pulled up and along"—which, in O'Connor's aesthetical vision, is an indication not only of Bishop's inherent goodness (by dint of his being imago Dei) but also of his corresponding beauty, since the one (good) is only increased by the other (beauty).[37] Tarwater, on the other hand, "was always slightly in advance of them, pushing forward." He is, in contrast to Bishop, intent on *not seeing*, since to see Bishop for what (and who) he truly is would be to give in to his prophetic calling; prophets are, after all, "realists of distances":

> Bishop looked like the old man grown backwards to the lowest form of innocence, and Rayber observed that [Tarwater] strictly avoided looking him in the eye. Wherever the child happened to be standing or sitting or walking seemed to be for Tarwater a dangerous hole in space that he must keep away from at all costs.[38]

Beauty for O'Connor is as much a matter of *seeing* as what is being seen, and not to see beauty is tantamount to a spiritual blindness, an indication that one could not recognize God in the vestiges of the material world (as we have noted was true of Ruller in O'Connor's story "The Turkey"). In this regard, Rayber is several aesthetic orders of magnitude beneath Tarwater. Rayber had become so inured to the beauty of Bishop that he could afford to look at him most of the time without recognizing anything; *most* of the time . . .

[36]The artist John August Swanson's painting *Jester* renders this dynamic beautifully. While the rest of the circus troupe sleeps on the floor, the jester climbs a ladder to look out the window to the distant stars in all of their beauty and mystery. The fool, in other words, knows more than the wise because his sense of wonder has not died.

[37]Ibid., 108. The transcendentals are a unity.

[38]Ibid., 112.

For the most part Rayber lived with him without being painfully aware of his presence but the moments would still come when, rushing from some inexplicable part of himself, he would experience a love for the child so outrageous that he would be left shocked and depressed for days, and trembling for his sanity. . . . His normal way of looking at Bishop was as an *x* signifying the general hideousness of fate. He did not believe that he himself was formed in the image of God but that Bishop was he had no doubt. The little boy was part of a simple equation that required no further solution, except at the moments when with little or no warning he would feel himself overwhelmed by the horrifying love. Anything he looked at too long could bring it on. Bishop did not have to be around. It could be a stick or a stone, the line of a shadow, the absurd old man's walk of a starling crossing the sidewalk. If, without thinking, he lent himself to it, he would feel suddenly a morbid surge of the love that terrified him—powerful enough to throw him to the ground in an act of idiot praise. It was completely irrational and abnormal.[39]

O'Connor's entire aesthetic approach is wrapped up in that passage, and it challenges the classical and modern notions of beauty as something that only brings pleasure: "a stick or a stone, the line of a shadow, the absurd old man's walk of a starling crossing the sidewalk" are not conventional images of beauty, and yet it is only this kind of beauty, in all of its divine and earthly permutations, that can elicit a corresponding "horrifying love" that leads to "an act of idiot praise." To be sure, Aquinas, O'Connor's erstwhile aesthetic mentor (via Maritain), is in fact credited with codifying the connection between beauty and pleasure, but Aquinas's notion of what accounted for pleasure, it seems to me, is more in line with Rudolf Otto's concept of *mysterium tremendum et fascinans* than with the more conventional idea of pleasure as something entirely pleasant.[40]

[39]Ibid., 113.

[40]Otto's famous phrase is easily misunderstood, though it is succinctly defined in the following two passages: in the first where he more fully tries to absorb its essential effect, and in the second where he compares and contrasts the phrase with Kant's notion of sublimity.

It may burst in sudden eruption up from the depths of the soul with spasms and convulsions, or lead to the strangest excitements, to intoxicated frenzy, to transport, to ecstasy. It has its wild and demonic forms and can sink to an almost grisly horror and shuddering. It has its crude, barbaric antecedents and early manifestations, and again it may be developed into something beautiful and pure and glorious. It may become the hushed, trembling, and speechless humility of the creature in the presence of—whom or what? In the presence of that which is a *Mystery* inexpressible and above all creatures.

Aquinas's hymn *Pange Lingua Gloriosi Corporis Mysterium* (Of the glorious body telling) expresses the mystery of the Catholic doctrine of transubstantiation and hints at Aquinas's approach to divine beauty:

> He, the Paschal Victim eating,
> first fulfils the Law's command;
> then as Food to His Apostles
> gives Himself with His own Hand.[41]

The full hymn (see addendum) provides an insight into O'Connor's own intention of rendering Bishop as a "Christ image," which she indicated in a letter to Hester in 1956: "In my novel I have a child—the school teacher's boy—whom I aim to have a kind of Christ image, though a better way to think of it is probably just as a kind of redemptive figure."[42] Aquinas understood the terrifying aspect of the Word made flesh that would cause "the heart in earnest" to fall "down in adoration," and this same "terrible . . . vision" occurs in relation to Bishop at the fountain (font) in the city park:

> [Rayber] stood arrested in the middle of a step. His eyes were on the child in the pool but they burned as if he beheld some terrible compelling vision. The sun shone brightly on Bishop's white head and the little boy stood there with a look of attention. Tarwater began to move toward him.
>
> He seemed to be drawn toward the child in the water but to be pulling back, exerting an almost equal pressure away from what attracted him. . . . Rayber had the sense that he was moving blindly, that where Bishop was he saw only a spot of light. He felt that something was being acted before him and that if he could understand it he would have the key to the boy's future.[43]

This will be all the more true if the uncomprehended thing is something at once *mighty* and *fearful*, for then there is a twofold analogy with the numinous—that is to say, an analogy not only with the 'mysterium' . . . but with the 'tremendum' aspect, and the latter again in the two directions already suggested of *fearfulness* proper and *sublimity*.

From Rudolph Otto, *The Idea of the Holy*, trans. John W. Harvey, 2nd ed. (London: Oxford University Press, 1950), 13, 66. The significance of the first passage's "speechless humility" might be appropriately applied to Rayber's reaction to the death of Bishop as an indication of the beginning of a conversion in him, rather than his inability to respond being an indication of his reprobate status (according to many critics).

[41]This hymn includes the *Tantum Ergo*, often sung in liturgical services today at the Benediction of the Blessed Sacrament.

[42]*HB*, 191.

[43]*VBA*, 145-46.

In glimpses throughout, but particularly at the end of the novel, Francis is both haunted and blessed by this tension of terrible beauty, not only as it is portrayed in Bishop, but also as it manifests itself in nature.[44] Nature becomes a contender for the reluctant prophet—the moon, the sun, the trees, and the shadows—all somehow part of a conspiracy for Francis's will. The riot of color and nature imagery in the last fifty pages is conspicuous, and when Francis finally succumbs to his fate, nature itself seems to respond with a resplendent benediction, tinged always, of course, with dark and light imagery and pyrotechnic portent:

> From time to time he plunged the torch into a bush or tree and left it blazing behind him. The wood became less dense. Suddenly it opened and he stood at its edge, looking out on the flat cornfield and far across the two chimneys. Planes of purpling red above the treeline stretched back like stairsteps to reach the dusk. . . .
>
> He whirled toward the treeline. There, rising and spreading in the night, a red-gold tree of fire ascended as if it would consume the darkness in one tremendous burst of flame. . . .
>
> By midnight he had left the road and the burning woods behind him and had come out on the highway once more. The moon, riding low above the field beside him, appeared and disappeared, diamond-bright, between patches of darkness. Intermittently the boy's jagged shadow slanted across the road ahead of him as if it cleared a rough path toward his goal.[45]

Two of the most beautiful and arresting passages in the novel occur just as Francis and Bishop are leaving in the boat, and they effectively serve as the backdrop for the little boy's sacramental death:

> Part of a red globe hung almost motionless in the far side of the lake as if it were the other end of the elongated sun cut through the middle by a swath of forest. Pink and salmon-colored clouds floated in the water at different depths. . . .

[44]In many instances where nature is portrayed in the novel, it is layered with an implied threat—as the opening lines of the final chapter illustrate, where every line hums with a sense of the sublime and ominous.

[45]Ibid., 238, 242, 243. I am struck by O'Connor's use of the adjective *rough* to describe the path Tarwater is on, with "his face set toward the dark city, where the children of God lay sleeping" (243). Tarwater is Yeats's "rough beast" in "The Second Coming," with "A gaze blank and pitiless as the sun" who "Slouches towards Bethlehem to be born." O'Connor wrote a letter to Hester in 1955, a year or so after she'd begun work on *The Violent Bear It Away*, in which she describes her approach to writing: "I believe there are many rough beasts now slouching toward Bethlehem to be born and that I have reported the progress of a few of them" (*HB*, 90).

The boat with the two of them in it was near the middle of the lake, almost still. They were sitting there facing each other in the isolation of the water, Bishop small and squat, and Tarwater gaunt, lean, bent slightly forward, his whole attention concentrated on the opposite figure. They seemed to be held still in some magnetic field of attraction. The sky was an intense purple as if it were about to explode into darkness.[46]

Nature is on the edge of her seat. Everything, even the sun, is motionless, still. The conflation of the imagery of the sacrament of baptism with the crucifixion is palpable here. An innocent is about to be put to death, but—one must hesitate to conclude this too quickly—simultaneously to be given new life.

And like the limp that Jacob earns in his battle with the angel, even the scars that Francis earns in the battle against God become badges of divine solidarity: Francis's unquenchable hunger and thirst, his violated body, are but signs of the sacrificial obedience that God demands of his saints. In what serves as the epigraph of this chapter and must have been a seminal passage for O'Connor in von Hügel's *Letters* (she underlines a portion of it in her own copy), he warns his niece Gwen of the same terrible beauty that awaits (and inheres in) the life of a believer: "It is, really, a very hideous thing; the full, truly free, beauty of Christ alone completely liberates us from this miserable bondage [of the heathen philosophies]."[47]

In his *Institutes*, John Calvin makes a similar point about the beauty (splendor) of God in the presence of his saints:

> Hence that horror and amazement with which the Scripture always represents the saints to have been impressed and disturbed, on every discovery of the presence of God. For when we see those, who before his appearance stood secure and firm, so astonished and affrighted at the manifestation of this glory, as to faint and almost expire through fear.[48]

In two separate letters to Ted Spivey, written a year apart, O'Connor refers to *The Violent Bear It Away* as both "a hymn to the Eucharist" and as a novel "built around a baptism."[49] *The Violent Bear It Away* was clearly informed by

[46]*VBA*, 197-99.

[47]*Letters*, 65. I call it "seminal" because it manages to combine all three elements of the terrible beauty, violent goodness, and foolish truth of Christianity in four lines.

[48]John Calvin, *Institutes of the Christian Religion (Book One)*, trans. John Allen (Philadelphia: Philip Nicklin, 1816), 48.

[49]*HB*, 341, 387.

O'Connor's views of the sacraments, which in turn offer a key not only to her thoroughly sacramental vision of the world as it is expressed in her stories, but to her sense of God as well, who she believed could only be understood in incarnated form: grace through material. The only truth we know, she insisted, is incarnated truth, and her approach to writing exemplified this incarnational sensibility: "When fiction is made according to its nature," she wrote, "it should reinforce our sense of the supernatural by grounding it in concrete, observable reality."[50] But when one ventures into the world of *things*—of physical realities and mercurial weather, backwoods prophets and idiot children—one ventures into a world of suffering and violence, of unpleasantness and doubt, where things break and dissolve. And yet, it is only in and through this broken world that glimpses of God can be seen and heard, just as it is only through water, bread, and wine that the sacraments are rightly administered; just as it is principally on the cross that Jesus' love is most deeply felt and his person most distinctively known: "No matter how you read it," Jill Baumgaertner writes, "the gospel contains birth in a cold, dirty stable and violent death on Golgotha."[51]

But that is not all it contains. Marilyn McEntyre, in an essay titled "Mercy That Burns: Violence and Revelation in Flannery O'Connor," suggests another side to this reality: "It is worth noting that O'Connor specifically suggests an observable relationship between ugliness and sin and between beauty and grace, but her reframing of those terms is so complex that both aesthetic and moral judgments are surprisingly realigned"[52]

O'Connor's exalted prose is fitted to its subject: the images of blood and fire in red and gold, of bursts of flame and the dirt of a grave, of seeds opening in one's veins . . . all of these images speak to the sacramental nature of the divine summons, first in forgiveness, and then into mission. Francis *can* act, it turns out, but only with either the Spirit's help or the devil's encouragement.

In the end, nature and nurture conspire together to realize O'Connor's purposes for the novel. Nature's splendor crackles and shines from the page, but it is Bishop who represents the handiwork of God in its rawest form,

[50]*MM*, 148.
[51]Baumgaertner, *Flannery O'Connor*, 26.
[52]Marilyn McEntyre, "Mercy That Burns: Violence and Revelation in Flannery O'Connor," *Theology Today* 53, no. 3 (Fall 1996): 332.

nature untainted by deliberate, willful sin, unable to hurt anyone. Young children (preadolescent) and the mentally disabled are often portrayed in literature as the divine image in human form, as angels in disguise, since for their entire lives they essentially remain the way that they were created, and thus the normal processes of redemption and sanctification do not seem to apply. And even though the novel's explicit purpose revolves largely around the necessity of young Bishop's baptism—a necessity that was absolutely crucial to O'Connor's Roman Catholic theology—his *effectively* being born into a state of primal innocence is part of God's divine calculus, which subverts as it perplexes. Bishop is, *in effect*, trapped in the innocence of a redeemed state while, at the same time, beheld by the world as suffering from a cruel fate. For this reason, Bishop is not merely a Christ figure but, more properly, a *cross* (or crucified) figure, and it is precisely the immediacy of Bishop's condition in relation to God's creative action in the world that accounts for the tension of terrible beauty in *The Violent Bear It Away*.

THE VIOLENT GOODNESS OF GOD

"THE PROPHET I RAISE UP OUT OF THIS BOY WILL BURN YOUR EYES CLEAN." This capitalized line occurs twice in the novel, both times directed at Rayber by Mason Tarwater.[53] Prophets generally do not escape the wrath they preach on others. In O'Connor's stories, in fact, it is more frequently the prophets, rather than those to whom they prophesy, who find themselves in the line of God's fire:

> The old man, who said he was a prophet, had raised the boy to expect the Lord's call himself and to be prepared for the day he would hear it. He had schooled him in the evils that befall prophets; in those that come from the world, which are trifling, and those that come from the Lord and burn the prophet clean; for he himself had been burned clean again and again. He had learned by fire.[54]

A cost is paid in any personal encounter with the living God of Abraham, Isaac, and Jacob, who calls his people to obedience and suffering, which is the way of joy in the divine economy. Moses, Noah, Jonah, Jacob, the prophets: all found the divine summons terrible in their exactitude and severity, and God

[53]*VBA*, 76, 147. In every instance in the novel where the word *violent* appears, it is attached to a divine referent.

[54]Ibid., 5.

marked them indelibly and painfully—every one of them—lest they mistake the summons for a spiritual vision of merely allegorical significance, or a ruse of the devil, or a case of the worms. Indeed (O'Connor seems to imply), if this is the God who sent his own Son to die a ghastly death at Golgotha, how can those caught up in the same plan for salvation avoid a similar fate? Toward the end of the novel, Francis begins to understand the existential stakes involved in assuming the prophetic office, how the life of a prophet must involve sacrifice, pain, even death, if one is to reach a state of sanctified grace. The warp and weft of following in the bleeding stinking mad shadow of Jesus offers no easy way, no shortcut to holiness. The recalcitrant and renegade Francis learns something else too: that the more one resists the truth of one's calling, the harder the truth pushes back: "Tarwater learned the hard way but he has a hard head."[55]

The converse is also true: the world is often actually spared the winnowing, cleansing fire of the Lord, but at its own expense. Francis tires of hearing how, when his great-uncle was a young man, he had busied himself proclaiming the destruction of the world, only to be left with a world intact, rising "every morning, calm and contained in itself."[56] And when the prophesied fire finally came, it came for Mason, not for the world, and it burned him body and soul.

This ironic reversal often leads to a misunderstanding of the countervailing thematic tensions rife in O'Connor's stories. In his essay "The Outside and the Inside: Flannery O'Connor's *The Violent Bear It Away*," Sumner Ferris interprets the novel from the perspective of a clear binary, "that of the believer and that of the unbeliever, the violent and the passive, the saved and the damned."[57] By insisting on such a clear-cut dualism, however, Ferris is forced to conclude not only that Rayber creates "a hell for himself through his denial, a hell of vacuity, the awful state of the spiritual trimmer deprived equally of torment and grace," but also that "Tarwater's rejection of God is more violent and less pharisaical than Rayber's" and

[55]Jean Cash, *Flannery O'Connor: A Life* (Knoxville: University of Tennessee Press, 2004), 332.

[56]Ibid. This same dynamic is present in Romans 1, where the *absence* of God's action leads to destruction: "Therefore God gave them up to their passions." This same passage in Romans also points to the reversal of wisdom and foolishness, where a sort of reverse theological osmosis occurs when one is abandoned to one's own proclivities, to one's personal freedom.

[57]From Sumner Ferris, "The Outside and the Inside: Flannery O'Connor's *The Violent Bear It Away*," *Critique: Studies in Modern Fiction* 3, no. 2 (1960); included also in *The Critical Response to Flannery O'Connor*, ed. Douglas Robillard (Westport, CT: Greenwood, 2004), 53.

"[his] proud rejection of God has excommunicated him from the society of the faithful," thus making his obeying the call to be a prophet at the end of the novel "a specious one, a capitulation to circumstances rather than to God; for although he has fulfilled God's will, he has rejected God's ways. It is with the passion of fanaticism and despair, not of religion, that, hellfire behind him and darkness before him, he begins to walk back to the city."[58] This conclusion is contradicted by O'Connor, who writes in a letter to Ted Spivey about her second novel in order to "make it clear that Tarwater escapes the Devil by accepting his vocation to be a prophet."[59]

Not only is Ferris's theology inconsistent (Tarwater is in God's will, yet apparently also among the company of unbelievers and the damned), but he misunderstands O'Connor's use of fire and darkness because he cannot see past the reductionist dualism he has created. There is no room in Ferris's interpretive schema for the growth of a character, or for the fires of purgation that burn, not in order to damn but to redeem, and this marks the critical limitation of his interpretation.

In his essay "Dark Night: Dark Faith," Richard Giannone adopts an interpretive approach that creates the same reductive binary as Ferris and, as a result, makes what I believe to be the same mistake. He refers to Haze Motes as an "unbeliever" and equates his and other unbelievers' experiences in O'Connor's stories with "prototypical images of dark, depressed places with [O'Connor's] unbelievers' modern experience of hitting the spirit's bottom. . . . Like Dante's dark pit, O'Connor's inky ditch is filled with judgment and meaning."[60] He tries to nuance this position by claiming that O'Connor's "modern abyss is not devoid of hope," but then immediately claims that in this abyss, Motes carries through "his atheistic task all the way to death at twenty-two."[61] Where is there room in Giannone's vision for the believer's abyss intoned in Psalm 40:1-2 ("I waited patiently for the LORD; he inclined to me, and heard my cry. He drew me up from the desolate pit, out of the miry blog"), or of the mystical darkness invoked in *The Life of*

[58]Ibid., 54, 56.

[59]*HB*, 505.

[60]Richard Giannone, "Dark Night, Dark Faith: Hazel Motes, the Misfit, and Francis Marion Tarwater," in *Dark Faith: New Essays on Flannery O'Connor's "The Violent Bear It Away,"* ed. Susan Srigley (Notre Dame, IN: University of Notre Dame Press, 2012), 8-9.

[61]Ibid., 9.

Moses or *The Cloud of Unknowing*? Giannone equates Motes's "grim mood and determination" with Sartre's "cruel and long-range affair" of atheism and insists that Motes and Tarwater are "ardent, even principled, exponents of nihilism."[62] Such a view runs directly counter, however, to O'Connor's insistence that Motes is "a kind of saint. His overwhelming virtue is integrity," and "Haze is saved by virtue of having wise blood; it's too wise for him ultimately to deny Christ."[63]

Giannone seems able to only understand Motes's and Tarwater's struggles as "the struggling to believe," whereas I want to argue that it is precisely the opposite: theirs is the struggle to *not* believe.[64] In the same letter from O'Connor that Giannone quotes in his essay, Giannone elects to leave out the part where O'Connor, echoing von Hügel, writes, "What people don't realize is how much religion costs. They think faith is a big electric blanket, when of course it is the cross. It is much harder to believe than not to believe."[65]

Giannone's crucial misstep, it seems to me, is in his aligning O'Connor's understanding of divine absence with Nietzsche's death of God, as if both represented "the mystic's dark night." This lack of distinction between the two forces Giannone to the confusing conclusion regarding the journey of the "entrenched" nihilist, namely that

> the torment and desolations of the dark night strengthen the soul through purgation of doubt. The dark night, then, from the standpoint of the mystical desire, is a necessary stage in the growth of spiritual awareness. In the end, the soul surrenders as the crisis passes; the dark night fades; and the spirit moves toward union with God.[66]

This is not the journey of the entrenched nihilist. It is the journey of that beast slouching *toward*, not away from, Bethlehem. In Giannone's accounting of things, integrity in nihilism, impressive unbelief, empathy with unbelievers— each in the end receives the same reward as the faithful. O'Connor, not surprisingly, sees it differently:

[62]Ibid., 11.

[63]*HB*, 89, 350.

[64]Giannone, "Dark Night, Dark Faith," 10.

[65]*HB*, 354; see von Hügel's *Letters*, where he expresses a similar sentiment: "Religion has never made me comfy. . . . All deepened life is deepened suffering" (22).

[66]Giannone, "Dark Night, Dark Faith," 12.

The Christian novelist is distinguished from his pagan colleagues by recognizing sin as sin. According to his heritage he sees it not as sickness or an accident of the environment, but as a responsible choice of offense against God which involves his eternal future. Either one is serious about salvation or one is not.[67]

To be sure, O'Connor calls Haze Motes an "admirable nihilist" in one of her letters, but she then quickly adds that "his nihilism leads him back to the fact of his Redemption."[68] Francis, Haze, and even Rayber, all accused of nihilism by a good number of O'Connor critics, are rather, I believe, in varying states of purification *from* nihilism toward salvation.[69] O'Connor would not have been interested in a pure nihilist, nor would she have known what to do with one if she'd met him. She herself was accused of being a "hillbilly nihilist," an accusation she famously denied by preferring, instead, the moniker "hillbilly Thomist." O'Connor, I have tried to suggest all along, was interested in portraying her characters' struggles with redemption, not with damnation. Take, for example, Rayber's reaction to the death of Bishop, which I see as an indication of the beginning of a conversion in Rayber rather than his speechlessness being an indication of his reprobate status:

> He stood waiting for the raging pain, the intolerable hurt that was his due, to begin, so that he could ignore it, but he continued to feel nothing. He stood light-headed at the window and it was not until he realized there would be no pain that he collapsed.[70]

Preston Browning considers Rayber's reaction "the absolute desolation of Rayber's soul." If O'Connor had stopped before the final line of this passage, Browning may indeed be right. But O'Connor does not stop there. It is the lack of empathy for this son's death that is simply intolerable for Rayber, and so it is his recalcitrance, and not his soul, that is destroyed in that final sentence. The horror of this realization, in fact, marks the very possibility of his conversion, which speaks to O'Connor's willingness to hold out some hope

[67]*MM*, 167.

[68]*HB*, 70.

[69]Such an insistence (that Francis et al. are nihilists) stems, I believe, from interpreting O'Connor's fiction with a Manichaean dualist template.

[70]*VBA*, 203. See Preston Browning, *Flannery O'Connor: The Coincidence of the Holy and Demonic in O'Connor's Fiction* (Eugene OR: Wipf & Stock, 2009), 82.

for Rayber's eventual redemption. It is true that O'Connor writes in one of her letters that Rayber makes "the Satanic choice," but in the very next line she immediately leaves open the possibility of his conversion: "His collapse then may indicate that he is not going to be able to sustain his choice—but that is another book maybe."[71] I think it is all but certain that he will not be able to sustain his choice, given what O'Connor writes earlier in the novel about Rayber's "terrifying love" for his son:

> He had known by that time that his own stability depended on the little boy's presence. He could control his terrifying love as long as it had its focus on Bishop, but if anything happened to the child, he would have to face it in himself. Then the whole world would become his idiot child.[72]

In a letter to Alfred Corn in 1942, O'Connor includes Christ in the realm of all that Rayber would be forced to love: "He had the idea that his love could be contained in Bishop but that if Bishop were gone, there would be nothing to contain it and he would then love everything and specifically Christ."[73] This, it seems to me, is the central mystery of Rayber's character. Much like Haze Motes and Francis Tarwater, Rayber doth protest too much. He believes in God, which is why he's so angry at him, in the same way that he loves Bishop, which is why he cannot stand him. Rayber is loathe to admit Bishop into his heart lest he is forced to accept his love for the boy, which would be an act of God's mercy, and which, as O'Connor (via von Hügel) makes clear, is a mercy that burns. It is no wonder that Rayber collapses.[74]

This tension of violence as a means of grace, of the "costingness" of following Christ, is evident everywhere in O'Connor's stories, of course, but it is often misunderstood or underrepresented, as if all the violence in her stories is either the work of the devil or of God's making the best of the devil's work.

[71]HB, 484.

[72]VBA, 182.

[73]HB, 484.

[74]O'Connor's characters are usually defined more by what they defy than by what they assent to. Paradoxically, in their defiance they end up assenting even more fully. The more they struggle against the will of God, in other words, the more they end up fulfilling it. Even the Misfit is not an exception in this regard. Most readers assume he represents the devil, in spite of the fact that O'Connor indicates the reverse: "I can fancy a character like the Misfit being redeemable" (HB, 350). Even the last line of the story, spoken by the Misfit, "It's no real pleasure in life," expresses a sense of remorse. Does the devil have remorse?

But O'Connor did not see it in such simple terms. Violence cuts both ways, she believed, depending on who is doing the violating:

> We hear many complaints about the prevalence of violence in modern fiction, and it is always assumed that this violence is a bad thing and meant to be an end in itself. With the serious writer, violence is never an end in itself. It is the extreme situation that best reveals what we are essentially. . . . *Violence is a force which can be used for good or evil,* and among other things taken by it is the kingdom of heaven.[75]

O'Connor is clearly not suggesting that demonic forces are taking the kingdom of heaven; she means that the violent are, who are followers of Christ.[76] Violence is not always—or even usually—a morally pernicious category in O'Connor's theology. By whom and for what purpose such violence is perpetrated makes all the difference to O'Connor's thinking, and I suspect she gets this from Scripture. In Exodus 21:12-13, just after the giving of the Ten Commandments, we read of the statutes concerning violence, and then this: "He that smiteth a man, so that he die, shall be surely put to death. And if a man lie not in wait, but God deliver him into his hand; then I will appoint thee a place whither he shall flee" (KJV).[77] In other words, at times even God, according to his inscrutable providence, ordains the murdering of another (such a murder being referred to as one's "fate" in the Hebrew). This is a hard truth: just the kind, in other words, that O'Connor was constantly incorporating into her artistic vision. Which brings us to the central scene of divine violence in the novel, the drowning-baptism of Bishop.

One cannot help but think of the suffering servant in Philippians 2:8, who "humbled himself, and became obedient to the point of death, even death on a

[75]*MM*, 114; emphasis mine.

[76]Stanley Edgar Hyman believes that O'Connor intended for this passage to mean that "the violent are enemies of the kingdom, capturing it from the righteous" (Stanley Edgar Hyman, *Flannery O'Connor* [Minneapolis. Universtity Minnesota Press, 1966], 24). But if this is what O'Connor intended for the title to mean, much of the book would not make sense. The *violent* in the story are the very ones who believe and preach the gospel, who set fire to the woods, drown children, and shoot people's ears off. Not surprisingly, Hyman's view of violence necessarily leads him to conclude that the Tarwaters, young and old, are crazy. Indeed, is this not what 1 Corinthians 2 is essentially saying by suggesting that what Christians believe to be true is precisely what the world will consider mad?

[77]The NRSV unhelpfully translates the passage, "Whoever strikes a person mortally shall be put to death. If it was not premeditated, but came about by an act of God, then I will appoint for you a place to which the killer may flee," making the divine action sound more like something described in an insurance brochure.

cross." Bishop, O'Connor's suffering servant (the startling grotesque, the dis-
figured figure of the Son), also humbles himself, becoming obedient unto
death.[78] Francis does end up *at* the drowning, of course, but he does not
actively participate in its commission. It is the "idiot child," not Francis, who
has primary agency in the baptism, both at the fountain and in the lake (in the
first instance only attempted, but in the second, actually realized). That
O'Connor repeats the fountain scene, almost word for word in two separate
sections but only twenty pages apart, compellingly points to the eschatological
significance of the event from O'Connor's perspective.[79] When Bishop is
finally baptized, in other words, we must be prepared to be confronted by
eschatological truth, so that the *now* of the boy's death must not trump the *not
yet* of his sealed salvation.

[78]Jill Baumgaertner believes that "Bishop's consent to or understanding of the sacrament is not an issue in
the novel, especially since he is mentally retarded and incapable of understanding the ritual" (Baumgaert-
ner, *Flannery O'Connor*, 183). Baumgaertner's assumption is certainly questionable: Who is to say what
the spirit of a mentally handicapped boy can or cannot understand about the mysteries of the sacrament,
or what the Holy Spirit is capable of allowing a baptized person—handicapped or not, infant or other-
wise—to comprehend? Indeed, aren't the sacraments *sacraments* precisely because they are a suprara-
tional event? Baumgaertner's conviction that Bishop doesn't understand the significance of his baptism
betrays the text of the story. Bishop stood in the fountain, O'Connor writes, "with a look of attention."
When Rayber removes him, the boy howls and bellows, somehow knowing that he has been denied his
spiritual birthright. The words O'Connor carefully chooses in the pivotal scene at the lake are also instruc-
tive. She writes of Bishop's eyes, which for O'Connor were always the door to the soul, that they were
"fixed" on Tarwater's "as if they were waiting serenely for a struggle already determined." Bishop then
throws his hat overboard, indicating his readiness—even impatience—in getting down to business. The
point is, Bishop knows more than Baumgaertner—and others, including Rayber—have assumed.

[79]Why O'Connor would basically plagiarize herself in the second scene raises interesting questions,
and ones that are not easily resolved. The repetition, of course, is purposeful and, as Asals suggests
about her fiction as a whole, may serve an eschatological purpose; see Frederick Asals, *Flannery
O'Connor: The Imagination of Extremity* (Athens: University of Georgia Press, 1982), 3. Her description
in the second scene is worded in such a way as to indicate that the reader has not yet been to this place,
and so it must be described. And yet we have been, twenty pages earlier. The second scene, as it turns
out, is not a second occurrence but a reminiscence of the first and only time they went to the fountain.
We know this because, in both cases, it happens the day after the nighttime tent revival. But
O'Connor's decision to repeat the scene almost word for word serves, I think, a deliberately theo-
logical purpose: to point to the eschatological nature of baptism, the now-but-not-yet initiation of
the believer into the body of Christ, which is meant to impress upon the reader the true significance
of this time-bending sacrament. Meaning that when the deed is finally done in the lake, it is not the
death of Bishop but his rebirth, sealed in his baptism, that is the main action, and the one the reader
should focus on. We should resist the temptation to conclude that O'Connor simply made a mistake
by repeating herself. She labored painstakingly over each word of this novel for nearly eight years. This
repetition of the scene was intentional.

EXCURSUS: THE FOUNTAIN SCENES

FIRST SCENE

They had come out into the center of the park, a concrete circle with a fountain in the middle of it. Water rushed from the mouth of a stone lion's head into a shallow pool and the little boy was flying toward it, his arms flailing like a windmill.[80] In a second he was over the side and in. *"Too late, goddammit,"* Rayber muttered, *"he's in."* He glanced at Tarwater.

The boy stood arrested in the middle of a step. His eyes were on the child in the pool but they burned as if he beheld some terrible compelling vision. *The sun shone brightly on Bishop's white head* and the little boy stood there with a look of attention. *Tarwater began to move toward him.*

He seemed to be drawn toward the child in the water but to be pulling back, exerting an almost equal pressure away from what attracted him. Rayber watched, puzzled and suspicious, moving along with him but somewhat to the side. As he drew closer to the pool, the skin on the boy's face appeared to stretch tighter and tighter. Rayber had the sense that he was moving blindly, that where Bishop was he saw only a spot of light. He felt that something was being enacted before him and that if he could understand it, he would have the key to the boy's future. His muscles were tensed and he was prepared to somehow act. Suddenly his sense of danger was so great that he cried out. In an instant of illumination he understood. Tarwater was moving toward Bishop to baptize him. Already he had reached the edge of the pool. *Rayber sprang and snatched the child out of the water and set him down, howling, on the concrete.*[81]

SECOND SCENE

They had walked deeper into the park and he began to feel again the approach of mystery. He would have turned and run in the opposite direction but it was all on him in an instant. The path widened and they were faced with an open space *in the middle of the park, a concrete circle with a fountain in the center of it. Water rushed out of the mouth of a stone*

[80]Italicized passages indicate similar or identical wording.
[81]*VBA*, 145-46.

lion's head into a shallow pool below and as soon as the dim-witted boy saw the water, he gave a whoop and *galloped off toward it, flapping his arms* like something released from a cage.

Tarwater saw exactly where he was heading, knew exactly what he was going to do.

"Too late, goddamit," the schoolteacher muttered, "he's in."

The child stood grinning in the pool, lifting his feet slowly up and down as if he liked the feel of the wet seeping into his shoes. The sun, which had been tacking from cloud to cloud, emerged above the fountain. A blinding brightness fell on the lion's tangle marble head and gilded the stream of water rushing from his mouth. *Then the light, falling more gently, rested like a hand on the child's white head.* His face might have been a mirror where the sun had stopped to watch its reflection.

Tarwater started forward. He felt a distinct tension in the quiet. The old man might have been lurking near, holding his breath, waiting for the baptism. His friend was silent as if in the felt presence, he dared not raise his voice. *At each step the boy exerted a force backward but he continued nevertheless to move toward the pool.* He reached the rim of it and lifted his foot to swing it over the side. Just as his shoe touched the water, *the schoolteacher bounded forward and snatched the dimwit out. The child split the silence with his bellow.*[82]

The attentive reader sees the final act of Bishop's sacramental death as a culmination, not merely of Francis's calling, but also of nature's—and thus grace's—anointing (von Hügel's "grace through nature"). When Bishop runs to the allegorical baptismal font (fountain) at the center of the park in the first of the two fountain scenes, and he places himself inside the basin in an act of sacred defiance—his head bathed in light as if consecrated—we are made to feel its portentous significance: the heavens themselves are conspiring in a sort of sacramental liturgy.[83] And it is Bishop who, in the final consummation, does not actively resist but instead aids and abets his own salvific demise, and

[82]Ibid., 164-65.

[83]When we are told that "the sun shone brightly on Bishop's white head," O'Connor intends to draw us back to the girl prophet Lucette Carmody's words the night before, "Will you know the Lord Jesus then? The mountains will know Him and bound forward, the stars will light on his head, the sun will drop down at His feet" (ibid., 133).

hardly with Tarwater's consent. Note carefully the sequence of events from the dock to the actual drowning as it is rendered in Tarwater's reminiscence of the event, and note the active and passive roles that each character plays:

> The two were in front of [Rayber] half way down the dock, walking slowly, Tarwater's hand still resting just under Bishop's hat; but it seemed to Rayber that it was Bishop who was doing the leading, that the child had made the capture. . . . They were sitting there facing each other in the isolation of the water, Bishop small and squat, and Tarwater gaunt, lean, bent slightly forward . . . they seemed to be held still in some magnetic field of attraction. . . . [Tarwater] looked through the blackness and saw perfectly the light silent eyes of the child across from him. They had lost their diffuseness and were trained on him, fish-colored and fixed. . . . Bishop took off his hat and threw it over the side where it floated right-side-up, black on the black surface of the lake. . . . The boy [Tarwater] edged the boat toward a dark clump of bushes and tied it. Then he removed his shoes, put the contents of his pockets into his hat and put the hat into one shoe, while all the time the grey eyes were fixed on him as if they were waiting serenely for a struggle already determined. . . . The sky was dotted with fixed tranquil eyes like the spread tails of some celestial night bird. While he stood there gazing, for the moment lost, the child in the boat stood up, caught him around the neck and climbed onto this back. He clung there like a large crab to a twig and the startled boy felt himself sinking backwards into the water as if the whole bank were pulling him down.[84]

Bishop does practically everything but drown himself, and it is in this paradoxical act that all the mystery and terrifying aspect—indeed, the sacramental beauty—of God's violent goodness is made manifest. Like Christ who "never said a mumblin' word" on the way to the cross, so too Bishop, I contend, willingly goes to his death, and thus to his rebirth, through the sacrament of holy baptism that Tarwater, in spite of himself ("as if the whole bank were pulling him down"), invokes.

I use the phrase "sacrament of holy baptism" deliberately. O'Connor intends this drowning to be a formal liturgy. Earlier in the story, Rayber is looking out over the eerily still scene of the black lake when suddenly "the quiet was broken by an unmistakable bellow"; then "the bellow stopped and came again . . . steadily, swelling," and finally "it blared out one last time, *rising*

[84]Ibid., 197-216.

out of its own momentum as if it were escaping finally, after centuries of waiting, into silence."[85] Three bellows, one for each Person of the Godhead, Tarwater performing the whole tortured liturgy all the way down to the invocation of the triune God—Father, Son, and Holy Ghost—not from his own power or will but in a kind of helpless (and yet free) obedience to the momentum of some divine summons centuries in the making.[86]

EXCURSUS: BISHOP'S BAPTISM AND THE PROVIDENCE OF GOD

Sumner Ferris is the only critic I am aware of who notices Tarwater's passivity in the crucial baptism scene, but he fails to understand its theological significance. He can only say, for example, that Tarwater "half-accidentally drowns and half-unwittingly baptizes Bishop."[87] Ferris is half-right. The drowning is not accidental, not even half-accidental. It is intended from the beginning, but not by Tarwater. He had designs on such things, to be sure, but he only ever half-intended to drown the little boy. He was certainly conflicted about it, but to call the drowning a half-accident is to say both too much and too little.

Ferris goes on to say that Tarwater had a task to perform, that of bringing "spiritual life through baptism to his cousin Bishop," but Tarwater hardly intends such a thing. In fact, he actively resists it. Ferris rightly suggests that Bishop is "drawn to Tarwater almost as though he knew why he had come." And he is—and does. Bishop knows, but Tarwater doesn't. Again, Ferris correctly says that it would be a mistake to assume that the young prophet "is simply responding to his great uncle's psychological indoctrination." Ferris recognizes how, for O'Connor, the baptism of Bishop is absolutely critical, that it is "the most important action Tarwater could perform." This is not a matter of peer pressure, which would be the psychologically reductive explanation. Tarwater, according to Ferris, is "being forced to do it by a concatenation of circumstances beyond his control . . . which, to the

[85]Ibid., 202.

[86]This paradoxical dynamic of a free compulsion O'Connor herself attributes to Tarwater: "Tarwater is certainly free and meant to be; if he appears to have a compulsion to be a prophet, I can only insist that in this compulsion there is the mystery of God's will for him" (*MM*, 116).

[87]Ferris, "The Outside and the Inside," 50.

Christian, is another way of saying Providence."[88] Yes! Ferris even goes on to point out that

> twice in the novel Bishop tries to jump into a fountain; the second time he is illuminated by a sudden bright shaft of sunlight as by a nimbus. And even when Tarwater has decided, as a final act of rejection, to drown his cousin . . . Bishop himself stands up in the boat, climbs onto Tarwater's back like the Christ child onto St. Christopher's and falls into the water with him. That is, Bishop, having been refused salvation through baptism by his own father, *forces* Tarwater to give it to him . . . although it is at the cost of his own physical death.[89]

Ferris, as pointed out earlier, concludes that Tarwater "may be an instrument of God's providence without being of His company."[90] Aside from mistaking the second fountain scene for a second occurrence (most critics miss this fountain redux), it seems Ferris is too eager to pronounce this novel a tragedy (the main point of his essay), so that it had to end badly for the protagonist (on Ferris's terms). But Ferris gets ahold of the wrong horror. The bad ending isn't that Tarwater is damned. The "bad" ending is precisely that he's been saved in order that he accept his calling as a prophet, which will inevitably lead, O'Connor reminds us, to "the children of God doing Tarwater in pretty quick."[91]

Just after this scene, Tarwater goes to great lengths to convince a truck driver that in spite of his having baptized the little boy, he killed him too, and as such is no emissary of God's will and is thus ready to return home with that matter settled:

> "I'm in full charge there. No voice will be uplifted. I shouldn't never have left it except I had to prove I wasn't no prophet and I've proved it." He paused and jerked the man's sleeve. "I proved it by drowning him. Even if I did baptize him that was only an accident. Now all I have to do is mind my own bidnis until I die. I don't have to baptize or prophesy."[92]

[88]Ibid., 54.

[89]Ibid., 54-55; emphasis mine.

[90]Ibid., 55.

[91]C. Ralph Stephens, ed., *The Correspondence of Flannery O'Connor and the Brainard Cheneys* (Jackson: University Press of Mississippi, 1986), 93.

[92]*VBA*, 210.

But Tarwater learns just the opposite in a blazing epiphany upon his return home, where he must finally and irrevocably accept his portion as a prophet of God who is fated to do anything *but* "mind [his] own bidnis." Tarwater has continued to say he can *act* throughout the novel: "I can pull it up by the roots, once and for all," he tells Rayber. "I can do something. I ain't like you. All you can do is think what you would have done if you had done it. Not me. I can do it. I can act."[93] And yet in the very scene that renders the central action to which he has been called—whether by his "friend" to drown the child or by his great-uncle to baptize him—acting is precisely what Tarwater does *not* do.[94] It is Bishop who leads Tarwater to the boat, and it is Bishop who hops on his back like a crab and effectively pulls Tarwater backward into the water (presumably with God's assistance). The baptismal death becomes something akin to an assisted *suicide*, which is a trope in O'Connor's work (see "The River" and "The Lame Shall Enter First").[95] It is, in some sense, a reenactment of the Abrahamic sacrifice, but instead of staying the knife (so to speak), God stays Tarwater's will. It is God who is the main actor in the baptismal drama, and it is God who takes Bishop's life back from Rayber. And it is God who all but pulls the baptismal formula out of Tarwater's lips (though Tarwater is not without some agency here), thereby securing the idiot child's (and presumably Tarwater's) salvation. Bishop's death by drowning—or, more accurately, his death by baptism—is the exempted violence indicated in Exodus 21:13. Tarwater may be the killer, but he is not the murderer. He's hardly even the baptizer. He is but a vessel for both.

If this is all true, the central conflict of the novel, then, is not the paradoxical nature of Tarwater's double action and how that plays itself out in his character, but the role of God in this event and the way that Tarwater must come to terms with the Lion of Judah (prefigured, of course, in the earlier fountain scenes). The tension in this central conflict, in other words,

[93]Ibid., 196.

[94]Most critics disagree. Browning, as a representative example, says that "when Tarwater does finally decide to act, his prophecy is fulfilled: he acts decisively, drowning the idiot boy in a lake" (Browning, *Flannery O'Connor*, 82). Tarwater's action is hardly decisive.

[95]In an interview she gave in 1960 about Bevel's suicide by drowning in "The River," O'Connor declared that this wasn't a bad thing; on the contrary, "He comes to a good end. He's saved from those nutty parents, a fate worse than death. He's been baptized and so he goes to his Maker; this is a good end" (Rosemary Magee, ed., *Conversations with Flannery O'Connor* [Jackson: University Press of Mississipi, 1987], 58). Another baptism unto death. O'Connor clearly had this in mind with Bishop's baptism.

isn't psychological or even moral, but deeply theological, and Tarwater's conflicted response points to the boy's coming to terms with his fated calling and with a God who would direct him to such violent means—and ends. He has been defeated in his efforts to rebel, in other words, by a God who is far more rebellious than he. The violence he tries to inflict on God is doubled back on him to an almost infinite degree. The question then becomes not how Tarwater will deal with the paradoxical impulses at war inside him, but how he will respond to such a divine summons, wrought in such abject defeat.[96] And that he is defeated is not in question. As he awakes from the vision of the baptismal death of Bishop while asleep in the cab of the truck, he is stricken: "Suddenly in a high raw voice the defeated boy cried out the words of baptism, shuddered, and opened his eyes." Tarwater's calling is simultaneously his curse.[97] The reader is reminded of the prophecy the old man made about young Tarwater, "'The day may come,' his great-uncle said slowly, 'when a pit opens up inside you and you know some things you never known before.'"[98]

This brings up the obvious dilemma of the question of freedom in general and Tarwater's freedom in particular. Most critics agree that the central tension lies in the decision Tarwater must make to follow the path set out by either his uncle or his great-uncle, or as Tarwater's "friend" puts it, to follow himself or follow Jesus. O'Connor addresses this question specifically: "Tarwater is certainly free and meant to be; if he appears to have a compulsion to be a prophet I can only insist that in this compulsion there is the mystery of God's will for him and that it is not a compulsion in the clinical sense."[99] It is fascinating to consider that O'Connor leaves the question of the fate of one of her characters in God's hands, as if he had a hand in what happens in the conceit of the story. I believe he does, as I have explained

[96]To be sure, O'Connor understood free will to be competing wills within a person. See further discussion below.

[97]*VBA*, 216. O'Connor concurs, as she indicates in a letter to Hester after she had completed the novel: "Now about Tarwater's future. He must of course not live to realize his mission, but die to realize it. The children of God will dispatch him pretty quick. Nor am I saying that he has a great mission or that God's solution for the problems of our particular world are prophets like Tarwater. Tarwater's mission might only be to baptize a few more idiots" (*HB*, 342).

[98]O'Connor touches upon the irony of Tarwater's defeat in a letter she wrote in 1962 to Alfred Corn: "Rayber and Tarwater are really fighting the same current in themselves. Rayber wins out against it and Tarwater loses; Rayber achieves his own will, and Tarwater submits to his vocation" (*HB*, 485).

[99]*MM*, 116.

elsewhere. More importantly for our consideration here, however, is the point that O'Connor raises regarding the mystery of God's will, which she accords with a certain compulsion. The causal joint of double agency, where we leave off and where God begins, and vice versa, is a mystery, like evil, that we are compelled to endure.

And so, though this tension of Tarwater's choosing one road over the other certainly cannot be denied in the novel, it also cannot be accorded the central place the consensus of O'Connor scholars has given it, and for at least two reasons. The first harkens back to the very difference in the conceptions of freedom that Rayber and Old Mason Tarwater represent. Rayber is the emblem of modernity and its valorization of absolute autonomy. We are masters of our own destiny and have the power—nay, the responsibility—to save ourselves, as Rayber counsels young Francis to do. From Rayber's perspective, the tension really *does* lie with what young Tarwater will decide. But Old Tarwater sees freedom differently (and, I am contending, so does O'Connor) by suggesting that a person's autonomy is bounded on all sides not only by multiple influences all vying for one's allegiance (O'Connor's understanding of free will) but also by a God who, as the principal influence, does not simply take no for an answer and then quietly leave. The very construction of the central dilemma in the novel depends, in other words, on which conception of freedom the reader applies, Rayber's or Mason's. Most O'Connor scholars mistakenly accept Rayber's premise regarding what freedom is, then decide from there what the central dilemma is. But this is to bury the premise in the conclusion by allowing Rayber's conception of freedom—the modern conception—to set the terms for the question.

But what if we were to take Mason Tarwater's conception of freedom as the starting point in deciding what the central tension in the novel is, as I believe O'Connor does. Did she not say, "It is the old man who speaks for me"?[100] If we do, we are suddenly thrown into an entirely different arena, one in which the tension resides, not in Tarwater's singular will and the direction he might go, but in the multiple wills at play in himself and in the nature of those competing wills, and in particular, his contending with the will of God. O'Connor writes that "free will does not mean one will, but many wills conflicting in one

[100]*HB*, 350.

man. Freedom cannot be conceived simply. It is a mystery and one which a novel . . . can only be asked to deepen."

Before we move to examine the foolish truth of God in the novel, we must first deal more substantively with this aspect of freedom that is so central to questions of morality and the role of human volition and responsibility.

FREE WILL IN *THE VIOLENT BEAR IT AWAY*

A larger issue remains, which we have dealt with previously but which begs to be addressed again and with a slightly different focus, and that is the nature of free will in fictional characters in general and in this novel in particular.

We have, of course, the theological conundrum of free will on the human plane, but what about when this drama is transferred to the pages of fiction? Do characters have wills of their own, apart from their creator's? And more to the point, do they exercise a certain control over their wills within the conceit of the stories themselves? In Marshall Bruce Gentry's *Flannery O'Connor's Religion of the Grotesque*, Gentry suggests that "most critics who agree that O'Connor's characters sometimes achieve redemption . . . see such events as the result of grace that the characters have done everything possible to avoid."[101]

It is worth noting that Gentry chooses the verb *achieve* to characterize these characters' apparently unwitting redemptions. Gentry then goes on to argue that O'Connor's characters "lay the tracks for their own transport towards a redemptive experience,"[102] which reflects a more Catholic emphasis on the importance of human agency. And yet, Catholic doctrine defines redemption as "the restoration of man from the bondage of sin to the liberty of the children of God through the satisfaction and merits of Christ."[103] In other words, it is Christ who does the redeeming, not human beings. Gentry adds: "In the traditional definition, redemption results from the actions of Christ and of grace (the individual's role being merely to cooperate); redemption is experienced consciously; and the moment of redemption is a natural conclusion to a sequence of preparations."[104]

[101]Marshall Bruce Gentry, *Flannery O'Connor's Religion of the Grotesque* (Jackson: University of Mississippi Press, 1986), 4.

[102]Ibid.

[103]*Catholic Encyclopedia*, 1st ed., s.v. "redemption," www.newadvent.org/cathen/12677d.htm.

[104]Ibid.

But even this is not sufficient to explain the fate of O'Connor's characters, Gentry argues, since O'Connor's characters "consistently refuse to remain merely isolated individuals incapable of bringing about their own redemption."[105] By saying this, however, Gentry has thus moved from mere *cooperation* with God (toward a redemptive end) to a *control* over one's redemption. Gentry continues, "The question whether O'Connor's characters transform themselves or are transformed by external forces relates, of course, to the contrast between Catholicism and Protestantism in [O'Connor's] works." Indeed it does, and Gentry takes issue with a too-wide understanding of grace because, he says, it "makes the concept nearly useless." He also rejects the idea that grace is an exclusively external force since that would raise doubts "about whether many of [O'Connor's characters] are transformed."[106] It seems to me, however, that to insist that her characters are transformed is to resolve a mystery O'Connor was intent on preserving, even if that entails that a character's possible redemption occurs outside the bounds of the story itself, as Gentry complains that it would: "If the ultimate state of a character's soul depends on a momentary acceptance of grace, an action impossible to dramatize completely, then the climax of virtually every work by O'Connor occurs, as it were, offstage."[107] Again, I'm left to ask why the climax of any of her stories *must* be redemptive to begin with, and in keeping with O'Connor's respect for mystery, I can easily imagine a climactic ending that merely hints at a character's redemption rather than seals it. Why tie up with a nice little bow a package that has just been opened for us?

Furthermore, and perhaps more importantly, Gentry's characterization of grace runs afoul of both Catholic and Protestant notions by suggesting that grace is anything *other than* an exclusively external force. To be sure, as Gentry suggests, it can come through any number of forms, including even the demonic (and that it must come *through* a form is not in dispute here), but we must not confuse transit with origins, epistemology with ontology. Grace is all God's when it comes to the doctrine of redemption, whatever form it takes and however it is received. In perpetuating such a confusion of means and ends, however, Gentry is led to conclude that "characters unconsciously bring

[105]Ibid., 7.
[106]Ibid.
[107]Ibid.

about their own transformation," and he insists that "only when we redefine 'grace' as a force characters control . . . do I consider the term helpful in describing O'Connor's works."[108] Once again, it isn't enough for Gentry that O'Connor's characters cooperate in their redemption—they must *control* it. In theological terms, then, it appears that Gentry stumbles precisely where he succeeds—he has given back to O'Connor's characters the control he believes they deserve in their own redemption, but in doing so, he's managed to wrest from them any truly redemptive end.

A Christian reader cannot help but find parallels for such a conception of freedom in Christ's agony in Gethsemane: "Yet, not my will but *yours* be done," Jesus cries (Lk 22:42). This is not the cry of someone who has no will. This is the cry of someone who has more than one will, according to O'Connor's view (and according to Christian orthodoxy), whose soul is a battlefield in which these multiple wills play out. But more importantly, this is the cry of one who is bound by God's will, and it is in that freedom that Jesus chooses to die.

This brings us to the second reason why Francis Tarwater's singular will and the agonizing choice he must make is not, and cannot be, the central tension in the novel. Earlier in the story, Old Mason Tarwater is catechizing young Francis about what true freedom is and why Rayber's promise of freedom is simply another form of control: "I saved you to be free, your own self!" Old Tarwater cries, "and not a piece of information inside his head!" Old Mason goes on to tell the young boy about the way Rayber once tried to make the old man an object lesson for a magazine article he was writing on the psychological delusions of being called by God, and it is here that the young Francis learns the true nature of freedom and the cost at which it is purchased:

> "Called myself!" the old man would hiss, "called myself!" This so enraged him that half the time he could do nothing but repeat it, "Called myself. I called myself. I, Mason Tarwater, called myself! Called myself to be beaten and tied up. Called myself to be spit on and snickered at. Called myself to be struck down in my pride. Called myself to be torn by the Lord's eye. Listen boy," he would say and grab the child by the straps of his overalls and shake him slowly,

[108]Ibid., 8.

"even the mercy of the Lord burns." He would let go the straps and allow the boy to fall back into the thorn bed of thought, while he continued to hiss and groan.

"Where he wanted me was inside that schoolteacher magazine. He thought once he got me in there, I'd be as good as inside his head and done for and that would be that, that would be the end of it. Well, that wasn't the end of it! Here I sit. And there you sit. In freedom. Not inside anybody's head!" and his voice would run away from him as if it were the freest part of his free self and were straining ahead of his heavy body to be off. Something of his great-uncle's glee would take hold of Tarwater at that point and he would feel that he had escaped some mysterious prison. He even felt he could smell his freedom, pine-scented, coming out of the woods, until the old man would continue, "You were born into bondage and baptized into freedom, into the death of the Lord, into the death of the Lord Jesus Christ."

Then the child would feel a sullenness creeping over him, a slow warm rising resentment that his freedom had to be connected with Jesus and that Jesus had to be the Lord.[109]

It should be reemphasized that O'Connor does not see such a construal of freedom as an absence of free will. On the contrary, the existence of multiple wills only adds to the drama of one's decisions. She tells Alfred Corn that "free will has to be understood within its limits; possibly we all have some hindrances to free action but not enough to be able to call the world determined."[110] It is precisely within this tension of the limits of free will that O'Connor's sense of the term must be understood. She does not see people as *tabula rasa*, able to make decisions from some theological free zone. The choice comes in the interplay of the many wills competing for one's allegiance, and because one's choice is not determined absolutely, it is therefore "free," but it is not an absolute freedom either. Much depends, of course, on whose will one chooses. If the will of the Lord is chosen, O'Connor seems to imply, one "loses." (Tarwater wrestles with the Lord but only Rayber "wins.")

Von Hügel writes in his *Letters* that true freedom is the freedom wherein one *cannot* sin, where it is not even a possibility, and that "the possibility of sin arises, not from freedom of the will as such, but, on the contrary, from the imperfection of that freedom."[111] O'Connor marks this passage in her copy of

[109]*VBA*, 19-21.
[110]*HB*, 488.
[111]*Letters*, 221.

the book and likewise contends, in her defense of Hazel Motes, that "a person's integrity lies usually in what one is not able to do."[112]

This radically subversive and biblical notion of freedom confuses and confounds many an O'Connor scholar, who, as a result of their confusion, misconstrue the central conflict occurring in young Tarwater. Browning, like Gentry and many others, understands Tarwater's freedom to be bound up in his ability to act, to "make things happen."[113] Such a construal of freedom, however, leads Browning to make a number of erroneous assumptions and conclusions, among them that

> throughout both *Wise Blood* and *The Violent* the demands of commitment to God require a relinquishment of self tantamount . . . to destruction of the personality. The ultimate implication of Miss O'Connor's fictional treatment of freedom appears then to be that man, relentlessly pursued by the Hound of Heaven, has no meaningful choice, since what purports to be free choice is really a decision for a God who commands violent self-abnegation and madness or for the nothingness of evil and self-destruction.[114]

But isn't "a God who commands [either] violent self-abnegation and madness or . . . the nothingness of evil and self-destruction" just another way of saying "those who want to save their life will lose it, and those who lose their life for my sake will find it" (Mt 16:25)? To the rational mind, both are equally scandalous. Put another way, doesn't Browning's implied incredulity regarding the "ultimate implication" of O'Connor's view of freedom simply present another even greater problem for him, namely that Browning's issue isn't so much with O'Connor's treatment of freedom as it is with Jesus'? The conception of freedom articulated in the Gospels operates with the controlling paradox that in giving up one's will to Christ, one's true will is in fact returned. We are freer, Scripture tells us, as slaves of Christ than as our own masters—that is, as slaves to ourselves.[115]

[112]The marked passage in O'Connor's copy of von Hügel's *Letters* is noted in Arthur Kinney, *Flannery O'Connor's Library: Resources of Being* (Athens: University of Georgia Press, 1985), 24.

[113]Browning, *Flannery O'Connor*, 85.

[114]Ibid., 87. It should be noted that it isn't an *implication* that O'Connor is making about a believer's freedom. She explicitly states in a letter to John Hawkes, "Haze knows what the choice is and the Misfit knows what the choice is—either throw away everything and follow Him or enjoy yourself by doing some meanness to somebody" (*HB*, 350).

[115]Browning, seemingly compelled by the need to justify (in his view) O'Connor's questionable view of freedom, is moved to point out "that nowhere does she suggest that all men either do or should

O'Connor was often chided by her readers for being too hard on Tarwater, particularly in the rape scene at the end of the novel. The French critic André Bleikasten accused O'Connor of "being a misanthrope whose God is hardly distinguishable from Satan."[116] To all such missives, O'Connor would respond in a fashion similar to her response to a Mrs. Terry, who also had deep concerns about the violence of that scene:

> Thank you for your letter. I sympathize with your friend's feeling and repulsion at the episode of Tarwater and the man in the lavender and cream-colored car. It was a very necessary action to the meaning of the book, however, and one which I would not have used if I hadn't been obliged to. I think the reason he doesn't understand it is because he doesn't really understand the ending, doesn't understand that Tarwater's call is real, that his true vocation is to answer it. Tarwater is not sick or crazy but really called to be a prophet—a vocation which I take seriously, though the modern reader is not liable to. Only the strong are called this way and only the strong can answer. It can only be understood in religious terms. The man who gives him the lift is the personification of the voice, the stranger who has been counseling him all along; in other words, he is the devil, and it takes this action of the devil's to make Tarwater see for the first time what evil is. . . . Without this experience of the evil, his acceptance of his vocation in the end would be merely a dishonest manipulation by me. Those who see and feel what the devil is turn to God. Tarwater learned the hard way but he has a hard head.[117]

Is it claiming too much to say that the violent goodness of God is evident even in the rape scene? I think it is, as such an act represents the second use of violence—the violence used for evil—that O'Connor refers to in *Mystery and*

possess that inclination toward religious faith with the intensity and ferocity of some of her driven, half-crazed protagonists" (Browning, *Flannery O'Connor*, 87). But then, a few lines later, he concedes that O'Connor was "right behind [Old Tarwater] 100 per cent." He qualifies this by suggesting that O'Connor never intended Old Tarwater "to be taken as a model of the Christian life" (87). But in a letter to Betty Hester in 1959, O'Connor reveals that her rendering of Tarwater simply involved asking herself, "What would I do here?" (*HB*, 358), and one can safely presume that O'Connor did not mean to ask herself what she would do as a character in someone's novel, but rather, what she would do if she had been in Tarwater's shoes. Coming from someone who took her faith as seriously as O'Connor, I am not sure what more of an endorsement she could have made for what one ought to do as a Christian.

[116]As cited in Ralph Wood, *Flannery O'Connor and the Christ-Haunted South* (Grand Rapids: Eerdmans, 2004), 190.

[117]Jean Cash, *Flannery O'Connor: A Life* (Knoxville: University of Tennessee Press, 2002), 332.

Manners.[118] But to even ask the question should not immediately strain the bonds of credulity when one considers the radical nature of O'Connor's understanding of God's terrible mercy. This is the severe mercy of O'Connor's God, a mercy that subverts the world's—and the church's—well-intentioned but often sentimental sympathies. It is a severity that does not submit to rational inquiry but, instead, marks out the contours of a divine love—a fierce and terrible love, which is met on those whom God loves—his prophets and disciples both. This "wrenching encounter with divine judgment," as Ralph Wood puts it, is transformative in that it takes this recalcitrant soul and saves him from damnation.[119] O'Connor recognizes this wrenching encounter for what it is—God's violent goodness—and insists that we can understand it as such only through the eyes of a living faith, as she writes in her essay "The Catholic Novelist in the South": "Our response to life is different if we have been taught only a *definition of faith* than it is if we have trembled with Abraham as he held the knife over Isaac."[120] This, as O'Connor says in one of her letters, is "the violence of love."[121]

EXCURSUS: THE RAPE SCENE

O'Connor indicated her sympathy with those who didn't understand the need for the rape of Tarwater, though she defended its use: "I sympathize with your friend's feeling of repulsion at the episode of Tarwater and the man in the lavender and cream-colored car. It was a very necessary action to the meaning of the book, however, and one which I would not have used if I hadn't been obliged to."[122] The ending of the novel, in other words, is key to understanding the significance of the rape, the necessity of which "can only be understood in religious terms." The rapist is the personification of the devil, O'Connor admits, and it takes this repulsive action "to make Tarwater see for the first time what evil is." But this raises the vexing and legitimate question: does God *will* this action for the good of his purposes? I don't think so, as Tarwater's agency is operative here: "He accepts the devil's liquor and he reaps what the devil has

[118]*MM*, 114.
[119]Wood, *Christ-Haunted South*, 6.
[120]*CW*, 859.
[121]*HB*, 381.
[122]As quoted in Richard Giannone, *Flannery O'Connor and the Mystery of Love* (Urbana: University of Illinois Press, 1989), 255.

to give." In other words, God does not will it, but he allows for its possibility. The good that comes out of it is an example of God's making good use of an action the devil wrought.

Is the reader left to assume, then, that had Tarwater not been raped, he would not have surrendered to his calling to be a prophet? Again, I don't think so. O'Connor invokes the necessity of the rape scene, not for theological reasons, but for aesthetic ones: "Without this experience of evil, his acceptance of his vocation in the end would be merely a dishonest manipulation by me." O'Connor includes the scene, in other words, because the conceit of the story demands it. So to ask what would have happened if it hadn't occurred is like asking what would have happened if Cinderella hadn't lost her slipper. If you're going to go down that road, Chesterton reminds us, then you might as well ask why she had to return at midnight in the first place. Or why she was made a princess. Or why a fairy godmother showed up. To ask such questions, in other words, is to admit an unwillingness to allow a story to stand on its own two artistic feet. It turns out that, like a good hillbilly Thomist (and Maritain disciple), O'Connor writes the scene for the good of the work. This is the hard fact of Christian Realism, which insists on looking at life, not as it should be, nor as one might want it to be, but as it is. The rape scene is in the story because it has to be; because *that's* what happened. In this sense, it must be admitted that, at least here, O'Connor is following the New Critical dictum to write a story that is to be judged on its own terms.

God, the silent character in all of O'Connor's stories, is rendered at the extreme (is there any other way to render the God of Abraham, Isaac, and Jacob?), so that just as water can both baptize and drown, and as fire can both purify and destroy, so too God can save as he condemns, resurrect as he sacrifices.[123] Bishop, the principal object of God's violent goodness, comes to a bad end only if one sees the idiot child as some "mistake of nature" as Rayber calls him. But O'Connor implies that Bishop comes to a good end even in the midst of the violent drowning since it is his simultaneous baptism that has the final word and creates the lasting effect, thus rendering this double action

[123]"The silence speaks," Baumgaertner writes, "the drowning saves, the fire purifies and destroys, the cross tortures and redeems" (*Flannery O'Connor*, 201). Everything that destroys, in other words, potentially also redeems.

ultimately salvific. It ends well for Bishop even as it ends tragically, as he is saved from a father who does not know how to love him and who has no saving story from out of which he can. Bishop would be more dead were he to go on living under the specter of his father's restrictive and ultimately morbid tutelage than if he were to actually die. This interpretation cannot be offered lightly, lest it become theologically trite, but such an interpretation cannot be ignored either, simply because of its subversive implications.

So, too, for Francis, who can experience redemption only after he is raped (with the important caveat in mind that I discussed above). Up to that point, he remains defiant unto death, and will do anything—even kill—in order to upbraid the mantle of his calling. It isn't until he is violated for his violation that he finally begins to see the folly of trying to escape his calling as a prophet. God is a relentless and jealous pursuer, who will use (almost?) all means necessary to free us from the bondage of our sin even—or especially—if it means that we must die in the process. Jesus meets his fate in such a manner, and O'Connor seems to suggest that we ask too much if we ask for anything less for ourselves. And yet it is only in this irrational, even foolish, theological surrender of one's will that one truly comes alive.

The Foolish Truth of God

> That "God," the "supreme being" and the "supreme good," should be revealed and present in the abandonment of Jesus by God on the cross, is something that it is difficult to desire. . . . In spite of all the "roses" which the needs of religion and theological interpretation have draped around the cross, the cross is the really irreligious thing in Christian faith. It is the suffering of God in Christ, rejected and killed in the absence of God, which qualifies Christian faith as faith, and as something different from the projection of man's desire.[124]

Jürgen Moltmann's conviction that the incredulity of the Christian story demands a faith that cannot be mistaken for wish fulfillment also points to the very reason one might not have such a faith to begin with: it sounds foolish. Very early in the novel, the reader gets a sobering introduction to Old Mason Tarwater, who appears the fool for Christ in all his glory:

[124]Jürgen Moltmann, *The Crucified God* (Minneapolis: Augsburg Fortress, 1993), 37.

He had been called in his early youth and had set out for the city to proclaim the destruction awaiting a world that had abandoned its Saviour. He proclaimed from the midst of his fury that the world would see the sun burst in blood and fire and while he raged and waited, it rose every morning, calm and contained in itself, as if not only the world, but the Lord Himself had failed to hear the prophet's message.[125]

And again, later in the first section, when Old Tarwater would recall for the young Francis the weekly afternoon visits he would make to his sister's house in order to lead her to repentance, he would abruptly stop the story, O'Connor tells us, and

> jump up and begin to shout and prophesy there in the clearing the same way he had done it in front of her door. With no one to hear but the boy, he would flail his arms and roar, "Ignore the Lord Jesus as long as you can! Spit out the bread of life and sicken on honey. Whom work beckons, to work! Whom blood to blood! Whom lust to lust! Make haste, make haste. Fly faster and faster. Spin yourselves in a frenzy, the time is short! The Lord is preparing a prophet. The Lord is preparing a prophet with fire in his hand and eye."[126]

Old Mason really believes this foolishness, and he makes it his life's work to instruct his great-nephew in the same foolish truth, the same "hard facts of serving the Lord." O'Connor does not suffer her fools lightly, either, and Old Mason is no exception. In fact, she makes it perfectly clear at the outset that he is, quite literally, a little "touched": "Then one morning he saw to his joy a finger of fire coming out of it and before he could turn, before he could shout, the finger had touched him and the destruction he had been waiting for had fallen in his own brain and his own body."[127] His brain, and not just his body, is destroyed.

O'Connor's critics thus cannot be blamed for seeing in the figure of Old Mason, or his grandnephew Francis, two people who have lost their minds.[128]

[125]*VBA*, 5.

[126]Ibid., 60.

[127]Ibid., 6.

[128]Preston Browning thinks Old Mason is a wrathful and violent—possibly even demonic—fanatic. David Eggenschwiler avers that he's a grouch with an "excess of egoism," Louise Gossett calls him "insane," and Frederick Asals brands him a "criminal" (all quotations taken from Browning, *Flannery O'Connor*, 34). Stanley Hyman concludes, after quoting from the apostle Paul's first letter to the Corinthians about the foolishness of God being wiser than men and the wisdom of this world as foolishness to God (1 Cor 1:18-25), that "the way to wisdom is through the folly" and that "Old Tarwater, taken to the insane asylum

But because we know O'Connor, and because the perceptive Christian reader will know O'Connor's God, we cannot help but make direct connections between the old man and the prophets of old. They share the same occupational hazard of being thought crazy, of being part of the lunatic fringe, hulking around on the margins of society preaching their firebrand gospels and generally being fools for Christ. Young Tarwater's "friend" never misses a chance to intone this truth, telling the boy early on that the old man "favored a lot of foolishness." Rayber, too, often refers to Old Tarwater as a fool and makes it one of *his* life's missions to educate the young Francis out of his great-uncle's fanaticism. And Francis, for his part, understands "his great-uncle's madness" and is deathly afraid "that it might be passed down." But why afraid? Because it is the believer who has the more difficult time than the unbeliever in O'Connor's stories: "It is much harder to believe than not to believe."[129]

In O'Connor's accounting, the secular life in many respects is the easier one—though the characters who insist on such a life are nonetheless left with the truth, which hangs over them like a death sentence (and principally because O'Connor thought it *was* a death sentence—either to oneself or to God—a sentence of death not to acknowledge the difficult, even terrifying beauty, goodness, and truth of God). To go one's own way, as Rayber does throughout the novel up until almost the very end, is, from O'Connor's perspective, to suffer the consequences of the false freedom warned against in Romans 1: to be left to oneself and one's fallen desires is, in fact, the judgment of God. Von Hügel echoes this in his study of St. Catherine of Genoa, where she understands God's judgment as a merciful justice in that he does not force our obedience: "When we shall have departed from this life in a state of sin, God will withdraw from us His goodness, and will leave us to ourselves."[130]

in a straitjacket for his wild prophesying, is God's Fool" (Hyman, *Flannery O'Connor*, 39). He continues that "young Tarwater's vision of following 'the bleeding stinking mad shadow of Jesus' hinges on the same paradox: Jesus' way is mad only by 'the wisdom of this world'" (39). Carol Shloss, in *Flannery O'Connor's Dark Comedies: The Limits of Inference* (Baton Rouge: Louisiana State University Press, 1980), comes to this conclusion about young Tarwater: "By all the canons of realism that O'Connor purported to espouse, a boy who has not eaten in four days, and whose worms prevent him from stomaching any food, is surely near the point of death. In addition, having murdered an idiot child, set fire to a wilderness, and been molested and raped, he is almost certainly mad" (97). But it is precisely the madness of holiness, as Hyman explains, that makes the Christian faith so offensive to the modern ear. It cannot—nor should not—be easily explained away.

[129]*HB*, 354.
[130]*Mystical*, 1:283.

To walk the narrow path of belief was to walk in the "bleeding stinking mad shadow of Jesus," which is why, in O'Connor's stories, the terror of God *is* the plight of the believer. That's where the drama lies, not in her characters' condemnation, but in their redemption. The gospel, for all its good news, is tarwater to the reluctant, recalcitrant prophet and lackluster, lukewarm believer. It is thus easy to see how O'Connor's stories were not written principally for the nonbeliever, who would have likely missed the depth of her stories, but for the presumptive believer, who in the 1950s and early 1960s counted for much or most of the American populace, who saw their nationality as conferring on them automatic Christian affiliation, but who nonetheless were (O'Connor believed), for all their presumption, almost as deaf, dumb, and blind as the atheist. It is precisely to *them* that she felt the need to shout and draw startling images: not to the deaf but to the *hard* of hearing, and not for the blind but for the *almost* blind. This was the audience, ironically, who did not hold the same beliefs as O'Connor; not the pagan North—for which God appeared to have vacated the premises—but the believing South, a place that Christ still haunted. Her theology is acidic, but only to those who already believe. The grand irony in this, of course, is that it is only those who unwittingly share her beliefs—or claim they do—who really feel the sting of her stories. And it is in this sense that the typical O'Connor reader vicariously experiences the same fierce treatment her believing—or half-believing—characters do. She is hard medicine, and her stories are a fierce antidote to the nihilism she claimed pervaded the air we breathe: "If you live today you breathe in nihilism. In or out of the Church, it's the gas you breathe."[131]

By necessity, then, O'Connor created grotesque characters and distorted visions precisely so that we might see beyond the humdrum distortions of daily life, which could kill. O'Connor's was a subversive vision, one that understood foolishness for wisdom and vice versa. She saw the world not for what it appeared to be, but for what it was, and she was wary not to confuse one with the other. In an early letter to Betty Hester, O'Connor explains her position on the matter of belief:

> To see Christ as God and man is probably no more difficult today than it has
> always been, even if today there seem to be more reasons to doubt. For you it

[131]*HB*, 97.

may be a matter of not being able to accept what you call a suspension of the laws of the flesh and the physical, but for my part I think that when I know what the laws of the flesh and the physical really are, then I will know what God is. We know them as we see them, not as God sees them. For me it is the virgin birth, the Incarnation, the resurrection which are the true laws of the flesh and the physical. Death, decay, destruction are the suspension of these laws.[132]

A massive paradox unsettles reason and emotion. The truth revealed by faith is horrible—it disturbs and disgusts. And so the world is not indifferent but hostile to the possibility of redemption, which is why this novel is not a coming-of-age story about the struggles between doubt and faith, as virtually all critics have claimed it to be, but a study of obedience and disobedience.[133] At play here is Kierkegaard's conviction that the modern world is not beset by doubt when it comes to the claims of faith, but by disobedience:

> For the misfortune of our age . . . is disobedience, unwillingness to obey. And one deceives oneself and others by wishing to make us imagine that it is doubt. No, it is insubordination: it is not doubt of religious truth but insubordination against religious authority which is the fault in our misfortune and the cause of it. Disobedience is the secret of the religious confusion of our age.[134]

In her published prayer journal, O'Connor's entry of January 2, 1947, reads, "No one can be an atheist who does not know all things. Only God is an atheist. The devil is the greatest believer & he has his reasons."[135] Even the devil can recite the Apostles' Creed. Unbelief versus belief, then, is not the issue for O'Connor, nor is it, finally, the issue for her characters. As I have said elsewhere, the struggle on the part of her characters is almost always one of the demands of *belief*, not the vagaries of *unbelief*, for the simple reason that belief in O'Connor's universe exacts a far greater toll than unbelief—at least in this life.

[132]Ibid., 100.

[133]Browning says that Tarwater, "like Hazel Motes and The Misfit, is caught on the horns of the faith-doubt dilemma" (*Flannery O'Connor*, 72). No, it is much more than that. Faith itself is a faith-doubt dilemma ("Lord, I believe. Help my unbelief"). In a recent essay George Weigel captures the much greater issue at stake, which is the question of obedience versus disobedience and whether any of us needs to be redeemed in the first place: "A world indifferent to its need for redemption is not indifferent to the possibility of redemption; it's a world hostile to that possibility. Down the centuries, the mockery endured by Christ on the cross may stand as the paradigmatic expression of that hostility." George Weigel, "Easter with Flannery O'Connor," *First Things*, April 2014, www.firstthings.com/web-exclusives/2014/04/easter-with-flannery-oconnor.

[134]Søren Kierkegaard, *Fear and Trembling and The Book on Adler* (New York: Knopf, 1994), 295-96.

[135]*Prayer Journal*, 25.

It is the believer who takes it on the chin in O'Connor's stories because, as O'Connor explains, they're the ones who can handle it, if only just barely: "It has always seemed necessary to me to throw the weight of circumstance against the character I favor. The friends of God suffer, etc. The priest is right, therefore he can carry the burden of a certain social stupidity."[136] Mason Tarwater can afford to play the fool, in other words, because he's *right*.

And so the principal struggle in *The Violent Bear It Away* is one of obedience, not faith, and it is an obedience to God's overwhelming will that confronts and challenges, first Old Tarwater and then Francis (and finally, Rayber). Is God's summons finally too hard to resist? It seems so, though we must be careful not to eradicate the will of O'Connor's characters completely, lest we eviscerate the conflict that inheres in their stories. But it cannot be denied that the struggle represented in Hazel Motes, the Misfit, and Tarwater involves a struggle to submit to God's will. The Misfit is one of the only main characters in O'Connor's stories who manages to cling to his recalcitrance, but it comes at a terrible cost: his humanity. The Misfit is the exception that proves the rule, in other words (Rufus Johnson is, perhaps, another example) in that, by winning his independence, he loses his life. It is a Pyrrhic victory of eternal consequences.[137] What is significant about this (among other things) is how, for O'Connor, faith involves more than simply belief, since even the Misfit, it turns out, is a believer. This is in keeping not only with O'Connor's more Hebraic (as opposed to Greek) biblical sensibilities, but with the conviction she expresses in her prayer journal that the devil is among the most ardent of believers.

In O'Connor's fictive world, then, to repeat an earlier contention, her characters are defined as much by what they deny as by what they affirm— or, to put it more accurately, by what they try to run away from as by what

[136]*HB*, 121.

[137]In his declaration that the Grandmother would have been a good woman if someone had been there to shoot her every minute of her life, the Misfit unwittingly acknowledges that what the Grandmother did was, indeed, *good*. He sees it as good, her gesture of reaching out to touch him, and not only good, but also true, and perhaps even beautiful. So the Misfit's fight against his own belief is achingly palpable here. Perhaps O'Connor's choice not to give the story's antagonist a name, preferring to refer to him by the simple moniker "the Misfit," is an open invitation to allegorize his character. Most see him as a stand-in for the devil, though it seems that he is more than simply that: he is in some sense the alter ego of Christ, who himself was a Misfit, perhaps the archetypal misfit (just as Christ was also referred to as a "D.P." in "The Displaced Person").

they surrender to. This is certainly true of Haze Motes and his rejection of the shriveled Jesus, which O'Connor says is significant because "its meaning is in its rejection."[138] Browning argues that Haze's denial of Christ "has the urgency of a religion" and "like Melville's Ahab, he must have something to rage against in order to be."[139] Of all the stories in O'Connor's oeuvre, though, none perhaps is more defined by this affirmation-by-rejection as *The Violent Bear It Away*. Both Tarwater and Rayber represent this struggle, though in different ways and for different reasons—and with different outcomes. And the resistance is understandable, given that the truth they are asked to swallow is, in very profound ways, a bitter pill:

> The truth does not change according to our ability to stomach it emotionally. A higher paradox confounds emotion as well as reason and there are long periods in the lives of all of us, and of the saints, when the truth as revealed by faith is hideous, emotionally disturbing, downright repulsive. Witness the dark night of the soul in individual saints. Right now the whole world seems to be going through a dark night of the soul.[140]

The novel serves as an exhibit of how dark nights of the soul can be experienced, either in abject denial, and thus in false enlightenment, as Rayber does, or in an embracing of the darkness, as Tarwater does. And Tarwater does so because the figure of his great-uncle is always lurking in the background, his presence always a shadow to his doings: "[Rayber] understood that the boy was held in bondage by his great-uncle . . . and he saw that he was engaged in a desperate heroic struggle to free himself from the old man's ghastly grasp."[141] By being left more or less to his own devices, Rayber is abandoned to himself. Tarwater, on the other hand, with his proximity to God (and the devil), is precluded from such abysmal relief and must contend for his soul, must wrestle with the angels and demons that surround him (quite literally). In the end, Francis cannot shake his great-uncle's catechesis; no amount of rebellion, not even murder, allows him to do so.

[138]*HB*, 403.
[139]Browning, *Flannery O'Connor*, 34, 36.
[140]*HB*, 100.
[141]*VBA*, 106.

The literary epigraph of *The Violent Bear It Away* is found on its last page: "GO WARN THE CHILDREN OF GOD OF THE TERRIBLE SPEED OF MERCY." An almost identical line is given much earlier in the book, in the second section, when Mason exhorts Francis to "'go warn the children of God,' saith the Lord, 'of the terrible speed of justice.' Who will be left? Who will be left when the mercy of the Lord strikes?"[142] O'Connor's alignment of God's mercy and justice is interesting, given that mercy, defined as an act of "kindness or forgiveness shown to an offender," is, by its very definition, inherently unjust. If O'Connor's readers have been sufficiently indoctrinated by secular notions of equality and fairness, they are more inclined, as the laborers in the vineyard were, to accept justice rather than mercy, no matter the cost. After all, it is God's grace and not his judgment that has proved to be the more scandalous thing, and it would have been so for O'Connor's audience, which she all too well understood. Along with Karl Barth, O'Connor believed the gospel to be "undeserved mercy rather than much-deserved wrath,"[143] and there is nothing that incites wrath in a sinful world like undeserved mercy.

Rayber cannot, in fact, abide by any such mercy, not for his son, not even for himself, and yet, this rational and generally agreeable uncle from the city is the character whom most of O'Connor's audience would have empathized with. This third tension (the foolish truth of God), represented biblically in the second person of the Trinity, Christ, the Logos, recognizes that an acknowledgment of spiritual reality is typically the first step one takes in encountering God, whereas its denial is the chief characteristic of a world steeped in materialistic assumptions and shorn of divine transcendence. Such a tension is rife in the novel's 1952 southern Tennessee setting, which amounted to ground zero for the clash between backwoods American religiosity and the burgeoning materialism of its growing cities. (The Scopes Trial took place in Tennessee for a reason.) For this reason, O'Connor considered the South a Christ-*haunted*—rather than Christ-*centered*—region, owing to that particularly southern malady of having at once a deep and abiding attraction to Jesus coupled with an equally desperate aversion to him.

Francis Tarwater's repartee with his inner voice, who first is a stranger but soon becomes a friend, sets the stage for this tension to play itself out in his

[142]Ibid., 60.
[143]Wood, *Christ-Haunted South*, 10.

character as the novel progresses. Tarwater's determination to expunge all traces of his uncle's old-time religion are emblematic not only of that particular region's deep ambivalence toward the influence of Christ in the culture but also of the larger modern world's more explicit taking up of arms against its restrictive religious past. Carol Shloss gives voice to the kind of incredulity that the secular mind (or the properly socially conditioned gentrified Christian mind) thinks of O'Connor's Tarwater: "For an author to maneuver her subject so that his end can be viewed positively only if the reader can accept self-defeat as victory, death as mercy, sacrament as blasphemy, and murder as inconsequential, is a notable fictional achievement."[144] Shloss left out "foolishness as wisdom." What Shloss clearly cannot abide by is the subversive world of grace (and the very "cost" of following Christ), where it is precisely these reversals, as crazed as they seem, that bestow benediction. The cross of Christ could be described in the very paradoxical binaries that Shloss uses to try to discredit O'Connor's intentions: self-defeat as victory, death as mercy, sacrament as blasphemy (or perhaps, more accurately, blasphemy as sacrament), murder as (ultimately) inconsequential insofar as Jesus was raised from the dead. And it is, indeed, a notable achievement to pull something like this off—not just for Flannery O'Connor, but for God.[145]

O'Connor had some idea of what she was getting into by introducing a story whose controlling theme, according to her, required prayer and fasting. She understood that hers was an antagonistic audience, and in order to *reach* them in any significant way, her writing had to clear the sinuses. Such a bracing experience, of course, would have to be as effective on her reading audience as it would be on any character she introduced into her story that reflected the beliefs and mores of that audience. Such was Rayber, in whom O'Connor found the perfect embodiment of her critique of modern American culture with its materialistic assumptions and what James C. Edwards calls America's "normal nihilism."[146] If Rayber is anything in the novel, he is a congenial (though not quite congenital!) nihilist, but as such, his congeniality only runs

[144]Shloss, *Flannery O'Connor's Dark Comedies*, 99.

[145]To her credit, Shloss quotes Stuart Burns, who, I believe, captures the paradox of divine madness (if one can call it that) exactly right: "In a world in which the eminently plausible and sweet voice of reason turns out to be the dragon of perverted seduction and betrayal, madness (if one wishes so to call the prophetic vision) is a necessary adjunct to salvation" (ibid., 100).

[146]As quoted in Wood, *Christ-Haunted*, 20.

skin deep (and so, finally, does his congenital nihilism). Beneath the veneer, which manifested itself primarily in a total commitment to rationality and pragmatism, is a soul starved for meaning and a terrifying love for his son that knows no bounds. The sheer beauty of his love for his son was terrifying to Rayber because it signified a reality greater than his measured rationality could comprehend. Had this sensation of the transcendent reality of love simply been about Bishop, however, it would perhaps have taken on a senti-mental caste. But, as the narrator makes clear, it simply *begins* at Bishop:

> The love that would overcome him was of a different order entirely. . . . It was love without reason, love for something futureless, love that appeared to exist only to be itself, imperious and all-demanding, the kind that would cause him to make a fool of himself in an instant. And it only began with Bishop. It began with Bishop and then like an avalanche covered everything his reason hated. . . . The longing was like an undertow in his blood dragging him back-wards to what he knew to be madness.[147]

The presence of the Spirit of God in Rayber's life makes him miserable, and it takes up residence in him like an "affliction" that "lay hidden in the line of blood that touched [his family]," and "those it touched were con-demned to fight it constantly or be ruled by it." Rayber thus spends his life dedicated to controlling this primal urge through "what amounted to a rigid ascetic discipline. He did not look at anything too long, and he denied his senses unnecessary satisfactions."[148] His manic need for control and his deep and abiding suspicion of mystery, along with his unwavering com-mitment to retain his personal and autonomous "dignity" at all costs, are hallmarks of a life given over to the demonic, and O'Connor understood it as nothing less. Ralph Wood argues that O'Connor "depicts in George Rayber . . . a thoroughly self-damned man,"[149] and the narrator seems to bear this out: "He kept himself upright on a very narrow line between madness and emptiness, and when the time came for him to lose his balance, he intended to lurch toward emptiness and fall on the side of his choice. He recognized that in silent ways he lived an heroic life."[150] I cannot venture

[147]*VBA*, 113-14.
[148]Ibid., 114.
[149]Wood, *Christ-Haunted*, 6.
[150]*VBA*, 115.

quite as far as Wood in suggesting that Rayber is "thoroughly" damned, for reasons stated earlier, but it is clear that for O'Connor, two ultimate choices presented themselves to humanity in the form of Tarwater's dilemma: only two roads diverge in a wood, and one takes either at great cost since there is no turning back ("way leads on to way" in Robert Frost's words). Either one follows Christ in his bleeding stinking mad shadow, or one takes another, far easier road. There is no room for the "partially saved" in O'Connor's theological lexicon for the simple reason that she found such an existential state utterly foreign to the biblical witness.

To a world (personified in Rayber) that values personal autonomy and rational inquiry above all other things, the scandal of the universal-but-provincial, corporate-but-intimate, mystical-but-particular claims of the gospel represents a stumbling block and existential irritant, a foolish "truth" indeed. And O'Connor believed that it is precisely in that irritation, in that foolishness, that the world experiences the mysterious and paradoxical truth of God, who is not an ethereal, disinterested deity cocreating with us in some delicate, cosmic balance of equals, but the God of people with names: Abraham, Isaac, and Jacob; indeed, the God with a name, "Yahweh" in the Old Testament, "Jesus" in the New. O'Connor insisted on such scandalous specificity:

> All my own experience has been that of the writer who believes, again in Pascal's words, in the "God of Abraham, Isaac, and Jacob and not of the philosophers and scholars." This is an unlimited God and one who has revealed himself specifically. It is one who became man and rose from the dead. It is one who confounds the senses and the sensibilities, one known early on as a stumbling block. There is no way to gloss over this specification or to make it more acceptable to modern thought. This God is the object of ultimate concern and he has a name.[151]

And this God with a name also calls us by name, which, to someone as constitutionally averse to intimacy as Rayber, was tantamount to the kind of spiritual rape that John Donne extols in his "Holy Sonnet XIV," an unadulterated ravishing of cosmic significance.[152] This terrifying love that Rayber had for his

[151]*MM*, 161.

[152]"Take me to you, imprison me, for I, / Except you enthrall me, never shall be free, / Nor ever chaste, except you ravish me." The word *ravish* carried the same connotation for Donne's audience that the word *rape* does for us today. It was intended to shock, unsettle, offend.

son Bishop, and which would cover the entire cosmos if he wasn't careful, was a direct threat to his own reason, which Rayber relied on as an anchor to keep him from crashing into this unbidden cosmic force, this force that was calling *him* by name. It is precisely God's attentiveness to the details of life that Rayber could not abide: "He was not afraid of love in general. He knew the value of it and how it could be used."[153] But "love in general" is a contradiction in terms, at least from the biblical perspective, for to love is to love some*thing*, some*one*—it is not listed among the virtues for a reason. It is neither an emotion nor an intellectual disposition. The indictment implied against Rayber's character was, of course, an indictment of O'Connor's reading public.

Wood writes, "So deep is the spiritual infection of our time that O'Connor turned her fiction into a kind of scalpel for excising, ever so painfully, the undetected cancer eating away at church and culture alike."[154] This cancer, which finds its most common manifestation in the spiritual malaise of post-modern culture, preys upon Rayber throughout the novel, and it is precisely his deep ambivalence toward this malaise, and the cognitive dissonance that is subsequently wrought, that proves the truth is at work in him, however much he might protest to the contrary. "'The cry of revolt against such a god,' Barth insisted when referring to the existentialism of Nietzsche, Marx, and Freud, 'is nearer the truth than is the sophistry with which men attempt to justify him.'"[155] Is it too much to say that God's truth—or at least its shadow—is present to some degree in the terrible philosophies of these existentialists?

The mysterious truth of God reflects its shadow in Rayber, to be sure, who becomes the unwitting repository of all that is wrong with a culture devoid of divine transcendence—indeed, of those who do not have the ears to hear. His hearing aid, which he must turn on in order to hear clearly, thus becomes a sign of the world's desire for distraction, and it is axiomatic in the novel that whenever Rayber turns off his hearing aid, the truth is being sounded some-where in his vicinity. This anagogical device of O'Connor's thus serves as a tangible reminder of how the modern world, represented in Rayber, cannot abide by what Dante understood to be the terrible love of God, and Rayber's collapse near the end of the story into a heap of silent despair is a harbinger of

[153]*VBA*, 113.
[154]Wood, *Christ-Haunted*, 155.
[155]Karl Barth, *The Epistle to the Romans*, as quoted in Wood, *Christ-Haunted*, 157.

the world's fate if it does not *engage* God and allow itself to be transformed by his Word. And yet, it is precisely in this collapse that we get a hint of the possibility of surrender, which for some can only come in abject defeat.

Tarwater must also finally be defeated before he can surrender, but in his defeat and surrender he is afforded the eyes to see, eyes that would "never be used for ordinary sights again."[156] He had the eyes of Christ, the eyes of a prophet, and had now become a realist of distances who could see beyond the surface of things to what glimmered just beneath. His was a double vision of the world that saw not only through space but through time, not only to what *is* but also to what *would be*. He saw the stranger, his "friend," the devil, finally vanquished in an arch of fire, and then saw Buford, whom he had earlier ignored but now ran to greet. He sees the cross, and only then catches a glimpse of that other country, "stretching out before him, surrounding him . . . the clear grey spaces of that country where he had vowed never to set foot."[157] "Blessed are the pure in heart, for they shall see God" (Mt 5:8). Now Tarwater's vision was piercing the very air, and through it he caught a glimpse of the heavenly banquet, and then of the Old Man, Mason Tarwater. This is O'Connor's benediction, and in its midst the young prophet marks himself with the dirt and ashes from the grave from whence he'd come, and to where he was now going.

O'Connor's subversive gospel, in the final analysis, is brought to a controlled theological intensity in *The Violent Bear It Away* and serves as a sustained meditation on the subversive nature of belief itself, which, in turn, can help the reader toward a deeper reading of her work. O'Connor writes with the same counsel she gave, namely, with two distinct but inseparable eyes that cast for the reader a double vision of both what appears on the surface, in this case a foolish gospel—good news that is "bleeding stinking mad"—with what exists both before and beyond that surface, which is the need to cry that foolish gospel out because it saves, and because this bleeding stinking mad shadow is, after all, the shadow of Jesus, and if we choose to follow *him*, then we have no choice but to follow in his *shadow*.

This triple threat of God's severe love, instructive for a much-needed "crisis theology" in our times, can thus not only help us to understand O'Connor's writing on a level deeper and more consonant with her intentions, but also aid

[156]*VBA*, 233.
[157]*VBA*, 239.

us in understanding our own lives as well, on that level where "time, space, and eternity meet," which O'Connor understood to be the province of the writer with Christian concerns. As it happens, it is also the province ("that far country") of the Christian believer, and it is precisely here, at this mysterious junction where time and space double back on themselves in the light of eternity, that we are redeemed.

Conclusion

O'Connor's Cathedral of Fire

Gold, when once it has been fully purified, can be no further consumed by the action of fire, however great it be; since fire does not, strictly speaking, consume gold, but only the dross which the gold may chance to contain. So also with regard to the soul. God holds it so long in the furnace, until every imperfection is consumed away. And when it is thus purified, it becomes impassible; so that if, thus purified, it were to be kept in the fire, it would feel no pain; rather would such a fire be to it a fire of Divine Love, burning on without opposition, like the fire of life eternal.

BARON FRIEDRICH VON HÜGEL, THE MYSTICAL ELEMENT OF RELIGION

He stood there, straining forward, but the scene faded in the gathering darkness. Night descended until there was nothing but a thin streak of red between it and the black line of earth, but still he stood there. He felt his hunger no longer as a pain but as a tide. He felt it rising in himself through time and darkness, rising through the centuries, and he knew that it rose in a line of men whose lives were chosen to sustain it, who would wander in the world, strangers from that violent country where the silence is never broken except to shout the truth. He felt it building from the blood of Abel to his own, rising and engulfing him. It seemed in one instant to lift and turn to him. He whirled toward the treeline. There, rising and spreading in the night, a red-gold tree of fire ascended as if it would consume the darkness in one tremendous burst of flame. The boy's breath went out to meet it.

THE VIOLENT BEAR IT AWAY

O'Connor's subversive theo-literary approach, which she found helpfully systematized in Baron von Hügel's writing and which she employed in her fiction, has an unmistakably purgatorial effect: God's beauty shocks, terrorizes, and offends; God's goodness ruins, defeats, and destroys; and God's truth burns, condemns, and shames, all for the sake of redemption, both for her characters *as well as* for her readers. For O'Connor, the meaning of life and the contours of her artistic vision were unified in the redemptive work of Christ, which informed both her love for her characters and for her reading audience— why take the trouble to shout otherwise?—and she did not veer from that commitment, even from the beginning, as she indicates in an early letter to the Fitzgeralds about the authorial intentions behind *Wise Blood*: "And of course no unbeliever or agnostic could have written [*Wise Blood*] because it is entirely Redemption-centered in thought."[1] Such redemption, which for both O'Connor and von Hügel found its ultimate object in the cross, is shocking material. But it shocks in order that it might reveal, that it might redeem. O'Connor's intentions, as indicated earlier, were not didactic, they were midrashic—even (and with no apologies) blatantly apologetic. She shouted and drew large and startling figures for a reason—and not just be-cause her art demanded it, which it did, but because her stories were and are, finally, prophetic altar calls to a tired world. What, after all, is the prophet's art if not to tell the truth, to offend, even? But to what end? Beauty? Goodness? Truth? O'Connor's work, informed as it was by Baron von Hügel's three ideas, invites the reader to take seriously the inseparability of grace and nature, accept the "costingness" of Christian belief as a basic premise in her stories, and be willing to dispense with the need for the instant answer. To even attempt such an approach is, I think, to do her stories the justice they deserve.

O'Connor's fiction represents a long and creative engagement with the mystery of God's shocking and subversive love. Her stories burn her readers' eyes so that, like her characters, we might see Christ, might catch a glimpse of him from behind the trees of our mind, might spy grace through the canvas of nature and the habit of art. The cost—and gift—of such a burning is a clarity of vision, and yet the mystery of God, in whom the crucified Christ is the mot juste, remains, and is made even more inscrutable by the distortions of this

[1]HB, 70.

world and by our sin. To that end, her characters—Old Tarwater, little Bishop, Rayber—tell *our* stories. We are Francis Marion Tarwater, and his recalcitrant soul brings more honor to God in his dead-serious struggle to believe than the bland, secular nostrums of a measured and respectable Christianity. And it is finally through her characters' redemptive sufferings that the purpose of the subversive nature of God's terrible beauty, violent goodness, and foolish truth is witnessed. In *A Wreck on the Road to Damascus*, Brian Abel Ragen captures this subversive tension in O'Connor's work:

> By embodying the most lofty Christian doctrines in stories that seem grotesque and violent, O'Connor reclaimed a large region of literature for the religious writer. In earlier centuries, especially in the Middle Ages, religious concerns were not separated—in literature or in life—from the grotesque or violent. In Dante or in the mystery plays, Christian doctrines are presented in images that may offend the nose or shock the eye. But in twentieth-century America the usual assumption is that religious matters must be discussed in *gentle* and decorous ways—and anything that is always gentle and decorous can, in the end, only seem trivial. When O'Connor follows the example of the Old Testament prophets and presents the Lord's message in harsh and violent images, she restores life and interest to religious literature. In her stories, the acceptance or rejection of the offer of grace does seem a matter of life and death, for it is presented with the same seriousness as other life and death matters. Thanks in part to O'Connor's example, fiction writers who see the world in the light of the Christian mysteries can no longer be expected to observe any stifling decorum.[2]

And thanks in part to O'Connor, those of us who, in our own fitful and limited ways, attempt to follow in the bleeding stinking mad shadow of Jesus need not be expected to observe the stifling decorum of a "respectable" Christianity, either. The central tension in her fiction comes from this not-so-decorous juxtaposition of violence and goodness, terror and beauty, foolishness and truth, and O'Connor saw no way around it. She came from that country "where the silence is never broken except to shout the truth,"[3] and shout she did, in the form of her shocking stories and grotesque characters. They make us bristle because we know her stories are true—and that we are her characters.

[2]Brian Abel Ragen, *A Wreck on the Road to Damascus* (Chicago: Loyola University Press, 1989), 197-98.
[3]*VBA*, 242.

She said as much herself, explaining that her "prophet freaks [were] 'figures of our essential displacement, images of man forced out to meet the extremes of his own nature.'"[4]

Among O'Connor's manuscripts at Georgia College are some random scribblings from her teenage years, and buried among the pages is this untitled poem, written around age fifteen, in four quatrains, beginning with these lines:

> I'm not a little angle [sic],
> I lack that certain grace,
> My hands are always dirty
> And I never wash my face.[5]

O'Connor, of course, was a character in her own stories as well, and had been from childhood. What kid, after all, teaches her chicken to walk backward? Dirty and lacking grace, to her death a cripple with an attitude, Flannery O'Connor raged with a winsome but divine summons. And yet, however dirty her hands and face may have been—and we can safely bet they were—and whatever graces she may have lacked that precluded her from attaining to angelic status, she was, in all the dirtiness of her childhood and the brokenness of her adult years, a picture of fierce obedience and tenacious faith; of a terrible beauty that can only be seen in the dark mysteries of the foolish truth of the gospel and is wrought only in the violence of affliction, which God reserves for his saints.

[4]Rosemary Magee, ed., *Conversations with Flannery O'Connor* (Jackson: University Press of Mississippi, 198), 112.

[5]See also Stephen Driggers et al., *The Manuscripts of Flannery O'Connor at Georgia College* (Athens: University Press of Georgia, 1989), 4.

Addendum

Literature as Liturgy

> *I try militantly never to be affected by the pious language of the faithful but it is always coming out when you least expect it. In contrast to the pious language of the faithful, the liturgy is beautifully flat.*
>
> THE HABIT OF BEING

> *Silence once broken will never be whole again.*
>
> THOMAS BECKETT, *THE UNNAMABLE*

Every story is a breaking out of silence into silence, and "silence once broken will never be whole again," as Thomas Beckett reminds us in his extended meditation on silence and the search for meaning in his novel *The Unnamable*.[1] If liturgy, then, is the framing of silence in the presence of God, as Maximus the Confessor seems to suggest, then the function of story and the practice of liturgy would appear to be at odds. Oliver Davies, in his wonderful essay "Cosmic Speech and the Liturgy of Silence," makes the case for this paradoxical relationship between human speech and divine silence in his opening paragraph:

> In his writings on the liturgy, Maximus the Confessor speaks of two distinct kinds of silence. The first is "the silence of the unseen and unknown call of the deity much hymned in the innermost sanctuaries," while the second is "another silence that speaks rich in tone" [Maximus the Confessor, *Mystagogy*, Chapter

[1] Thomas Beckett, *The Unnamable* (London: Faber & Faber, 2012), 110.

Four]. The latter, which appears to be a human "silence" invested in liturgical speech, summons the former, which is the divine silence. Although precise designation of meaning is difficult in this demanding passage from the *Mystagogy*, the reader is confronted with what appears to be an exchange of silence, or an echoing, perhaps, across a divine-human boundary. It is part of the giftedness of liturgical speech, it seems, to be porous to the approach of the divine silence, to be able even in some sense to "summon" that silence which is a "call," and which is "much hymned in the innermost sanctuaries." Indeed, perhaps the paradoxical meaning of this passage is that the priest can summon the divine silence through the words and "the altar of the mind" since it is already there, as heart and ground of all this is distinctive about liturgical speech. Such a calling, such a summoning, would in that case not be the straining of human speech with its own limits: a wrestling or struggling with its boundedness in the face of its divine creator. Rather it would be the realization of human speech as liturgy: the embrace of its own ground as properly creaturely speech, which is to say a human way of speaking which knows itself to be founded in and responsible before a divine silence which, while prior, is also dynamically present, as call, as a waiting to be summoned, in the "innermost sanctuaries" of the human imagination.

Another way to put this is that liturgy must in a sense mediate, or make present to us, or allow us finally do discern and to hear, the silences of God.[2]

I have wanted to make the case throughout this study, and now is the time I must, that an element of O'Connor's fiction that makes it so demandingly transcendent is its silence: that is, in the depth of meaning that presents itself to us between the words offered to us on the page. A modicum of such a phenomenon occurs in all storytelling—some refer to it as the metanarrative that lies behind all stories—but some stories have it more than others, and O'Connor's have it more than most.[3] Her short stories are, effectively, long parables, which is why so much can be said in a relatively small amount of space. Given this element of O'Connor's stories, her fiction becomes

[2]Oliver Davies, "Cosmic Speech and the Liturgy of Silence" in *Liturgy, Time, and the Politics of Redemption*, ed. Randi Rashkover and C. C. Pecknold (Grand Rapids: Eerdmans, 2006), 215.

[3]There is much skepticism in postmodernity regarding the totalizing nature of metanarratives and their reliance on the exclusive nature of some transcendent and universal truth, but O'Connor was not shy about the totalizing effect of the Christian metanarrative, which she not only held to but also amplified in her fiction: "Many of my ardent admirers would be roundly shocked and disturbed if they realized that everything I believe is thoroughly moral, thoroughly Catholic, and that it is these beliefs that give my work its chief characteristics" (*HB*, 147-48).

particularly suitable for use in liturgy; it is that porous language that Davies speaks of wherein the silence of God can speak.

I am struck by the fact that my first introduction to the world of O'Connor scholarship came in the form of a paper I delivered at a conference in Milledge-ville, Georgia, titled "The Startling Figure of God in *The Violent Bear It Away*," wherein I end the paper with these closing words from the eulogy spoken at the Requiem Mass offered up for O'Connor's resurrection:

> Truth—the living God—is a terrifying vision, to be faced only by the stout of heart. Flannery O'Connor was such a seer, of stout heart and hope. From her loss we salvage the memory of a "stranger from that violent country where the silence is never broken except to shout the truth."

O'Connor was one acquainted with such a country, where the silence is broken (and can never be whole again), but only to shout the truth. Such a vigorous paradox, of shouting the truth in the silence of the liturgy, reminds me once again of another of G. K. Chesterton's paradoxes on the final page of his magisterial *Orthodoxy*, where he writes, "So we sit perhaps in a starry chamber of silence, while the laughter of the heavens is too loud for us to hear."[4]

Jordan Cofer contends that O'Connor's approach "is not formulaic as much as it is liturgical—that is, in some ways [O'Connor's repeated patterns] match the traditional liturgical layout."[5] The interpretive act begins and ends in God and both creator/interpreter and the work itself are porous agents in the interpretive moment. For this reason, we must understand the human agent not merely as reflection but as icon of the creative work of God, for which the work we are interpreting is but a further refraction of God's total creative process. In other words, all true works of art, but especially those that earnestly express the *habitus* of the artist, are, in some measure, works of God.

O'Connor suggests as much when she claims that the writer does not have total control over the meaning of any story and can even be surprised by a story's meaning *after* it has been written: "This is not a piece of knowledge that I consciously put into my stories; it is a discovery that I get out of them."[6] She

[4]G. K. Chesterton, *Orthodoxy* (London: John Lane, 1908), 298.
[5]Jordan Cofer, *The Gospel According to Flannery O'Connor: Examining the Role of the Bible in Flannery O'Connor's Fiction* (New York: Bloomsbury Academic, 2014), 2.
[6]*MM*, 118.

claimed that she was occasionally shocked by some of the events in her own stories, for example when the Bible salesman Manley Pointer steals Hulga's wooden leg in "Good Country People": "This is a story that produces a shock for the reader, and I think one reason for this is that it produced shock for the writer."[7] At one point, O'Connor goes so far as to claim that as soon as the words are put down on paper, they exist on their own "without its author," and that the more complex the story, "the less important it is who wrote it and why."[8] Such a claim, often used by others to prove her allegiance to the New Critical method, is the exception that proves the rule in that it shows how O'Connor's art comes from a wellspring of inspiration rather than from any particular literary school or method.[9] O'Connor's art leaves room, in other words, for shock and surprise and, as such, is more amenable than most fiction to the movement of the Holy Spirit in the context of liturgy. O'Connor's stories allow the Spirit room to breathe and the words of Scripture to speak.

O'Connor's writing works on an anagogical level, which requires the mediation of the Spirit of the triune God, who brings both to the text and to the reader (or worshiper) a level of meaning exponentially greater than their intersubjective dialectic can account for. O'Connor, in fact, valorizes such an approach:

> I often ask myself what makes a story work, and what makes it hold up as a story, and I have decided that it is probably some action, some gesture of a character that is unlike any other in the story, one which indicated where the real heart of the story lies. This would have to be an action or a gesture which was both totally right and totally unexpected; it would have to be one that was both in character and beyond character; it would have to suggest both the world and eternity. The action or gesture I'm talking about would have to be on the anagogical level, that is, the level which has to do with the Divine life and our participation in it.[10]

To participate in the divine life is precisely the function of liturgy, and so O'Connor's art, by suggesting "both the world and eternity," becomes an es-

[7]Ibid., 100. She adds in one of her letters that "there was less conscious technical control in GCP than in any story I've ever written. Technique works best when it is unconscious, and it was unconscious there" (HB, 171).

[8]MM, 126.

[9]See ibid., 156, 167, 175, etc.

[10]Ibid., 111.

pecially appropriate medium to use in the context of liturgical worship. Even O'Connor's focus on the importance of gesture as a clue to "where the real heart of the story lies" provocatively hints at its possible multiple uses in the service of the divine liturgy, which effectively serves the same function, which is to indicate where the real heart of the story lies—namely, in the gospel as it is embodied in the ritual gestures of the sacraments.

O'Connor understands fiction to operate fundamentally at the religious level—at a level that must "suggest both the world and eternity"—and that we "participate" in that life in such a way that we are both subject and object. And so she deliberately embeds into the heart of her stories a vision she wants her readers to see, a vision ineluctably religious and, in her case, deliberately Christian. She recognizes a need for, and explicitly invites, an anagogical reading of her stories, and I am suggesting that she opens a concomitant invitation for their liturgical function.

To that end, the use of O'Connor's fiction as an aid in liturgy would utilize a deliberately trinitarian model of engagement where the reader/worshiper and the text/author are both intermediary subject and object, respectively, while God is the ultimate Subject and Object of worship.[11] In such an approach and within the context of a liturgical setting, the reader/worshiper is informed of the text's meaning by being known in Christ as the object of his love in such a way that the text itself, as well as the theological commitments of its author, become windows through which we catch glimpses of divine beauty, goodness, and truth. Though such a use of fiction runs the risk of being contrived in its appropriation in worship, it provides a corrective to other approaches that I believe suffer from abstracted meaning, such as the reading of poetry or the use of dance *as performances*: that is, where the experienced meaning of the action is separated from the purpose of worship. The test of any art that is to be used in a liturgical setting, it seems to me, is that its originally intended purpose has an openness to the revelation of God in Christ. Without such an openness, the art *as art* may serve to stir worshiper's hearts,

[11]God (Subject) → Reader/Worshiper (both subject and object) → Author/Text (both object and subject) → God (Object) creates an liturgical feedback loop. See Robert Johnston's discussion of the notion of the "literary critical circle" in *Useless Beauty: Ecclesiastes Through the Lens of Contemporary Film* (Grand Rapids: Baker Academic, 2004). In appendix C, he describes what I am calling the interpretive moment, wherein not only the text, but the author, reader, and *Sitz im Leben* implicit in the text are all considered together.

but it will also run the risk of serving as a distraction or interruption (see my taxonomy of diversion) from the central purpose of Christian worship.

The power of story resides in its ability to bring people in, to allow them participate in the lives of the characters in ways they wouldn't otherwise. In this sense, a story acts on its reader in a similar way that the practice of ocular communion worked on the medieval worshiper. Ocular communion, as Klemens Richter explains, was the belief "that there could be a . . . grace-giving contact with Christ through [a] holy stare."[12] In other words, as the celebration of the Eucharist took place, simply casting your eyes on the raised host was sufficient to have received the element itself as if you had ingested it. You had participated in the drama of the sacred liturgy.[13]

In the context of worship, O'Connor's words can serve as accent pieces in conversation with the words of the liturgy—as perhaps a call and response, or as an artistic offering prior to the liturgy proper. The primary intent of including O'Connor's art as a liturgical element into a service of worship is, of course, to aid the congregation in directing their attention and worship to God, but a secondary intent is to bring art—in this case O'Connor's—into worship in a way that allows it to be in seamless dialogue with the liturgy itself, in a way similar way to the paintings used in early Italian Renaissance churches. In doing so, the work of the artist serves at the behest of the Deus Artifex and becomes, in the words of O'Connor about church dogma, a "gateway to reality." The following is a brief selection of readings from *The Habit of Being* that could be read at a celebration of the Eucharist:

> I realize now that this is all I will ever be able to say about [the Eucharist] . . . that it is the center for existence for me; all the rest of life is expendable.
>
> I believe what the Church teaches . . . that [God] has revealed himself in history and continues to do so through the Church, and that he is present . . . in the Eucharist.
>
> For me it is the virgin birth, the Incarnation, the resurrection which are the true laws of the flesh and the physical. Death, decay, destruction are the sus-

[12]Klemens Richter, *The Meaning of the Sacramental Symbols: Answers to Today's Questions* (Collegeville, MN: Liturgical Press, 1990), 88.

[13]I am reminded of Charles Taylor's distinction among the three uses or levels of language: verbal, enactive, and portrayal, where portrayal presents rather than designates, and specifically includes ritual and art. Charles Taylor, *The Language Animal: The Full Shape of the Human Linguistic Capacity* (Cambridge, MA: Belknap Press of Harvard University Press, 2016). See esp. part 2, chap. 6.

pension of these laws. I am always astonished at the emphasis the Church puts on the body. It is not the soul she says that will rise but the body, glorified.

Remember that these things are mysteries and that if they were such that we could understand them, they wouldn't be worth understanding. A God you could understand would be less than yourself.[14]

With the help of O'Connor's words, then, the liturgy functions as a kind of summons wherein the worshiper is invited into dramatic participation with the sacraments through the medium of art.

O'Connor called herself a "hillbilly Thomist," and she committed a good portion of time studying and digesting the work of St. Thomas. It would be fitting, then, in any liturgy for the Eucharist in which her writing is used to conclude with a hymn written by Thomas himself and intended for use in the celebration of the Solemnity of Corpus Christi.[15] O'Connor would have been pleased, I think, to know that she and the man she couldn't help but love might be co-conspirators in the celebration of the Blessed Sacrament. The broken body, the blood spilled . . . these were just the sort of tributes to God that O'Connor had fashioned for herself through the medium of her art. Aquinas's hymn is particularly appropriate in this regard in that it speaks to the heart of the terrible beauty, violent goodness, and foolish truth of God that is the host, Christ himself, the Word made flesh:

> Sing, my tongue, the Saviour's glory,
> of His Flesh, the mystery sing;
> of the Blood, all price exceeding,
> shed by our Immortal King,
> destined, for the world's redemption,
> from a noble Womb to spring.
> Of a pure and spotless Virgin
> born for us on earth below,
> He, as Man, with man conversing,
> stayed, the seeds of truth to sow;
> then He closed in solemn order
> wond'rously His Life of woe.
> On the night of that Last Supper,

[14]*HB*, 125, 479, 100, 354.
[15]The hymn is titled *Pange Lingua* (Sing, my tongue).

seated with His chosen band,
He, the Paschal Victim eating,
first fulfils the Law's command;
then as Food to His Apostles
gives Himself with His own Hand.
Word-made-Flesh, the bread of nature
by His Word to Flesh He turns;
wine into His Blood He changes;
what though sense no change discerns?
Only be the heart in earnest,
faith her lesson quickly learns.
Down in adoration falling,
This great Sacrament we hail,
O'er ancient forms of worship
Newer rites of grace prevail;
Faith will tell us Christ is present,
When our human senses fail.
To the Everlasting Father,
And the Son who made us free
And the Spirit, God proceeding
From them Each eternally,
Be salvation, honour, blessing,
Might and endless majesty.
Amen. Alleluia.

Bibliography

Appleby, R. Scott. *The Ambivalence of the Sacred: Religion, Violence, and Reconciliation*. Lanham, MD: Rowman & Littlefield, 1999.

Aristotle. *Metaphysics*. The Internet Classics Archive. http://classics.mit.edu/Aristotle/metaphysics.html.

———. *The Rhetoric and Poetics of Aristotle*. New York: Modern Library, 1984.

Asals, Frederick. *Flannery O'Connor: The Imagination of Extremity*. Athens: University of Georgia Press, 1982.

———. "Panel Discussion. April 7, 1974." *Flannery O'Connor Bulletin* 4 (1974): 57-58.

Aquinas, St. Thomas. "Pange Lingua Gloriosi Corporis Mysterium." Thesaurus Precum Latinarum. www.preces-latinae.org/thesaurus/Hymni/Pange.html.

———. *The Summa Theologica*. New York: Benziger Brothers, 1948.

Augustine. *Confessions*. 2nd ed. Indianapolis: Hackett, 2006.

Bailey, John. "Flannery O'Connor: Andalusia in Milledgeville." *John's Bailiwick* (blog). April 9, 2012. The American Society of Cinematographers. www.theasc.com/blog/2012/04/09/flannery-oconnor-andalusia-in-milledgeville.

Basselin, Timothy. *Flannery O'Connor: Writing a Theology of Disabled Humanity*. Waco, TX: Baylor University Press, 2013.

Baumgaertner, Jill P. *Flannery O'Connor: A Proper Scaring*. Chicago: Cornerstone, 1988.

Beckett, Thomas. *The Unnamable*. London: Faber & Faber, 2012.

Bedoyere, Michael de la. *The Life of Baron von Hügel*. London: J. M. Dent & Sons, 1951.

Bieber Lake, Christina. *The Incarnational Art of Flannery O'Connor*. Macon, GA: Mercer University Press, 2005.

Bloesch, Donald. *Essentials of Evangelical Theology*, vol. 2. New York: Harper-Collins, 1978.

Brinkmeyer, Robert. *The Art and Vision of Flannery O'Connor*. Baton Rouge: Louisiana State University Press, 1989.

———. "'Jesus, Stab Me in the Heart!': *Wise Blood*, Wounding, and Sacramental Aesthetics." *New Essays on Wise Blood*, edited by Michael Kreyling. New York: Cambridge University Press, 1995.

Browning, Preston. *Flannery O'Connor: The Coincidence of the Holy and Demonic in O'Connor's Fiction*. Eugene, OR: Wipf & Stock, 2009.

Brueggemann, Walter. *The Prophetic Imagination*. 2nd ed. Minneapolis: Fortress, 2001.

Buechner, Frederick. *Wishful Thinking: A Theological ABC*. San Francisco: HarperSanFrancisco, 1993.

Burns, Marian. "The Ridiculous and the Sublime: The Fiction of Flannery O'Connor." PhD diss., University of Manchester, 1984.

Calvin, John. *Institutes of the Christian Religion*. Edited by John T. McNeill. Translated by Ford Lewis Battles. Louisville: John Knox Press, 1960.

Camille, Michael. "Simulacrum." In *Critical Terms for Art History*, edited by Robert S. Nelson and Richard Shiff. Chicago: University of Chicago Press, 1996.

Campbell, Stephen John. *The Cabinet of Eros: Renaissance Mythological Painting and the Studiolo of Isabella D'Este*. New Haven, CT: Yale University Press, 2004.

Cash, Jean. *Flannery O'Connor: A Life*. Knoxville: University of Tennessee Press, 2002.

Catechism of the Catholic Church. The Holy See. www.vatican.va/archive /ENG0015/_INDEX.HTM.

Catherine of Genoa, St. *Treatise on Purgatory: The Dialogue*. Edited by Charlotte C. Balfour, Helen Douglas-Irvine, and Battistina Vernazza. London: Sheed & Ward, 1946.

Chesterton, Gilbert Keith. *Orthodoxy*. New York: John Lane, 1908.

Cofer, Jordan. *The Gospel According to Flannery O'Connor*. New York: Bloomsbury, 2014.

Cole, Kevin. "Flannery Ain't No Baptist." *Keven Cole* (blog). http://kevers .net/baptistflannery.html.

Craig, Randall. *The Tragicomic Novel: Studies in a Fictional Mode from Meredith to Joyce.* Newark: University of Delaware Press, 1989.

Davies, Oliver. "Cosmic Speech and the Liturgy of Silence." In *Liturgy, Time, and the Politics of Redemption,* edited by Randi Rashkover and C. C. Pecknold. Grand Rapids: Eerdmans, 2006.

Davis, David Brion. "Violence in American Literature." *Annals of the American Academy of Political and Social Science* 364 (March 1966): 28-36.

Desmond, John. "Flannery O'Connor and the Displaced Sacrament." In *Inside the Church of Flannery O'Connor,* edited by Joanne H. McMullen and Jon P. Peede. Macon, Georgia: Mercer University Press, 2007.

Di Renzo, Anthony. *American Gargoyles: Flannery O'Connor and the Medieval Grotesque.* Carbondale: Southern Illinois University Press, 1993.

Drake, Robert. *Flannery O'Connor: A Critical Essay.* Grand Rapids: Eerdmans, 1966.

Drefcinski, Shane. "A Very Short Primer on St. Thomas Aquinas's Account of the Various Virtues." Paper delivered at Southwest Wisconsin Medieval and Renaissance Conference, Platteville, WI, September 22, 1999.

Driggers, Stephen G., Robert J. Dunn, and Sarah E. Gordon, eds. *The Manuscripts of Flannery O'Connor at Georgia College.* Athens: University of Georgia Press, 1989.

Ebrecht, Ann. "Flannery O'Connor's Moral Vision and 'The Things of This World.'" PhD diss., Tulane University, 1982.

Eco, Umberto. *The Aesthetics of Thomas Aquinas.* Cambridge, MA: Harvard University Press, 1988.

———. *The Name of the Rose.* New York: Harcourt, 1983.

Eggenschwiler, David. *The Christian Humanism of Flannery O'Connor.* Detroit: Wayne State University Press, 1972.

Elder, Walter. "That Region." *Kenyon Review* 17 (1955): 661-70.

Elders, Leo J. *The Metaphysics of Being of St. Thomas Aquinas in a Historical Perspective.* Leiden: E. J. Brill, 1993.

Eliot, T. S. *Murder in the Cathedral.* New York: Harcourt, 1964.

———. "Religion and Literature." In *Essays: Ancient and Modern.* New York: Harcourt, Brace, 1932.

Ferris, Sumner. "The Outside and the Inside: Flannery O'Connor's *The Violent Bear It Away*." In *The Critical Response to Flannery O'Connor*, edited by Douglas Robillard. Westport, CT: Greenwood, 2004.

Fodor, Sarah J. "Marketing Flannery O'Connor: Institutional Politics and Literary Evaluation." In *Flannery O'Connor: New Perspectives*, edited by Sura Rath and Mary Neff. Atlanta: The University of Georgia Press, 1996.

Gentry, Marshall Bruce. *Flannery O'Connor's Religion of the Grotesque*. Jackson: University Press of Mississippi Press, 1986.

Getz, Lorine M. *Flannery O'Connor: Her Life, Library and Book Reviews*. New York: Edwin Mellen Press, 1980.

Giannone, Richard. "Dark Night, Dark Faith: Hazel Motes, the Misfit, and Francis Marion Tarwater." In *Dark Faith: New Essays on Flannery O'Connor's "The Violent Bear It Away*," edited by Susan Srigley. Notre Dame, IN: University of Notre Dame Press, 2012.

———. *Flannery O'Connor and the Mystery of Love*. Urbana: University of Illinois Press, 1989.

———. *The Spiritual Writings of Flannery O'Connor*. Mary Knoll, NY: Orbis, 2003.

Gilman, Richard. "On Flannery O'Connor." *New York Review of Books*, August 21, 1969, 24-26.

Golden, Robert E., and Mary C. Sullivan. *Flannery O'Connor and Caroline Gordon: A Reference Guide*. Boston: G. K. Hall, 1977.

Gonzalez-Andrieu, Cecilia. *Bridge to Wonder: Art as a Gospel of Beauty*. Waco, TX: Baylor University Press, 2012.

Gooch, Brad. *Flannery: A Life of Flannery O'Connor*. New York: Little, Brown, 2009.

Gordon, Sarah. "Flannery O'Connor's *Wise Blood*." *Critique: Studies in Modern Fiction* 2 (Fall 1958): 3-10.

———. "Surface Matters in Flannery O'Connor's Fiction." Address given at Startling Figures Conference, Milledgeville, GA, April 16, 2011.

Greeley, Andrew. *The Catholic Imagination*. Berkeley: University of California Press, 2000.

Grenz, Stanley. *Theology for the Community of God*. Grand Rapids: Eerdmans, 2000.

Gretlund, Jan Nordby, and Karl-Heinz Westarp, eds. *Flannery O'Connor's Radical Reality*. Columbia: The University of South Carolina Press, 2007.

Hardon, John. "The Meaning of Virtue in St. Thomas Aquinas," in *Great Catholic Books Newsletter* 2, no. 1.

Hardy, Donald E. *The Body in Flannery O'Connor's Fiction: Computational Technique and Linguistic Voice*. Columbia: University of South Carolina, Press 2007.

Hart, David Bentley. *The Beauty of the Infinite: The Aesthetics of Christian Truth*. Grand Rapids: Eerdmans, 2004.

Hartman, Carl. "Jesus Without Christ." *Western Review: Journal of the Humanities* 17 (1952): 76-80.

Hewitt, Ava, and Robert Donahoo, eds. *Flannery O'Connor in the Age of Terrorism: Essays on Violence and Grace*. Knoxville: University of Tennessee Press, 2011.

Howe, Irving. "Flannery O'Connor's Stories." *New York Review of Books*, September 30, 1965.

Hyman, Stanley Edgar. *Flannery O'Connor*. Minneapolis: University of Minnesota Press, 1966.

Johnston, Robert. *Useless Beauty: Ecclesiastes Through the Lens of Contemporary Film*. Grand Rapids: Baker Academic, 2004.

Kant, Immanuel. *Critique of Judgment*. New York: Dover, 2005.

Kessler, Edward. *Flannery O'Connor and the Language of Apocalypse*. Princeton: Princeton University Press, 1986.

Kierkegaard, Søren. *Fear and Trembling and The Book on Adler*. Princeton, NJ: Princeton University Press, 1994.

———. *Practice in Christianity*. Edited and translated by Howard V. Vong and Edna H. Hong. Princeton, NJ: Princeton University Press, 1991.

Kilcourse, George. *Flannery O'Connor's Religious Imagination: A World with Everything Off Balance*. Mahwah, NJ: Paulist Press, 2001.

Kinney, Arthur F. *Flannery O'Connor's Library: Resources of Being*. Athens: University of Georgia Press, 1985.

Kirkland, William. "Baron Friedrich von Hügel and Flannery O'Connor." *The Flannery O'Connor Bulletin* 18 (1989): 28-39.

Kovach, Francis J. "Beauty as a Transcendental." In *New Catholic Encyclopedia*, 2:184-86. 2nd ed. Detroit: Thomson/Gale, 2010.

Kung, Hans. *Justification: The Doctrine of Karl Barth and a Catholic Reflection.* Philadelphia: Westminster Press, 1964.

Lewis, C. S. *The Abolition of Man.* New York: HarperCollins, 2001.

Magee, Rosemary. *Conversations with Flannery O'Connor.* Jackson: University Press of Mississippi, 1987.

Maritain, Jacques. *Art and Scholasticism.* London: Sheed and Ward, 1943.

Martin, Regis. *Flannery O'Connor: Unmasking the Devil.* 2nd ed. Ann Arbor, MI: Sapientia, 2005.

Mattson, Craig. "Keeping Company with Wayne Booth—A Review Essay." *Christian Scholar's Review* 38, no. 2 (2009).

May, John. "*The Violent Bear It Away*: The Meaning of the Title." *Flannery O'Connor Bulletin* 2 (1973): 83-86.

Mazur, Matt. "Wise Blood." *PopMatters: The Magazine of Global Culture,* July 20, 2009.

McEntyre, Marilyn. "Mercy That Burns: Violence and Revelation in Flannery O'Connor." *Theology Today* 53, no. 3 (Fall 1996): 330-38.

McMullen, Joanne Halleran, and Jon Parish Peede, eds. *Inside the Church of Flannery O'Connor: Sacrament, Sacramental, and the Sacred in Her Fiction.* Macon, GA: Mercer University Press, 2007.

Merton, Thomas. *The Literary Essays of Thomas Merton.* New York: W. W. Norton, 1985.

"Method and Methodology." Proz.com: The Translation Workplace. March 17, 2005. www.proz.com/kudoz/English/educ-ation_pedagogy/973883 -method_and_methodology.html.

Miller, Walter M. *A Canticle for Liebowitz.* New York: Bantam Books, 1978.

Milton, John. *The Complete Poetry and Essential Prose of John Milton.* New York: Modern Library, 2007.

Moltmann, Jürgen. *The Crucified God: The Cross of Christ as the Foundation and Criticism of Christian Theology.* Minneapolis: Fortress, 1994.

Montgomery, Marion. *Hillbilly Thomist: Flannery O'Connor, St. Thomas and the Limits of Art.* Jefferson, NC: McFarland, 2006.

Muller, Gilbert H. *Nightmares and Visions: Flannery O'Connor and the Catholic Grotesque.* Athens: University of Georgia Press, 1972.

Niebuhr, Reinhold. *Christ & Culture.* New York: Harper Torchbooks, 1951.

Oates, Joyce Carol. *New Heaven, New Earth.* New York: Vanguard, 1974.

O'Connor, Flannery. *Everything That Rises Must Converge*. New York: Farrar, Straus and Giroux, 1964.

———. *A Good Man Is Hard to Find*. New York: Harcourt, Brace, 1955.

———. *The Habit of Being: Letters of Flannery O'Connor*. Edited by Sally Fitzgerald. New York: Farrar, Straus and Giroux, 1979.

———. *Mystery and Manners: Occasional Prose*. New York: Farrar, Straus and Giroux, 1970.

———. *O'Connor: Collected Works*. New York: Literary Classics of the United States, 1988.

———. *A Prayer Journal*. Edited by William Sessions. New York: Farrar, Straus and Giroux, 2013.

———. *The Violent Bear It Away*. New York: Farrar, Straus and Giroux, 1960.

———. *Wise Blood*. New York: Harcourt, Brace, 1952.

Otto, Rudolf. *The Idea of the Holy*. Translated by John W. Harvey. 2nd ed. London: Oxford University Press, 1950.

Pannenberg, Wolfhart. *Anthropology in a Theological Perspective*. Edinburgh: T&T Clark, 1999.

———. *What Is Man?* Philadelphia: Fortress, 1970.

Parker, James. "The Passion of Flannery O'Connor." *The Atlantic*, November 2013, 36-37.

Penner, Myron. *The End of Apologetics: Christian Witness in a Postmodern Context*. Grand Rapids: Baker Academic, 2013.

Piggford, George. "Contentment in Dimness: Flannery O'Connor and Friedrich von Hügel." In *Ragione, Fiction, e Fede: Convegno internazionale su Flannery O'Connor*, edited by Enrique Fuster and John Wauck. Rome: Edizioni Santa Croce, 2011.

Polanyi, Michael. *Personal Knowledge*. Chicago: University of Chicago Press, 1958.

Prescott, Theodore, ed. *A Broken Beauty*. Grand Rapids: Eerdmans, 2005.

Ragen, Brian Abel. *A Wreck on the Road to Damascus: Innocence, Guilt, and Conversion in Flannery O'Connor*. Chicago: Loyola University Press, 1989.

Richter, David, ed. *Falling into Theory: Conflicting Views on Reading Literature*. 2nd ed. New York: Bedford/St. Martin's, 2000.

Richter, Klemens. *The Meaning of the Sacramental Symbols: Answers to Today's Questions*. Collegeville, MN: Liturgical Press, 1990.

Rilke, Rainer Maria. *Duino Elegies*. Translated by Edward Snow. New York: North Point Press, 2000.

———. *Where Silence Reigns: Selected Prose*. New York: New Directions Books, 1978.

Robillard, Douglas, ed. *The Critical Response to Flannery O'Connor*. Westport, CT: Greenwood Press, 2004.

Rogers, Jonathan. *The Terrible Speed of Mercy: A Spiritual Biography of Flannery O'Connor*. Nashville: Thomas Nelson Publishers, 2012.

Samway, Patrick. "Toward Discerning How Flannery O'Connor's Fiction Can Be Considered 'Roman Catholic.'" In *Flannery O'Connor's Radical Reality*, edited by Jan Nordby Gretlund and Karl-Heinz Westarp. Columbia: University of South Carolina Press, 2006.

Scarry, Elaine. *On Beauty*. Princeton, NJ: Princeton University Press, 1989.

Schmemann, Alexander. *For the Life of the World*. New York: St. Vladimir's Press, 1973.

Scott, R. Neil. *Flannery O'Connor: An Annotated Reference Guide to Criticism*. Milledgeville, GA: Timberlane Books, 2002.

Sessions, William. "La mia amica Flannery O'Connor, la grande scrittrice americana che non smise mai di 'perseguitare la gioia.'" *Tempi*, July 13, 2014. www.tempi.it/la-mia-amica-flannery-oconnor#.VIYkXHZphKp.

———. "Real Presence." In *Inside the Church of Flannery O'Connor: Sacrament, Sacramental, and the Sacred in Her Fiction*, edited by Joanne Halleran McMullen and Jon Parish Peede. Macon, GA: Mercer University Press, 2007.

Shaw, Mary Neff. "'The Artificial Nigger': A Dialogic Narrative." *The Flannery O'Connor Bulletin* 20 (1991): 104-16.

Shloss, Carol. *Flannery O'Connor's Dark Comedies: The Limits of Inference*. Baton Rouge: Louisiana State Press, 1980.

Smith, Christian. *Moral, Believing Animals: Human Personhood and Culture*. Oxford: Oxford University Press, 2009.

———. *What Is a Person? Rethinking Humanity, Social Life, and the Moral Good from the Person Up*. Chicago: University of Chicago Press, 2010.

Spivey, Ted Ray. *Flannery O'Connor: The Woman, the Thinker, the Visionary*. Macon, GA: Mercer University Press, 1995.

Srigley, Susan. *Flannery O'Connor's Sacramental Art*. Notre Dame, IN: University of Notre Dame Press, 2004.

Staton, Shirley. *Literary Theories in Practice*. Philadelphia: University of Pennsylvania Press, 1987.

Stephens, C. Ralph, ed. *The Correspondence of Flannery O'Connor and the Brainard Cheneys*. Jackson: University Press of Mississippi, 1986.

Stephens, Martha. *The Question of Flannery O'Connor*. Baton Rouge: Louisiana University Press, 1973.

Swafford, Andrew Dean. *Nature and Grace: A New Approach to Thomistic Ressourcement*. Eugene, OR: Pickwick Publications, 2014.

Sykes, John. *Flannery O'Connor, Walker Percy, and the Aesthetic of Revelation*. Columbia: University of Missouri Press, 2007.

Tate, Allen. *Essays of Four Decades*. Chicago: Swallow Press, 1968.

Taylor, Charles. *A Secular Age*. Cambridge, MA: Belknap Press of Harvard University Press, 2007.

———. *Sources of the Self: The Making of the Modern Identity*. Cambridge, MA: Harvard University Press, 1992.

Tennyson, G. B., and Edward Ericson, eds. *Religion and Modern Literature: Essays in Theory and Criticism*. Grand Rapids: Eerdmans, 1975.

Torrance, T. F. *The Christian Frame of Mind: Reason, Order, and Openness in Theology and Science*. Eugene, OR: Wipf & Stock, 2010.

Traynor, John. "Books." *Extension* 55 (July 1960): 25.

Turner, Victor. *The Ritual Process: Structure and Anti-structure*. Chicago: Transaction, 1969.

Underhill, Evelyn. *Mysticism: A Study in the Nature and Development of Spiritual Consciousness*. New York: Noonday Press, 1955.

von Hügel, Friedrich. *Essays and Addresses on the Philosophy of Religion*. 2 vols. London: J. M. Dent & Sons, 1921–1925.

———. *Letters to a Niece*. Chicago: Henry Regnery, 1955.

———. *The Mystical Element in Religion as Studied in Saint Catherine of Genoa and Her Friends*. 2 vols. 2nd ed. London: J. M. Dent & Sons, 1923. Reprint, 1999.

Wartenberg, Thomas, ed. *The Nature of Art: An Anthology*. 2nd ed. Belmont, CA: Thomson/Wadsworth, 2007.

Weigel, George. "Easter with Flannery O'Connor." *First Things*, April 16, 2014. www.firstthings.com/web-exclusives/2014/04/easter-with-flannery-oconnor.

Wood, Ralph. *Chesterton: The Nightmare Goodness of God*. The Making of Christian Imagination. Waco, TX: Baylor University Press, 2011.

———. *Flannery O'Connor and the Christ-Haunted South*. Grand Rapids: Eerdmans, 2004.

———. "God May Strike You Thisaway." In *Flannery O'Connor in the Age of Terrorism: Essays on Violence and Grace*, edited by Avis Hewitt and Robert Donahoo. Knoxville: University of Tennessee Press, 2010.

Zuber, Leo J., and Carter Martin, eds. *The Presence of Grace and Other Book Reviews by Flannery O'Connor*. Athens: University of Georgia Press, 1983.

Name Index

Names of fictional characters are in italics.

Scripture Index

STUDIES *in* THEOLOGY *and the* ARTS

IVP Academic's Studies in Theology and the Arts (STA) seeks to enable Christians to reflect more deeply on the relationship between their faith and humanity's artistic and cultural expressions. By drawing on the insights of both academic theologians and artistic practitioners, this series encourages thoughtful engagement with and critical discernment of the full variety of artistic media—including visual art, music, literature, film, theater, and more—which both embody and inform Christian thinking.

ADVISORY BOARD:

- **Jeremy Begbie,** professor of theology and director of Duke Initiatives in Theology and the Arts, Duke Divinity School, Duke University

- **Craig Detweiler,** professor of communication, Pepperdine University

- **Makoto Fujimura,** director of the Brehm Center for Worship, Theology and the Arts, Fuller Theological Seminary

- **Matthew Milliner,** assistant professor of art history, Wheaton College

- **Ben Quash,** professor of Christianity and the arts, King's College London

- **Linda Stratford,** professor of art history and history, Asbury University

- **W. David O. Taylor,** assistant professor of theology and culture, director of Brehm Texas, Fuller Theological Seminary

- **Gregory Wolfe,** publisher and editor, *Image*

- **Judith Wolfe,** lecturer in theology and the arts, Institute for Theology, Imagination and the Arts, The University of St. Andrews

Finding the Textbook You Need

The IVP Academic Textbook Selector
is an online tool for instantly finding the IVP books
suitable for over 250 courses across 24 disciplines.

ivpacademic.com